High Renaissance Art in St. Peter's and the Vatican

High Renaissance Art in

AN INTERPRETIVE GUIDE

George L. Hersey

The University of Chicago Press

Chicago and London

St. Peter's and the Vatican

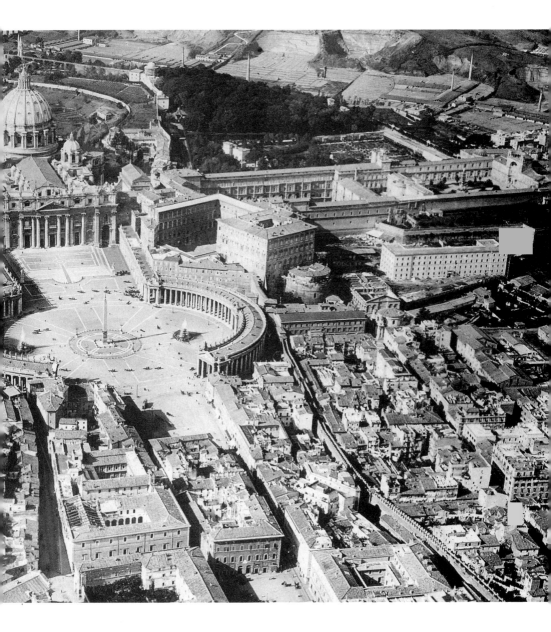

George L. Hersey is professor in the Department of the
History of Art at Yale University.

The University of Chicago Press, Chicago 60637
The University of Chicago Press, Ltd., London
©1993 by The University of Chicago
All rights reserved. Published 1993
Printed in the United States of America

02 01 00 99 98 97 96 95 94 93 1 2 3 4 5 6

ISBN (cloth): 0-226-32781-7
ISBN (paper): 0-226-32782-5

Library of Congress Cataloging-in-Publication Data

Hersey, George L.
 High renaissance art in St. Peter's and the Vatican : an
interpretive guide / George L. Hersey.
 p. cm.
 Includes bibliographical references and index.
 1. Art, High Renaissance—Vatican City. 2. Art, Italian—Vatican
City. 3. Bramante, Donato, 1444?–1514—Criticism and
interpretation. 4. Michelangelo Buonarroti, 1475–1564—Criticism
and interpretation. 5. Raphael, 1483–1520—Criticism and
interpretation. 6. Art patronage—Vatican City. I. Title.
 N6920.H45 1993
 709'.456'3409031—dc20 92-20649

To Donald and Rachel, James and Jane

Contents

Preface

Every day thousands of people visit St. Peter's and the Vatican. Some do so for religious reasons, others for the art. Still others come, I suppose, simply because not to have seen it all would mean a life less fully lived. And, of course, these and the other possible reasons can overlap. Yet if, as I have done, you spend much time there and begin to watch the crowds, you note that many people, though clearly impressed, seem bewildered. So overwhelming is the abundance that, even among the most earnest, the end result is often a kind of groggy wonder.

Those with good guidebooks or good guides do better. But even they usually learn only such things as that Raphael's *Transfiguration* (fig. 102) is "superb," "one of his last works" or that the Sistine ceiling has recently been cleaned and is now whiter and brighter than it used to be (fig. 138). The guides, guidebooks, and (when they exist) labels give dates, names, subjects, and a certain amount of lore but little else. And even then, much, most, has to be omitted. A complete tour of St. Peter's and the Vatican, fully explicated as to the history and meaning of each tomb, altar, statue, and picture, would take just about forever.

It is better, therefore, to look carefully at a few things—to follow a thread through the labyrinth, one that supplies new conjunctions and discoveries even as it allows the visitor to ignore, for the moment, many treasures. I propose to conduct such a tour. It will concentrate on three great artists—Bramante, Michelangelo, and Raphael, and on four great papal patrons—Julius II, Leo X,

Clement VII, and Paul III. The book begins with an introduction on the Renaissance papacy. There follow chapters on the visual personality that each pope fashioned for himself, on the new basilica of St. Peter's, on the Cortile del Belvedere and relevant objects in the Vatican Museums, on Raphael's Stanze, on Michelangelo's Sistine Ceiling and *Last Judgment*, on Raphael's Logge and, as a suitable finale, on the vicissitudes of Michelangelo's planned tomb for Julius II. Except where otherwise indicated, all works are located in the Vatican or St. Peter's. Photographs not otherwise credited are reproduced courtesy of the museum in question.

I have included a few works outside the Vatican, notably certain tombs in Santa Maria del Popolo, Santa Maria sopra Minerva, and San Pietro in Vincoli. And I discuss a number of papal portraits found in collections outside Rome—things that are too closely linked to Vatican events to leave out. On the other hand I have not considered three Vatican monuments of the High Renaissance that are currently difficult for the ordinary tourist to visit. These are the Cappella Paolina by Antonio da Sangallo the Younger (1540; with Michelangelo's two late frescoes *The Conversion of St. Paul* and the *Crucifixion of St. Peter*, 1542–49; fig. 1), the Sala Regia (begun in 1540 also by Sangallo, completed 1573, stuccoes by Perino del Vaga and Daniele da Volterra, frescoes by Vasari and others; fig. 2). The third work that I omit, reluctantly, is the Loggia and Stufetta of Cardinal Bibbiena with its scenes from the life of Venus by Raphael pupils. While Raphael's Logge are also closed they can be visited if an advance request is made (Information Desk, entrance to the Vatican Museums). I have therefore given them a chapter. Everything else (given the usual Italian problems with strikes, etc.) is open to the public.

At the end of the book is a list of further reading. Writings in English are emphasized, but there are a few non-English items that have shaped my own ideas. This of course is only a tiny part of the huge specialist literature that exists, a literature written in many languages and scattered through many publications. In it the tendency has been to consider each theme, person, and program separately. The advantage of a more general volume like this is that the group identity of these achievements, and their common meanings both conscious and otherwise, can be brought out. I am presuming that my readers would like something more readable and enlightening than an ordinary guidebook and more accessible than the professional scholarship. I have tried to write a text for the beginning student and educated general reader. Yet I secretly hope that even specialists will find new thoughts in my pages.

Like all guidebooks this is intended for readers who are, or plan to be, on the spot. Thus the illustrations emphasize comparative material, plans, and the like, though I also illustrate most of the things you will be standing in front of. The text ought to be read before going to the places discussed, since most of these are so crowded and noisy. But bring the book along. It will be needed for reference and recognition. I do not seek out stylistic comparisons—these belong to slide lectures and exhibitions. For the moment iconography is the thing. We will be looking mainly at sculptured and painted populations. The first question has to be, who precisely are these men and women, these heroes so consciously basking in their own beauty and splendor? Why were they cho-

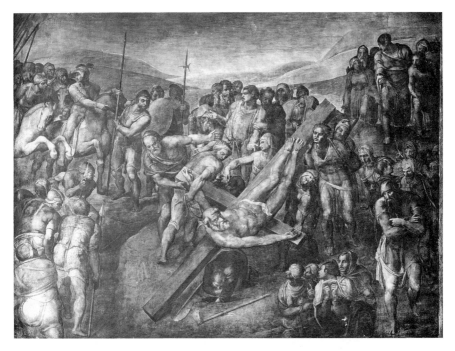

1. Cappella Paolina. Michelangelo, *The Crucifixion of St. Peter*, 1542–49. Alinari/Art Resource, N.Y.

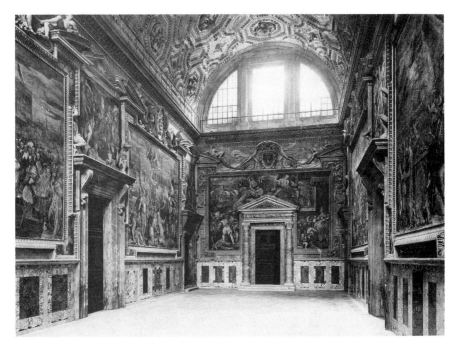

2. Sala Regia, 1540–73. Architecture by Antonio da Sangallo the Younger, stuccoes by Perino del Vaga and Daniele da Volterra, frescoes by Giorgio Vasari and others. Alinari/Art Resource, N.Y.

sen and grouped as they are? After all, if we are the visitors these people are our hosts. We should know their names and deeds.

Finally, the book is personal. It contains opinions and speculations. It is not a digest of received ideas. I stand at the visitor's side with (I hope) a fresh and consistent viewpoint. I also let others talk, e.g. the splendid contemporary historian Francesco Guicciardini, the humanist Jacopo Sadoleto interpreting the newly discovered *Laocoön* (fig. 84) and the Augustinian friar Giles of Viterbo (excellently studied by J. W. O'Malley), whose little 1507 book on Julius's policies is so fascinatingly soaked in the atmosphere of these years.

Acknowledgments

would like first of all to thank the many generations of Yale students, graduate and undergraduate, who have served as sounding boards for, and often contributors to, the ideas expressed herein. For years my colleagues on the faculty have also suffered my various interpretive *démarches*, have offered corrections and extensions to my thoughts, and have generally been all that colleagues should be.

I want particularly to thank Thomas Greene, who as my colleague in a course on the High Renaissance in art and literature has been an inspiring and constant companion. Many others have been helpful beyond the call of scholarly duty. Creighton Gilbert deserves particular thanks for having gone through the manuscript with a fine-tooth comb. With his unparalleled knowledge of the subject he has untangled many a snarl. I owe a proportionally equivalent debt to Gloria Kury, Charles McClendon, Philip Jacks, and Alvin L. Clark, Jr.; John W. O'Malley, S.J., has done the same from the point of view of theology and Church history. Others who have been of specific assistance are: Jodi Cranston, Jeffrey Collins, Chad Coerver, Richard Field, Kathleen Weil-Garris Brandt, James Hersey, Dieter Graf, Helen Chillman, and two expert but anonymous readers for the University of Chicago Press. I am also grateful to Karen Wilson, John McCudden, Candace Rossin, and Dennis Anderson, who made the manuscript's transformation into a book so pleasant. I have finally benefited from a welcome and indeed essential sojourn at the American Academy in Rome whose director, Joseph Connors, was helpful and encouraging in every respect.

1 Introduction: "The Liberation of Italy"

Here is our Italy: though considering the pleasure she takes in being tyrannized I would call her neither rightly ours, nor Italy.

Giles of Viterbo, 1507

he achievements we will be looking at form the backbone of Italian High Renaissance painting, sculpture, and architecture. They have been endlessly influential in subsequent art. What is less often noted is that the politics and ideology behind these great works was as ambitious as the artistic instinct that guided them. Let us take a look.

First, a paradox. Nowadays we assume, at the very least, that it was all worth doing. Many people at the time, however, considered Julius's plans, especially those for rebuilding St. Peter's, to be a monumental vanity. Some, like the great Dutch humanist, Erasmus (fig. 3), objected on the grounds of expense and false pride; others held that Old St. Peter's (built by Constantine, first Christian emperor of Rome) was too holy to tear down and that any rebuilding would disturb the tomb of Peter himself, first pope and prince of the apostles, which lay beneath Constantine's basilica.

But Julius II was hardly dismayed by these complaints as he summoned the greatest artists of the age to Rome. Nor did this extraordinary man limit his commissions to the city itself. He built the archbishop's palace at Avignon, constructed model fortresses at the Italian towns of Grottaferrata, Ostia (fig. 4), and Civitavecchia, and provided the legendary house of the Blessed Virgin (which centuries before had been miraculously transported to the Italian city of Loreto) with a new architectural setting. Nor was his patronage limited to the visual arts. At Fano he established the first printing-house for the Arabic language. In the Vatican he instituted the Cappella Giulia,

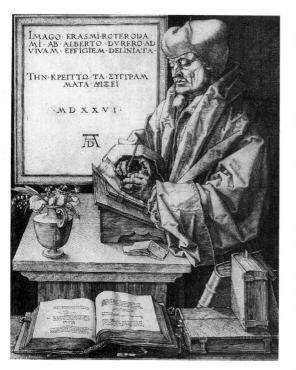

Within the image:

```
IMAGO· ERASMI·ROTERODA·
MI· AB·ALBERTO· DVRERO·AD
VIVAM· EFFIGIEM·DELINIATA·

ΤΗΝ· ΚΡΕΙΤΤΩ· ΤΑ· ΣΥΓΓΡΑΜ
ΜΑΤΑ· ΔΙΞ ΕΙ

·MDXXVI·
```

3. Albrecht Dürer, portrait of Erasmus, 1526.
Photo Yale Art Gallery.

a choir famed for its liturgical music. And
he was the friend and admirer of human-
ists such as Sigismondo de' Conti, a chron-
icler of Julius's pontificate and a man of the
highest culture. The renowned humanists
Jacopo Sadoleto and Pietro Bembo were
part of his circle.

The Setting

What was Julius like? What are the roots
of his greatness as a patron, and how does
that greatness appear, if it does, in the po-
litical, military, and religious aspects of his
career? Francesco Guicciardini, a brilliant,
pessimistic contemporary, says the pope
had a "grand, indeed vast spirit, impatient,

precipitous, open, liberal." Contemporaries
also agree that he was a man of almost un-
believable ambition, for himself and for
the Church.

Ambition for the Church's welfare in
Renaissance Italy, if one happened to be
pope, consisted of playing the game of
politics. The game—one, let us note, not
without agony and death—was conducted
mainly through the formation of tempo-
rary military alliances. Italy in the six-
teenth century was not a single country
but a complex of dozens of states. These,
singly or in groups, would seek out agree-
ments with the three superpowers of
Europe—the Holy Roman Empire, France,
and Spain—in order to threaten or if
necessary defeat, militarily, their own local
and regional enemies. The superpowers
played this game because so many of the
Italian states were rich political prizes. An
Italian town and its adjacent region could
thus change hands frequently, and perhaps
even go from French to Spanish, or from
Spanish to imperial status (i.e. become
part of the Holy Roman Empire), several
times in a few years. The shifts were
achieved partly through political agree-
ments and partly through military occupa-
tion; through bribery, assassination, or
marriage; or through some combination of
these. The bloodthirsty picture of Italian
political and court life we get in Elizabe-
than and Jacobean drama is not all that
exaggerated.

Below the three superpowers in impor-
tance, but ranking much higher than
the smallest Italian states, were the five
largest and most populous Italian political
entities: the Kingdom of Naples, which
occupied the whole southern half of the
peninsula plus the island of Sicily; the
Duchy of Milan, which included all of
Lombardy; the Republic of Venice, which

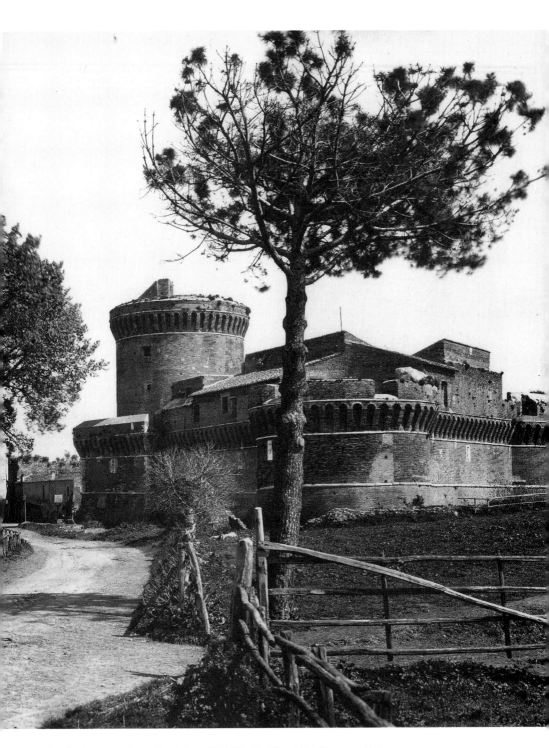

4. The fortress at Ostia. Baccio Pontelli, 1483–86. Alinari/Art Resource, N.Y.

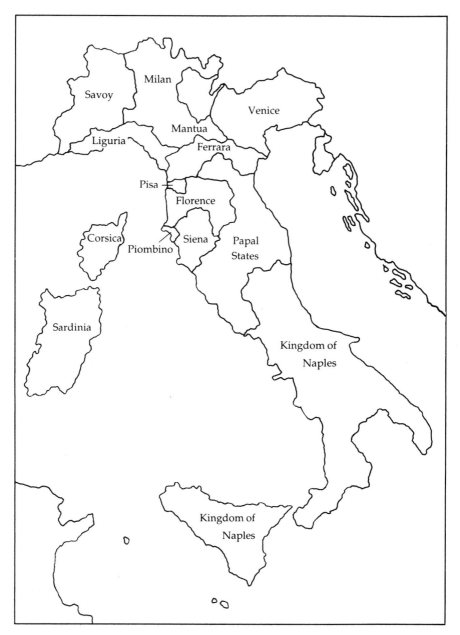

5. Map of Italy, 1500–1532. Author.

ruled a considerable amount of territory on both shores of the Adriatic; the Republic of Florence, which ruled most of Tuscany; and the Papal States, which consisted of various towns and territories throughout central Italy (fig. 5). These five medium powers, so to call them, were constantly passing in and out of submission to the superpowers. They also fought among themselves to annex smaller states. Put as simply as possible, it was papal policy during the first three decades of the sixteenth century to raise the Papal States to superpower status and rid the peninsula of Spanish, French, and imperial armies.

Julius's ultimate aim, indeed, was that the popes should rule a major part of the Italian peninsula. But the popes had a wider claim than this, for they claimed spiritual sovereignty over all Western Christians and, theoretically at any rate, over the whole of the earth. Papal policy thus had a visionary scope well beyond that of any mere nation-state. And the popes' ability to excommunicate their political enemies was no small weapon either. On the other hand they lived in constant fear that other rulers, political or ecclesiastical, might summon general councils of the Church that would claim the power to depose them, or might seek to reform the Church so as to limit or abolish papal independence.

The publicly proclaimed alliances by which the political game was played were often accompanied by secret ones. These could be the exact opposite of their public counterparts. Indeed the prudent ruler usually maintained several contradictory alliances at once. Thus in 1526 Francis I of France (fig. 6) signed a peace accord with the Holy Roman Emperor, Charles V (fig. 11). But almost at the same time he signed another accord, the League of Co-gnac, with the pope, Florence, Venice, and Milan *against* the emperor. He could then honor whichever treaty he wished. Most other rulers did the same. In the sixteenth-century Italy, and to a lesser extent all of Europe, was a dense network of alliances, open and secret, often contradictory, always shifting into new combinations as each player strove to achieve his goals at the expense of the others.

The military situation was a virtual celebration of instability. Troops were paid in plunder. If not paid they often refused to fight or else went over to the enemy. A well-heeled general in a besieged city could escape relatively unscathed by paying a "fine" to the besiegers. Bargaining was of course involved. Thus Leo X, when his troops surrounded Urbino, let Francesco Maria della Rovere, the duke (fig. 7), abandon his capital and take his library (books formerly housed in the Vatican's Stanza della Segnatura) and artillery with him. This allowed Leo's nephew Lorenzo II de' Medici to take over the duchy. But by the terms of the agreement the pope had to supply back pay both to his own army and to Francesco Maria's!

In actual warfare the emphasis was on pageantry as much as fighting. Billowing uniforms with fantastic plumed helmets, banners, and gorgeous weapons that looked like huge pieces of jewelry were as important as tactics and strategy—or, better, the showy accoutrements actually played a role in both. War was considered glorious—the most difficult and important activity men could engage in. It was an art form, a way of life. Julius loved the colorful campaigns that surged up and down the peninsula in those years and often participated personally. Several of the subjects in Raphael's Vatican Stanze depict papal battles and victories (figs. 120, 126), as do

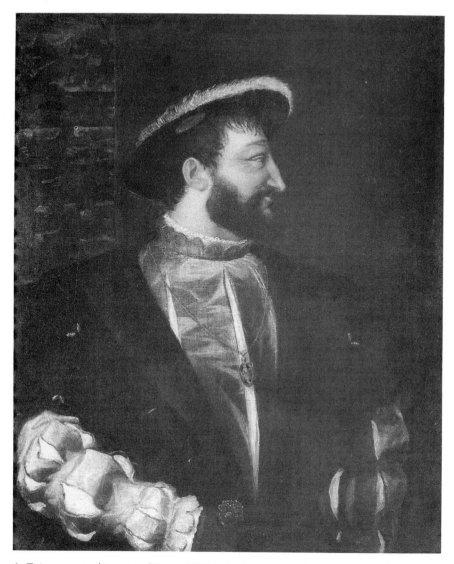

6. Titian, portrait of Francis I of France, 1538. Paris, Louvre. Giraudon/Art Resource, N.Y.

the exquisite medals made by sculptors of the period.

But in the early years of the sixteenth century these pageant-wars were being replaced by a grimmer kind in which the northerners excelled the Italians. Julius himself complained of this: "in Italy, con-

sumed for many years by the imagery of war more than by war itself, there is not the nerve to withstand French ferocity." The same could be said of the Spanish and imperial threats. France and Spain had become modern nation-states in part because they built up large armies armed with

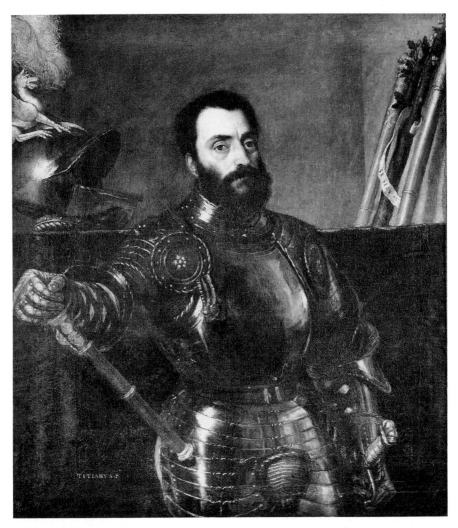

7. Titian, portrait of Francesco Maria della Rovere, begun 1536. Florence, Uffizi. Alinari/Art Resource, N.Y.

weapons unheard-of in Europe until a few decades earlier. By Julius's time the fortifications designed to counteract the new types of artillery had reached an unprecedented scale. The major European nations were providing themselves with these things. But Italy, though it had pioneered both the new artillery and the new forts, was not a nation-state and had no great army. Nor did Italian military leaders, many of them *condottieri* who hired themselves out to the highest bidder, have a high opinion of their own countrymen as fighters. Swiss—cf. the Swiss guards at

today's Vatican—and Germans were preferred. It is a strange fact that in the Italian wars of the sixteenth century so many of the soldiers, on whatever side, were foreigners.

Julius participated to the full in this political and military culture. He was not really a humanist or intellectual, despite his relationships with cultivated men and even though he knew parts of the *Aeneid* by heart and had a large personal library housed in Raphael's Stanza della Segnatura. To some extent he would have fitted in with people in our own more recent history like J. P. Morgan and Henry C. Frick, formidable figures from the golden age of American art collecting. Julius certainly would have approved of Frick's sending in an attack force of private police against his striking steelworkers. But he would probably have expressed a certain pity for Frick, and Morgan, too, thinking that for all the money they spent on art and architecture at the turn of the twentieth century the results were hardly comparable to what he had achieved at the turn of the sixteenth.

It is Guicciardini who records Julius's remark about Italians preferring the imagery of war to war itself. And there is no better way to look at the life and times of Julius and his successors than through Guicciardini's eyes. He was one of the first great modern historians. Though a man of the Renaissance, he shunned the elaborate Latin rhetoric of such contemporaries as Jacopo Sadoleto. He wrote a vigorous contemporary Italian. His *Historia d'Italia* is to a great extent an eyewitness's and even a participant's account.

Guicciardini was modern in another sense. He eschewed the intricate cyclical patterning that historians of his age so often employed, and which we will see in the writings of Giles of Viterbo. The imposition of such patterns tends to make history rigidly deterministic. Men and women become actors in detailed scenarios written by God. Like many other preachers of his time, too, Giles practiced what is called "epideictic" (showing forth, displaying) oratory, a style of speechmaking that often depended heavily on visual imagery, which continually asked the hearers to look, see, contemplate, reflect, or set some subject before their eyes. In contrast to the cyclical historians Guicciardini made the human leaders of his time fully responsible for their acts. Individuals—even popes and kings—are portrayed with thoroughly human failings. The glorification and triumphalism that we see in so much Renaissance historical writing is absent in Guicciardini. Indeed, the grand thesis of Guicciardini's book is that in attempting to unite the powers of prince and pope, and in trying to make divided Italy a modern nation-state, Julius was attempting the impossible; that, himself obsessed with such dreams, and having infecting his two weakhearted successors, Leo X and Clement VII, with these overreaching aims, Julius became the instrument of Italy's downfall. Ironically, then, the political and religious background of Julius's epochal patronage of Michelangelo, Raphael, and Bramante is a tale of gradual failure and defeat.

Julius's Life

Julius II was born Giuliano della Rovere in Albissola, a Ligurian town near Savona, on December 5, 1443. The family had already produced a pope, Giuliano's uncle, Sixtus IV, whose reign (1471–84) spanned Giuliano's twenty-eighth through forty-first years. The youth received a Franciscan education

but did not, apparently, join the order. His rise was rapid. In accordance with the custom of the time he held many ecclesiastical posts at once, collecting their salaries and revenues but not having to perform their duties on a regular basis. In 1472 he became bishop of Grottaferrata and ten years later archbishop of Bologna. His other sees included Vercelli, Avignon, Sabina, and Carpentras. He was also cardinal-bishop of Ostia, which made him the highest-ranking member of the College of Cardinals, and which became his stronghold in his battles with the Borgias. Under Sixtus IV he served as papal legate to the Marches on Italy's central east coast, and in 1476, and again in 1480–82, he was papal legate to France, where his diplomatic skill helped resolve the succession of the Duchy of Burgundy. In 1474 he quelled a revolt against papal rule in Umbria.

In Rome, meanwhile, Giuliano was appointed cardinal-priest of the church of the Santi Apostoli and of San Pietro in Vincoli (St. Peter in Chains). He flourished during his uncle's papacy. He flourished further under Sixtus's successor Innocent VIII (1484–92), who in large part owed his election to Giuliano. Indeed during Innocent's reign Giuliano was hailed as *"papa et plusquam papa,"* pope and more than pope. But events earned him the enmity of the Arágonese dynasty then ruling the Kingdom of Naples, and of the Orsini, one of the most powerful Roman families. Nor were his early military exploits always successful. Those in the Marches in 1487 threatened disgrace. Nonetheless, supported by Venice and Milan, Giuliano in the end sustained his cause. On his return to Rome he was given a triumphal procession. He was developing a taste for pageantry that became famous.

Only in 1492, when Rodrigo Borgia, a Spaniard, was elected as Alexander VI, did Giuliano's fortunes take a turn for the worse. The reasons for the ill will between the two men seem to lie in the intrigues that accompanied the papal elections of 1484 and 1492. In the latter Giuliano bitterly fought Borgia's candidacy. So great was the Spaniard's anger, in return, that Giuliano had to take refuge at Ostia. Ten years earlier he had fortified the port there as a defense against the Turks. Now it was his haven (but also prison) from harassment by Alexander, whom he managed to prevent from capturing it. The fort itself (fig. 4), designed by Baccio Pontelli, was something of a milestone in the development of military architecture and constitutes an early hint that the future pope would be an architectural and artistic innovator.

In 1494, after a short reconciliation, the enmity between Giuliano and the new pope turned mortal. Giuliano fled to France. There he urged Charles VIII to go ahead with a projected invasion of Italy. His strategy was twofold. After Charles's army had invaded and conquered the peninsula, Giuliano and various like-minded cardinals, with French backing, would summon a council of the church to depose Alexander. The secret corollary for Giuliano, in all probability, was that he himself would then be elected pope by the council.

It was in these years that Giuliano's obsession with imprisonment set in. We have seen that his titular church was San Pietro in Vincoli. This church contains, and is dedicated to, the chains that bound St. Peter in Jerusalem and a twin set that bound him in Rome. Julius saw himself as another Peter, locked up by a pope he considered to be little less than the Antichrist. Indeed Giuliano, a man of extremes, saw the whole Church as Alexander's captive. And

Italy, too, he saw in chains, oppressed and tortured by Alexander's Spanish family. In 1494 the Borgias, officially or unofficially, governed much of the papal territory. Giuliano even issued a medal depicting the Church as bound and gagged, and celebrating himself as its *tutor* (guardian) and appointed liberator (fig. 23). As pope he continued to see the Church chained, this time by the forces of heresy, barbarism, and heathenism. It is hardly surprising that one of the frescoes in the Vatican stanze represents the miracle of St. Peter's liberation from prison (fig. 119).

Peter's first imprisonment was in Jerusalem. But Rome, for many, was really a metaphor for Jerusalem—Jerusalem, the site of the Jews' temple which in turn became the prototype of the Christian church building. Thus the poet Nagonius celebrated Julius II as the "expeller of Jerusalem's enemies" in the Bologna campaign of 1506. Papal military headquarters, wherever they happen to be, *are* Jerusalem to Nagonius, and the pope's enemies are always metaphorical Babylonians, Persians, Egyptians, and other captors of the Hebrews. Girolamo Bardoni, in still another poem, will have the city of Jerusalem herself address Leo X in this vein. Rome-as-Jerusalem will also loom large in the design of the new St. Peter's.

For Giuliano, then, Charles VIII would come to Italy not for his own purposes but as the instrument of its true liberator, Giuliano della Rovere. There were precedents for this, and Giuliano knew them well. He urged the French king to imitate his great ninth-century predecessors, Pépin le Bref and Charlemagne. Pépin, he said, had conquered towns such as Urbino and donated them to the popes. The donations were confirmed by Pépin's successor, Charlemagne, who in turn gave even

larger Italian territories, including all of Giuliano's native Liguria, to the Church to rule. In return, the pope of the time, Leo III, bestowed on Charlemagne and his successor-kings of France, the epithet "Most Christian." Some of these medieval precedents for Giuliano's policy are depicted in the Vatican Stanze. But of course French aims in invading Italy now were different from Giuliano's. The French wished, certainly, to lessen the power and influence of Spain. But they also wanted to weaken the pope. They even questioned his right to secular rule and especially his right to appoint the bishops of French dioceses.

But it is Giuliano della Rovere who concerns us. His aim was to use one superpower to get rid of the other: once France had been used to remove Spain, and had itself been removed, Giuliano would unify the frail Italian coalitions into a single mass, a mass to be unified by a single will, namely, the Italians' enmity for their former oppressors. Then something approaching a united Italy, under Giuliano della Rovere as pope, would come into being.

With Giuliano's support, then, the French army conquered most of Italy within a decade. Furthermore, by behaving as occupying armies usually do behave, the French managed to bring off Giuliano's plan to unite the peninsula, or most of it, in common hatred of the invaders. On the other hand no Church council was convoked to unseat Alexander. Instead, he conveniently died in 1503. One cannot help but reflect that from Giuliano's viewpoint it was far easier to get rid of Alexander by having him poisoned than by having him deposed. Guicciardini writes that the day after the pope's death his body turned "black, swollen, and extremely disgusting—manifest signs of poison." Alex-

ander's son, Cesare Borgia, a cardinal and captain general of the pontifical armies, was poisoned at the same meal but managed to survive. Whoever the poisoner was, it was not Giuliano della Rovere, though it could have been one of his agents. For by this time he was back in France. Also by 1503, Charles VIII was dead and the future pope was at the court of the new king, Louis XII. Louis was continuing the French occupation of Italy. His troops actually ringed Rome at the time of Alexander's death.

With Alexander gone Giuliano was free to return to the papal city. But here a new roadblock appeared. The College of Cardinals was divided between French, Spanish, and Italian factions. Giuliano's aim, of course, was to see to it that, failing his own election, the next pope would at least not be Spanish or French; either outcome would have ruined his plans. A last-minute compromise candidate was the cardinal of Siena, Francesco Piccolomini. He had the double advantage of being Italian and being on the point of death. With Giuliano's support, therefore, Piccolomini became Pius III. By pushing his candidacy Giuliano might also have wished to allay any suspicions that he had had a hand in Alexander's death. In any event the new pope duly died, from a wrongly treated leg ulcer, after reigning less than a month.

Then, in the last weeks of October 1503, by a piece of consummate guile too complicated to describe here, Giuliano managed to gain the support of Cesare Borgia, the son of his arch-enemy Alexander VI. Cesare was still the most powerful of the Spanish cardinals. The alliance between Giuliano and Cesare united the Spanish and Italian factions against the French. Giuliano was now the favored candidate. Even the French did not really ob-

ject to him; they still presumed he was their friend. How wrong they were! Anyway, so it was that on October 31, 1503, about a month short of his sixtieth birthday, Giuliano della Rovere became pontifex maximus.

The Reign of Julius II

The pontificate of Julius II, though brilliant beyond most others, was tragic—for Rome, for Italy, for Europe. It quickly became apparent that the new pope was not only a warrior and politician but a visionary. Before long he was being called a saint. The continual horror and treachery of the times made theologians think of the biblical apocalypse that describes the last days of humankind. The Book of the Apocalypse (in the Protestant Bible, Revelation) was widely interpreted as a prophecy directed right at Renaissance Italy. It looked forward to a time, perhaps an immediate time, when there would be a great battle, Armageddon, between the forces of Christ and those of the Antichrist. All men on earth would fight in one or the other of the two great armies. After the forces of the Antichrist were slain, Christ and his saints would return to rule during the millennium, a thousand-year finale to humanity's earthly sojourn. This would be followed by the last judgment, in which the dead would rise and be judged, the blessed going to heaven and the damned to hell. This, of course, is the subject of Michelangelo's great fresco on the Sistine Chapel's altar wall (fig. 181).

So much is traditional Christian doctrine. What was new in Renaissance Rome was that people were gradually waking up to the globe's actual size and the full extent of the earth's population. The existence and extent of the New World, and the true

extent of Asia and Africa, were only now being more correctly estimated. The last days of humanity thus loomed toward Renaissance Rome on an unwonted scale.

One preacher and thinker at the papal court who was a major exponent of these ideas was Giles of Viterbo (1469–1532). Giles was Prior General of the Augustinians and a courtier-friar who may have helped work out the iconographical schemes of the Sistine ceiling and some of Raphael's Stanze. In any event in 1507 Giles preached a sermon, in Julius's presence, celebrating the discoveries of Manuel I of Portugal, whose captains had recently sailed to India and Ceylon. Giles embedded the Portuguese discoveries in an elaborate cyclical theory of history according to which Julius's own reign becomes a preamble to a great new Christian age, perhaps the Millennium itself. His sermon portrays the pope as one of the great men of history—a Moses, a Socrates, a Peter. "You," says Giles, who come "after more than 250 popes, after 1,500 years, after so many Christians and emperors and kings, you and you alone. . . will build the roof of the most holy temple so that it reaches heaven." Giles means the new St. Peter's, but also that greater church which is humanity summoned en masse to Rome as the New Jerusalem, to Sion, to the fulfillment of the visions of the Apocalypse.

Julius's age, continues Giles, is in fact the last of history's golden ages. It is the repetition and summation of the great ages of Greece and Rome. Not only is the pope Peter's successor, he is the heir of classical civilization. He will be Christ's field marshal and viceroy during the battle to come. The contemporary battles of the papal armies are *modelli*, miniature foretastes, of the apocalyptic war that will end all wars. This idea was reinforced, in Giles's ac-

count, by early Christian history and the policies of the Roman emperors, wherein a single empire of Christ grew out of the emperors' pagan empire. The symbol of this vast central growth in human history, for Giles, is the family emblem of the Della Rovere, the oak, which has one massive trunk rooted in the earth of the past and whose branches fill the heavens that are the future (fig. 8). That emblematic tree, read rightly, is the prophet of Julius's future glory.

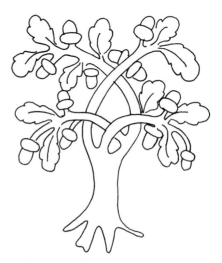

8. The Rovere Oak. Author.

To contemporary Europeans, for example, Christopher Columbus, the discovery of the New World was a special sign from God that Armageddon was imminent. Islam's satanic forces were massing to the east. It is for this very reason that God now adds to the armies of Christ by opening new western lands to Christian enterprise. Giles points out that Manuel—his name in Latin being Emmanuel, the Savior, one of Christ's own names—is among the first of the pope's viceroys to deliver these new peoples to the spiritual

sovereignty of the Holy See. This is Julius's favorite theme, the liberation of Italy, transformed into the liberation of the New World.

Giles never questions the idea that Europe was the destined owner of the rest of the earth. It was taken for granted that European kings, under the pope, *should* rule the globe. (While this view is no longer generally held, the present pope, John Paul II, has said that the nature of European history is such that Europe should lead the world.) But the new Renaissance empire was constructed in a spirit very different from the liberal, adaptive, ecumenical doctrines of the present-day Roman Catholic Church. To the Renaissance popes there was only one true religion, the Catholic faith. No human soul could hope to be saved outside it. Non-Catholics, it was thought, would either burn in hell forever or pass through terrible punishments in purgatory before entering heaven. Given this belief, along with the need to augment Christ's armies in the face of an impending showdown, conversion, by any means, was not only justified but a moral duty. The Christian generals who imposed this choice looked upon themselves as heroes. Every new soul added to Christ was one subtracted from the Antichrist. In this context it is quite proper not only to baptize the new peoples but to force them to contribute offerings, of labor or wealth, to the faith that was their sole hope. What is tribute, exploitation, slavery even, when the victim is repaid with the greatest boon there can be—baptism into the body of Christ?

In Renaissance theology such sufferings and offerings, whether voluntary or not, are "works," as are the building and decoration of churches and the performance of ceremonies. By performing these works the individual could hope to accumulate sufficient grace from God to whittle down his or her season in purgatory and hasten the translation to heaven. The indulgences sold in the Germanies by the Dominican monk Johann Tetzel and others, which remitted days in purgatory on payment of a fee, were similar "works." The practice constituted one reason why Luther preached a religion of salvation by faith alone, exclusive of any good deeds the believer might have accomplished. He was to write: "if the pope knew of the exactions of the purveyors of indulgences he would prefer to see the basilica of St. Peter reduced to ashes rather than see it constructed with the skin, the flesh, and the blood of his flock." But in fact none of the popes of Luther's time, except the short-lived Adrian VI, had any objection to the idea that Christians should contribute their lifeblood to the basilica's fabric. Christianity was a sacrificial religion. It is after all based on Christ's offering of his own skin, flesh, and blood. Indulgences did in fact pay for the reconstruction of St. Peter's and the Vatican. Some say that this was a major cause, or at least occasion, of the Reformation itself.

Let us turn from Giles's triumphant future back to Guicciardini's squalid present. Julius began his reign by enlarging the Papal States or, as he put it, liberating Italy. His alliance with Cesare Borgia, the instrument of his election, once more served him. Thus did Cesena, Perugia, Piombino, Mantua, and several smaller holdings belonging to great Roman families like the Orsini and the Colonna, return to papal control. Most of these cities stood in a long descending line, a belt of fortified citadels across the central part of the peninsula (fig. 9). Their reacquisition occurred between the election of Julius in 1503 and

the departure of Cesare, by now disgraced, in May 1504. In later years Julius attempted, with considerable short-term success, to fill out with further acquisitions and conquests the ancient boundaries of what he considered to be the Holy See's temporal birthright. These boundaries were more or less those of the ancient land of Etruria, which, long before Christ, had stretched from the Tiber to the Apennines. In this aim Julius was abetted by Giles of Viterbo, who preached that the god of Etruria, Janus, was also the god of the Vatican and the pagan twin of Moses and St. Peter.

The next phase of Julius's policy, as suggested earlier, meant playing off France and Spain against each other. As, in the Bible, the foreign tax-collector Heliodorus was driven from the temple by an angel of the Lord, so these new Heliodoruses would be expelled by the pope (fig. 117). In 1503, the very year of Julius's accession, the French, who had occupied Naples from 1494, left the city in favor of a Spanish occupation. In return for accepting Spanish rule in Naples Julius demanded that the viceroy there periodically and publicly swear himself the pope's vassal. This was done, together with the traditional gift of obeisance, the presentation to the pope by the viceroy of a handsomely caparisoned horse every Christmas. This ceremony— just the sort of thing Julius delighted in— dramatized the fact that all south Italy was the pope's feudatory.

But the French still held much of upper Italy. And there were French pockets elsewhere. Accordingly Julius spent much of his pontificate marching up and down the peninsula trying to seize French-held cities. It was thus, in 1506, that he obtained the surrender of Gian Paolo Baglione, lord of Perugia, who had joined the French

cause. In the same year he forced Giovanni Bentivoglio to abandon Bologna, thereby saving that city from a French attack. Having been archbishop of Bologna before his election Julius was given a triumph and greeted as the city's liberator. A colossal bronze statue of him by Michelangelo was erected on the facade of San Petronio. (It was destroyed by the populace in 1511 during a short return of French rule. It probably resembled seated statues of popes like that of Paul III on his tomb; fig. 40) Julius had similar triumphal entries in Perugia and Forlì. On his return to Rome yet another triumph reaffirmed him as a liberator.

Venice, however, remained Julius's obsession. He seems to have relished hating the Republic. He was unable to see that a united Italy would never be possible without a permanent papal alliance with Venice, which was the one large peninsular power that managed to remain relatively immune to French, Spanish, and imperial bullying. Venice was also antipapal. The Venetians, for example, had refused to deed the pope two cities they had seized from the Borgias, Faenza and Rimini. But above all it was the overweening Venetian ambassador in Rome, Alvise Pisani, and the Republic's violation of certain ecclesiastical privileges, that infuriated Julius. So, with many reservations (since it involved a risky but useful temporary alliance with his French enemies), the pope joined the League of Cambrai, which aligned him with the Emperor Maximilian and Louis XII. This in turn brought to bear the threat of the Holy Roman Empire and its armies against the troublesome Venetians. In 1510 the League defeated the Venetian army at the little town of Vailate near Bergamo. In a subsequent accord Venice was forced to cede Faenza and Rimini to the

pope. In Rome, Julius made the Venetian ambassadors do public penance for their country's sins.

But we have seen that every alliance seemed to need a contrary one. So it was that in these very years, fearful that the League of Cambrai would increase French power in Italy, the pope made agreements with his old enemies, the Venetians, to expel the French. With Julius in personal command papal armies at Bologna attacked the duke of Ferrara, a French ally, and won. The penultimate defeat of the French in Italy (at least during Julius's reign) was

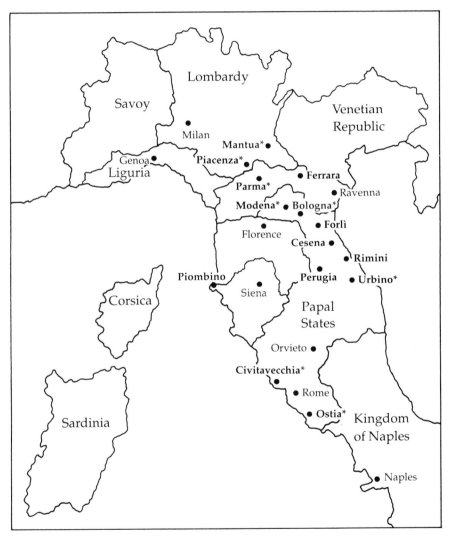

9. The expansion (and contraction) of the Papal States, 1503–50. States recovered, acquired, or conquered, at least temporarily, by Julius II are in boldface. Those relinquished by Leo X and Clement VII are marked with an asterisk*. Author.

achieved via the formation, by the pope, of yet another alliance, the Holy League (1511) between Venice, Spain, and England.

Another way of playing these games was through ecclesiastical councils. Here more than anywhere else the themes of Rome as the center, and of Italian liberation, come through. It was rumored that Louis XII of France bizarrely hungered for the papal crown himself. In 1510 he convoked a national conference of bishops at Tours. In the following year, the year the Holy League was formed against him, he summoned a synod, or council of regional bishops, at Pisa. Here once again northern prelates questioned the pope's authority to make appointments and decree dogma, just as the French kings had so often rejected the popes' claims to be Italy's secular rulers. The Pisan synod passed a decree called the Pragmatic Sanction in which the French bishops promoted the idea of semi-independent national churches as opposed to a unified church ruled from Rome. And just as every league had a counter-league so every council had a counter-council. Thus in 1511, in Rome, to counteract the Council of Pisa, Julius summoned the Fifth Lateran Council. Its first act was to declare the Council of Pisa schismatical and all its resolutions null and void.

Other issues were the perennial ones of ecclesiastical reform and the constant Turkish threat to invade Europe. But these worries were always bathed in Julius's concerns for papal primacy. Constantine, it was thought, had donated to the popes certain priestly and political powers of the western emperors. It was because of this "donation" that the popes came to call themselves pontiffs, i.e., *pontifices maximi*, a title used by the pagan emperors. In the 1440s the Neapolitan humanist Lo-

renzo Valla proved that the document recording this donation was a forgery. But the real polemics did not break out until Protestant controversialists in the 1630s used Valla's essay as evidence not only that Constantine had not donated imperial privileges to the popes, but to show (quite falsely) that there had been no such institution as a papacy at all in the early Christian centuries; and, indeed, that St. Peter had never set foot in Rome. If this was accepted (and eventually, by many Protestants, it was), the whole historic basis of the papacy disappeared. So one of the Church's chief concerns came to be the establishment, more powerfully than ever, of Peter's presence in Rome. The artistic programs we look at do their best to put this claim across.

The Lateran Council, one of the most important in the whole history of the Church, was still in session when Julius II died on February 21, 1513. Surprisingly, given the military and political weakness of the Renaissance papacy, Julius achieved a considerable part of what he wanted. Borgia power was indeed extinguished. The French did invade and Giuliano della Rovere did march with them as their temporary ally. In the first years of his papacy Spain was driven from the parts of Italy it infested (though we have seen that it reappeared in new areas, notably the south). And, finally, Julius got rid of the French, though only in the year before his death. Italy, in short, was more fully a papal possession than at the beginning of his reign. As to the outer sphere of Julius's policy, the Portuguese and Spanish kings were admitting papal sanction over new lands in the Far East and in the West. Finally, further in the background, the developing Turkish threat seemed to solidify the prospect of a vast apocalyptic showdown.

What should our final opinion of Julius II be? To Guicciardini he was the instrument of Italy's ruin. De'Conti, his admirer, called him a saint. (The two things are of course not mutually exclusive.) The phrase "Renaissance pope" is now a byword for a corrupt, lascivious pontiff more interested in splendid ceremonies than the Gospel. This does not really suit Julius. He was not corrupt so far as we can tell nor even, by the relaxed standards of the time, particularly lascivious. He did like ceremonies and pageants; but he was in the end, and mainly, a fiercely devoted, wary, efficacious ruler, a man ruled by perverse and fascinating dreams.

Leo X

One mark of Julius II's effectiveness is that with his death things began to get out of hand. It was 1513: the Spanish acted first. The Spanish viceroy of Naples, Raimondo di Cardona, marched an army toward Piacenza and forced it to submit. Frightened, Parma followed suit and surrendered. Spanish soldiers also prevented the Duke of Ferrara, Julius's relative, from recovering lands he was claiming in Reggio Emilia.

Thus when Leo X was elected as Julius's successor he faced a deteriorating situation. The two men in any case were very different. The new pope had been born Giovanni de' Medici, at Florence, on December 11, 1475. He was thus twenty-two years younger than Giuliano della Rovere. He was also the son of Lorenzo the Magnificent. His earliest teacher had been the poet Angelo Poliziano. One must therefore begin by contrasting the fame of the Medici and the glorious culture of quattrocento Florence, which was that of Poliziano, Leonardo, and the young Michelangelo, with Giuliano della Rovere's much more restricted upbringing in the little Ligurian coastal town of Savona.

Another difference between the two families was that the Medici were a numerous clan bent on their own interests; and with more interests than the Rovere to further. For a pope such a family was a mixed blessing. Leo and his successor, also a Medici, were to allow family interests, and the family members who pursued them, to dominate their papal duties in a way Julius II did not.

This large family requires a (simplified) genealogy:

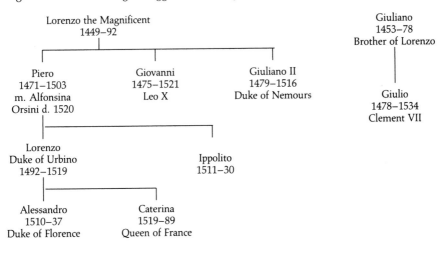

Lorenzo the Magnificent
1449–92

Piero
1471–1503
m. Alfonsina
Orsini d. 1520

Giovanni
1475–1521
Leo X

Giuliano II
1479–1516
Duke of Nemours

Giuliano
1453–78
Brother of Lorenzo

Giulio
1478–1534
Clement VII

Lorenzo
Duke of Urbino
1492–1519

Ippolito
1511–30

Alessandro
1510–37
Duke of Florence

Caterina
1519–89
Queen of France

In large part because of his distinguished background Giovanni de' Medici had a precocious career. At the age of eight, the minumum for entering the clerical state, he was awarded a number of important Florentine, Tuscan, and French benefices. At eleven he was abbot of Montecassino. That was in 1486; in the same year Innocent VIII made him a cardinal-deacon. After studying canon law at Pisa he was appointed legate to the papal states and Florence. This was in 1492, the year of his father, Lorenzo's, death. We should recall that it was also the year of Alexander VI's election. The young prelate found himself embroiled among the factions created by that event. When Alexander triumphed, Giovanni emerged as his enemy. On the principle that "the enemy of my enemy is my friend," the young Medici became something of an ally to Giuliano della Rovere.

During this period, especially after 1494, the year the Medici were exiled from Florence, Giovanni traveled incognito throughout Europe. On returning to Rome in 1500 he established himself in the palace now known as the Palazzo Madama, his family's sumptuous Roman residence, which was to be rebuilt in the seventeenth century and which is now the seat of the Italian Senate. Living there, Giovanni seemed more interested in art and literature than politics. Indeed, far more than Julius II he was a student; yet almost as much as Julius he was a builder. He restored and decorated two of his churches, Santa Maria in Domnica, Rome, and Santa Cristina at Bolsena. Later on he was active in the political and military causes espoused by Julius II. Ultimately he was reappointed legate to the Romagna with the idea that that region's western neighbor, rebellious Florence, now under

the sway of the spellbinding but seditious Dominican, Savonarola, would be brought back to Medici obedience.

But the battle of Ravenna, April 11, 1512, was a black day for Giovanni's hopes. Taken prisoner by the French, he was brought to Milan. These months marked the nadir of papal fortunes. The French army, with its legendary generals Gaston and Odet de Foix (the latter an ancestor of the artist Toulouse-Lautrec), proved superior to the Church's army, whose main strength came from temporary Spanish contingents. Eventually, however, Giovanni managed to escape his French captors. With the formation of the Holy League mentioned earlier, under which Venice, Spain, England, and the papacy expelled the French from Italy (1512), Giovanni was able to negotiate the return of his family as rulers of Florence with himself as governor. But the Battle of Ravenna remained a crucial trauma. He was to have Raphael interpret it in the Stanze as sign of the recurrent "barbarian" (i.e. French) threat to Rome (fig. 120). With the death of Julius II, Giovanni de' Medici's succession was assured. He entered the office as a conciliator and man of peace. But the defect of these qualities was that he lacked Julius's huge ambitions and political and military ferocity. Worse, he proved to be inactive, passive—anything but the lion whose name he took. Fortunately he did commit himself to Julius's great designs for the rebuilding of St. Peter's and the Vatican.

Giovanni de' Medici was thirty-seven when he was crowned—exceedingly young for a pope. Youth goes with pleasure, and Leo's greatest energies, such as they were, were expended in the pursuit of the latter. "God gave us the papacy," he said, "let us enjoy it!" (Or at least he is said to have

said it.) The love of ceremony that had characterized his predecessor's pontificate became, in Leo's, a love of play and spectacle. In a somewhat similar way Julius's love of warfare diminished, in Leo, into a love of hunting. Leo was serious about his duties, in the eyes of most of his contemporaries, but most agreed that he was ineffectual.

Leo X began his reign by reaffirming papal support of the Holy League against France. However, in accordance with his peaceful nature he sought to bring hostilities to a close rather than pressing for victory. He also managed to persuade the French king to recognize the anti-French Lateran Council. On the whole his method was the same as Julius's but without that pope's fire. Leo continued to treat secretly with the enemies he was publicly sworn against. (The doctrine of open agreements openly arrived at had no place in Renaissance diplomacy.) He also continued the policy of enlarging the papal dominions. Now that Julius had almost doubled papal territory in central Italy, Leo's aim was to go beyond that and increase papal sway over Lombardy and Naples.

But, as noted, the new pope was simultaneously eager to further his family's interests. In 1513 he appointed his nephew Lorenzo governor of Florence. Later his brother Giuliano II would govern Parma, Piacenza, Modena, and Reggio Emilia. He also deposed Julius's nephew Francesco Maria della Rovere as duke of Urbino and installed, in his stead, the younger Lorenzo de' Medici, known as Lorenzo II. (We saw earlier that Francesco Maria received a high price for his acquiescence.) Leo meanwhile sought the councils of Machiavelli, author of *The Prince*, as to the proper rule of the newly acquired state. This was appropriate enough—

though Leo needed no one to give him lessons in duplicity. The problem was that Leo, like Alexander VI, in parceling out papal lands to relatives, was diluting the parts of his authority that were purely Roman and papal.

The question of renewed "barbarian" invasions came into Leo X's life in 1515 when Francis I began to march south. The papal loyalists were defeated at the Battle of Marignano. The resulting Peace of Viterbo (1515) forced the Holy See to relinquish Parma and Piacenza. Leo also had to promise to restore Modena and Reggio Emilia to the French-backed house of Este. But this was one of many promises he did not keep. Another was to let Francis inherit the Kingdom of Naples on the death of Ferdinand the Catholic, current king of Spain. In return for these and other undelivered sacrifices Leo had a promise from Francis for help in a crusade against the Turks—a promise in turn not kept by Francis. Yet, I repeat, these networks of unkept promises and contradictory alliances could be useful in postponing open hostilities. But the drift of Leo's policies was clear: he was giving away Julius's laborious achievement.

Leo's court was an island of expensive fun in the midst of this darkening sea. Guicciardini writes: "Rome and the whole court basked in the highest flower of felicity. . . [Leo] being by nature given to ease and pleasure and now, in his overweening careless grandeur, and estranged from practical affairs, [he was] obsessed every day with music, jokes, and buffoons, and, inclined more than was proper to the most infamous pleasures, he seemed totally foreign to the idea of war." In order to pay for his gala life, Leo's fundraising techniques became more and more aggressive. Partly because of the pope's fiscal

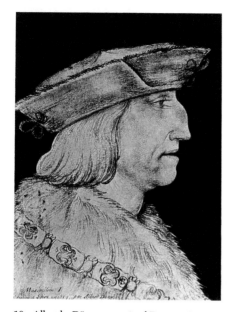

10. Albrecht Dürer, portrait of Emperor Maximilian, 1519. Paris, Bibliothèque Nationale. Giraudon/Art Resource, N.Y.

policies Alfonso Petrucci and other cardinals plotted in 1517 to assassinate him. The plot was discovered and Petrucci was imprisoned. Characteristically, Leo used the incident as an opportunity to collect money. Petrucci's four co-conspirators were made to pay colossal fines. Then, to consolidate his power in the college of cardinals, the pope added thirty-one new members to it, an unheard-of increase and one that not only strengthened his political position but also, since the red hats were sold for large fees, his pocketbook.

Leo also sought to reinforce his power in France. There were what might be called Leonine precedents for this. Centuries earlier his predecessor and namesake, Leo I, had been victorious over anti-papal forces in Gaul. That resulted in the edict of Valentinian III which laid it down that "nothing should be done in Gaul contrary

to ancient usage without the authority of the bishop of Rome." Another problem common to the two Leos, I and X, was dissident church councils. And, under Leo I as under Leo X, Italy was prey to invasions. Guicciardini, himself a papal adviser, saw Leo, guided by such precedents, as the continuator of Julius's tragic desire to be both prince and prelate. Indeed Guicciardini traces this fatal double role back to agreements made by yet another Leo, Leo III, with Charlemagne. All this will be alluded to in the Stanze.

Meanwhile the question of who was to succeed the aging Maximilian (fig. 10) as Holy Roman Emperor became an issue. We may pause to note that the latter was a special kind of rival to the popes. Both claimed to be the legitimate heirs of the emperors of ancient Rome. In the sixteenth century the two ancient political parties that embodied these claims, the Guelphs (papal) and the Ghibellines (imperial), were still in existence, if somewhat fossilized; but many of the issues they had represented were vigorously alive. As Julius II had enormously increased the power of the papacy, so Maximilian had increased that of the emperor. Nonetheless Leo managed to engineer an alliance between the papacy and the Empire based on historical precedents that implied papal dominance over the emperor. The idea duly finds expression in the Stanze, as well.

Had he been a princeling like so many earlier emperors, Maximilian's successor would have had difficulty stepping into Maximilian's shoes. But when the old emperor died in 1519 the contenders for the imperial crown were Europe's two major kings, Francis I and Charles of Hapsburg, king of Spain. A unified European empire that excluded the pope's leadership might have been possible under either man, so

Leo quite naturally opposed both. But he was especially against Charles, whose mere election as emperor, without further military or political action, would have put Spain, the Empire, and Naples into one pair of hands. Nonetheless Charles was elected. And, as the emperor Charles V, he outshone even Maximilian (fig. 11). He became the greatest of the Holy Roman Emperors and indeed one of the great men of history. In keeping with the prudent double-dealing of the period Leo blessed his election but made a secret alliance against him with Francis—whose prominent nose (fig. 6), as losing candidate, was much out of joint.

11. Titian, Charles V on horseback at Muhlberg, 1548. Madrid, Prado. Alinari/Art Resource, N.Y.

Charles V does not impinge painfully on papal affairs until 1521. The issue was religion. In 1517 Luther had nailed his ninety-five theses to the door of a Wittenberg church. But it was not until 1520 that the reformer began to publish his "libels" (from *libellus*, little book) against the pope. On May 8, 1521, in part spurred by these events, Charles and Leo signed an accord. In return for Charles's support against the Lutherans Leo bestowed on the emperor Parma, Piacenza, and Ferrara. The pact also guaranteed the continuation of Medici rule in Florence. Thus did Leo trade imperial support against German Protestantism—support that was a mere promise—for actual Church lands. Julius would never have done such a thing. But, and this part *is* Julius-like, Leo simultaneously made a compact with the French king to drive imperial forces out of Naples. If successful, France would rule the southern kingdom but grant to the pope a northern slice of Neapolitan territory. Nothing came of the scheme. Leo also sent armies to regain Parma and Piacenza (contrary to the agreement he had just signed). But this, too, came to nothing.

Nonetheless on November 25, 1521, after the agreement with Charles V, Leo was greeted in Rome with a triumphal procession. It was not one Julius would have relished. It simply proclaimed Charles V as the dominant figure in Europe. But the careless, red-faced roly-poly pope who participated in that triumph, more as Charles's acolyte than anything else, by now had only a few weeks to live.

Leo was certainly not an evil man. Personally honest, if given to the normal sort of diplomatic lying, he was extremely pious. He approved the reform of various religious congregations, condemned magic and divination, and protected the rights of some of the recently discovered New World peoples. He did the same, at home, for the Jews. But history has decided that his weaknesses outweighed his virtues. Aside from his obsession with fun and his weak foreign and fiscal policies, he suffered all sorts of scandal to exist in his court while flocks of fellow-Florentines descended on Rome like buzzards to obtain funds and favors.

Leo also proved, despite his pact with Charles V, to be strangely indifferent to Lutheranism, unaware of its seriousness. Luther's preaching against the indulgences grated, of course, but once again Leo was indecisive, merely mandating jail and excommunication after a series of lesser measures had been taken. Only in 1520, with the bull *Exsurge Domine*, were Luther's teachings directly prohibited, and he was not excommunicated until January 3, 1521. Leo also esteemed Erasmus, who never ceased to protest his loyalty to the Church.

Leo was an important patron of culture. He reorganized the University of Rome, augmented both his own and the Vatican libraries, established a Greek college and publishing house, encouraged the study of Arabic and Hebrew, was a protector of the Venetian printer Aldus Manutius, and charged Raphael with making an archaeological map of ancient Rome. He had many humanist advisers and secretaries, including Sadoleto, Bembo, and Cardinal Bibbiena. Guicciardini knew Leo well, though he did not much approve of him. On the other hand the great humanist Baldassare Castiglione, the Mantuan ambassador to Rome and author of *The Book of the Courtier*, was the pope's good friend. Two important Renaissance epic poems are dedicated to Leo, Sannazaro's *De partu virginis* and Vida's *Christiad*.

Both are attempts to revive and continue classical Roman epic poetry and pagan piety, tying them to Renaissance Christianity. Leo also encouraged and patronized another poet, Giangiorgio Trissino, who was later, in turn, Palladio's patron. The pope's relationship with Ariosto was frosty but he did make possible the publication of the *Orlando Furioso*.

Leo followed Julius in being a great constructor. In Rome he carved out the via di Ripetta and began the church of San Giovanni dei Fiorentini. He also began the reordering of the Piazza del Popolo. He enlarged Julius's collection of ancient statues in the Belvedere. It was under Leo, too, that Raphael produced the Stanza d'Eliodoro, the Stanza dell'Incendio, and the cartoons for the Sistine Chapel tapestries, thus completing the decoration of the side walls of that room. In all these ways Leo filled in the outlines of his predecessor's dreams. In some ways his patronage was more varied than Julius's, though never as grand in conception.

Finally, in keeping with his strong Florentine interests, Leo commissioned (sometimes indirectly) much work in that city—e.g., from Michelangelo, as noted, a new (unbuilt but influential) facade for the Medici family church of San Lorenzo, and Michelangelo's Medici Chapel and Biblioteca Laurenziana in the same complex. Characteristically, of the three projects only the library was completed more or less as planned. Characteristically again, a huge statue of the pope, a conceptual pendant to Phidias's fabled statue of Zeus at Olympia, was being planned for the Capitoline Hill but was abandoned. Indeed when Leo X died on December 1, 1521, his funeral was relatively modest—a sign both of the unexpectedness of his death and of the financial profligacy that was

catching up with him. To an extent, therefore, Leo's artistic patronage, though admirable in intentions and for the most part in results, followed the self-defeating patterns established by his politics. One almost agrees with Guicciardini's hyperbolic conclusion: "He died without a deed." His true importance, as noted, is that he allowed work to continue on the mighty schemes of Julius II. But perhaps this only shows that the momentum of those projects had become unstoppable.

Clement VII

Giulio de' Medici was the natural son of the elder Giuliano, brother of Lorenzo the Magnificent (see chart above). The father had been killed in the Pazzi conspiracy of 1478. The son was born in that very year to a mother known to posterity only as Fioretta. Like Lorenzo's own children, Giulio de' Medici emerged from childhood in the atmosphere of intense culture and love of art that the Magnifico instilled in his household.

As had been the case with his cousin Giovanni, Giulio at an early age found himself in possession of rich benefices. Long before he was ordained a priest, indeed when he was only ten, he was prior of the Capuan monastery of the Knights of Malta. When still in his early teens he became a canon lawyer, and when in 1492 the seventeen-year-old Giovanni de' Medici went to Rome as a cardinal the fourteen-year-old Giulio was part of his retinue. As with Giovanni, too, Giulio was forced into exile by the crisis of 1494—first to Bologna, then to smaller towns such as Città di Castello. At other times during these years he lived in Rome in Giovanni's household.

The pairing off of the two young Me-

dici continued. In the later 1490s Giulio accompanied his cousin on his grand tour of Europe. On their return to Italy in 1500 the head of the family, Piero II, assigned Giulio the task of furthering the relationship between Clarice, Piero's daughter, and Filippo Strozzi. The two were married in 1509—the year Erasmus visited Rome. This Medici-Strozzi alliance (the Strozzi being one of the most powerful Florentine families) increased the Medici threat against their Florentine enemies. That threat affected Vatican affairs. It had been anti-Medici sentiment, among other things, that impelled the republican *gonfaloniere* or chief magistrate of Florence, Piero Soderini, to allow the Council of Pisa to meet in his realm. In turn, when Florentine factions revolted against Soderini they were abetted by Giulio de' Medici who, for the purpose, entered Florentine territory in disguise. On this occasion Giulio's attempt to unseat Soderini failed. But the Medici did not give up. Although they were foiled again in 1510, we have seen that in 1512 their forces entered Florentine territory, ruthlessly sacked Prato, and marched into Florence in triumph. By this time Piero de' Medici was dead and Giovanni was about to elected pope. Hence it fell to Giulio to take charge of his native city.

There, he established an alliance with Henry VIII of England, under whom he was appointed cardinal protector of that country. This agreement was obviously intended to offset the existing alliance between France and Spain and stave off their desires to divide Italy between them. A further alliance, between Henry and the Holy See, was also projected. Nor did Giulio neglect his other power base in Rome. After being made a cardinal-deacon he accumulated several well-heeled benefices including Santa Maria in Domnica (for-

merly in Giovanni de' Medici's possession), San Clemente, and San Lorenzo in Damaso. Curiously enough, during all this time he had still not been ordained priest. This was rectified in 1517 when he was both ordained priest and consecrated bishop. He thereafter played an active role in the Lateran Council.

Meanwhile Francis I decided to invade Italy, asserting, as French kings always did on these occasions, ancient claims over Lombardy and Naples. The opposing papal armies were led by Lorenzo de' Medici II, an able general, with Giulio as military legate. Giulio himself proved to be a fairly able commander and arranged the defenses. At the same time he had to work hard to persuade Leo, as always so little the lion, not to make concessions to the French but rather to go into battle. The Medici-papal forces in fact did hold off the invaders; after the victory Leo staged a triumphal entry in Florence on November 30, 1515, very much in celebration of the fact that a triumph was *not* being celebrated there by Francis.

In 1517 Giulio became Leo's vice-chancellor. Now almost forty, he was an excellent administrator. Characteristically, however, he continued to give much attention to the affairs of his family. Their interests were weakened by the death of Giuliano II de' Medici, duke of Nemours, in 1516, and that in 1519 of Lorenzo II, who had in the interim taken Giulio's place as governor of Florence. Another important family member, Alfonsina Orsini de' Medici, widow of Piero II, died in 1520. As a result of these losses Giulio had to visit Florence often in these years.

In Rome, meanwhile, he was faced with the Lutheran question that Leo had for the most part cavalierly neglected. As Luther himself was fond of pointing out,

Giulio was no theologian; and, like Leo, he had not at first taken Luther seriously. He did, however, in 1520, establish a committee to study Luther's ideas. This was followed by Leo's bull of condemnation, already mentioned. Meanwhile one of Giulio's secretaries, Girolamo Leandro, went to Germany to present this document to the Diet of Worms, a council summoned by the Catholic bishops of the area to pronounce on Luther's doctrines. In Rome, at a consistory of February 6, 1521, the cardinals were speaking of the "two fires" that now threatened the Church—the Lutheran conflagration in Germany and Spanish troop movements in the Kingdom of Naples. The situation in north Italy was also threatening, and as the French advanced to the south Giulio once again joined the papal armies fighting there. On November 19, 1521, he and his troops entered Milan, Guicciardini with them.

It was the eve of Leo's death. And despite his achievements and connections, it was by no means clear that Giulio de' Medici would be the next pope. Francis I, for example, threatened schism if Giulio was elected. But Giulio was scouring the College of Cardinals for support. He received some but not enough, and the first votes went against him. Orsini, a member of an anti-Medici Roman family, and Piero Soderini, the now-deposed Florentine gonfaloniere, with French backing managed to prevent Giulio's victory. A cardinal who was not even present, Adrian of Utrecht, was elected as a compromise. But like Pius III, Adrian VI had a short-lived papacy. Both were "bridge-popes" whose reigns gave the next "real" pope time to organize his election.

Adrian was a sign of the times. One of the criticisms of Roman culture made by

Luther's sympathizers and by Erasmus (like Adrian a Dutchman) was that it was obsessed, indeed infected, with paganism. Thus Erasmus wrote even against the imitation of Cicero's Latin style. He excoriated the Italian habit of referring to the saints as gods and to churches as temples, and scolded the Roman clergy for collecting antiquities. In all these respects the new pope was a faithful Erasmian. Adrian called the Sistine Chapel "a bathroom full of nudes," and when he was shown the famous statue of Laocoön (fig. 84), which Julius had set up in Bramante's Statue Court, he solemnly cursed it.

In fact with Adrian, as with Luther and Erasmus, we uncover the deep differences between northern and southern piety. To the northerners paganism and Christianity were utterly antithetical. To the southerners classical paganism was a sort of brother to the Old Testament, a preparation for the full flowering of the Gospel. Add to this the powerful suspicion, on the part of many northern intellectuals, of the visual arts generally, and specifically of religious art. The Protestant controversialists of the period make it clear that the Vatican art programs, which were conceived in part to counter the claims of what was to become Lutheranism, only exacerbated the north-south difference. Raphael and Michelangelo, particularly, were condemned as purveyors of diabolical sensuality.

In politics Adrian at first seemed unwilling to counter the Soderini conspiracies against the Medici. In addition, in the early months of his reign the ex-gonfaloniere and his followers obtained promises of help from France. But finally Giulio managed to convince the pope that Soderini and his followers were planning war between France and the Empire. Soderini was arrested. His trial had not ended when

Adrian died, on September 13, 1523; but Soderini was now effectively disarmed.

Meanwhile Giulio helped Adrian arrange an alliance between Charles V (Adrian's former pupil), the papacy, and Florence against France. This meant, of course, that with Adrian's death Giulio's candidacy would have the emperor's support. A consistory to elect a new pope was summoned. Though the meetings were supposed to be secret, there were abundant leaks. There was also strife—not merely among the factions named but generational conflict between the young cardinals, headed by Giulio (now aged forty-five) and the older ones, who backed Cardinal Alessandro Farnese (later Paul III). Giulio assured his own election by converting Cardinal Orsini to his cause. The price: the promise of the vice-chancellorship of the Church, the gift of the Palazzo Riario in Rome, and more.

On November 19, 1523, only about a month after Adrian's death, Giulio de' Medici was elected and took the name of Clement VII. That name underlined the new mood that, he hoped, would pervade the College of Cardinals after long weeks of unpleasant politicking. Yet though he had been a valiant prince, military leader, and organizer, Clement as pope was a disappointment. His first acts, it is true, were auspicious. He proclaimed that the league between the papacy and the Empire was not to be considered inimical to any other European state—e.g. France. As a sign of this good will he sent a letter to Francis I detailing his intentions for a new campaign against the Turks. By now, too, he more fully appreciated the potential harm of the Lutheran threat, and even treated it as a judgment against the Church's worldliness. He responded to Lutheranism by demanding a reaffirmation of Constantine's dona-tion. In a similar spirit, faced by hostile agitation for either a national council of German bishops or a general church council, he instead proposed, in 1524, summoning to Rome the highest-ranking cardinals of each country. In this way the Church could be reformed under him, as opposed to his being reformed out of it.

Meanwhile the French returned to their Italian concerns. On October 28, 1524, having chased Charles V's armies out of France, they entered Italy and soon took Milan. Another French army was marching on Naples. Only Francis I's vacillating and foolhardy military behavior, culminating in his defeat at Pavia, February 25, 1525, when he was taken prisoner, saved the day. Francis's defeat put a damper on French pretensions in Italy for a few years. The pope thereupon dismissed those of his counselors he considered to be pro-French and turned firmly to Spain and the Empire.

But where with Julius II such shifts and changes normally were moves in an energetic, successful game, with Clement, as with Leo, they more and more came to be signs of timidity and indecision. For instance, despite the apparent success of his alliance with Charles V, Clement secretly tried to get out of it. Guicciardini, Clement's sometime subordinate in the papal government, tells of the pope's growing indecisiveness. Like Leo's love of pleasure, Clement's love of tergiversation became legendary.

A peace signed at Madrid on January 14, 1526, brought a temporary end to the conflicts between Charles V and Francis I. This was followed by a contrary alliance, the League of Cognac, between the pope, Florence, Venice, Milan, and Francis I. On learning of Francis's volte-face, however, Charles V threatened to start up revolts in

Florence, Siena, and the Papal States. Later in the same year Pompeo Colonna, a cardinal from a great Roman family allied with Charles V, marched his armies against Rome and entered the city. A truce was quickly declared, but the pope immediately took measures to punish Colonna. Contrary to agreements he had just made, he filled the city with troops.

The Sack of Rome

Colonna decided on an epic revenge. His armies now included French and mercenary forces commanded by the duke of Bourbon and troops from Milan and Naples. An even worse threat to Clement was composed of the men following the duke of Frundsberg, leader of a horde of German Landesknechte or mercenary troopers. These had descended on Florence and one of the last of the Medici heroes, Giovanni delle Bande Nere, had died at their hands. Now they headed for Rome. Frantic discussions were held. Clement began offering suicidal terms. These were accepted by some of the oncoming captains but not all. He tried to stop Bourbon by excommunicating him, while seeking to raise new funds by selling cardinalates. Meanwhile the attackers had no overall command: each army fought on its own. And, often, the troops themselves refused to obey their commanders. But most remained loyal: their pay, after all, was to consist of loot, and Rome was one of the richest cities in the West. So despite all treaties, despite all entreaties, the march continued. On May 6, 1527, Spanish and German soldiers entered the city and began to sack it. Benvenuto Cellini writes fascinatingly of these days. The sculptor acted as a cannoneer on the ramparts of Castel Sant'Angelo and later melted down

papal jewelry to raise money to pay the fines exacted by the victors.

The ferocity and bloodthirstiness, especially of the fanatical Lutherans, reached almost twentieth-century levels.

The doors of churches and convents were smashed, their contents hurled out into the streets, their bells and clocks, chalices and candlesticks beaten into fragments, their sacred treasures defaced, their holy relics used as targets by arquebusiers, and their ancient manuscripts as litter for horses. Priceless vestments were tossed over the shoulders of drunken whores, and nuns changed hands on the throw of a dice. The name of Martin Luther was carved with a pike on one of Raphael's frescoes in the Stanze. Shops and houses were so thoroughly plundered that even the hinges were wrenched from the shutters and the handles from the gates. The rich were held as hostages for ransom, the poor being tortured and slaughtered out of hand. Priests were stripped naked and obliged to take part in profane travesties of the Mass and to utter blasphemies on pain of death; orgies and gambling games were held around altars splashed with blood and wine; crucifixes were hurled about the streets. Fingers were cut off for the sake of rings; arms were lopped off for bracelets, ears for pendants. . . It has been estimated that on the first day alone 8,000 people were killed. (Christopher Hibbert, *The House of Medici, Its Rise and Fall*, New York, 1975, 245)

The Sack was a tragedy from which the Renaissance papacy, and indeed one may say the Renaissance itself, never really recovered. With 23,000 dead in a population of 55,000 it was compared to those other epic destructions, of Jerusalem, Carthage, and Babylon. As to Giles's prophecies of war, in a sudden, terrible swerve these now showed a face of horror. In the aftermath Clement was to commission Michelangelo to paint a *Fall of the Rebel Angels* as an analogy to this terrible event. Under

Paul III this commission became the Sistine Chapel's *Last Judgment* (fig. 181).

Clement was now a prisoner in his own palace. Bartolommeo Gattinara, representing the Colonnas' Orsini allies, was treating with the pope as early as May 7, the very day after the catastrophe. But the pontiff was stubborn and the occupation and vandalism continued for months. Clement's allies fled. On the night between the 6th and 7th of December 1527 he himself escaped and reached Orvieto. Once outside Rome he renounced his tentative peace agreements with the Orsini and the Colonna and regathered his armed forces. A new policy was emerging. He summoned a consistory. It was agreed that the pope should henceforth forswear expansionist political ambitions and concentrate on his ecclesiastical office. On returning to Rome, indeed, Clement even benefited from the invaders' guilt. Such were their enormities, it was said, that many of them when it was over could only cringe and seek forgiveness. In the end, the pope promised amnesty for the Colonna and agreed to pay a fine of 400,000 ducats. He renounced Parma, Piacenza, Modena (which had temporarily reentered the papal dominions), Ostia, and Civitavecchia.

Clement's fears were further allayed when, in February 1529, Charles V wrote him proposing a firm basis for international peace. The prospect was sweetened in that the emperor for once did not mention calling a general council. As part of this plan the Medici, who had in the meantime once again been exiled from Florence, would return there. And as a mark of this newfound imperial favor Alessandro de' Medici married the emperor's natural daughter Margherita. In 1532, finally, Alessandro would become the first Duke of Florence, supplanting the old informal Medici hegemony with a true hereditary duchy. The emperor, meanwhile, landed at Genoa on August 12, 1529 and met personally with the pope the following November in Bologna (fig. 38).

But the dread notion of a general council would not go away. Through the diplomacy of a certain Lorenzo Campeggi it began to seem possible that German princes who had left the Roman communion might be brought back if a general council were held and if that council were to reform the mass, abolish priestly celibacy, and allow certain changes in holy communion. It is not clear how Clement himself stood on these issues but it is clear that he thought such a council would challenge his personal supremacy. "A pair of drunken Germans [Luther and the Swiss reformer Zwingli] will turn the council and the whole world upside down," he predicted. "Let them! I'll go up on the mountains, and then let them elect a new pope, or even a dozen popes so that each country will have its own." Clement was raging, but what he said turned out to have truth in it. The national movement in the Church—Anglicans in Britain, Lutherans in Germany and other northern countries—did create permanent splits in Western Christianity. An English "pope," namely, the English king, and various German and North European equivalents eventually appeared on the scene. In accordance with this new independence, in 1533 Thomas Cranmer, archbishop of Canterbury, took upon himself the hitherto purely papal privilege of annulling the marriage between Henry VIII and Catherine of Aragon.

A divorce brought peace to England but it took a marriage to turn the trick in Italy and France. Clement himself officiated at the wedding of Caterina de' Medici, his

niece and the daughter of Lorenzo II, to the future Henri II of France. With this the Milanese situation turned completely around. Instead of fighting off French claims to that city, Milan and Lombardy would now become part of Caterina's dowry along with Parma and Piacenza. Caterina's royal French marriage, and that of her cousin Maria, much later, to Henri IV, assured the prosperity of Medici interests in the great monarchy to the north. Ironically, this happened just as Medici power in Rome, and Roman power itself, and, above all, papal power, were on the wane. Clement, meanwhile, was increasingly ill. He never really recovered from the Sack and died on September 25, 1534.

The grand dreams of the first decade of the century were dead. The balance of European power which for Julius, precariously and for a few brief years, had been centered on a Rome swollen with possibilities for Italian, European, even global sovereignty, a Rome that in Giles of Viterbo's flights could even contemplate a glorious battle for the soul of humanity—that balance of power, that orchestration of spiritual and political force, had deserted Italy forever.

Despite his being a Medici, Clement's excursions into art patronage did not always yield the finest fruits. Thus he had a fondness for that uneven sculptor, Baccio Bandinelli, and was responsible for Lorenzetto's unfortunate statue of St. Peter on the Ponte Sant'Angelo. But his favorite sculptor was the brilliant Benvenuto Cellini. And he continued with the programs undertaken by Julius and Leo. The work on St. Peter's moved slowly ahead, the Vatican Cortile di San Damaso was finished, the Stanze continued to be decorated, and the Castel Sant' Angelo remodeled so as to include new rooms for a papal residence. One of these puts Clement in an unexpected light. It has a bathroom painted with risqué scenes from the life of Venus (fig. 12). Clement also repaired the damage done during the Sack in the Vatican Palace, and new tapestries and carved doorways were made. Like Leo a lover of illuminated manuscripts, he commissioned several for the Sistine Chapel choir. He also restored a number of damaged Roman churches and completed the three streets leading to the Porta del Popolo. And one must also mention Clement's patronage outside the city—notably his responsibility for the Medici Chapel in Florence, which was originally designed to provide four tombs, two for the two Medici secular leaders now buried there, and, as well, an unrealized pair for Clement and Leo (fig. 226).

Paul III

Paul III Farnese (reigned 1534–49), the last great Renaissance pope, had spent most of his life waiting in the wings. Considered *papabile* ("popable") from an early age, he achieved his destiny only at the age of sixty-six. This destiny, however, made him one of the noblest and most reasonable of pontiffs, and Michelangelo's greatest patron. After Julius's rage and the hesitations of the two Medici, Paul provides a quiet but impressive finale to our history.

Alessandro Farnese was born in 1468 at the town of Canino, near Viterbo, the son of Pierluigi Farnese and Giovanella Caetani. He thus united two important local clans. The family owned properties at Bolsena and south of Viterbo, but this was nothing in comparison to the bountiful holdings the future pope was to bestow on his relatives. Alessandro received a hu-

manistic education in Rome and in Florence, where he frequented the court of Lorenzo the Magnificent and intended to become a diplomat. There he would have known Giovanni and Giulio de' Medici as slightly younger contemporaries.

In 1493 Alessandro's path to ecclesiastical glory was shown to him in a way that may seem peculiar. Alexander VI fell in love with Alessandro's sister Giulia, who became his mistress. To prevent the vengeance of her natural protector, the pope named Giulia's brother a cardinal deacon. Alessandro's rank, as cardinal, was of course high but he did not at first receive ordination to the priesthood. His earliest posts involved church administration: he was put in charge of the dioceses of Corneto, Montefiascone, Parma, and Benevento. Meanwhile as the result of a relationship with a noble Roman lady, and perhaps with other ladies, he produced four children—Pierluigi, Paolo, Ranuccio, and Costanza. In the 1520s, however, he renounced family life, was ordained priest and almost immediately consecrated cardinal-bishop of Ostia, Julius II's old see. He also thereby became dean of the College of Cardinals. By this time Clement VII was pope. Cardinal Farnese seems to have been his frequent adviser, though the two men in fact had generally different views. On October 13, 1534, after only ten years in the priesthood and one day of conclave, Alessandro Farnese was elected pope.

He took the name of Paul, the greatest of the apostles after Peter, Peter's companion in founding the Church at Rome, and in martyrdom and death there. Paul III's predecessor-popes had also been distinguished. Paul I (reigned 757–67), like Alessandro Farnese a Roman, was a saint. Paul II (reigned 1464–71) was Pietro Barbo of Venice, one of the major figures

after the return of the papacy from Avignon to Rome.

Paul III's policy was to unite Europe by reabsorbing the Protestants into the Catholic Church and then confronting the threats of Turkish invasion with a military force drawn from all Europe. This meant, for one thing, an iron neutrality on his part between the opposed forces of Charles V and the Empire on the one hand, and those of France under Francis I on the other. As to the ideal of a liberated Italy, on Paul's accession the greater threat was the Empire. Imperial troops occupied both the Kingdom of Naples and the Duchy of Milan. Like Julius, Paul heartily wished to absorb these regions as parts, or at least allies, of the Papal States.

But unlike his immediate predecessors Paul III was keen on ecclesiastical reform and wished to achieve it through church councils. He was also the first pope to assess the true nature of the Protestant defection. To his way of thinking a council might bring the Lutherans back into the fold. But the problems between France and the Empire dogged his attempts. In 1534 active war prevented the summoning of a council originally scheduled to meet in Mantua and then planned for Vicenza. One of the leitmotifs of Paul's career was this peripatetic phantom council, which had as many announced venues as it had postponements.

There were other vexations. A commission he appointed in 1537 issued a secret document, *De Emendanda Ecclesia*, which proposed all kinds of splendid and necessary reforms. Unfortunately the text was leaked to the Protestants, who triumphantly pointed to it as proof that their accusations against Catholicism were acknowledged by the papacy itself. Consequently none of the document's provisions

were at first enforced. When the question died down Paul was able to put through some of the measures. Others were enacted by the Council of Trent.

Meanwhile there were other modes of reform, or at least improvement. Paul made excellent appointments to the College of Cardinals, including Sadoleto and Bembo. He actively encouraged the revision of existing monastic orders and the

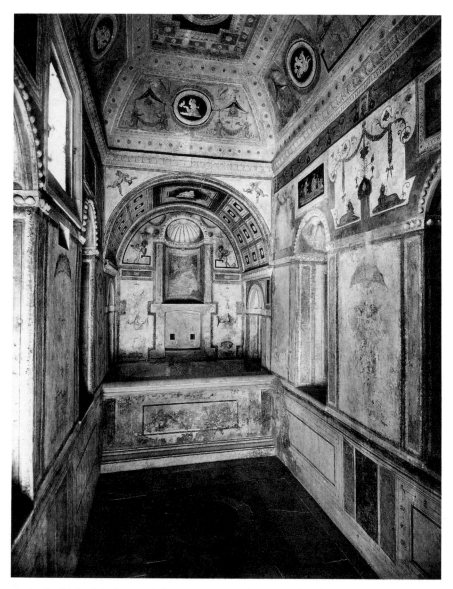

12. Raphael School, bathroom of Clement VII in Castel Sant'Angelo. Alinari/Art Resource, N.Y.

formation of new, strict ones. The Jesuits received his official approval on September 27, 1540. These and other orders, for example the Capuchins, an important Franciscan reform group, were often aimed at overseas missions, which now began to consider that Rome was their headquarters ("every good mission begins at Rome" was the saying). The missionary orders were particularly strict about purity of doctrine and expunging heresy. But his attempt to get the European powers to exert economic and military sanctions against England failed, and Anglicanism joined Lutheranism as another brand of Protestant infidelity. Some years after Henry's excommunication Paul established the Roman Inquisition (with authority for the Papal States only).

Important as was the conversion of the New World, and crucial as it was to reconvert the Protestants, the greatest menace remained Islam. The Turkish incursions into Europe, their threat to turn it into an Islamic enclave as had been done centuries before in Spain—these were truly frightening possibilities. Talk of crusades to the Holy Land was replaced by talk of defending Christian Europe from Islamic invaders. Charles V managed to raise a considerable army and drive the Turkish fleet back to Tunis, which was then taken by Christian forces in 1535. This was followed by successful defenses of the southern Adriatic in 1537. These victories were celebrated by the artists, authors, and musicians at Paul's court, and we shall see that the Turkish threat, in an earlier embodiment, appears in the Stanze (fig. 126).

In 1544 the oft-proposed council finally found a definitive home: Trent. Proceedings began in 1545. The Emperor wanted to discuss reform, the pope dogma; but the real aim of the council, which was to involve the Protestants, was not realized due to Lutheran recalcitrance. After three tumultuous years in Trent, the outbreak of an epidemic there drove the group to Bologna. Nonetheless the Council of Trent, whose labors lasted until 1563, managed to hammer out the newly austere doctrines of church government and personal piety, of church decoration and art, that go by the name of Counter-Reformation.

But Paul's careful political neutrality was meanwhile coming undone. His elder son, Pierluigi, on whom he had lavished every privilege and possibility, and who was now lord of Castro, Nepi, Parma, and Piacenza, began to turn pro-French. As a result Paul's plan to make his son governor of Milan, then an imperial holding, foundered, and Pierluigi was murdered with the complicity of the governor he sought to replace, Ferrante Gonzaga. This was on September 10, 1547. In 1552 Pierluigi's son Orazio went completely over to the French side and married a natural daughter of Henri II. Elsewhere there were continuing revolts against papal rule—at Florence, Siena, Ferrara, Mantova; and in Rome itself.

Like his two Medici predecessors Paul used the papacy to raise his family's social level. Indeed, since the Medici were powerful well before Leo's election, Paul may be said to have raised his family rather further than the Medici popes had raised theirs. Thus Pierluigi Farnese's other son, Ottavio, became duke of Piacenza. Other grandsons became cardinals. In the same year as Orazio's marriage to Henri II's daughter came that of Vittoria Farnese to Guidobaldo II della Rovere, duke of Urbino; so now the family was allied with Julius II's, an act that quelled antipapal movements in Guidobaldo's state. By the end of Paul's reign the Farnese were one of

the great Italian families and came to rule Camerino and Parma as well as the other cities mentioned.

Paul was a patron in the Julian image. Ariosto, in the *Orlando Furioso* (46.13), pays him tribute. He was better educated than Julius, with a relish for Greek inscriptions, e.g that inside the dome and around the main frieze of St. Peter's; his teacher had been the famous Pomponio Leto. As cardinal he had presided over a salon in his Roman residence the Palazzo della Cancelleria, still standing on the Corso Vittorio Emanuele. In that palace is a fresco by Giorgio Vasari celebrating the pope as a patron of the arts. Copernicus's *On the Revolutions of the Heavens* (1543) was dedicated to Paul. It was also he who urged Vasari to start writing his *Lives of*

the Painters, a foundation-stone of art historiography. Giangiorgio Trissino, Palladio's patron, was another author the pope backed. Aretino seems also to have been a member of the circle, at least before Farnese's election to the papacy.

But the greatest monument to Paul's patronage is his employment of Michelangelo. "For thirty years," he once told the artist, "I have longed to employ you, and now that I am pope shall I deny myself the fulfillment of my wish?" He went personally to see the artist at his house at the Macel de'Corvi near Trajan's Column. The *Last Judgment*, commissioned in different form by Clement VII, was recommissioned by Paul, who endowed the artist with a lifetime annual salary of 1,200 ducats. But we shall see that Paul's patronage

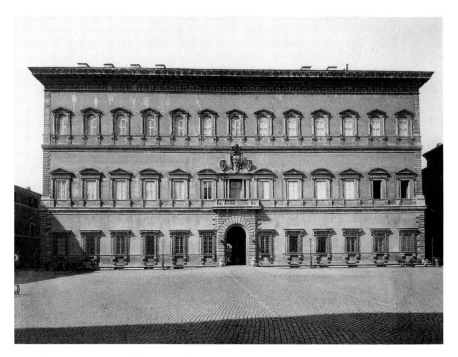

13. Palazzo Farnese, Rome, begun 1514 by Antonio da Sangallo the Younger; from 1546ff. by Michelangelo; completed by Giacomo della Porta. Alinari/Art Resource, N.Y.

of Michelangelo was more extensive even than this.

Paul undertook much building throughout the papal states, especially fortifications. Here Baldassare Peruzzi was the chief figure. But there are Sangallo fortifications at Ancona, Ostia, Assisi, Agnani, and elsewhere, and the Rocca Paolina at Perugia, completed in 1543. Paul also continued with his predecessors' excavation and preservation of antiquities. As an urbanist he built the present via del Corso, the via Paolina, the connections between Piazza Navona and Piazza Sant'Apollinare, and much besides. Aside from the work at St. Peter's, his architectural monuments are the Palazzo Farnese (1514ff., much of it by Michelangelo; fig. 13) and the initiation of the new Campidoglio by Michelangelo in honor of Charles V's visit to Rome in the 1530s. To these should be added the Roman church of Santo Spirito in Sassia, Sangallo again being employed (1538–44). Paul also began the developments at Frascati that led to the famous later villas there.

If the popes' original dream of empire, New Jerusalem, and millennium revealed itself to be fantasy, it was a fantasy that will nonetheless be gloriously reflected in art. The new basilica and Vatican complex, the Sistine Chapel, the Raphael Stanze and Logge, the tomb for Julius II, and the *Last Judgment* were the children of that dream. The fact that work on these projects, some of them wildly expensive, continued all during these fifty years of blood, infamy, and weakness is a testament to the dream's power.

2 Personae

 n 1443 Pope Eugene IV (reigned 1431–47), who had spent a decade of exile in Florence basking in its artistic climate, returned to Rome. He and several of his successors then took it upon themselves to bring a similar Renaissance to the papal city. In this, Eugene was only anticipating his successor, Nicholas V (reigned 1447–1455). Thus did Eugene commission bronze doors for Old St. Peter's (1433–45), still to be seen on the inner facade of the present basilica. They are by a Florentine artist, Filarete, and are one of the earliest important examples of Renaissance sculpture in Rome. The relief panels glorify Jesus, Mary, Peter, and Paul, embedding them in garlanded frames that swarm with tiny classical figures. As the artist's signature we see Filarete himself riding on a mule accompanied by other pilgrims (fig. 14). Nicholas, also fresh from Florence where he had been Ghiberti's patron, commissioned frescoes from Gentile da Fabriano for the Lateran Palace. Another major Early Renaissance work is the Chapel of Nicholas V (fig. 15) in the Vatican, with its frescoes by Fra Angelico (1448–50). These represent the stories of saints Stephen and Lawrence in the purest, most moving of Early Renaissance styles. In the vault the evangelists are seated on clouds.

As another instance of the impact in Rome of the Florentine Renaissance one can mention Masolino da Panicale's delicate and decorative frescoes in San Clemente (upper church, left aisle), which show the impact of his younger but greater inspirer, Masaccio. These date from before 1431. The two great early quattrocento sculptors,

14. Filarete, detail of the artist on a donkey from the bronze doors of St. Peter's, 1433–45. Alinari/Art Resource, N. Y.

Lorenzo Ghiberti and Donatello, are also recorded in Rome. Today there is no sculpture there by Ghiberti, but the Tesoro of St. Peter's does display a 1432 ciborium by Donatello (fig. 16) that is well worth looking at. It is one of the most beautiful pieces of Early Renaissance sculpture in the city.

After these tentative beginnings comes an ambitious plan for urban and artistic renewal foretelling the gargantuan dreams of Julius II. In the early 1450s Gianozzo Manetti, a humanist at the papal court, painted a prose picture of a rebuilt Rome designed by Leone Battista Alberti, one of the great architects of the period. This was in the reign of Fra Angelico's patron, Pope Nicholas. Alberti's plans were not really put into effect but are nonetheless important in the history of art. Mostly because of his treatise on architecture, written in Rome in the 1450s, Alberti's ideas were well known and set their stamp on much later work. Indeed, as part of Nicholas's scheme Bernardo Rossellino (1409–64) began a vast new apse for Old St. Peter's— massive foundations (fig. 17) which, though never completed, helped dictate the layout of Bramante's subsequent founda-

tions, and in turn affected Michelangelo's definitive work.

Later in the fifteenth century Paolo Romano, Isaia da Pisa, and the Dalmatian Andrea Bregno were filling the churches of Rome with classicizing marble tombs directly influenced by ancient Roman art. These would have their impact on the papal tombs discussed in this chapter. The most important fifteenth-century sculpture in Rome, however, is, once again, Florentine—two magnificent tombs by Antonio Pollaiuolo (1431/2–98), one for Sixtus IV, 1493, in the Tesoro of St. Peter's, and the other for Innocent VIII, 1498, in the second bay of the basilica's left aisle (figs. 18, 19).

Sixtus IV was indeed a major patron. Not only did he erect the Sistine Chapel, he commissioned for it the frescoes by Signorelli, Perugino, Botticelli, and others that decorate its upper walls (1481–83; figs. 140, 141). These, in turn, influenced both Michelangelo and Raphael in their Vatican work and elsewhere.

Another major Early Renaissance program is the Borgia Apartments in the Vatican (now devoted to the Museum of Modern Religious Art; notice the quattro-

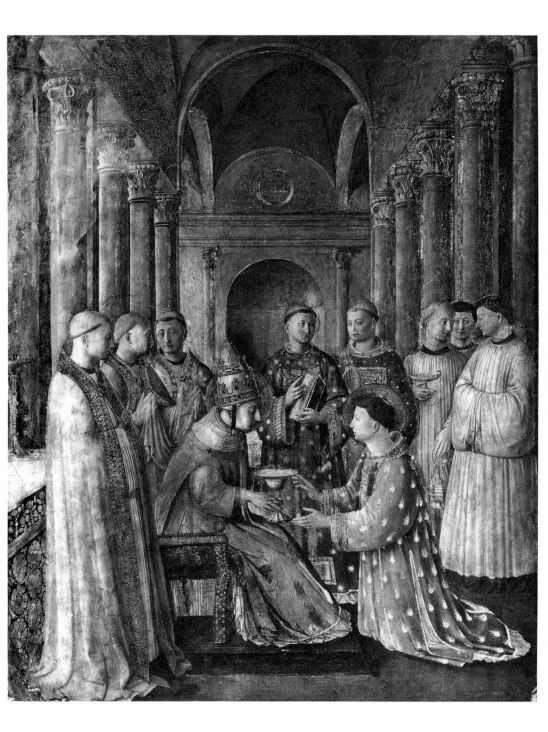

15. Fra Angelico, frescoes in Chapel of Nicholas V, 1448–50. *St. Lawrence Is Ordained Deacon by Sixtus II*. Alinari/Art Resource, N.Y.

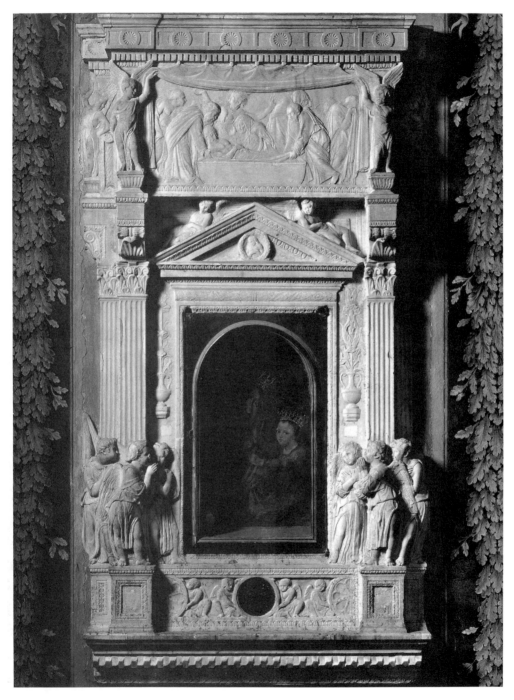

16. Donatello, ciborium, 1432. St. Peter's, Treasury. Alinari/Art Resource, N.Y.

cento ceilings; fig. 20). These were Alexander VI's living quarters. They were decorated by the elegant Perugian artist Pinturicchio (1492–95), who also, by the way, provided some exquisite frescoes, including a *Coronation of the Virgin*, for the apse of Santa Maria del Popolo. The iconography consists of prophets, sibyls, the liberal arts, Old Testament kings and prophets, and popes. The masterpiece is Sala V, dedicated to the pagan images that glorify the Borgia name, plus scenes from the Bible and legends of the saints. In 1889–97 the frescoes were restored by Ludwig Seitz.

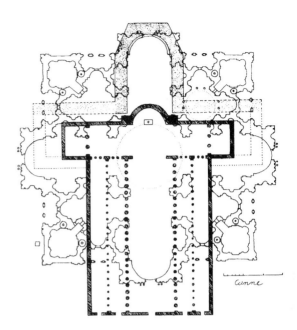

17. Bernardo Rossellino, plan of new apse (in stippled area) of St. Peter's, begun 1452. From Metternich and Thoenes, *Die Frühen St.-Peter-Entwürfe, 1505–14*.

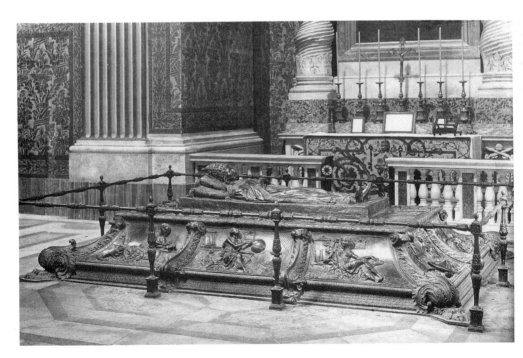

18. Antonio Pollaiuolo, tomb of Sixtus IV, 1493. St. Peter's, Treasury. Alinari/Art Resource, N.Y.

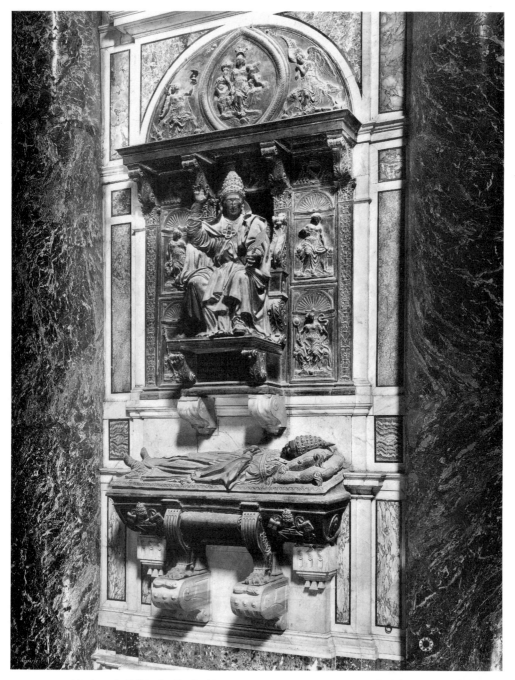

19. Antonio Pollaiuolo, Tomb of Innocent VIII, 1498. St. Peter's, Cappella del Coro. Alinari/Art Resource, N.Y.

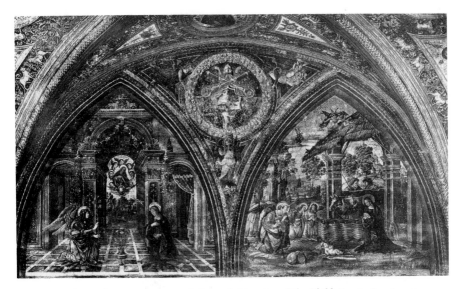

20. Pinturicchio and assistants, *Annunciation* and *Adoration of the Child*. Borgia Apartments, Sala V, 1492–95. Alinari/Art Resource, N.Y.

Meanwhile Rome was also being filled with important early Renaissance palaces such as Francesco del Borgo's Palazzo Venezia (begun 1455 by Pietro Barbo, later Paul II) and the Cancelleria (begun 1483 by Cardinal Raffaele Riario; architect unknown). But a great and unforgotten name is that of Donato Bramante. Born near Urbino and recently active in Milan, Bramante made his Roman debut with the cloister of Santa Maria della Pace (1500–1504) and the slightly later cylindrical temple of San Pietro in Montorio (fig. 21), both of which introduce the true solidity and grandeur of the High Renaissance to the papal city—and to the world, for that matter.

Meanwhile the most important sculptural group in St. Peter's today is Michelangelo's *Pietà* of 1499–1500, in the first large chapel to the right as you enter (fig. 22). It was made when the artist was about twenty-five for Cardinal Jean de Bilhères,

legate of Charles VIII to the Holy See. With its youthfully glamorous figures, its delicacy, its quiet emotion and exquisite surfaces, the *Pietà* sums up the achievements of the Florentine Early Renaissance. The artist's more tormented and no less famous later *Pietàs* in the Duomo, Florence, in the Florence Academy, and in the Castello Sforzesco, Milan, illustrate the High Renaissance's concern with more powerful and disturbing emotions.

Personal Imagery

In the Renaissance one's personal image, the memorably individualized and probably heroic face, was at least as important as such things are today. Indeed, despite the importance for us of well-calculated photographs and television images, Renaissance portraits were if possible charged with even more meaning than are ours. For the Renaissance as for us, visual in-

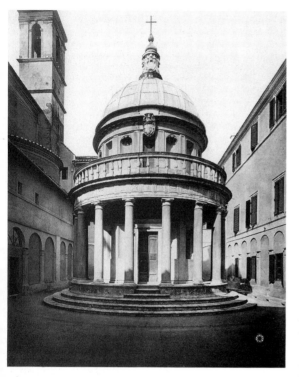

21. Bramante, San Pietro in Montorio, 1501–3. Rome.

formation, symbolism, and slogans were all-important. The period possessed an enviably gifted pool of artists able to create its portraits. By far the most widely circulated images of the popes were those engraved on coins and medals. These usually consisted of a portrait on one side, known as the obverse, and, on the other side, the reverse, an allegory or emblem with a motto proclaiming some basic policy or virtue. Coins and medals carried messages of peace, freedom, alliances between states and regions, and of the expansion of the Church's empire.

Medals could have a significance that is hard for us to recapture. Some of the meanings seem absurd and farfetched. Yet

if we want to match the mood of the High Renaissance we must follow its fantasies. There were plenty of hard-nosed realists in the period, for example Machiavelli and Guicciardini. But it was the fantasticators like Giles of Viterbo who had the papal ear and who, we shall see, did much to create the atmosphere in which the Vatican artistic programs were pursued.

Typology

It was common to think that certain links that people discerned between, say, Babylon, Jerusalem, and Rome, or between Moses, St. Peter, and Julius II, had been intended by God for the instruction of humankind. Such correspondences between scriptural events and personages and those of a later time constituted what was called typology. This discipline holds that scripture can be read as a set of detailed foreshadowings of modern events. And pagan history yields equivalent guidance. The ancient or biblical person or event, known as the "type," controls its modern counterpart, the "antitype." And one important visual mode for expressing the link between type and antitype was through coins and medals.

An honorific medallion is not a coin but a work of sculpture designed on the principle of the coin, with round format, reliefs on each side, and figures and inscriptions. Like coins, medals or medallions could be of lead, bronze, silver, or gold but they were not used as currency. They were issued on great occasions as mementoes. They could also have a talismanic value. Thus when a new building was begun, for example the new St. Peter's, medals memorializing this event were thrown into the foundation trenches (fig. 48). This was to assure a successful

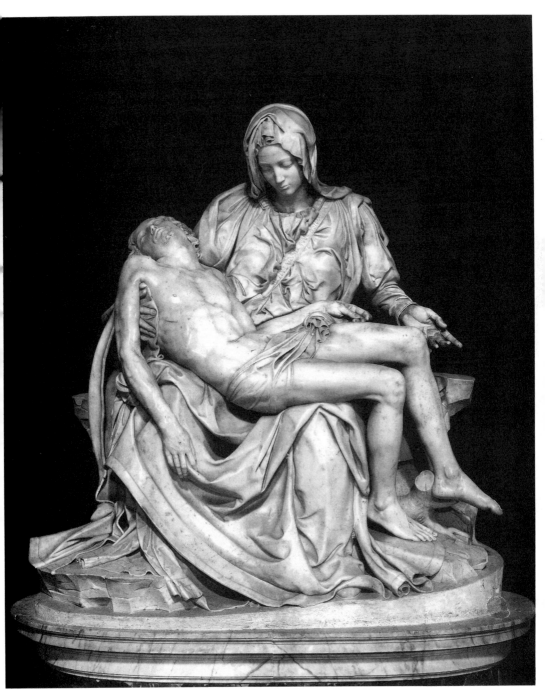

22. Michelangelo, *Pietà*, 1499–1500. St. Peter's, Cappella della Pietà. Alinari/Art Resource, N.Y.

building campaign and a lasting structure. (The Biblioteca Apostolica Vaticana sometimes has displays of Renaissance medals. See Chapter 4. There are also permanent displays of medallions in the Tesoro of St. Peter's.)

Emblems of Julius II

The commonest symbol on Julius's papal coinage was borrowed from medals issued before he became pope. This was the Della Rovere oak (fig. 8). The oak, whose four branches are arranged in St. Andrew's crosses (horizontal X's) from which, in turn, twelve acorns sprout, appears everywhere—not only on coins and medals but in buildings, sculptures, paintings, decorative arts, and in written texts. For Renaissance emblematists the oak had a sacrificial aspect. It was, for example, the traditional material for the crosses used in crucifixions. It formed the posts to which prisoners were chained when they were flogged or scourged. But the oak was also a symbol of strength, a byword for military and administrative firmness, and was considered particularly an attribute of the strong-hearted hero in maturity. And oak leaves were in antiquity fashioned into judges' crowns. In "Della Rovere," therefore, Giuliano had a name thoroughly suited to his personality and policies.

To Giles of Viterbo, however, the Della Rovere oak was more than an embodiment of the pope's persona. It was, we have seen, a model of the universe and a prophecy of Julius's coming role in the Golden Age. In his 1507 sermon in St. Peter's, Giles quotes Virgil on Aeneas resisting the pleas of Dido, a passage that compares the hero to an oak fighting against a storm (*Aeneid* 4.441ff.): "As the oak with its strength against the northern Alpine winds, which struggle against each other as they blow now this way, now that, . . . creaks, and its high branches strike the earth as its trunk strains; it clings to its cliff, and as much as its summit towers to heaven so do its roots extend to Tartary." The oak, which is here presented as the power that makes Aeneas forsake his love and fulfill his destiny by founding Rome, functions as a pole of the universe. Giles then embellishes the emblem by quoting Isaiah 6:13: "the land bereft of religion shall regain it as an oak tree spreads its branches." Thus does the Rovere oak also mark the Church's happy future.

That oak even explains the organizing principles of Giles's theory of history. The four golden ages (of Lucifer, Adam, Janus, and the Christ of the millennium) are the tree's four branches. The oak is particularly expressive of this last phase. "The rising and the setting of the sun across the wastes of ocean are the reflection of the golden acorns of [Julius's] golden tree." "There meanwhile extend from the trunk four branches like the four parts of earth. The first is to be the foundation, earth. . . . the second is water, the third winds and the air, the fourth light and heavenly fire." The tree itself is the world. Its acorns are the papal realms— the proposed Julian empire. But the acorns also stand for the twelve apostles—and each acorn, we learn, symbolizes a particular apostle—and, as well, those apostles' travels around the globe preaching the Gospel. As if all this wasn't enough the acorns also stand for the fruits these early travels have borne in more recently discovered lands.

This same oak is also the pillar and begetter of the new St. Peter's. The original repository of the Mosaic Law was an oak

tree. This was the aboriginal temple of the Old Testament. Giles likens Julius to the high priest who, in scripture, designs, builds, and in a way also is, the temple, which is of course the type of Bramante's building. He quotes Ecclesiastes 50:1: "The high priest is the pillar of the house and in his days he strengthened the temple. He himself built the height of the temple." Just as pope and priest are architectural pillars, so their supporting

function applies to their political jurisdictions: "You are a pillar of the house as you govern the papal states," Giles continues, "restoring them from hatreds, seditions, and harm, filled with blood as they are, and nearly collapsed. You impose calm on their dire ruins, laid low by faction, as, wonderfully, at the same time you are lord of the political realm." The new temple will be a model of the political settlement by which Julius the Oak rules.

Another Julian symbol is the Vatican rock, the *mons vaticanus*. As a place-name the word "vatican" was said to come from the practice of seeking *vaticinii*, prophecies, from the site's guardian deity. According to Giles, furthermore, that guardian deity was Janus, the Roman god of entrances, conclusions, and new beginnings. We have seen that Janus is also the Etruscan namesake of the historical cycle that led to Julius's arrival on the scene. Janus is the pagan prototype of St. Peter, which in turn makes the popes the continuators of the prophetic office and cult of Janus. (There is a proposition that would have set Luther's teeth on edge!)

Medals of Julius II

A medal made when the pope was still Giuliano della Rovere (fig. 23) shows the full-faced profile of a man in skullcap and cape with hood, longish hair curling under the cap's edge, keen eyes, firm chin, and something of a cauliflower ear: a tough old warrior. And already messages that will be repeated in the future reign appear. The obverse is inscribed: "Giuliano della Rovere, cardinal of San Pietro in Vincoli, Keeper of the Church's Liberty." On the reverse is an allegory in which a ship carrying a seated, gagged woman with an arrow in her left hand points out the

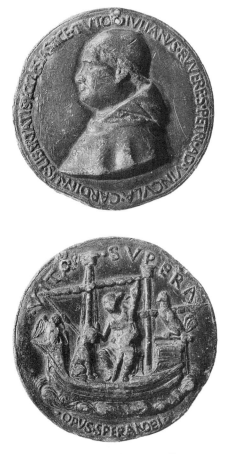

23. Sperandio, medal of Giuliano della Rovere, 1488. Obverse and reverse. London, British Museum (Hill 395).

eyes of a lynx (?) perched in front of her. On the bow is a pelican, at the tiller a cock. The cock, symbol of wakefulness, guides the ship of the Church (the seated woman), whose lookout is the lynx. Meanwhile the Church's role-model is the female pelican, emblem of charity, for she, it was thought, pierces her own breast to feed her young.

Why is the Church bound and gagged? The most obvious answer lies in the name of Giuliano's official church in Rome, San Pietro in Vincoli, St. Peter in Chains. When Peter, who became the first pope, was imprisoned the whole of the Church was bound and lacked guidance. Indeed these very chains, we saw, are preserved in San Pietro in Vincoli. Meanwhile we also saw that Giuliano was claiming that Alexander VI had "imprisoned" the Roman Church. The idea seems to be reflected in this medal.

Medals could make statements in series, answering or amending each other. The very title of Paolo Giovio's contemporary book *Dialogo delle imprese* (an *impresa* is a line of conduct represented by a motto and a symbolic figure), serves to suggest the idea. Thus, as pope, Julius issued a medal with his portrait on one side and on the other the conversion of St. Paul (fig. 24). It is inscribed with the words spoken to Paul by God: "It will be hard for you that you kick against my goad" (Acts 26:14). In other words God elicits Paul's obedience just as Paul, in Rome, will elicit the Church's. The coin may simultaneously refer to particular punishments administered by Julius, e.g., the deposition of the Bentivoglio in Bologna. But the image might further, or even instead, attack French claims that the Church should be governed by national synods rather than by the pope. In other

words Julius would here be replying, to the French, that the pope in Rome is God's goad. (That Rome is meant we see from the SPQR on the shield—*senatus populusque romanus*.) The next voice in the debate came in the year before Julius's death when he celebrated his final victory over the French with a coin showing himself on horseback chasing them out of Italy. The scene is indubitably a sequel to the one we just looked at. But now the horseman is back in his saddle and, grasping God's goad, he uses it against the Church's enemies.

But the biblical theme Julius most often borrowed was that of freedom from enslavement: "let my people go." We have seen how often the phrase "Babylonian captivity" appeared. The original

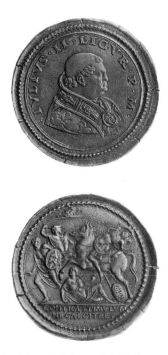

24. Pier Maria Serbaldi, medal of Julius II. Obverse and reverse. London, British Museum (Hill 866).

Babylonian captivity had occurred between the fall of Jerusalem in 586 B.C.E. and 538 B.C.E., in which year a new Jewish state was founded in Palestine. During the years preceding that achievement, however, thousands of Jews had been forced into exile in Babylon. It was to mark the official end of this captivity that, in 516 B.C.E., the new temple in Jerusalem was built. The episode was invoked not only when the popes were exiled to Avignon but, by Julius, when Alexander exiled him to Ostia. Luther, meanwhile, would refer to Julius's own papacy as a Babylonian captivity, as did the antipapal French Catholics. French coins made for circulation in Italy bore a motto from Isaiah (14:22): *perdam Babylonis nomen,* "I shall cut from Babylon the name." The Lord of Hosts promises to extirpate the remnant, the son, and nephew, and even the very name of Babylon [i.e. Rome], the sinful city, the city of whores, which enslaves the chosen people [i.e., in this reading, the French].

Raphael's Portrait

We turn to Raphael's famous London portrait of Julius (fig. 25). That, too, may be read emblematically, and as embodying one of Julius's desired personae. But it is not the persona of the warrior hero. Loren Partridge and Randolph Starn in their notable book on this picture point out that it is "the first independent painting (as opposed to sculpture) of a single pope in the history of art."

It was painted a year or so before Julius's death. The sitter is very different from the Julius in other portraits. Nowhere here is the man of action, the mighty oak. Instead we see a fatigued and aged figure, sunk in his chair, almost subordinate to the expanse of green fabric on the wall above his head. The pope's hollow eyes are not directed at the viewer but seem to burn with inward pain. He is "informally" dressed—i.e. he does not wear his tiara or pontifical vestments. Instead, he has on a pleated white alb and over it a hooded cape called a *mozzetta.* On his head is a red velvet cap with ermine border called a *camauro.* Only the acorns carved on the back of his chair establish his identity as a Della Rovere. His right hand loosely holds a handerkerchief or *mappa*—an ancient Roman symbol of authority.

And then there is the famous beard, so often remarked on by contemporaries, for this was still a clean-shaven age though beards were returning to fashion. But Julius's beard is far from being the lush mass of locks we see in most Renaissance beards—e.g Michelangelo's *Moses* (fig. 220). Julius's beard was grown in 1510 when Bologna renounced papal rule and the French returned to occupy the city temporarily. It was grown not as an adornment but as an ex voto, a sign that he had made a vow. The vow was that he would not shave until the French were driven from Italy. So the beard was not ornamental but penitential, indeed a mortification of the flesh. This is expressed, perhaps, by its lank thinness in the picture. Appropriately enough, Julius's namesake Julius Caesar had similarly grown a beard after being defeated by the Gauls, and we are told that he too vowed not to shave until he had avenged himself. Similarly again, Pope Julius I (reigned 337–52), another of Julius's "types," had grown a beard after being defeated by a Gaulish army, the beard not to be removed until the enemy was vanquished. Finally in 1527, twenty-

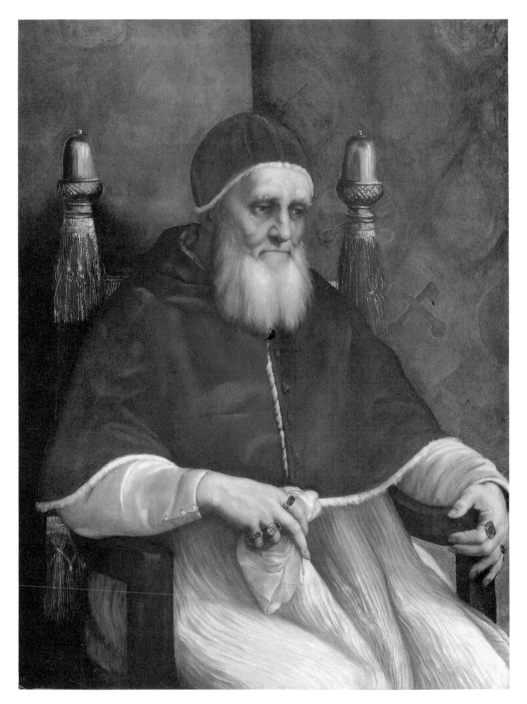

25. Raphael, portrait of Julius II, 1511–12. London, National Gallery.

four years after Julius II's death, Clement VII, as a sign of his determination to put to rout his Lutheran enemies, would also grow a beard.

But there is a supplementary possibility. Raphael's portrait suits, and could even illustrate, the fact that towards the end of his life, and at his death, Julius was adored, by some, as a saint. Canonization was supported, in particular, by Sigismondo De'Conti. And Giles of Viterbo apostrophizes Julius, still living, if not as a saint at least as a great Christian hero: "Good God, what years you spend, what quarrels you resolve, as much in Italy as among the barbarians [i.e., fighting non-Italians]; what swords you suffer, what poisons, what plots, what machinations of murder do you not set at naught by serving God, called as you are to this throne for the restoration of the temple, as of the empire, so that you may fully achieve the glory of religion?"

A painting such as Raphael's much-copied portrait might have been intended to play a role in the canonization process. It was the practice for a prospective candidate to be portrayed by means of a "true effigy"—a portrait from the life showing the person as he or she actually was, in all weakness and self-offering to God. "True effigies" avoided idealization and usually presented the candidate at the point of death, worn out from illness, prayer, and the desire to die. Sometimes these effigies were actual death masks. They were exhibited during the canonization process. Of all the images of Julius that we have, only this Raphael portrait may be said to resemble such a *vera effigies*. Whether or not Raphael's picture was actually made as a "true effigy," it is worth noting that, for years after it was painted, it was exhibited at festivals with a companion *Nativity*,

also by Raphael, in the nave of Santa Maria del Popolo.

Leo X

Leo X was a Medici, so his main emblem was the famous sign of red balls (usually six in number) arranged in an upright oval on a gold escutcheon (fig. 26). The device

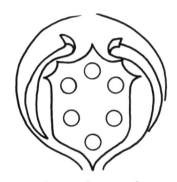

26. The Medici coat-of-arms. Author.

stands for the family's professions of banking and pawnbroking and thus fits in with its notable history of artistic patronage (since pawnbroking often involved works of art). But the balls had other meanings, including the ball of the earth itself. They were also equated with apples and oranges as symbols of regeneration. The golden apples of the Hesperides, often associated with the Medici, were called *mala medica*, healing apples. Standard praise for the two Medici popes was that they were the doctors (*medici*) who would cure the ailments of Italy and the Church. With Leo, especially, this image of the doctor shaded over into images of other care-givers—shepherds, succorers, and the like, who feed and comfort their charges.

Leo's emblematic presence could also involve pagan gods. There are medals of

1513—16, possibly by Vettor di Antonio Gambello (fig. 27), on whose obverses the pope appears as a tonsured pontifex maximus. On the reverse, with the motto "thy [i.e. God's] virtue is my whole light," is Apollo, holding a sun whose rays shine down on a lion—Leo—who in turn sets his paw commandingly on a globe which is also a Medici ball. Behind is a tree from which hang a bow and quiver. Apollo, sun god and "far shooter," patron of the Muses, would here be illuminating Leo with inspiration. For astrological reasons Leo particularly associated himself with Apollo.

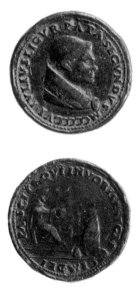

27. Vettor di Antonio Gambello (?), medal of Julius II, 1513–16. Obverse and reverse. London, British Museum (Hill 445).

Raphael's Portrait of Leo X

Raphael painted Leo X in 1518 (fig. 28). The portrait is now in the Uffizi. To some degree it is derived from the portrait of Julius. But where Julius characteristically appeared alone, and perhaps even as a pro-spective saint, Leo appears with two relatives and no tinge of saintliness. On his left stands his cousin and successor, Giulio de' Medici. Another relative, Cardinal Luigi de' Rossi, is also present. In contrast to the worn and wasted Julius, Leo, clad in fur-lined damask and lace, fills his space as roundly and confidently as the globe over which he aspired to spiritual sovereignty. His ample arms dominate the foreground, one hand resting on an open illuminated codex (the Hamilton Bible [fig. 198], opened to the beginning of St. John's Gospel: "In the beginning was the Word. . . . "). The other holds a reading glass. Let us recall that this page of John's Gospel introduces that other John, the Baptist, patron of Florence. Beside the book is an ornate gilded bell. As Vasari notes, the bell, book, and reading glass make up a handsome still life, as does the splendid chair whose globe-finial reflects the window of the room in which the scene takes place.

When one compares this with other images of Leo, for example the medallic portraits just discussed, one is struck, in the latter, by the sitter's serenely powerful profile, his air of inner triumph. In this portrait, on the other hand, the pope's face, in three-quarter view, is slightly sullen, his camauro well down around his head so that no hair shows, his gaze fixed on the middle distance. It is an informal family portrayal, in fact, and we are not surprised to learn that it was made for the Medici in Florence and hung in their palace. Yet there are no family emblems (except possibly the ball on the chair finial). Much to the fore, instead, is the sense that this pope supports his nephews, reads sumptuous books, and reveres Florence's John the Baptist—who of course is also the pope's namesake. The picture has little to do with Leo's career in Rome. Note too that there

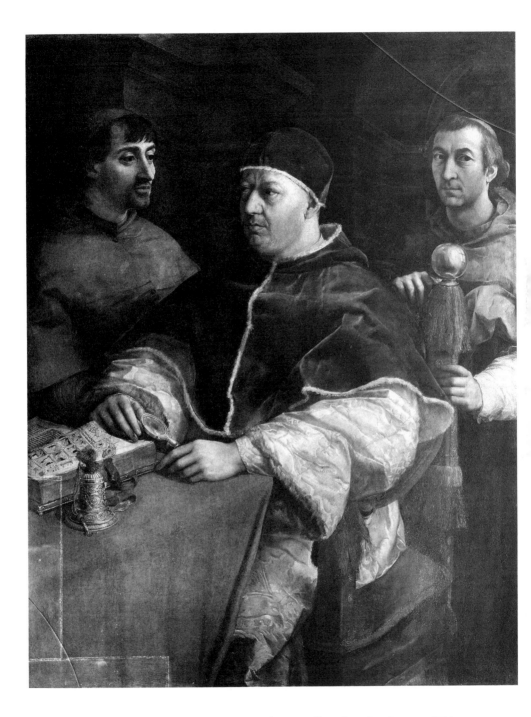

28. Raphael, portrait of Leo X and his nephews, 1518. Florence, Uffizi. Alinari/Art Resource, N.Y.

is no reference to lions. It is finally strange that Raphael, a master of serenity, should have shown his sitter as slightly morose. Perhaps the portrait was intended as a kind of denial, to his family in Florence, of the sitter's reputation for jollity and high living.

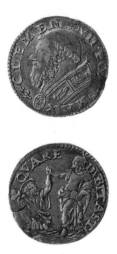

29. Benvenuto Cellini, Due Carlini coin of Clement VII. Obverse and reverse. British Museum, London.

Clement VII

The dialogue among coins and medals continued under Clement and reached new heights of medallic beauty. Clement was a lover of virtuoso metalwork and as noted made use of Cellini's genius as well as employing lesser figures such as Caradosso and Valerio Belli. Cellini in fact redesigned the papal coinage, creating what many numismatists consider the most beautiful money ever made. The stylistic and iconographic mood continues from the earlier reign: the pope is the peacemaker, rescuer, and guardian presence, though for obvious reasons Clement often returned to Julius's use of prisoner images, and on at least one occasion even displayed himself as something of a warrior. But Clement's main persona was Christ. There is, for example, a silver coin (fig. 29) bearing his nobly bearded portrait on the obverse, while, on the reverse, Christ rescues St. Peter from a sea-storm saying "O thou of little faith, wherefore hast thou doubted?" (Matt. 14: 31ff.). Speaking these words, Christ had saved the apostle when death threatened. Faith can do the same again when Peter's successors are similarly menaced; indeed they may rebuke their fainthearted allies with these very words. The image reappears all during Clement's troubled papacy.

With Cellini the possibilities of medallic sculpture achieved a lustre, a delicacy, a power, that the form had never before possessed. There, is for example, a magnificent gold *due carlini* coin of Clement VII. On the reverse is Christ seminude and bound to the column during the tortures that were part of his Passion. He is a thick muscular man, a conception obviously influenced by Michelangelo's Christ in Santa Maria sopra Minerva and, even more, by the captives Michelangelo was carving for the Julius tomb (Chapter 8, figs. 221, 222). Across the center of the relief are the words *ecce homo*, "Behold the man," spoken by Pilate when he displayed the bound Christ to the crowd of Jews demanding his crucifixion. With his full beard, and with his powerful build and the cloak falling in slender folds from his shoulders to the ground, Christ-Clement resembles a battered gladiator. He is well suited to the fierce portrait on the other side. Around the exergue (circumference) are the words *pro eo ut me deligerent*, "would that they had chosen me, not him." The words clearly refer to Clement's captivity and suffering during the Sack. To reinforce the point, the word *Roma* is in-

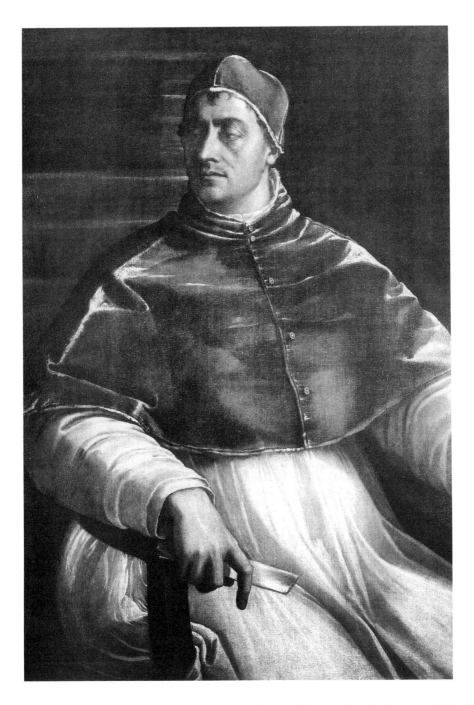

30. Sebastiano del Piombo, portrait of Clement VII. Naples, Capodimonte. Alinari/Art Resource, N.Y.

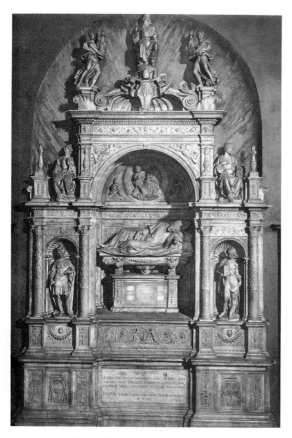

31. Andrea Sansovino, tomb of Girolamo della Rovere, 1505. Rome, Santa Maria del Popolo. Alinari/Art Resource, N.Y.

ecuted a number of paintings of his patron, who appears in them as a hawk-nosed, bearded man, massive of face and body, and with great black eyebrows (fig. 30). He does not look at all like the waffling bureaucrat he was; perhaps that is the point of these pictures. There are individual portraits in which Clement gestures in blessing, and a drawing for a group portrait in which we see him seated at a table with Charles V and courtiers—part of an increasingly abundant genre, in this period, that portrays famous men in councils and committee meetings.

Julius's Twin Tombs in Santa Maria del Popolo

The ideas present in these objects also appear in that key Renaissance sculptural genre, the tomb. Every pope has a family of some sort and many, including the two Medici popes, worked hard to glorify their relatives, providing jobs and appointments for the males and for the females lucrative marriages. The same had been true of many of the fifteenth-century popes. But, perhaps in part because Alexander VI had been so nepotic, Julius played the family man in a different sense.

Let us look very briefly, then, at what must pass for family monuments in the church of Santa Maria del Popolo (on the piazza of that name)—the very church where Raphael's portrait of Julius was displayed on feast days. The building is by no means solely a Della Rovere shrine. Other papal families such as the Cybo have tombs and chapels here, and so for that matter do the Borgias. Yet well before Julius's accession this was already pretty much the Della Rovere church in Rome. In it Sixtus IV had erected side chapels that were the first in Renaissance Rome to be designed as in-

scribed below Christ's feet, just as, earlier, Julius II had inscribed SPQR beneath Paul's conversion. On another doppione by Cellini the pope in full vestments kneels before Christ and takes the cross from him. In the same vein is a medal displaying Peter's liberation from his Jerusalem prison with the motto: *misit d[eus] angel[um] suum et liberavit me*. Peter's imprisonment was ended via the intervention of an angel (Acts 12).

Clement's chief court portraitist was Sebastiano del Piombo (1485–1547). He ex-

tegral parts of the structure they partly constitute (the present decor, however, is mostly due to Bernini).

In 1505 Julius set out to continue his uncle's work. The choir was extended and completed by 1510, the design being generally attributed to Bramante. There is a barrel-vaulted area housing the altar and an apse finished off in the form of a scallop-shell niche. In 1512 ceremonies honoring the Virgin were held here, and as noted the pendant to the Julius portrait was a Raphael *Nativity*. Stained-glass windows depicting incidents in the life of the Virgin, and inscribed with Julius's name, adorn the choir. The vault of the latter is decorated with frescoes by Pinturicchio stylistically recalling those that Raphael and his assistants were creating in the Stanze. They depict the coronation of the Virgin, the evangelists, the fathers of the Church, and the sibyls who predicted Christ's coming. If the style is Raphael-esque the iconography is related to that of the Sistine ceiling. But in Santa Maria del Popolo, as nowhere else in Julius's Roman programs, the Virgin reigns.

What concern us are two tombs standing in this choir just behind the present high altar (figs. 31, 32). One is for Julius's nephew Cardinal Girolamo Basso della Rovere, the other for his sometime ally, sometime enemy, Cardinal Ascanio Sforza. Girolamo Basso was the son of Luchina della Rovere, Sixtus IV's sister. He achieved prominence by overseeing, among other things, the Della Rovere benefactions such as the Santa Casa at Loreto. He was an important and bitter enemy of Borgia's election and, of course, an ally of Julius II. He combined religious with military service and marched with Julius's army in 1506 when Bologna was taken. He died the next year.

On the other hand Ascanio, the

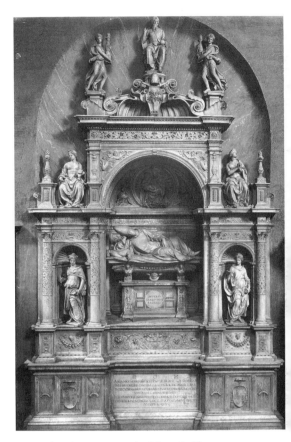

32. Andrea Sansovino, tomb of Ascanio Sforza, 1509. Rome, Santa Maria del Popolo. Alinari/Art Resource, N.Y.

brother of Lodovico Sforza, the duke of Milan deposed by the French in 1494, had been Rodrigo Borgia's backer in 1492, which made him very much Giuliano della Rovere's enemy. When Milan fell to the French two years later the two men were still enemies since Giuliano at the time was still on the French side. But 1503 was also the year of Giuliano's epochal volte-face; many of the future pope's former enemies accordingly became his friends. This happened with Ascanio Sforza, who thereupon voted for Giuliano in the papal

election. In that same year the two men were allies again, in a military attempt to wrest Lombardy from French rule.

So the two tombs are monuments, one to a blood relative and the other to a political ally. And they are almost identical. Girolamo's tomb dates from 1505ff. Ascanio's was completed in 1509, two years after his death. It has a bittersweet inscription befitting its occupant's problematic relationship with Julius, which reads in part: "Julius II Pontifex Maximus, mindful of his [Cardinal Sforza's] memory, and virtuously forgetful of his controversies, erected this monument when the church was being [re]built from its foundation." In short the tombs suggest that Julius could include former opponents as well as blood relatives among his family. Giles of Viterbo in a similar mood, and in these very years, likens Julius to Simon, son of Onias (Ecclus. 50 : 1), whose true family was what he calls the Hebrew church.

Like many Renaissance tombs these are triumphal arches. The dead person is shown entering heaven in a kind of upward procession. Doubtless Bramante was influential in their general design; Ascanio Sforza had been the architect's close friend in Milan. And the architectural style here is closer to Bramante's Milanese work than to his Roman. It is fully classical but richly decorated in low relief with many small details forming an allover pattern, and with slender, thickly disposed support features including engaged columns, pilasters, many jogs, and heavy cornice elements. The general effect is quite similar to Bramante's work at Santa Maria delle Grazie (a Sforza commission), and Santa Maria presso San Satiro, both in Milan. In this way do the tombs declare Ascanio's and Julius's Milanese connections.

Sculpturally, on the other hand, the

tombs are completely Florentine, the offspring of the young Andrea Sansovino's first great monument, the Corbinelli altar in Santo Spirito, Florence (1492). However, in comparison with earlier Renaissance tombs, whether Lombard or Florentine, the two in Rome do something different. Flanked by noble Virtues in upper and lower niches, the effigies, instead of being laid out on their backs, sleep, resting on one elbow. It is a pose ultimately derived from ancient Etruscan tomb art (fig. 33). Later it was to become widely popular (fig. 211). In its Christian context it suggests that death is not the end but a long sleep, after which the departed person will wake to the trumpet of the Last Judgment. We will see this "Etruscan" idea again in Julius's effigy on his own tomb and, since in these years the device is still rare, we may perhaps attribute it to Julius's belief in the Della Rovere family's Etruscan origins.

The Tombs of Leo and Clement in Santa Maria sopra Minerva

Clement and Leo ended up in another pair of twin tombs, in Santa Maria sopra Minerva, not far from the Pantheon (figs. 34–38). Much larger than those in Santa Maria del Popolo, they too stand on either side of a deep choir behind the church's high altar. Both were erected in 1542 by Baccio Bandinelli (1488–1560). They are based on Michelangelo's 1525 project for the tomb of Julius II (fig. 225), but also go back in sources to the classicizing Roman tombs of the Early Renaissance. The fact the the tombs are twins, however, reflects the two tombs just looked at and, as well, Clement's commission to Michelangelo for the Medici tombs in Florence, which we noted were originally to consist of two pairs of twins, one for the two warriors,

Lorenzo and Giuliano, and one for the two Medici popes.

The original scheme was to use Michelangelo designs as executed by a certain Alfonso Lombardi. But, instead, in 1536 Bandinelli was commissioned to do the figures and decoration, while the architecture was to be by the younger Antonio da Sangallo. Originally intended for Santa Maria Maggiore, the final decision brought them here, and the apse of Santa Maria sopra Minerva was remodeled accordingly. This of course only increased the similarity between this program and that in Santa Maria del Popolo.

At least one preliminary drawing by Bandinelli bears little relationship to the finished tombs but does illustrate a dramatic shift in what might be called tomb theology during these years. The scheme, now in the Museum of Art, Rhode Island School of Design (fig. 36), shows the dead pope in full pontificals rather self-consciously reclining, Etruscan fashion, on a low sarcophagus. Two angels bearing torches solemnly cover his body with a pall. The pope's soul, displayed as a naked classical figure in contrapposto (i.e. with the vertical axes of head, torso, pelvis, and legs forming a graceful irregular zigzag), is borne aloft in a mandorla or oval nimbus by five fluttering child angels. This image has been linked to a decree of the Fifth Lateran Council, of 1513, *Apostolici regiminis*, which, in attacking certain Paduan theologians who denied the soul's immor-

33. Etruscan tomb with recumbent figure, tufa, 2d/1st century BCE. Copenhagen, Ny Carlsberg Glyptotek.

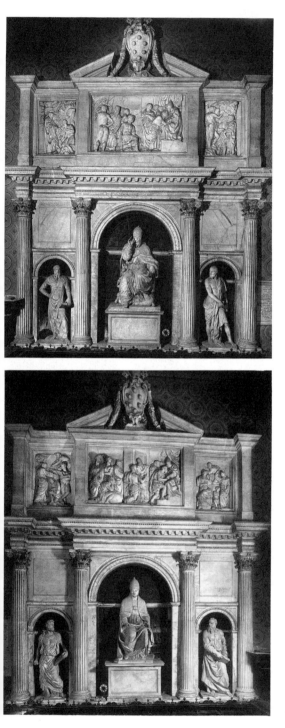

tality, reaffirmed the dogma that Christians could hope for individual physical resurrection after death. (The same idea stood behind Michelangelo's *Last Judgment*.) The fact that the resurrected soul is nude, though there is a long tradition for it, also reflects the Lateran Council teaching that after death the blest express pure innocence through their nudity. Such a body is not a mere bonebag, a mark of sin in the medieval manner, but a vessel of innocence, gloriously fresh, God's own portrait. This nudity is contrasted, in Baccio's sketch, with the dead pope's abandoned regalia below. Within the lunette of the upper arch, finally, floats God the Father, blessing a seated group below consisting of Christ, his mother, and six male saints. In the center the dove of the Holy Ghost swoops downward in rays of glory that beam outward from God to illumine the pope's ascending soul.

The style of Baccio's figures is almost too Michelangelesque. The lower angels are clearly lifted from the Sistine Chapel ignudi (figs. 158, 159; or even from the Eve, fig. 152), while the soul is Michelangelo's Christ (1519–21) in this very church, completed just before Baccio went to work. (We saw Benvenuto Cellini being inspired by the same statue in medals for Clement VII.) The upper seated figures in the drawing meanwhile derive from the Sistine prophets. In an equally Michelangelesque way the tomb's "architecture" consists simply of superimposed bodies

34. (*above, left*) Baccio Bandinelli, tomb of Clement VII, 1536–42. Rome, Santa Maria sopra Minerva. Alinari/Art Resource, N.Y.

35. (*left*) Baccio Bandinelli, tomb of Leo X, 1536–42. Rome, Santa Maria sopra Minerva. Alinari/Art Resource, N.Y.

within the arched niche. As in the Sistine ceiling and the *Last Judgment* all architectural qualities of thrust, support, symmetry, and lift are embodied by dynamic, gesturing human figures, though I must make it clear that Bandinelli is leaving space in his design for an architectural frame that was not yet established.

The tombs as they stand today, in contrast, have nothing of the drawing we have just looked at; and this change is indicative of a relative decline, between the 1520s and the 1540s, in the power of Neoplatonic teachings about the soul's innocent nudity. By the end of the Council of Trent, indeed, nudity will be practically banned in religious art. Thus in the finished tombs Bandinelli rejects his earlier nude figures and the equally Michelangelesque architecture almost entirely composed of bodies. Instead he made the tombs abstractly architectural—and political rather than theological. Each consists of a powerful two-story elevation of which the lower part is a three-niche, four-column triumphal arch, with the niches containing statues. The upper part is similarly divided into three compartments filled with rectangular reliefs. The central relief, on each tomb, is crowned by a broken pediment and the garlanded arms of the pope. Among Bandinelli's collaborators were Nanni di Baccio Bigio, who executed the seated statue of Clement, and Raffaello di Montelupo, who did Leo's. Here, however, there is no "Etruscan" pose—though the Medici had as good a claim to be considered Etruscans as did the Rovere. Instead, the statues represent the popes enthroned on high pedestals, right arms raised in benedictions not without a hint of menace. In general mood and pose the two statues echo Sebastiano del Piombo's portraits of Clement. The gestures make us think also

36. Baccio Bandinelli, drawing for papal tomb, c1536. Providence, Rhode Island School of Design.

of the Michelangelo's destroyed statue of Julius II for Bologna, and even of the planned statue of Leo X that was to have stood on the Capitoline hill in Rome.

The two tombs' political aspects come forward in the upper reliefs. On Leo's tomb we see his 1515 meeting in Bologna with Francis I (fig. 37). That encounter, as we have said, was only superficially a "triumph" since it merely prevented the French king from marching further south and perhaps taking Rome itself. On Clement's tomb we see that pope meeting Charles V in 1530 (fig. 38), which marked

the settlement of issues that had led to the Sack. That encounter was of course even more of a submission than the one between Leo and Francis, for it involved the loss of important papal states. The event is here portrayed, however, as the reverse of what it was. It turns into Charles's submission to the pope who, enthroned in fa-

37. Bandinelli, relief of Leo X and Francis I from tomb of Leo X. Alinari/Art Resource, N.Y.

38. Bandinelli, relief of Charles V and Clement VII from tomb of Clement VII. Alinari/Art Resource, N.Y.

therly fashion, receives the obeisances of the bearded emperor in the midst of a crowd of courtiers and soldiers who have put their armaments to one side. Once again we have Clement's theme of weapons abandoned. But is the courtier in skin-tight hose on the far left, presenting his buttocks to the viewer, an irreverent comment? Anyway, as Kathleen Weil-Garris Brandt points out, the scene contains a portrait of the bearded Bandinelli, fingering his beard in the manner of Michelangelo's *Moses*.

Paul III

Paul III does not, like Julius and Leo as we shall see, frequently appear in frescoes as an observer of, or participant in, episodes from history. Paul's portraits, which are plentiful enough in the form of easel paintings and sculptures, are contemporary: they almost always portray him and him alone. They also avoid the overt messages that were incorporated into his predecessors' self-imagery. Props and symbols are played down so as to concentrate on the sitter's powerful personality. The most memorable portrait of Paul III is the much-copied one by Titian at Capodimonte, Naples (1543; fig. 39). We can recognize it as a dramatic replay of the Raphael portraits mentioned earlier—a confrontational image of a single seated figure whose brilliant costume dominates the picture's palette. Frederick Hartt notes the "electrifying display of rich reds." The crimson mozzetta has a life of its own, seated like a conical mountain around the old man's shoulders as his head thrusts forward. But psychologically it is the face, the wily eyes, the finlike nose, the close-cropped hair, and long gray square-cut

beard that commands attention. There is also the grasping power of the right hand whose long, supple fingers play with a gilded stole. Like so many seated portraits of rulers and men of wealth, there is the overpowering sense of an unpleasantly magnetic personality. Even relaxed, as here, the fingers are prehensile. They are part of the sitter's personality, which—like Julius's, Leo's, and Clement's for that matter—is by no means welcoming. We recall that fearsomeness was considered a virtue in Renaissance rulers.

Paul's other major monument is his tomb in the apse of St. Peter's, just to the left of Bernini's great sculptural setting for the chair of Peter. It is by Guglielmo della Porta (1500–1577) and dates from 1551–75 (fig. 40). Guglielmo had made several portrait busts of the pope and installed important tombs in Roman churches, e.g., those of Paolo and Federigo Cesi in Santa Maria Maggiore. But Paul's tomb, even reduced as it now is (partly because of Michelangelo's ill will), if it is not a masterpiece in the purest sense, is at least its maker's masterpiece. Its installation in 1575 was considered an event and a medal was struck. Originally it was to have been freestanding, larger, and much more elaborate, with eight herms (tall pedestals topped with human heads) and eight allegorical statues. At one point the artist even suggested including statues of the four seasons and of river gods. And there was even to have been a small interior chapel. So it was really less than a rival to the early and most ambitious versions of Michelangelo's Julius tomb (see Chapter 8). Vasari adds that the huge monument was to have been erected "under the first arch under the tribune" which might mean about where the original Julius tomb would have gone. But Michelangelo, who remained the Vatican

39. Titian, portrait of Paul III, 1543. Naples, Capodimonte. Alinari/Art Resource, N.Y.

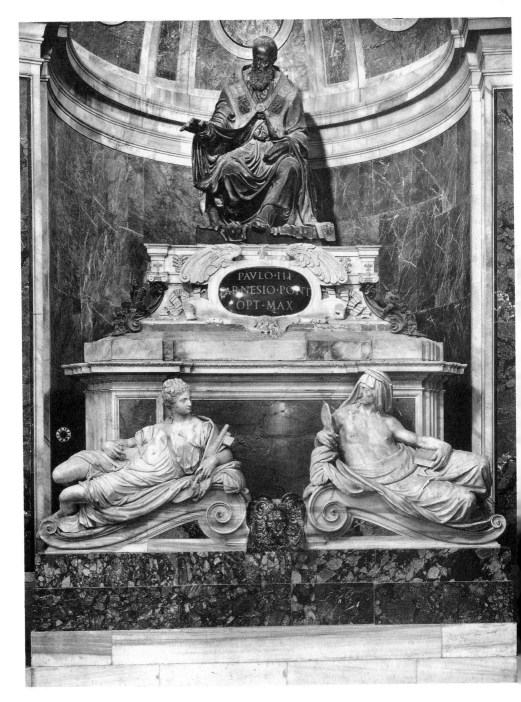

40. Guglielmo della Porta, tomb of Paul III, 1531–75. St. Peter's, apse. Alinari/Art Resource, N.Y.

artistic dictator until his death in 1564, objected that Della Porta's tomb would spoil the building's interior space. In the end the finished work was moved temporarily from one spot in the church to another, shedding elements each time. It was not until 1638 that it finally came to rest where it is.

As it stands today the tomb is set into a generous niche. There are only three figures, two female marble allegories reclining below and the seated bronze pope above. Behind the allegories is a sumptuously enframed antique sarcophagus supporting a scrolled podium with an inscription. The seated pope has the same physiognomy as the Titian portrait but the face is serener and more sorrowful. The beard falls like a curling stream across the sumptuous folds of the alb, which in turn is gathered by a stiff powerful cope, its border thick with tiny scenes. Rather than utilizing the awesome arm raised in blessing that we have seen in other High Renaissance popes, Paul's right hand is lowered and slightly relaxed, as if gently eliciting a supplicant's request.

The women below represent Justice (on the left, with the keys to heaven) and Prudence (with the mirror—she looks behind her, reflects). To some extent they are influenced by the allegories on Michelangelo's Medici tombs in Florence. The lore is that the magnificent, originally nude Justice is a portrait of the pope's sister Giulia who, we recall, was Alexander VI's mistress. By the same token the elderly Prudence is supposedly the pope's mother Giovanella Caetani. These suppositions are perfectly just: Paul owed a lot to both women. And that they should play the roles of these particular virtues is equally just—after all mothers embody prudence, and we have seen that when Alexander seduced Giulia he rewarded her brother with the cardinalate that started him on his career: a perfect piece of Renaissance justice. Two other women that once graced the tomb, an Abundance and a Peace, are now in the Palazzo Farnese. It would be interesting to discover if they represent other women in the pope's early life—e.g. the mothers of some of his children. At one point in the planning stages there were to be no less than twelve such ladies. At any rate if Paul was unlike Julius and Leo in his avoidance of emblematic portraits he followed his immediate predecessor, Clement, in his relish for the beauties of déshabille (see the Sala di Costantino, Chapter 6). One further note: if Michelangelo disliked Della Porta's tomb Bernini paid it the compliment of imitating it in his masterful monument, just the other side of the altar, for Urban VIII Barberini (1642–47).

At the beginning of our period, portraits, medallions, and tombs are rich with emblematic meanings. Della Rovere oaks and Medici balls are everywhere. They make statements about classical predecessors, biblical typology, apostolic tradition, mostly in the service of politics. In the reign of Paul III declarations of this sort are supplemented and in part replaced by a stronger focus on the sitter's personality and even costume. The human body comes to the fore; even nudity has its moments. We shall see comparable developments in the Vatican programs to which we now turn.

3 The New St. Peter's

he Vatican (figs. 41, 42) is so dominated by St. Peter's that, at first, it is difficult to get a sense of the place as anything more than an enframement for the church. What is today called Vatican City lies on the west bank of the Tiber between the lower slopes of two of Rome's many hills—to the north Monte Mario and to the south the Gianiculum. In ancient times the area was called the *ager vaticanus*, the Vatican Field—supposedly from the soothsayers or *vati* who held forth there. It was here that the Circus of Nero stood, to the left of the present church, and where innumerable Christians were martyred in 64 and 65 C.E. Peter was probably slain here in 67.

During most of the history of Christianity the Vatican has been the official seat of the Roman Catholic Church. It was also headquarters for the government of the Papal States as long as the pope retained his temporal powers. A decade after the unification of Italy in 1860–61, the papal domains became part of the Kingdom of Italy. On February 11, 1929, the Vatican was declared an independent state under the pontiff's personal rule. It has about 500 inhabitants and a territory of .44 square kilometers; so, as the indispensable Touring Club Italiano guide to Rome says, "it is 140 times smaller than San Marino."

The history of the new basilica (figs. 43, 74, 75) is a history of construction, but, with all its many proposed but unbuilt versions, it is also a history of architectural thought. The present chapter will show how the building we see today evolved out of certain High Renaissance formal experiments, first on Bramante's part under Julius

65

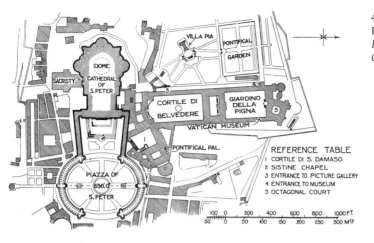

41. Map of the Vatican area. From Banister Fletcher, *A History of Architecture on the Comparative Method.*

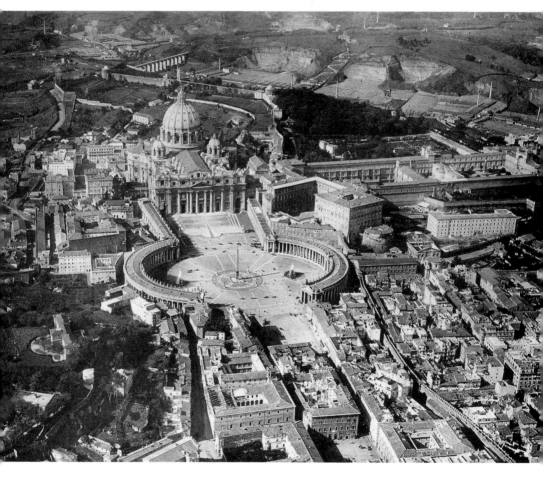

42. St. Peter's and the Vatican, air view. Alinari/Art Resource, N.Y.

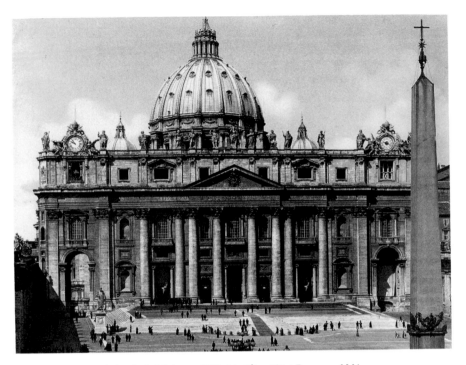

43. St. Peter's. Facade by Carlo Maderno, 1607–14. Alinari/Art Resource, N.Y.

II, then on Raphael's under Leo X, and finally on Michelangelo's under Paul III. But, throughout all changes of architect, patron, and time, the powerful logic of the original impulse was preserved. Though the church remains essentially a child of the High Renaissance its story stretches back to the first centuries of Christianity in Rome and forward from the High Renaissance into the Baroque art of the seventeenth century; and beyond that to modern times. St. Peter's is like an epic poem whose genesis and history reach out into every imaginable adjacent intellectual territory, wherein we may learn about Renaissance history, architecture, philosophy, cosmology, typology, and religion.

The story begins in the autumn of 1505. It was then that Julius II took up a task that his immediate predecessors had left dormant. At first the pope merely wanted to complete an expansion of the apse of Constantine's old basilica, utilizing foundations laid during the reign of Nicholas V (1447–55). That apse, we have seen, had been designed by the Florentine Bernardo Rossellino (fig. 17). But it was now, at least according to one of the options being considered, also to be the setting for Michelangelo's tomb for Julius, commissioned the previous spring. However, as his thought proceeded, the pope became more and more decided on a complete rebuilding of the early Christian church. Among the advisers who were most influential at first were Bramante, who came from near Urbino, and the Florentine Giuliano da Sangallo. Over the next

44. After Bramante. Reconstruction of 1506 plan (Uffizi A 1, 1506) for St. Peter's. From Metternich and Thoenes.

ing as a model and challenge throughout later architectural history. It is also the anti-type for a number of earlier architectural "types" that express such things as the spread of the Christian empire, Rome the New Jerusalem, the re-erection of St. Peter's tomb, and Julius's own prophesied role as the pope whose task was to ready the papal city for Christ's return to earth. Far more than that of the present building, Bramante's plan gives geometric form to Julian ecclesiology. It maps out with pene-trating, unforgettable clarity the Church's nature, mission, and goal as seen by Julius and his court.

Bramante

Bramante, we saw in the last chapter, had recently been working in Milan, rebuilding and remodeling a number of churches. These designs, and others made there by his friend Leonardo da Vinci, use multiple overlapping geometrical figures, broad, deep vaults and domes, and the classical or-ders of architecture. Giulio Claudio Argan has aptly called Bramante's Milanese work "volume as spectacle." But the Milanese buildings and projects also adhere to the local taste for red brick walls, terracotta ornament, and the high, narrow propor-tions that we saw being quoted, perhaps to express "Milanese-ness," in the Sforza and Rovere tombs in Santa Maria del Popolo. Such architecture essentially belongs to the Early Renaissance (fig. 31).

few years Bramante and Sangallo each produced alternative schemes, some for remodelings, some for a completely new structure.

The most important of these proposals was made in 1506 by Bramante (fig. 44). His central idea, apparently presented with variants, exists today in several forms—as partial floor-plans, as a perspective view (partly inconsistent with the plans), and in other documents. According to the Bra-mante expert Arnaldo Bruschi, the incon-sistencies among these conceptions show that, although construction on the church's central piers was begun soon after the 1506 plan was made, the shape of the rest of the building remained incompletely de-termined right through to the architect's death in 1514.

Nonetheless Bramante's scheme is one of the most significant ever devised. It powerfully influenced the building as we see it today. It has been equally stimulat-

When he got to Rome Bramante's style brought forth all kinds of new possibili-ties. In his schemes for St. Peter's he would reveal his close study of Roman im-perial buildings—especially the baths of Caracalla and of Diocletian—with their gi-ant flat pilaster groups, powerful enframe-ments, and lofty vaults. He would echo

their immensity as well as their style. Indeed Bramante would soon be credited by Raphael, and by the sixteenth-century writers Sebastiano Serlio and Giorgio Vasari, with having singlehandedly restored the architectural glories of imperial Rome after centuries of decadence.

Bramante and Leonardo were concerned not only with geometrical figures, especially the square and circle, but with the power of these shapes to generate others—shapes that were miniatures of the "parent" form. This concept of the generation of one form by another had a curious aspect: the male human body, in line with suggestions made by Vitruvius, was seen as a generator of squares and circles. In Leonardo's interpretation of Vitruvius, for example (fig. 45), the circle was the "mother" of the man, since his umbilicus is at the center of the circle mapped through the man's outstretched arms, slightly raised, and legs planted apart. Alternatively, when the man puts his feet together and extends his arms at right angles to his body, the gesture generates a square centered on the man's penis. Thus the man born of the circle "fathers" the square. One imitation of Leonardo's Vitruvian man, by the Milanese theorist Cesare Cesariano, even shows the figure with an erection. The square is thus shown at the very moment of its "conception." In the seventeenth century, related drawings were to be made showing the figure of St. Peter in a crucifixion pose, his head "generating" Michelangelo's dome and his arms the Bernini colonnades.

Bramante had arrived in Rome in c1500. Leonardo appeared there slightly later. The latter's sketches of central-plan churches, and Bramante's own first designs for St. Peter's, have much in common. Indeed one of Leonardo's designs, if we ex-

45. Leonardo da Vinci, Vitruvian man, 1485–90. Venice, Accademia, 228.

trapolate its plan from the perspective view he has left us, is, in contrast to the general run of church architecture at the time, strikingly similar to Bramante's (figs. 44, 46, 47). In both we see Greek crosses formed of vaulted main arms (shown in fig. 47 in black), with four identical domed chapels (in gray) set into the corners of the arms. Bramante's scheme, however, adds octagonal corner chapels. With its four great piers supporting the central dome and a cluster of subsidiary domes around them, Bramante's basic Leonardesque arrangement survives all subsequent changes of design and of architect to reappear, encased

46. Leonardo da Vinci, sketch for a central-plan church. Paris, MS Bibliothèque Nationale 2037, 3v. Alinari/Art Resource, N.Y.

and thickened, in the finished building
(fig. 76).

Leonardo's perspective view for the
plan given above calls for tall vertical pro-
portions. This does not match the most
frequently published Bramante view of the
new St. Peter's (fig. 48), which has a low
central dome, called a dish dome, based on
that of the Pantheon in Rome. But Bra-
mante is thought to have contemplated a
higher dome as well, more like the one ac-
tually built by Michelangelo. So one can
say that St. Peter's, as erected, combines
elements of Bramante's definitive scheme
along with ideas he is known to have
considered.

But I have said that Bramante was in-
terested in generating and multiplying
shapes. Looked at in more detail his
scheme consists of a large Greek cross each
of whose arms ends in an apse containing
a chapel (fig. 44). Symmetrically clustered
within the inside corners formed by the
cross's arms are four miniature Greek
crosses that, together, make up the basic
cube of the church's body. The arms of
these smaller crosses consist of further
miniatures. And *their* corners, in turn, are
filled in with yet smaller chapels or niches.
The principle is that of Chinese boxes—or,
for that matter, fractals. So we can speak
of a single macrochapel formed by the
main dome, four sets of what I will call
maxichapels, sixteen minichapels, and
thirty-two microchapels. The two latter
groups, however, the minis and the mi-
cros, consist of half-domes rather than
complete ones. Also, the minis and micros
that face toward the central piers are bro-
ken through to provide access to the
macrochapel.

Each new "generation" of chapels is
precisely one-half the size, and has pre-
cisely four times the frequency, of its pre-

Bramante's
Basic Scheme

Leonardo's
Basic Scheme

47. Basic scheme of Bramante's and Leonardo's
church designs in figs. 44 and 46, respectively.
Author.

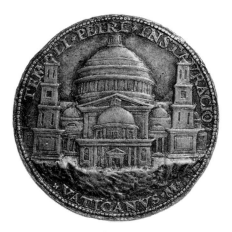

48. Caradosso, medal honoring the laying of
the foundation stone for St. Peter's, 1506. Re-
verse. London, British Museum (Hill 659).

Mini
Chapel

Maxi
Chapel

Maxi
Chapel

Micro
Chapel

Macro
Chapel

Maxi
Chapel

Maxi
Chapel

Parchment Plan: Distribution of Macro-Chapels,
Maxi-Chapels, Mini-Chapels, and Micro-Chapels

49. Basic scheme of St. Peter's with "Nested"
chapels. Author.

Domed
Pavilions

Open-Air
Apses

Parchment
Basilica

2000p

Mouth of Bernini's Colonnade

Bramante's Scheme for a Piazza
Roman palmi (1 palmo = .22 meters)

50. Dimensioned diagram of Bramante's sketch
of St. Peter's with a proposed square. Author.

decessor. The macrochapel dome measures
160 palmi (35.2 meters, c.115 ft. 6 inches;
1 palmo = .22 meters or 8 2/3 inches),
the maxichapel domes 80, the minis 40
and the micros 20. (I have used the mea-
surements that were worked out by a
modern scholar, Franz Graf Wolf von
Metternich.)

In another diagram (fig. 49) I have
X-rayed the parchment plan, removing
the outer 500-palmo square, the octagonal
chapels at its four corners, along with the
rest of the church's outer margin. This re-
veals the core of Bramante's conception in
a slightly different way. The black areas
filling the spaces between main dome and
the inner minichapels show how the shapes
of the four crossing piers were generated.
The same "genealogy" applies to the pro-
posed church's interior perspectives.

This sort of form-generation can pro-
gress toward larger as well as smaller
progeny. At one point Bramante thought
of setting his church into a huge enlarge-
ment of itself. With this project he would
have shifted the orientation of the whole
complex ninety degrees so that it faced
south, away from the Tiber and the Castel
Sant'Angelo and toward the obelisk then
standing near the presumed site of Peter's
martyrdom. I have redrawn the scheme
(fig. 50). There would have been an inner
square colonnaded space punctuated by
four apsed open-air halls, while the cor-
ners of the outer square would have con-
sisted of square domed chapels. (Bramante
also planned something similar, on a much
smaller scale, as a surrounding portico for
San Pietro in Montorio, Rome, fig. 21.)
My sketch shows that the Vatican piazza
would have been 2,000 Roman palmi (1,443
feet) square, two-thirds of the distance
from the present apse to the mouth of
Bernini's colonnades (shown in grey), and

that Bramante's piazza would actually have
covered a larger area than the present com-
plex. As Bruschi points out, constructing
this square piazza would have meant raz-
ing the Sistine Chapel and other parts of
the Vatican palace—which were at that
very time being built and decorated! Such
an act would also have made it terribly
clear that the proposed basilica was a brand
new building and not the mere "restora-
tion" of Old St. Peter's it was always
claimed to be. Probably for these reasons
Julius decided to keep the westward orien-
tation toward Castel Sant'Angelo.

51. Old St. Peter's, exterior. From Banister
Fletcher.

Old St. Peter's and the Tomb of the First Pope

Old St. Peter's had been erected by Con-
stantine in about 315 C.E. to honor the
bones of Peter. On November 18, 326, the
church was consecrated by Pope Sylvester I.
It was a huge building, with five columned
aisles and a wooden roof and short tran-
septs (fig. 51). Within, at the focus of the
choir and transept area, was a shrine to
the apostle which over the years acquired a
multistory apsidal superstructure called
the *confessio* (fig. 52), with provisions for
the visits of pilgrims. The church was en-
crusted with sumptuous mosaics, and
boasted the tombs of Christian emperors
as well as of innumerable saints and popes
(fig. 53). The interiors of the present
churches of Santa Maria Maggiore and
San Paolo fuori le Mura, in Rome, though
much rebuilt, and smaller, give some idea
of the look of Old St. Peter's. Outside the
basilica proper, to the east, extending in
front of the main facade, was an immense
open atrium or colonnaded square roughly
occupying the position of the Bernini
colonnades.

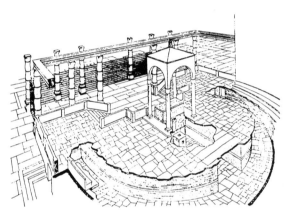

52. Cross-section of the *confessio*. From B. M.
Apollonj Ghetti, et al., *Esplorazioni sotto la
confessione di San Pietro in Vaticano*, 1951.

Discussions about rebuilding parts of
Constantine's dilapidated basilica had be-
gun in the fifteenth century when the
popes returned from Avignon. We have
seen that two of the architects involved
had been Alberti and Bernardo Rossellino,
who concerned themselves with such things
as further improvements to the apse and
the partial construction of a multistory
benediction loggia on the atrium facade
(fig. 194). Work on this new apse seems to
have continued intermittently on through

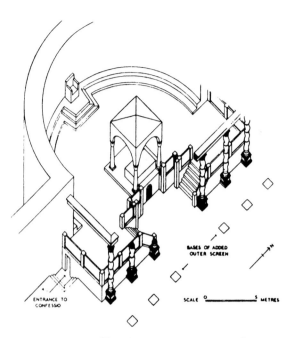

53. Old St. Peter's. Interior. From Jocelyn Toynbee and J. W. Perkins, *The Shrine of St. Peter and the Vatican Excavations*, 1956.

to Bramante's arrival. We just saw that at first Julius II planned to go on with it.

In deciding, instead, to raze Old St. Peter's in its entirety, Julius was proposing something new and shocking. The old church, after all, was the very sort of evidence needed to establish papal continuity from Peter onward. The pope's proposal to tear it down seemed rankly impious to many. The old building was positively riddled with the tombs, and therefore with the bodies, of saints and popes. Ennia Francia's book on the new basilica's construction shows the powerful taboos exerted by those bones. The very process of rebuilding only turned up more remains. Thus as late as February 1544 workmen in the Chapel of Santa Petronilla rediscovered the sarcophagus of Maria, wife of the Emperor Honorius. We have to bear in mind

that this age believed that the dead could wreak vengeance on those who violated their tombs.

In the end the new building reconsecrated, as much as possible, these remains. Thus the crossing we see today, though it mostly dates from after our period, is essentially a superstructure for the confessio. At the base of everything are Peter's bones. They lie well underground in a small stone chamber with a single small window. This was so sacred it was not touched and seldom even alluded to. The chamber is approached by a pair of curved stairs. Directly above these was the main altar of St. Peter's (fig. 52). This, like almost all altars in Christendom, contained relics of its own. Within the four crossing piers were installed the relics of the four saints—two women and two men—whose statues adorn them—Longinus, whose lance opened the wound in Jesus's side on the cross; Helen, who discovered the cross in the Holy Land; Veronica, who dried Christ's face with her veil; and the head of St. Andrew the Apostle (fig. 75). The existence of the relics within the piers (the veil, the cross, the lance, the head) is marked by reliefs set into balconies above the statues. The piers themselves stand over the tomb like guardians. But the whole of the present St. Peter's is really a magnificent carapace for its treasure of sacred bones, nails, pieces of cloth, and other artifacts of martyrdom.

The New St. Peter's as a "Work"

I spoke in the Introduction about the Christian idea of work—*opus Dei*. Probably the question most discussed at the time Bramante's project was undertaken was not its architectural novelty, nor even the destruction of Old St. Peter's, but the

cost. The enormous amounts of money involved were justified in two ways. One was that the new building was the antitype of costly types such as Solomon's temple. The second justification was that paying the cost was a religious act. "Thus," as Giles of Viterbo proclaimed, "all people are persuaded, on the basis of the visible pile of foundations already laid, that whatever will happen in the city of Rome, and among whatever great works there come to be, this will forever be the greatest of them; that nothing in Italy and indeed nothing in the universal orb of nations will ever be more sublime, or in cost more magnificent, or in excellence greater, more splendid, more admirable." Mottoes on Julius's medals add: "*non nobis, Domine, sed tuam gloriam*," "not for ourselves, but your glory, O Lord."

We nowadays tend to be somewhat embarrassed at the idea of huge sums of money spent on what might be called decoration. The High Renaissance was not that way. There is plenty of scriptural precedent for a belief in gold—both as money *and* as decoration. Giles cites Exodus 25, in which God commands Moses to accept the offerings of the children of Israel: gold, copper, silver, and other precious things. "And from these offerings a sanctuary was built according to plans given by Jehovah himself." Gold is the theme, gold the substance, of the sacrifice. The temple is to have a golden crown above its face. Four golden circles are to be at the angles of the Ark (of the Covenant). And there are to be other circles on the sides, the rings by which the Ark is carried (one thinks of Bramante's circular chapels). Gold also appeared on the temple's inner walls. "There was nothing in the temple that was not dressed [or protected] in gold." Even the floor, inside and out, was of golden tiles. If all this was true of Solomon's temple, Giles asks, can the new temple in the new Jerusalem be anything less? Ought it not indeed be more?

But I have said that not only is it right to contribute to the construction of the new basilica, it is wrong not to. The text of 3 Kings 6 makes it clear that the gold of the temple was a thank-offering for Israel's deliverance from Egyptian bondage. And so, Giles asks with Jeremiah, perhaps addressing potential contributors to the building fund, "in what manner is your gold hidden?" (Lam. 4:1). Wherefore do you keep your money from God? Gold is not merely wealth, it is the source of light, a poetic form of goodness and mercy. The gold we have on earth, he continues, especially those vast amounts of it to be found in the New World we are conquering at this very moment, is only the semblance of the finer and more abundant gold of heaven.

Gold is nothing less than the earthly expression of divine love (Rev. 21:18–21). It is God himself who orders his temple to be built, through taxes, through contributions, through the sale of indulgences and through the extraction of wealth from overseas peoples. (For this, see the Vatican's Museo Etnografico.) Even the medallions Julius issued depicting the new church may have been sold as contributions to the building costs (fig. 48) just as similar medallions are sold today in the Vatican gift shop. In doing such things, says Giles, we simply return to God a small portion of the gold (i.e. love, existence, revelation) that he has given us.

The New St. Peter's as a Tomb

Seeing Bramante's building as a huge new envelope for the confessio helps explain

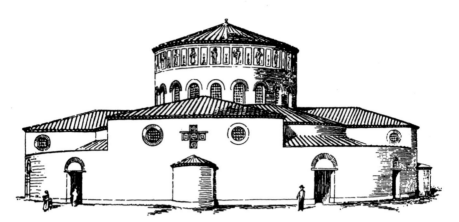

54. Rome, Santo Stefano Rotondo (consecrated by Pope Simplicius, reigned 468–83). From Banister Fletcher.

the Greek-cross plan with four identical arms and central dome. By taking this form the new structure proclaimed itself a burial place far more explicitly than did Constantine's basilica. The Greek cross with central dome was a characteristic shape for a martyrium or martyr's tomb, a special type of building going back to the beginnings of Christianity and with pre-Christian antecedents. A good example of

55. Detail of view of Jerusalem by Erhard Reuwich for Bernhard von Breidenbach's *Voyage to the Holy Land* (1486). The Dome of the Rock is labelled "Temple of Solomon."

56. Detail from Reuwich, Church of the Holy Sepulchre.

an existing martyrium, in Rome, is Santo Stefano Rotondo, about half a mile along the Via Claudia from the Colosseum—a round church consisting of vaulted arcs punctuated at the four points of the compass with raised bays, and with a central

57. Anthemius of Tralles and Isodorus of Miletus, Hagia Sophia, Istanbul, 532–537 CE. From Banister Fletcher.

circular colonnade supporting a cylindrical clerestoried tower (fig. 54). Like so many martyria and martyrium-like churches, Santo Stefano has no major axis, no main facade, and very little in the form of entrance emphasis. The same applies to Bramante's conception (fig. 47).

But another "martyrium," in Jerusalem, claims our attention. The celebrated mosque known as the Dome of the Rock is an octagonal structure with a tall central dome. (The site has been holy to many religions. It marks the place where Abraham undertook to sacrifice Isaac. The altar of David once stood here. Hadrian built a temple of Jupiter on the spot; today the building is sacred to Islam, for as a mosque it hallows the scene of the Prophet's ascent into heaven.) J. A. Ramirez has shown that, despite biblical evidence to the contrary, this building was often portrayed in the Renaissance as Solomon's temple (fig. 55). Thus, for some at least, the most sacred building of the Jews, the repository of the Law, had a shape comparable to that of Bramante's proposed new structure.

Even more sacred to Christians, how-ever, was the Church of the Holy Sepulchre, also in Jerusalem. In the Renaissance this building too was identified as Solomon's temple. Actually it was erected by Constantine over the tomb of Christ and subsequently rebuilt (fig. 56). The tomb itself is the center of a ring of columns that in turn is enclosed in an apse and ambulatory or walkway. Adjacent to this is a square domed compartment flanked by vaulted bays, ending on the side opposite the sepulchre with a similar but smaller columned ambulatory. The combination of tomb, column-ring, and ambulatory, fostering the movement of pilgrim crowds, is roughly similar in function to the confessio in Old St. Peter's (fig. 52). So it would have been unusual, in fact, if Bramante had *not* thought both of the Dome of the Rock and of the Church of the Holy Sepulchre when he received Julius's commission. The argument that he was replacing Constantine's Roman basilica with a huge version of the sepulchre that that same emperor had erected in Jerusalem for Christ himself—that should have muted some of the criticism.

58. Gerhard Mercator, Globe Urania Sphaera. Louvain, 1551.

But martyria are mostly small; Bramante's scheme calls for immensity. Even for this departure, however, there are precedents. A building of comparable scale to Bramante's, and with the same general plan-type as a martyrium, is Hagia Sophia, Constantinople (532–37; fig. 57). With its central dome and massed lower volumes, this has some of the look of Bramante's scheme without specifically prefiguring it. Other large buildings in this tradition belong to the Roman vaulted style, e.g. the calidarium of the Baths of Caracalla, Rome (211–217 c.e.), or the so-called temple of Jupiter in the palace of Diocletian at Split in Yugoslavia. One could also mention San Lorenzo Maggiore, Milan, whose Roman vaults would have been particularly familiar to Bramante.

The New St. Peter's as a "Mundus"

One of Giles's other frequent descriptive terms when speaking of Bramante's temple is *mundus*, world. The temple is an image of the earth, of the universe, or of some specific universe such as that of the priesthood, or the Church, or the Church's spiritual empire, etc. Bramante's scheme of cubes, hemispheres, central axes, and fourfold subdivisions into identical parts reflects the Renaissance concept, later echoed by John Donne, of a global map: "the round earth's imagined corners." The phrase refers to the inscription of a three-dimensional sphere or half-sphere on a rectangular sheet of paper. This cartographic concept, just coming into existence in Bramante's time, was also realized in Gerhard Mercator's globe, named the Urania Sphaera, of 1551 (fig. 58). Such were the maps that enabled navigators to get to the New World. Mercator's globe with its converging curved lines of longitude and its parallel curves of latitude, is akin to Giles's notion that the new basilica itself will be an airy globe. This same "global" pattern appears on the dome of the church today, both inside and out (figs. 68, 72). To us the imagery of latitude and longitude is so familiar we hardly see it. But it was a fresh idea in the Renaissance.

Giles uses these concepts to describe both the newly discovered parts of the earth and Bramante's new temple. "The Roman foundation and seat," wrote Giles, "that the prince of the apostles, along with the highest priests, instituted and dedicated as a temple, he commanded was to be raised up in two ways: as a vast massing of shrines, and as the new propagation of the empire." And, since the global maps of the time involved the four cardinal points of the compass, the four quarters of the globe, the four continents (America was considered a single continent and Australia had not yet been discovered), and various other quartets, including the four elements, the four temperaments, the four

evangelists, and the four branches of the Della Rovere oak, Giles found that the very universe itself, not to mention Bramante's new temple that modeled it, reinforced his notion of nature, God, and history. Here again Janus, god of compass points and of the Vatican, comes into play. It is not difficult to see how Bramante's scheme fits into and expresses these ideas. The central square crossing would be the central ark of the Covenant in Solomon's temple. The four lesser domes at its corners would be the "four rings" described in scripture and emphasized by Giles. The four corner complexes, four identical main arms, four octagonal chapels, four apses, echo Giles's other quaternities (fig. 44).

The Death of Bramante; Raphael

As we have noted work on the central piers was begun soon after the cornerstone was laid on April 18, 1506. But we have also noted that, even so, the building's final design, the specific placement of its outer walls and, especially, of the four apses, was still undetermined.

Seven years later, in 1513, when Julius died, St. Peter's looked like this: the dome piers had been completed to the level of the pendentives. (Pendentives are the concave masonry planes that fill the upper corners of a square bay and rise to meet the circular base of a dome.) The western choir walls had been raised to the point

59. St. Peter's in 1513, with housing for *Confessio*. From a drawing by Maarten van Heemskerck. Berlin, Staatliche Museen, Kupferstichkabinett.

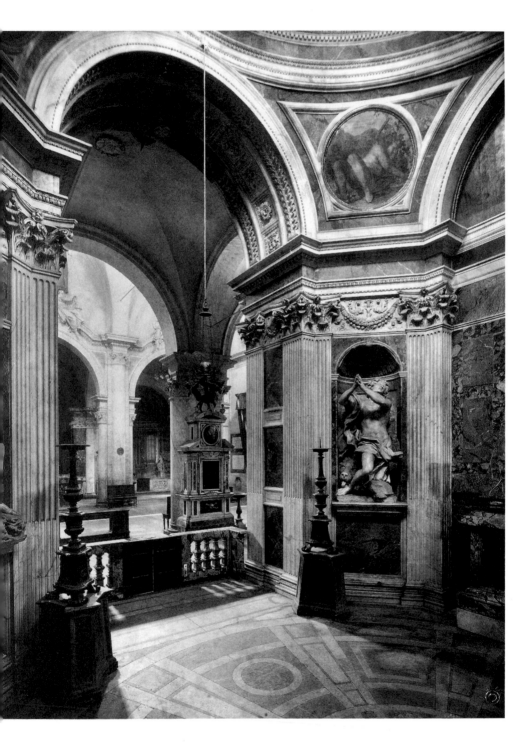

60. Raphael, Chigi Chapel. Santa Maria del Popolo, c1516. Alinari/Art Resource, N.Y.

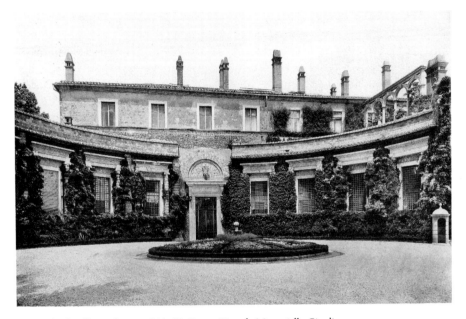

61. Raphael, Villa Madama, c1516–17. Rome, Piazzale Maresciallo Giardino. Alinari/Art Resource, N.Y.

where vaults spring out to cover the spaces below. The pair of nave piers just east of the crossing was also in place and, as well, pending the dome's completion, Bramante had built a small temporary structure to house the confessio and altar (fig. 59).

Bramante's successor was Raphael (1483–1520). The new architect-in-chief had had little architectural experience and so was given two of Bramante's experienced coadjutors, Giuliano da Sangallo and Fra Giocondo da Verona. Raphael's appointment seems to have been Bramante's dying wish. Thus were Raphael's late years (as Michelangelo's were to be) a plunge into architecture. Leo also made Raphael superintendent of antiquities and commissioned him to do a map of Rome showing its major ancient sites. As a fledgling architect Raphael designed the Chigi Chapel in Santa Maria del Popolo (1516; fig. 60)

and the little Sant'Eligio degli Orefici in the same year. In 1516–17 he began the unfinished but crucial Villa Madama for the future Clement VII (fig. 61).

Working mainly with Sangallo, Raphael produced at least two schemes for St. Peter's, one shortly after Bramante's death and the other, a variant of the first, shortly before his own death in 1520. Both pay homage to Bramante; yet both transform his huge martyrium into a longitudinal structure with a Latin rather than a Greek-cross plan, so that there is a long nave with shorter transepts and choir. The great dome is retained but is now set on a much more massive cylindrical columned drum. Around the curved ends of the transepts and apse Raphael provided vaulted passageways or ambulatories.

These are some of the ways in which Raphael varied his teacher's already flexible 1506 scheme. But note that he re-

tained Bramante's basic idea of nested chapels ranging from macro to micro. In fact, judging by C. L. Frommel's reconstructions (fig. 62a, b, c), it could be said that Bramante's church simply acquires its nave by adding four extra arrays of micros to its eastern arm. At the same time a great towered front and giant porticoed temple—the impressive facade Bramante's scheme so conspicuously lacked—was also added, to generate, ultimately, the facade we see today (fig. 43).

62a. Raphael's plan for St. Peter's, 1514–20. From C. L. Frommel, *Raffaelle Architetto*.

62b. Same. Elevation.

62c. Same. Interior.

63. Overdoor by Paris Nogari showing Michelangelo's plan for a Piazza San Pietro, c1546. Vatican Library. Alinari/Art Resource, N.Y.

Raphael's scheme also took up Bramante's rejected idea for a giant piazza featuring the obelisk. However the proposed facade and piazza now face east as in the present building. In other words Bramante had proposed leaving the obelisk where it was and shifting the church; Raphael proposed to leave the church and shift the obelisk. (Yet Raphael's scheme, be it noted, would like Bramante's have meant razing a good part of the Palazzi Vaticani.) In any event it seems to have been Raphael, or let us say Raphael, Sangallo, and Fra Giocondo, who came up with what turned out to be the definitive arrangement. Michelangelo was to echo this piazza directly in his own project of 1546, preserving its rectilinear form but surrounding it with colonnades. The scheme is depicted in a c1587 fresco by Paris Nogari in the Vatican Library (fig. 63). But it was only in the seventeenth century that Gianlorenzo Bernini actually did build such a huge space, transforming the High Renaissance rectangle into something resembling an enormous colonnaded keyhole—a trope, I call it, on the notion of Peter's keys (fig. 41).

As Frommel restores Raphael's planned interior (fig. 62c) we actually see pretty much what Bramante had had in mind. And it is not all that distant from what we see today. The interior essentially consists of huge main-aisle arches, nested subsidiary vaults, a wide crossing, and the tall columned drum and dominating hemispherical dome already mentioned. The difference from Bramante is of course the greater loftiness provided by that drum, which transforms both itself and its dome into an airborne temple. It is as if Bra-

mante's central-plan martyrium had not been rejected after all but had been lifted up to crown a more conventional church. The scheme recalls the old saying that the new St. Peter's would set the Pantheon on the Basilica of Constantine and Maxentius—i.e. would erect a domed round temple on top of a vaulted nave. The difference between Raphael's concept and the present church is the former's greater simplicity and its avoidance of such complications as interior coupled columns and elaborated coffers (the paneling on the inner surfaces of vaults and domes).

Raphael the Vitruvian

While he was elaborating these ideas Raphael was seeking out what he could learn from Vitruvius. This author of the only surviving architectural treatise from antiquity was enjoying a comeback in Renaissance Rome. Fra Giocondo had issued the Latin text of the treatise, with illustrations, in 1511. Raphael then had the text translated into Italian. Let us observe that, as an active designer, Fra Giocondo seems to have stood somewhat apart from Raphael and Sangallo. Though various idiosyncratic plans for St. Peter's have been attributed to him, it may be that he was appointed Raphael's assistant partly because he was an expert on Vitruvius.

Vitruvius, however, does not advocate the sort of massive vaults and central plan we find in Bramante's schemes. He champions rectangular temple-form buildings with rows of columns supporting wooden ceilings. And here we recall that Vitruvius lived before the vaulted imperial style, seen in such buildings as the Baths of Caracalla, had come into full existence. He in fact knew almost nothing of the Roman structures Bramante's plan invoked. Vitru-

vius emphasizes not vaults and domes but the column and its order—the omnipresent classical elements of base, shaft, and capital, of architrave, frieze, and cornice. Vitruvius's emphases help explain how and why Raphael was transforming Bramante's scheme.

How does one know that Raphael's revision of Bramante would have been so "columnar," so "Vitruvian?" Let us look at the way the architecture in his paintings changes. We begin with the airy basilica in the Vatican Stanze that houses *The School of Athens* (fig. 107). This was done about 1508, completely under Bramante's spell. We recognize the structure as Bramantesque in its flat, self-effacing pilasters, its emphasis on smooth white surfaces, its spare, delicate detail and its rolling vaults and rotunda. But the painted architecture Raphael created in later years, especially after Bramante's death, has a different character. If we look at frescoes dating from c1514 and later, such as *The Expulsion of Heliodorus, The Mass at Bolsena, The Oath of Leo III,* and *The Coronation of Charlemagne* (figs. 117, 121, 123, 124), we see lower, heavier, narrower, more enclosing vaults and, as well, things that do not appear at all in *The School of Athens*: round emphatic column shafts engaged into the walling systems, powerful, gilded, thickly clustered ornament, and heavy, projecting enframements. Supports in these later paintings, unlike those in the *School*, are stout, round, firm, and short. All this I would identify as Raphael's Vitruvian style, adopted during the last few years of his life. It would have been, I think, what he intended for St. Peter's. My one criticism of Frommel's reconstructions is that, as drawings, they are too pallid; they do not sufficiently bring out the robustness of Raphael's concept.

Aside from Vitruvius's increased prestige and availability there were other reasons why people at the time might have felt that the new basilica was better as a longitudinal columnar church than as a giant martyrium. Despite its evocation of Peter's tomb, the Roman Empire, Jerusalem, and the like, Bramante's design was resolutely antithetical to the building it was replacing. By abandoning that structure's lateral emphasis, its processional quality, Bramante's scheme, despite—or perhaps because of—its allusions to the architecture of the Near East, was unorthodox. It is not surprising that Raphael and others would draw plans making the new basilica more like the old. By making it more Vitruvian they were linking it more with Constantine. A Vitruvian temple, after all, reduced to its essence, is a walled rectangular enclosure with an outer ring of columns. The aisled basilica is a simple inversion of this, with the columns inside and the walls outside (fig. 64; I consider the basilica's apse and transept ancillary to this point and show them in dotted lines).

Raphael's associates, Fra Giocondo and Giuliano da Sangallo, would have been fond of such a scheme—Giocondo as a Vitruvius scholar and Giuliano because he would have been influenced by the Florentine tradition of basilican columnar churches. The glory of this tradition was the work of Filippo Brunelleschi. One of his churches, in fact, San Lorenzo, was the Medici family pantheon (fig. 65), to which Michelangelo in these very years contributed an unbuilt design for a facade (1515ff.), a funeral chapel (1521ff.), and a library (1524ff.).

The plan of what I take to be Raphael's newly Vitruvian church is portrayed in a dado scene in the largest and latest of the Vatican Stanze, the Sala di Costantino.

The scene depicts the laying of the cornerstone of *Old* St. Peter's. But two of the participants hold a plan that is unquestionably Raphael's scheme for the *new* St. Peter's. Indeed, since Old St. Peter's had been so much changed in the intervening centuries, some might well have thought that, originally, it *had* looked like this and that Raphael really *was* restoring an altered original. Two of Raphael's painted "Vitruvian" basilicas, those in *The Oath of Leo III* and the *Fire in the Borgo*, (figs. 123, 125), also represent Old St. Peter's and as far as they go are consistent with this plan.

St. Peter's after Raphael's Death

But Raphael's version of St. Peter's, though it was to influence the final outcome, languished as Bramante's had. And indeed the deaths of all four of the architects involved were clustered together: Bramante's in 1514, Fra Giocondo's in 1515, Sangallo's in 1516, Raphael's in 1520. Their patron, Leo, lived on only until 1521 and, as we recall, was followed by the unarchitectural Adrian VI. (These deaths, by the way, were often seen as divine punishment for the desecrators of Old St. Peter's.)

But now there was another Sangallo on the scene, Antonio the Younger, born in 1483 and therefore Raphael's exact contemporary. Antonio, who lived on until 1546, marked Raphael's passing by sending Leo a memorandum pointing out severe faults in the proposed design. Raphael's nave, he says, will be insufferably long and dark. The church will resemble an alley. Thereupon, as perhaps he was hoping, Clement VII appointed the younger Antonio da Sangallo architect of St. Peter's along with the Sienese Baldassare Peruzzi. The building campaign lasted from 1524 to 1527 when the Sack brought it to an un-

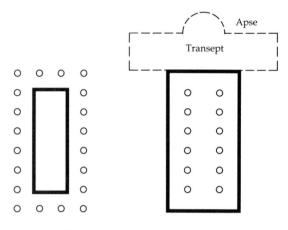

Apse

Transept

64. The Roman temple and the
early Christian church. Author.

The Vitruvian Temple Principle (left) and Its
Inversion into the Basilican Principle (right)

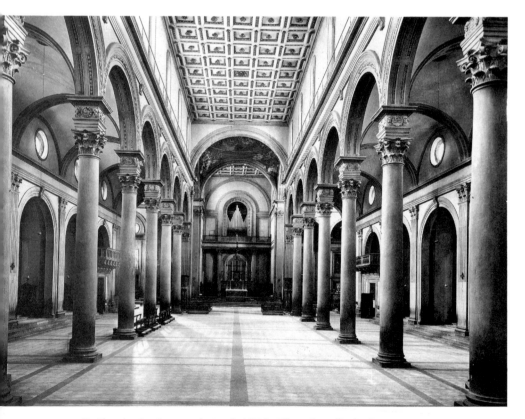

65. Florence, San Lorenzo, designed c1420 by Filippo Brunelleschi. Interior.
Alinari/Art Resource, N.Y.

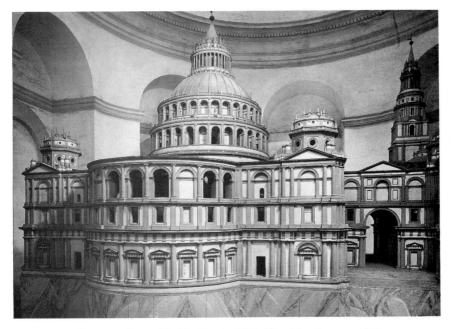

66. Antonio Labacco, wooden model of St. Peter's, c1537. Alinari/Art Resource, N.Y.

happy halt. During this time the southern transept received its walls and was partially vaulted.

It took Rome ten years to recover from the Sack. Then, in 1537, five years into the reign of Paul III, Sangallo was ordered to make a new design incorporating everything that had been built. Two years later a large wooden model was made of the church as then proposed (it cost the immense sum of 5,000 ducats; fig. 66). The model embodied further changes. Like Raphael's schemes it drew on Florentine precedents but also continued elements from Bramante that Raphael had rejected. Some of the Florentine elements, furthermore, were new. Thus the model's main facade is a stretched-out version of Brunelleschi's Pazzi Chapel facade at Santa Croce, Florence. The effect, in this instance however, is to trivialize the grandeur of the basilica

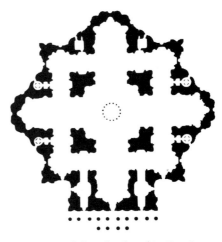

67. After Michelangelo, plan of St. Peter's, 1547ff. From Metternich and Thoenes.

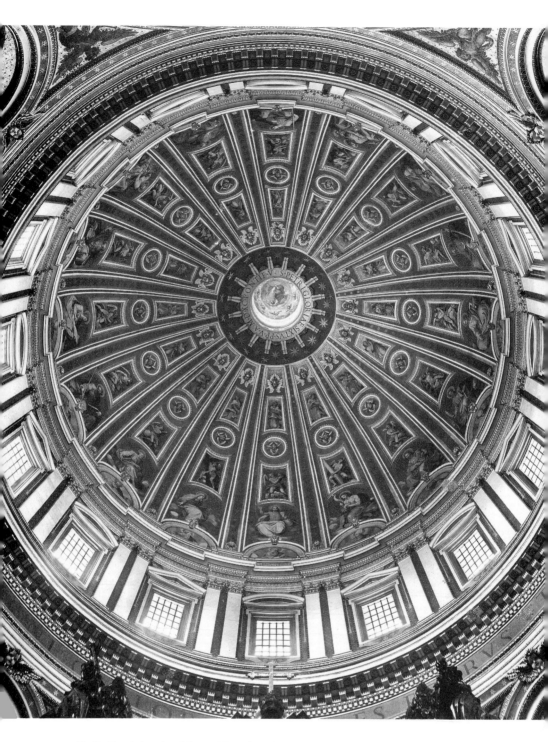

68. St. Peter's, interior of dome. Alinari/Art Resource, N.Y.

rising behind it. Bramante was right, as Michelangelo was to be: St. Peter's needed colossal (i.e. multistory) orders and nested macro and mini subdivisions, not layers of one-storey-high pilasters.

Aside from the model there were alternative independent proposals from Peruzzi and Antonio da Sangallo, some using the central plan, some the longitudinal. In 1543–44 the nave or central arm was vaulted, and in 1545–46 the left transept vaulting completed. New work designed by Antonio was begun, work Michelangelo would tear down when he took over. The history of St. Peter's during the reign of Clement VII well reflects that pope's reputation for wavering.

Michelangelo

It was not until on or about January 1, 1547, after Antonio da Sangallo's death, and with a new pope, that construction was definitively rebegun. The new architect-in-chief was the seventy-one-year-old Michelangelo, then at work on Paul III's Roman palace, the Palazzo Farnese (fig. 13). Michelangelo returned to Bramante's original scheme but greatly thickened the central piers and simplified, and made more massive, the outer walls (fig. 67). Today the inner piers, and the exterior walls of the apse and transepts, are much as Michelangelo built them. Michelangelo also removed Raphael's planned apse and transept ambulatories, thus shrinking the building's total size. He condensed the square corner chapels inward and thickened all walls and supports until they matched the newly strengthened main piers. Raphael's planned semidetached towered *Westwerk* was reduced to a portico consisting of a colossal temple-front four columns wide. This was backed by ten columns engaged to the fa-

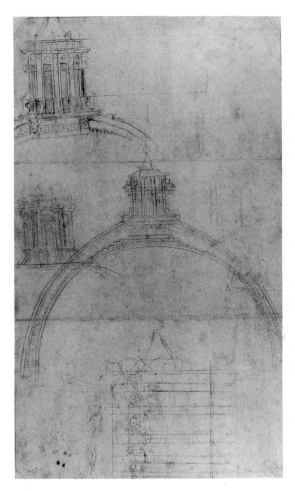

69. Michelangelo, sketch for St. Peter's with ellipsoidal dome. Haarlem, Teylers Museum, A29r.

cade (fig. 63). Thus did Michelangelo keep the symmetry of the Greek cross while suggesting the main axis of the Latin.

On the interior all that remains of Michelangelo's specific designs, as opposed to his general ideas, is the main drum and the apse vaults of the choir and transepts. (The present mosaic panels inside the dome are by the Cavalier d'Arpino and date from 1609–10 [fig. 68].) On the exte-

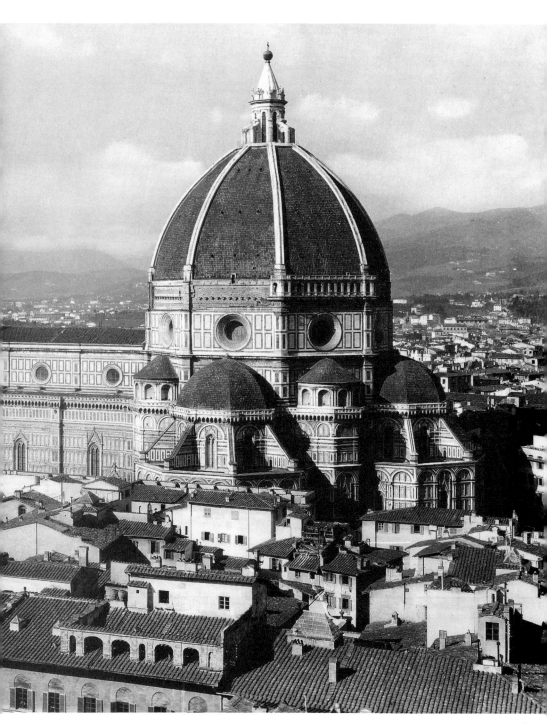

70. Florence, Santa Maria del Fiore, dome, begun 1421 by Filippo Brunelleschi.
Alinari/Art Resource, N.Y.

71. Michelangelo, St. Peter's, apse exterior, 1546ff. Alinari/Art Resource, N.Y.

rior, as noted, we see much more of Michelangelo. The cladding of the choir and transepts is his, as in most respects is the dome (figs. 71, 72, 73). Note, on the apse and transepts, that he has renounced Raphael's prominent "Vitruvian" column shafts in favor of Bramantesque flat pilasters. But what pilasters they are! Never before had these unobtrusive features been so invested with power and energy. They stand in pairs at various angles reflecting the square and curved shapes of the interior spaces. A formidable entablature and upper parapet zigzag in step with the pilasters around the crests of the walls. Be-

tween each set of pilasters are handsome windows—two storeys of them in the wider separations, three in the narrower.

The Dome

All this is simply a base for the dome. And Michelangelo's dome, which has had such innumerable progeny, had few ancestors. The ancient Romans normally built dish domes as in the Pantheon or in round temples like that of Vesta at Tivoli. These ancient domes, while often beautiful, were in essence economical ways of covering space. The dome of St. Peter's, in contrast,

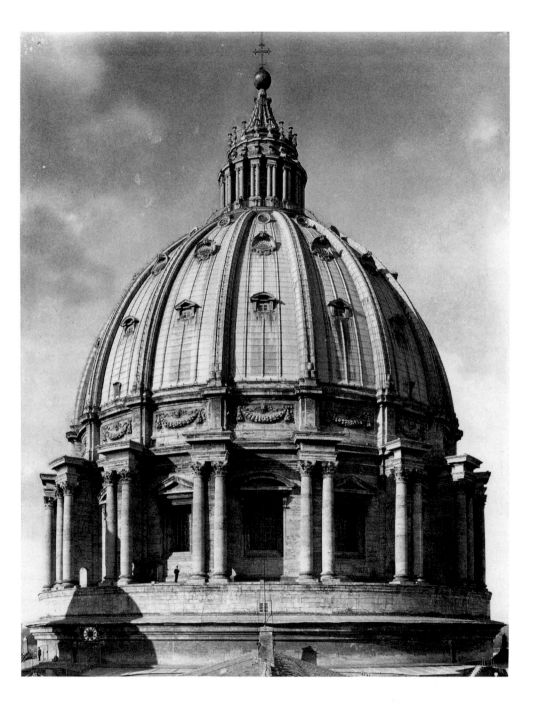

72. Michelangelo, St. Peter's, dome, 1546–64; continued by Giacomo della Porta and Domenico Fontana; completed 1601. Alinari/Art Resource, N.Y.

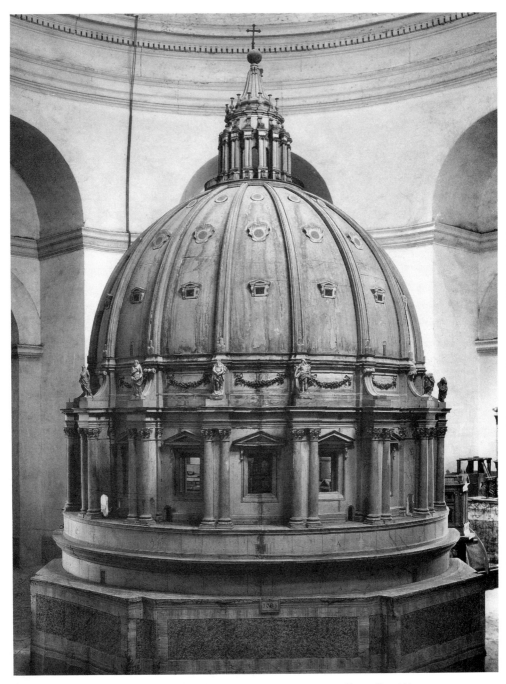

73. Model of Michelangelo's original dome scheme, 1563. Vatican Museums. Photo Alinari/Art Resource, N.Y.

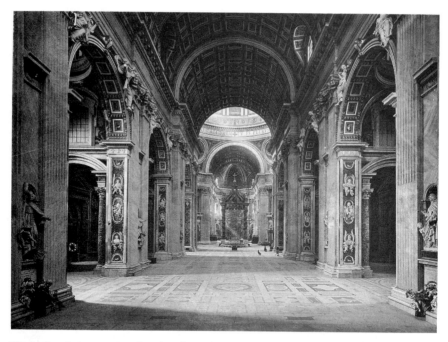

74. St. Peter's, interior. First three bays by Carlo Maderno (c1605–14) following Michelangelo's design for the nave, transepts, and apse (1546–64ff.). Alinari/Art Resource, N.Y.

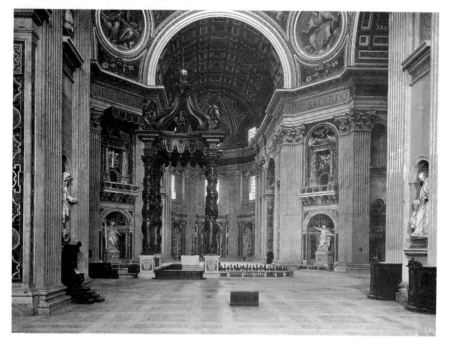

75. St. Peter's, crossing, with Bernini's scheme for statues of the four chief martyrs and their relics. Alinari/Art Resource, N.Y.

is a vast node of energy, in visual effect more like the tapering tower of a Hindu temple than anything from Roman antiquity.

In the definitive design the dome was a longitudinally-ribbed hemisphere with two rows of round dormers (fig. 72). It was supported on a drum ringed by paired freestanding columns forming a round temple. A miniature of this drum, a micro-temple, then formed the lantern. It was only after Michelangelo's death that his assistant and successor, Giacomo della Porta (1540–1602), raised the dome's curved profile into the ellipsoid we see today (figs. 72, 73). But Michelangelo had earlier made a sketch of just such a dome, so the idea was in the air (fig. 69). Della Porta's change accomplished two things: first, it made the dome definitively higher than its most august predecessor, Brunelleschi's cupola for the Florence Cathedral, Santa Maria del Fiore (fig. 70). Second, Michelangelo's dome now corresponded more closely *in shape* to Brunelleschi's. Yet that Michelangelo was all along thinking of Brunelleschi is not to be doubted. Of all the earlier domes he possibly or probably knew only this one had such prominent ribs. It is true that Leonardo, in this same Brunelleschian mode, had sketched heavily ribbed, and even ellipsoidal domes (fig. 46). But it was Filippo's structure that became the landmark, almost the logo, of Florence. And it remains to that city what the Eiffel Tower is to Paris and the Statue of Liberty to New York. Michelangelo's dome, of course, does the same for the papal city.

St. Peter's after Michelangelo

After Michelangelo's death in 1564 the dome was completed by Della Porta work-

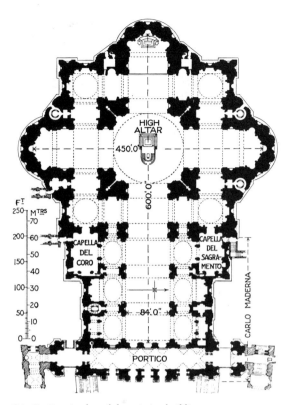

76. St. Peter's, plan of the existing building. From Banister Fletcher.

ing with Giacomo Vignola and Pirro Ligorio. Work continued, in fact, until 1605. Della Porta also built the subsidiary domes. Meanwhile Paul III's successor, Paul IV (reigned 1559–1565), was distressed that the building was shorter than Old St. Peter's, i.e. that it did not cover the eastern parts of the Constantinian foundations. Under Paul V (1605–21) Carlo Maderno (1556–1629) lengthened the nave by three chapels (figs. 74, 76) and built the grandiose facade we see today (fig. 43). But let us note that these additions generally follow Raphael's proposals of 1519. Towers similar to those planned by Raphael were begun, though they had

to be removed due to their excessive weight.

On the 18th of November 1626, just 106 years after its inception and 1,300 years after the consecration of Old St. Peter's, the new basilica was consecrated by Urban VIII Barberini (reigned 1623–44). The obelisk from the Circus of Nero had in the meantime been moved to its present site by Domenico Fontana in 1586. The magnificent colonnades (1656–67) are the work of Gianlorenzo Bernini (1598–1680; fig. 42). James Ackerman points out that the finished form of St. Peter's, through all the multiple transformations of its building and design history, has had a dynamism, a logic, that make it seem the work of a single mind. Even Michelangelo, as he himself said, felt locked into that momentum.

4 The Cortile del Belvedere and Museums

The Vatican Palaces

he Palazzi Vaticani (fig. 41) include more than 1,400 rooms, courtyards, gardens, and chapels. Yet the original papal residence in Rome was not here on the city's west side at all but off on the eastern border. There the early popes lived in a complex adjoining San Giovanni in Laterano. The structures had been the gift of Fausta, Constantine's second wife. At the Vatican itself only a modest set of dwellings, originally dating from the reign of Pope Simmachus (498–514), stood next to Old St. Peter's. Nonetheless important visitors sometimes lodged there—e.g. Charlemagne in 800 when he came to Rome to participate in the episodes depicted in Raphael's Stanza dell'Incendio (Leo III's oath and Charlemagne's coronation, figs. 123, 124). During the ensuing centuries the Vatican buildings were added to and used for various papal functions and as a refuge.

By the first years of the fourteenth century the question of a papal palace in Rome, whether at the Lateran or at the Vatican, had become irrelevant. The city was engulfed in street-fighting and the curia fled. Clement V, elected pope in Perugia in 1305, being French, determined to rule the Church from the serene and well-fortified city of Avignon. There his successors Benedict XII (elected 1334) and Clement VI (elected 1342) respectively built what are known today as the Old and New Palaces of the Popes (fig. 139). These form a superb complex, probably nobler as an architectural conception of power and luxury than any then-existing papal residence in Rome.

It was not until the 1450s, well after the "Babylonian Captivity" in Avignon was over and the papacy had reestablished itself in the

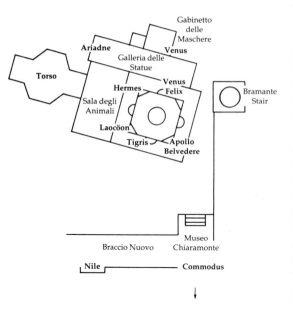

Gabinetto
delle
Maschere

Ariadne Venus

Galleria delle
Statue

Torso

Venus
Hermes Felix

Bramante
Stair

Sala degli
Animali

Laocöon

Tigris Apollo
Belvedere

Braccio Nuovo

Museo
Chiaramonte

Nile Commodus

77. Cortile del Belvedere, Bramante, 1506–14,
and others, 1514ff., and villa of Innocent VIII,
showing locations of statues discussed. Author.

Eternal City, that the Vatican complex be-
gan to be transformed into a definitive
dwelling-place. The reigning pontiff, Nicho-
las V, we have seen, dreamed of rebuilding
the whole city on Renaissance principles.
Clearly the papal palace would have been a
substantial element. Indeed this part of the
dream was partly realized, and the Cortile
del Pappagallo became the centerpiece of
a new palazzo. Today this part of the
complex contains the Borgia Apartments
(fig. 20) and, on the floor above, Raphael's
Stanze (fig. 41). Next, in 1475–81, Sixtus IV
built the Sistine Chapel adjoining Nicho-
las's residence. Then, beyond what was at
the time an open stretch of land leading to
Monte Mario to the north, Innocent VIII
in 1485 built a towered structure called the
Villa Belvedere. It is still there beneath the
transformations that have tied it to the pal-
ace grouping to the south and turned it into
the Museo Pio-Clementino (figs. 77, 78).

78. Same. View. Scala/Art Resource, N.Y.

In the meantime Alexander VI erected the Torre Borgia atop Nicholas's original palace. In 1509–10 Bramante endowed the tower with a large dome on an octagonal drum. The drum was articulated by Ionic pilasters and the dome by sixteen vertical ribs. There was a cylindrical lantern at the top. This structure, destroyed by fire in 1523, was probably one of the models for Michelangelo's larger but similar dome for St. Peter's (fig. 72). Other new structures in the southern complex were Raphael's Logge and Antonio da Sangallo the Younger's Cappella Paolina and Sala Regia (figs. 1, 2). Later sixteenth-century popes then filled out the courtyard of which Raphael's Logge form one side. Pirro Ligorio and Domenico Fontana were two of the architects. Among other important structures is Fontana's Library, which bisects the Cortile del Belvedere (fig. 41).

The Cortile del Belvedere

The Cortile del Belvedere consists today chiefly of two immense courtyards set end-to-end and running north (leftwards in the diagram, figs. 41, 78) from the Palazzi Vaticani over a distance of about 300 yards. (Confusingly, the lower courtyard, the one to the right, is separately known as the Cortile del Belvedere.) The courts are about 70 yards wide. The one nearer to the Museo Pio-Clementino is at a higher level and known as the Cortile della Pigna after the giant bronze *pigna* or pinecone displayed in its apse. The lower court, on the southern end of the complex, was designed for outdoor entertainments such as tournaments; one name for it was "the atrium of pleasure." One source for Bramante's ideas would have been the majestic hillside ramps, stairs, and exedra of the Temple of Fortuna outside Rome at Palestrina (fig. 79).

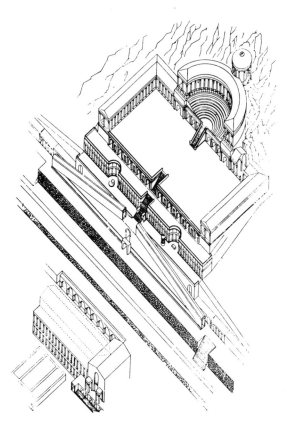

79. Palestrina, Sanctuary of Fortuna Primigenia, first century BCE/First Century CE. Restored. From Frank Sear, *Roman Architecture*. Copyright © Frank Sear 1982. Used by permission of the publisher, Cornell University Press.

The leading scholar of the Cortile, James S. Ackerman, has also shown that it was constructed under the influence of a particular genre of Roman painting—scenes in which figures disport themselves on wide steps and ramps with water in the foreground and a distant architectural or landscape background. The Cortile's long narrow shape and its seating for audiences suggest, too, associations with the Circus of Nero. That circus, we recall, had stood opposite the Cortile's site south of the basilica. Thus does the apostle's martyrdom

80. Bramante, spiral staircase in the Vatican, 1512. Nimatallah/Art Resource, N.Y.

seem to be remembered architecturally in Julius's new structure.

The "atrium of pleasure" functioned as a stage. It had three-story facades east and west and was dressed with Doric pilasters on the ground floor, Ionic on the second, and open loggias on the third. Performances could be viewed from the palace or, on the north, from steps forming bleachers located where the Library and Braccio Nuovo now are. The areas north of these steps were planned by Bramante as formal pleasure-gardens with boxwood parterres and fountains. The pinecone in the Cortile della Pigna was housed at the north end in a large, unroofed, pilastered exedra or niche. In its original form the exedra corresponded more or less to what

is there now but lacked its present semi-dome and other upper features. This exedra, with its stairs descending in a singular three-dimensional geometric pattern, was much copied in later garden architecture.

Work on the Cortile del Belvedere, well begun during the reign of Julius II, continued under Leo X. East of the statue court is the famous spiral staircase (1512; fig. 80), notable today as Bramante's only untouched contribution to the Palazzi Vaticani. With Bramante's death in 1514 Raphael took over and seems to have followed Bramante's intentions faithfully. But with Raphael's death in 1520, and with the immediately subsequent reigns of Adrian VI and Clement VII, work slowed. It was not until 1534 and the reign of Paul III that construction fully resumed. Baldassare Peruzzi rebuilt a collapsed corridor and completed other tasks before his death in 1536. In 1560 Pirro Ligorio added the upper parts of the exedra. This was in the reign of Julius III (1550–55), who then turned his attention from the Cortile to his own Villa Giulia, 1551–53, by Giacomo Vignola. The Cortile received renewed attention, however, in the early-eighteenth-century reign of Clement XI. His arms are displayed on the inside upper part of the exedra.

The great niche is now a mini-museum. The pinecone's base is a Roman figured capital from the Alexandrine Baths, third century C.E., representing, in relief, the coronation of a victorious athlete. The pinecone itself was found near the Baths of Agrippa and is signed by its artist, Publius Cincius Salvius. It probably decorated a fountain near the Temple of Isis. Its prickles are waterjets. It once stood in its own niche in the atrium of Old St. Peter's. Dante mentions it in *Inferno* 31 (composed in the first decades of the fourteenth cen-

tury), in lines inscribed below it. The pine-cone may have been cherished in part because in Latin a *pignus* is a token of love—for example the children of a marriage. The lovely bronze peacocks, meanwhile, came from Hadrian's nearby Mausoleum, now the Castel Sant'Angelo. The Cortile also bears the imprint of the great Neoclassical architect Michelangelo Simonetti (1724–87) who in 1773 created the Museo Pio-Clementino. In the Cortile della Pigna proper the elegant Ionic portico is his, along with the angle niches, the central fountain, and the masks in the gables.

The Statue Court

At the entrance to the Villa Belvedere Bramante built a small octagonal courtyard now known as the Cortile delle Statue. Though remodeled by Simonetti it still fulfills its original purpose, which was to display the collection of Roman and Hellenistic statues begun by Julius II (fig. 81). Paul III also contributed. He built niches for the *Commodus* acquired by Julius II and for the *Venus Felix* that stood opposite. And he commissioned decorative paintings for the other niches. All this was done during Peruzzi's period as chief architect. The Court's museum function was unprecedented in the recent past. It was, says Ackerman, nothing less than the first purpose-designed museum building since antiquity.

That pagan statues were being displayed—and therefore approved of—was in fact equally unprecedented. In the Renaissance ancient images had a magic, both

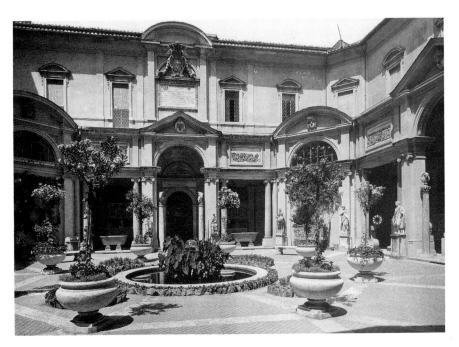

81. The Statue Court today. Alinari/Art Resource, N.Y.

82. *Apollo Belvedere*. Roman marble copy of fourth century BCE original, possibly by Leochares. From François Perrier, *Segmenta nobilium*, 1638. Courtesy Fogg Museum, Cambridge, Mass.

good and bad, that is difficult for us to recapture. When Christianity first came to Rome the Church fathers denounced all pagan images. Ancient art, especially statues, was thought, by some at least, to be actively demonic. Thus Arnobius, an African theologian who wrote during the reign of Diocletian (284–305 C.E.), says the evil qualities of pagan divinities are illustrated in that they could be forced to inhabit statues. Arnobius furthermore finds it false and blasphemous to give human form to base materials like bronze and stone. It is a heresy within a heresy (i.e., within paganism), he says, to imagine that the gods have ears, foreheads, necks, heads, buttocks, etc., as do humans who have been

made in the image of the one true God. So Arnobius. Was it not therefore a rash, possibly heretical thing that Julius II should display a collection of antique statues? Who was he to set himself up against the fathers of the Church?

André Chastel has recently traced the process by which Renaissance Rome slowly decided that its pagan statues, rather than being demonic idols, were marvelous works of art. But this very transformation has enriched the concept of "works of art" with some of the idols' old power. In other words the magic did not completely go away but was aestheticized and given a new name. It is a part of art's power, for us, that it should have revived, in masked form, these once-palpable forces. This, I believe, is why the original Statue Court was designed and seen as a holy place, a temenos; and it is also, I believe, why a sort of secular religiosity, a hushed quiet, an awe wrought with taboo, and, usually, a temple-like monumentality, pervade art museums to this day.

The diagram (fig. 77) shows where the original inhabitants of the Statue Court are now to be found.

STILL IN THE STATUE COURT

Apollo Belvedere

This is a Roman marble copy of a fourth-century original, probably of bronze, and possibly by the Greek sculptor Leochares (fig. 82). The young god is dressed only in a chlamys. He moves rapidly forward. Originally his famous far-shooting golden bow was in his left hand. In his right was a laurel bough symbolizing his powers as a healer.

The work was discovered during the quattrocento, probably in the vicinity of

San Pietro in Vincoli. When Giuliano della Rovere was cardinal of that church he put the statue in its gardens; it came to the Cortile in 1511. The French knew it from a bronze cast made for Fontainebleau for Francis I (1540). And they subsequently got to know it even better: after Napoleon's conquest of Italy, by the dictates of the Treaty of Tolentino in 1797 a large group of Vatican pictures and antiquities was shipped to France, this among them. The trophies were paraded in triumph in Paris in 1798 and in 1800 installed in the Musée Central des Arts. After Waterloo and Napoleon's fall, the Apollo Belvedere and many of the other Vatican pieces returned to Rome.

The work was long considered the greatest of all antique sculptures, almost superhuman in its beauty. Schiller claimed that no mere mortal could even describe its "celestial mixture of accessibility and severity, benevolence and gravity, majesty and mildness." The Neoclassical theorist Johann Joachim Winckelmann's poetic panegyric established the work's fame through the later eighteenth and nineteenth centuries. When Benjamin West, the American painter, saw it in 1760 he exclaimed: "My God! How like it is to a young Mohawk warrior!" The pose became standard for eighteenth-century portraits of Maecenases—e.g., as slightly varied (called the "borrowed attitude") in Reynolds' *Admiral Keppel*, in tribute to the artist's patron—his Apollo (Greenwich, Royal Naval Hospital). The *Perseus* by the Neoclassical sculptor Antonio Canova (1800) in the nearby Gabinetto di Canova illustrates its later influence. The illustration in figure 82 is from François Perrier's 1638 collection of prints of classical sculpture for study by artists unable to get to Rome (see below). Note that reproductive prints like this produce a mirror-image of the original.

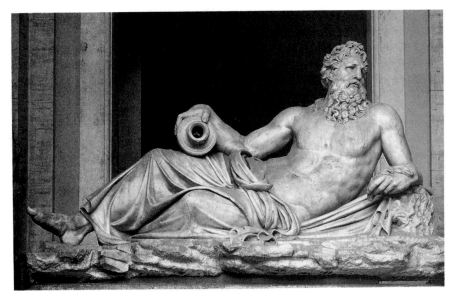

83. *Tigris.* Early Roman Empire. Alinari/Art Resource, N.Y.

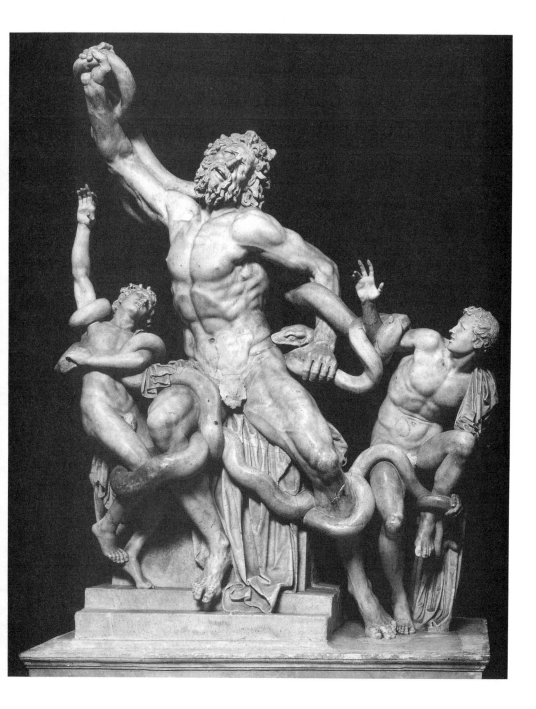

84. *Laocoön*. First century CE. Alinari/Art Resource, N.Y.

The Tigris

The so-called *Tigris* (fig. 83), dating probably from the early Roman Empire, and also known as the *Arno*, first mentioned in 1536, was in the court's northwest niche. It is of marble from the Greek island of Paros but with Renaissance restorations including a new, exaggeratedly Michelangelesque head. There are other repairs in the right arm and the hand holding the urn. These were not meant to fool people. Note the Medici ring carved on the urn's lip and the lion mask (for Leo X) inside. The restorations, by the way, are in Pentelic marble, from near Athens; so the statue affords a convenient way of telling apart these two famous ancient Greek marbles, Parian and Pentelic. A secondcentury Roman sarcophagus with a battle of Amazons serves as the base. The *Tigris* formed a pendant to the so-called *Cleopatra*, which was diagonally opposite, also mounted on an ancient sarcophagus.

Laocoön

A towering, struggling nude man accompanied by two youths is being snared in the coils of two giant snakes (fig. 84). This world-famous Hellenistic group dates from the first century C.E. and was rediscovered in Rome in 1506. It is currently thought to have been based on an earlier two-figure group made by a Hellenistic sculptor from Pergamon. In ancient Rome the *Laocoön* stood in the palace of the emperor Titus. Its creators, three Rhodian sculptors named Hagesandros, Polydoros, and Athenodoros, were hailed as geniuses. Since then the work's reputation, with its virtuoso marble-working, tangle of bodies, high polish, and horrific emotions, has had its ups and downs.

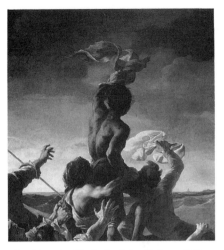

85. Géricault, *The Raft of the Medusa*, 1819. Detail. Paris, Louvre. Giraudon/Art Resource, N.Y.

Laocoön was a priest of Neptune who warned the Trojans not to touch the wooden horse the Achaians had brought into the city. In revenge for this attempt to circumvent them, the gods who backed the Achaian cause—Aphrodite, Hephaistus, and Athene—caused two sea-serpents to attack Laocoön and his sons as they were celebrating a sacrifice (there was a tradition of depicting sacrificers nude). Virgil, who tells the story (*Aeneid* 2.213ff.), writes a spirited description:

and first each serpent enfolds in its embrace the youthful bodies of Laocoön's twin sons and with its fangs feeds upon the hapless limbs. Then [Laocoön] himself, as he comes to their aid, weapons in hand, they seize and bind in mighty folds; and now, twice encircling his waist, twice winding their scaly backs around his throat, they tower above with head and lofty necks. He meanwhile strains his hands to burst the knots, his fillets steeped in gore and black venom as he lifts to heaven hideous cries.

One wonders if Virgil knew the Vatican statue when he wrote; he could have.

The Cortile del Belvedere and Museums 105

A poem about the piece by the humanist Jacopo Sadoleto, written when it was discovered in 1506 or shortly thereafter, throws light on the spirit of rivalry that so animated the actions of Julius and his circle. The word used was *paragone*, i.e. the comparison of different talents, arts, qualities. Thus as Leonardo wrote a paragone between the arts of painting and sculpture, Sadoleto in his poem seeks to rival Virgil in the passage just quoted. But, so exquisite is his description that he seems to be adding: "and my evocation of it is perhaps more marvelous than the sculpture itself." The poem is an excellent introduction to the Renaissance's highly dramatic way of empathizing with art. Here is a rough translation of Sadoleto's Latin hexameters:

See, from deep-packed earth and the huge entrails of ruined Rome, Laocoön's long-awaited new day dawns at last. The work that stood in royal halls and, Titus, ornamented your hearths, is a statue of divine skill. Now the proud walls of the city look down on it again, freed from its shadowed grave to live once more.

What first, what best, shall I describe? The unhappy father and twin sons? Or the sinuous snakes in coils of terrible aspect, their raging bodies like dragons? The real pain, the real wounds of the lifeless marble? The soul recoils at these things and the bosom beats for the mute image, its pity mixed with no little trepidation.

The searing snakes bind the group with two coils into one whole and force together faces, backs, and bodies with their twistings into a many-webbed net. Barely can our eyes look upon this fate of cruel slaughter, this disaster brought by beasts. One of these flashes out, seeks Laocoön, and coils around him, all-encompassing, to wound him with rabid fangs. The bound body of the priest strains on with twisting limbs, and you see the side of his body twisting away from his back. Laocoön, wracked by bitter pain and sharp tearing flesh, gives a great cry and

clenches his bared teeth to pluck away the creature, setting his arm on Chelydris's [one of the sons'] shoulder. His muscles swell and strength burgeons all over his body in a supreme effort not to be struck by the poison. Yet the wound brings the sound of his gasping. And the shiny serpent slides its way beneath and binds Laocoön's knees. His shanks and vitals swell at the poisoned strike, and his livid veins distend with dark blood.

No less does the powerful venom savage the sons. It works through them rapidly and their suffering knees go slack. Now one son's bosom bleeds, and you hear the father's supreme cry, and see his eyes roll out like whirling globes. The other son, his body not yet violated by the fangs, fights off with raised foot the beast's devouring tail, quailing at the sight of his poor father, and reaching for him, as great slow sobs and flowing tears fill him and his bewildered face is gripped by terror.

Sculptors [the poet addresses Hagesandros, Polydoros, and Athenodoros], such is the work that you have set before us; now greet our praise. And though rival achievements may seek eternal fame, your better genius here will seal your future forever. Great artists: whatever stolen skill may equal yours, whatever other fame may glow in heaven, you have vivified stiff stone into living men. We see you filling the living marble with senses that are alive—grief, anger, and pain. Almost, we hear that cry.

There is a bit more. Sadoleto captures the *Laocoön's* sense—a sense found in Michelangelo, who was greatly influenced by this sculpture—that powerful emotions are like fluids flowing through our arms, legs, and torsos, swelling our faces, and often forcing our bodies into positions of violent stress.

When the sculpture was first exhumed the priest's and his younger son's right arms had disappeared. A new arm for the priest (which Michelangelo, say the *ciceroni* or local guides, started but gave up on

in despair) was once displayed beside the group. The first definitive restoration was by Giovanni Angelo Montorsoli, who positioned the new arms in such a way as to alter the group's original pyramidal silhouette. Much later, however, Laocoön's missing arm was found and is now in place. A photograph on the left reproduces Montorsoli's arrangement. That arrangement remains important because it influenced generations of artists—e.g. the group in Géricault's *Raft of the Medusa* (Louvre; fig. 85).

Speaking of *paragoni*, in 1510 Bramante invited four Roman sculptors to make large wax copies of the group with Raphael as judge. Jacopo Sansovino's was considered the best and was cast in bronze. In 1523 Baccio Bandinelli undertook a full-sized marble copy for Leo X to give to Francis I. It is now in the Uffizi. Other copies are to be found in various European palaces and villas. Smaller versions appeared everywhere, and in every medium including jewelry. In the eighteenth century the group became the focus of philosophical debate about the boundaries of emotion in art, a debate to which Schiller, Goethe, and Herder all contributed, but whose most famous participant was Gotthold Ephraim Lessing. His essay, *Laocoön* (1766), was one of the manifestoes of Neoclassicism. Like several of the other statues in the court, therefore, this one played a key role in the development of European art between 1750 and 1850.

Venus Felix

A standing nude Venus with elaborately braided hair and a curling lock on each shoulder removes her rippling garment (fig. 86). Cupid, her son, his arms broken off, raises his face and right arm toward her. (She may have been taking from him a quiver of arrows or a bow.) This is another of Julius's finds. The place and date of discovery are unknown but the work once enjoyed immense prestige. It was illustrated, for example, in a book of engraved views of Roman statues by François Perrier, a notable French painter and printmaker. Such compilations were made for aspiring artists who were unable to travel to Rome but who sought to learn the classical conception of the human physique and to reuse it in their work. Thus did the *Venus Felix* enjoy a hidden afterlife not only as Venus but as a favored pose for female portraits. Recognizing these borrowed attitudes was a compliment both to the lady's looks and to the sophistication of the recognizer. This very thought, in fact, is found on the statue itself. The inscription on the base identifies the dedicator as Sallustia (Barbia Orbana), consort of Alexander Severus in the role of Venus. The modern cataloguer of these statues, Helbig, regards the work to be of imperial date and claims that despite the inscription the original subject may have been Faustina, wife to Marcus Aurelius. Many casts and copies of the work have been made. But this Venus was usually outshone by the Cnidian Venus (see below) and by the Venus de' Medici, now in the Uffizi but originally in Rome.

Hermes or Antinous

The gracefully standing marble youth, his right arm and left hand missing, is clad only in parts of a chlamys and a modern figleaf (fig. 87). (Antinous was Hadrian's favorite lover, and one of the emperor's pastimes was having portraits of the young man set up around the Empire.) The work is first recorded in 1543 when it

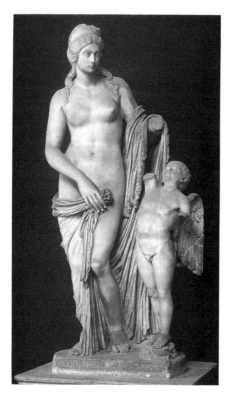 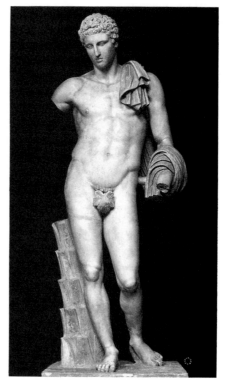

86. *Venus Felix.* Roman. Second half of second century CE. Alinari/Art Resource, N.Y.

87. *Hermes.* Hadrianic copy of a bronze original, possibly after Praxiteles. Alinari/Art Resource, N.Y.

was bought by Paul III. It was probably found on the Esquiline Hill near San Martino ai Monti, though another old opinion is that it came from near the Castel Sant'-Angelo. It is probably a Hadrianic copy of a Greek bronze original from the circle of Praxiteles. In the past it has been identified not only as Antinous but as Hercules, Meleager, Milo, and Theseus. The statue was much drawn and cast, especially the head. Bernini and Poussin were particularly keen on it, and the body was frequently used, especially by French artists, as a standard for male proportions. Like so many of its mates it sojourned in France, 1797–1816.

NOW IN THE GALLERIA DELLE STATUE

Ariadne (formerly *Cleopatra*)

A richly draped female reclines on a rocky bed, legs crossed, her left arm bent to support her head, her right arm protecting her cheek (fig. 88). The work has been known as Ariadne (its current title), Dido, and, simply, Nymph. It is a Hadrianic copy of a masterpiece of the Pergamene period in Hellenistic art, second century B.C.E. Julius II acquired it in c1512. Installed in a corner niche in the Sculpture Court, as noted, it presided over a fountain. In the 1530s, in line with the statue's rough-hewn support, the original niche was con-

verted into a grotto. The work was an important inspiration for sixteenth-century artists, among them Francesco Primaticcio.

It has also inspired poets. Three of the poems about it, respectively by Baldassare Castiglione, Bernardino Baldi, and Agostino Favoriti, are inscribed beside its present niche. The verses perform the same act of interpretation and reinterpretation we find in Sadoleto's lines on the *Laocoön*. Castiglione's poem claims that the stone couch is the one that, as Cleopatra's, was carried in triumph through the streets of Rome after the Battle of Actium (31 B.C.E.). The poems also explore Cleopatra's relation to the court's other statues. Baldi has her bidding adieu to the Nile and mournfully greeting the Tiber as she sounds the Julian

themes of captivity and liberation ("I would not permit my royal neck to suffer an unworthy chain"). His Cleopatra sees this very statue as her tomb. Jodi Cranston points out to me that the three poems unite the statues of the court into a kind of underworld, a Hades whose fountains are not really Nile and the Tiber (an antique *Tiber* was collected by Julius II for the Statue Court and is now in the Louvre) but Styx and Acheron. Bramante had indeed inscribed *Procul este, profani* over the entrance, words borrowed from Virgil (*Aeneid* 6.258ff.); they are shouted by a seer as Aeneas is conducted into the underworld: "Away, away, unhallowed ones! Remove yourselves from all the grove!" These inscriptions, taken together, make

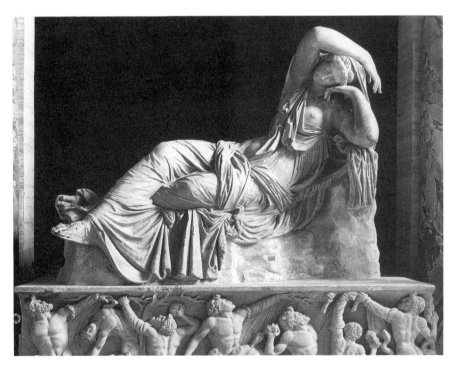

88. *Ariadne*. Late Hadrianic/early Antonine copy after a Pergamene original. Alinari/Art Resource, N.Y.

us see the Court's statues as the white shades or simulacra of departed gods, goddesses, and heroes. Baldi's phrase *gaudia mortis*, the joys of death['s liberation] could also serve as a motto. In these interpretations of Julius's collection, therefore, we get echoes of the old belief in the magico-religious power of statues.

So much for Cleopatra. We have seen that the sitter was alternatively identified as a nymph. In a grotto on his eighteenth-century estate at Stourhead, Wiltshire, England, Henry Hoare commissioned a copy of the Vatican work, accompanied by Alexander Pope's translation of a fifteenth-century Latin poem:

Nymph of the Grot, these sacred Springs I keep;
And to the Murmur of these Waters sleep,
Ah! Spare my slumbers, gently tread the Cave!
And drink in Silence, or in Silence lave.

So even as a nameless nymph the statue is filled with funeral imagery. The conceit of the young woman speaking to the visitor, asking him to be quiet, is an obvious play on the language of epitaphs. ("You who read these words, do so in a low voice lest you wake the sleeper," begins a Neapolitan epitaph of 1470.) Indeed one modern authority claims that the cave and its surroundings at Stourhead were themselves intended as a re-creation of the ancients' underworld. If so, Hoare might well have got the idea from the Statue Court. His combination of statue and poem became popular; Thomas Jefferson thought of trying out the idea at Monticello.

However the cataloguer of the Museo Pio-Clementino, Giambattista Visconti, thought the woman too heavily draped to be a nymph and rejected the identification as Cleopatra on the grounds that the snake is not biting her breast but rather takes the form of an arm bracelet. He proposed, instead, Ariadne languishing on the isle of Naxos awaiting the return of her lover Dionysus. There is a spark of irony in this identification, now universally accepted, since the Greek sculptor of the original of which this is a copy was said to be named Dionysos.

Now in the Gabinetto delle Maschere

The Venus of Cnidus

This work (fig. 89), discovered in 1536, is a Roman copy of Praxiteles' famous Aphrodite of Cnidos. The original, which is lost, was the most famous nude statue of ancient times. The goddess, preparing for her bath, has just removed her garment, which hangs down in her left hand and partly covers a water jug. In a somewhat parallel gesture her right hand covers her sex organs. Like the *Venus Felix* this work was accused of being blasphemous and depraved. In the 1830s Gregory XVI removed it from public display and forbade all access to it. Later it was publicly shown but dressed in ample tin drapery. Only in 1932 was modesty thrown to the winds and the statue exhibited as it is now.

We have noted the power, the magical life with which people endowed ancient statues. Here is another instance. The *Greek Anthology* (16.168), a collection of ancient inscriptions, epigrams, and the like, includes a poem in which the Cnidian Venus complains: "Paris saw me nude, and Anchises, and Adonis. I knew no other [mortal men] but these three. So where was Praxiteles able to see me thus?" The poem implies that the sculptor was spying, a voyeur. And since he now presents the person he spied upon to us, we viewers be-

come fellow voyeurs. Yet of course it is precisely the spied-upon one herself who speaks the lines, theoretically intended as an inscription for the statue. And here is more lore: In one of the ancient Greek tales now attributed to Pseudo-Lucian three young men once entered the chamber at Cnidos where the statue stood. On seeing it one of them cried: "Ares was certainly the luckiest of all the gods to [have gone to bed with her]!" And he leapt toward the statue to kiss it. But later they note a sperm-stain is beneath one of Ve-

nus's buttocks. It is the mark that an earlier statue-lover, Makarios of Perinthos, made during an attempt at anal intercourse. After this outrageous flouting of taboo, the temple guardian says, Makarios disappeared without trace. The present inscription records the name of a late eighteenth-century pope, Pius VI Braschi.

Now in the Sala delle Muse (Atrio del Torso)

The Belvedere Torso

This is the central part of a ruined nude figure of a seated muscular male (fig. 90). He was sometimes identified as Hercules (there is a wisp of fur, as from the Nemean lion's skin, on his left thigh). He was probably once part of a group, and is inscribed "Apollonius the Athenian, son of Nestor, made this." Dating from the first century B.C.E., the fragment is in what is called the Neoattic style. This, practiced in the final years of the Republic, attempted with some success to imitate the great works of the Athenian fifth century. The Belvedere Torso was known before the time of Julius II: it is recorded in a Roman collection in the 1430s. It was engraved soon after, with the legs shown restored. It may later have been in the collection of Andrea Bregno (1418–1503), who produced so many all'antica tombs for Roman churches (not one of them with a figure of this quality; cf. the d'Albret tomb, 1465, in Santa Maria di Aracoeli). Bregno died in 1503; shortly thereafter the torso came to the Cortile del Belvedere. It was an inspiration to Michelangelo and his imitators. In the eighteenth century visitors to the Uffizi in Florence were shown a wax copy, restored, and told that this had been one of Michelangelo's projects but that he

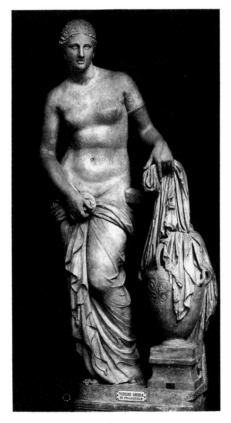

89. *The Venus of Cnidus*. Roman copy of the original by Praxiteles (fl. 370–330 BCE). Alinari/Art Resource, N.Y.

90. Belvedere Torso. First century BCE. Frontispiece from Perrier. Courtesy Fogg Museum, Cambridge, Mass.

And they, from ruined Rome unpent,
In metal carved by his consent,
Make his eternal monument.

So if the modern Romans have ruined their ancient statues, now those statues will have a truer immortality in the form of these engravings, which restore broken limbs and free the statues from Rome so that, on paper anyway, they may sojourn in France.

Now in the Galleria Chiaromonti

Commodus as Hercules

A powerful bearded standing nude stares into the distance (fig. 91). Draped in a lion-skin, he rests his club on the ground and

had given up on it, despairing at the ancient sculptor's superiority (cf. the story about Michelangelo and Laocoön's missing arm, above).

The Belvedere Torso had more appeal to budding artists than to kings and cardinals. Casts of it were, and still are, a staple in art schools. Students took a certain sour delight in its ruined condition. It appears for example on the title page of Perrier's book (fig. 90), where a remorseless Father Time devours the (restored) stump of the torso's arm. Dedicated to the French nobleman Roger du Plessis, the inscribed pedestal says of the patron:

Great in family, peace, and war,
He brings past glories to the fore—
These noble statues here engraved,
From Time's devouring tooth he's saved,

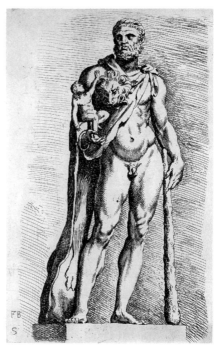

91. Commodus. Roman copy of a fourth century BCE original (the boy is probably later). Alinari/Art Resource, N.Y.

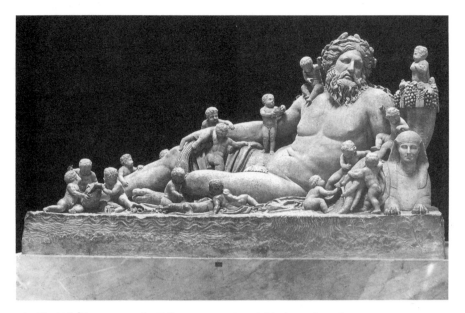

92. *The Nile*. Roman copy of a Hellenistic original, probably from Alexandria. Alinari/Art Resource, N.Y.

cradles an infant in his right arm. The infant (a substitute for the original) fondles the lion's inert but fearsome head. This is a Roman copy after a fourth-century B.C.E. original, loosely based on a famous Hermes with the infant Dionysus at Olympia. Found in 1507 in a house on the Campo dei Fiori, the Commodus was one of the first works installed in the Statue Court. It too visited France from 1797 to 1816.

The emperor Commodus (161–92) was the son of Marcus Aurelius and Faustina, the latter sometimes, we saw, being identified with Venus Felix (Faustina and Felix both mean "happy"). One of the most tyrannical and spendthrift of the emperors, Commodus was murdered by his mistress and his chamberlain. He is known to have had himself portrayed as Hercules. The boy is probably Hercules' son Telefos. Many later commissions were inspired by this group. As a land-clearer and civilizer

Hercules was frequently a type for garden-builders, e.g. Francis I and Louis XIV, or possibly Fouquet at Vaux-le-Vicomte.

Now in the Braccio Nuovo

The Nile

A huge bearded river god reclines on one elbow, his legs and trunk swarming with putti (fig. 92). He is a Roman copy after a Hellenistic Alexandrian work, possibly quite a bit larger, that Vespasian had installed in the Basilica of Maxentius. The *Nile* has been in the Vatican collections since before 1523 when it decorated the central fountain in the Statue Court. Like the *Tiber* the *Nile* was probably excavated from a site near the Pantheon. From the first it was often engraved and, equally often, the engravers edited the original. Either they displayed all the putti intact—

The Cortile del Belvedere and Museums 113

when discovered, they were badly broken—or else eliminated them. The putti we see today are eighteenth-century restorations. Perrier shows the original fragments of them. Pliny tells us that originally there were sixteen and that they represented the number of cubits by which the Nile rose in the rainy season. Note the crocodile, ibis, hippopotamus, sphinx, pygmies, and other riverine creatures on the pedestal frieze behind.

The Vatican Library

(Braccio Antico, by Domenico Fontana, 1585–90) This is one of the world's greatest research collections, rich in manuscripts and archives. The room, accessible to scholars but not tourists, has a magnificent ceiling painted with colorful grotteschi inspired by antiquity and by Raphael's Logge. Ancient Roman mosaics meanwhile form the pavement, and busts of worthies stand on herm-bases along the walls. In the atrium, which is open to the general public, the Library regularly stages important exhibitions of books, manuscripts, pictures, medals, etc. Note that one of the frescoed overdoors, by Paris Nogari (1536–1601), depicts Michelangelo's scheme for St. Peter's with a central-plan church in the midst of a colonnaded piazza (fig. 63).

The Pinacoteca Vaticana

(Vatican Picture Gallery) This was founded by Pius VI (reigned 1775–99) and contains a number of important High Renaissance works. Indeed originally it was far richer than it is now. Many of the Italian pictures presently in the Louvre were removed from this collection by Napoleon in 1797, though seventy-seven, from a much larger total, were returned in 1816 along with the Statue Court sculptures. The present galleries are by Luca Beltrami and date from 1932. Aside from their Renaissance paintings they contain a rich assortment of works by such artists as Simone Martini, Giovanni di Paolo, Giotto, Lorenzo Monaco, and many others.

In the vestibule the *Last Judgment*, late eleventh/early twelfth century, of Romanesque and Benedictine provenience (fig. 93), is worth comparing with Michelangelo's treatment of the theme in the Sistine Chapel (fig. 181). The main work in this room is Giotto's Stefaneschi Polyptych, executed with the aid of assistants. It once stood over the altar of the confessio in Old St. Peter's. On one side of it we see St. Peter enthroned among angels and saints and the man who commissioned the work, Cardinal Stefaneschi. In Sala IV note the magnificent fresco by Melozzo da Forlì, once in the Vatican Library, in which Sixtus IV nominates Bartolommeo Sacchi, known as Platina, as Prefect of the Library (1477). Among those present is the young Giuliano della Rovere, the future Julius II (standing, young and black-haired, in front of Cardinal Riario, who holds the document).

The Galleria degli Arazzi

(Hall of Tapestries; Room VIII; fig. 94) This contains several of the tapestries made for the Sistine Chapel from full-scale color designs by Raphael. The artist had earlier experimented with this idea in the fictive tapestries he painted on the ceiling of the Stanza d'Eliodoro (see Chapter 5). There are ten remaining tapestries in the Vatican set and seven surviving designs, or cartoons, for them. The cartoons, now in London, date from 1515–16 when Raphael was Leo X's chief artist. This first of the several sets (others are at the Ducal Castle,

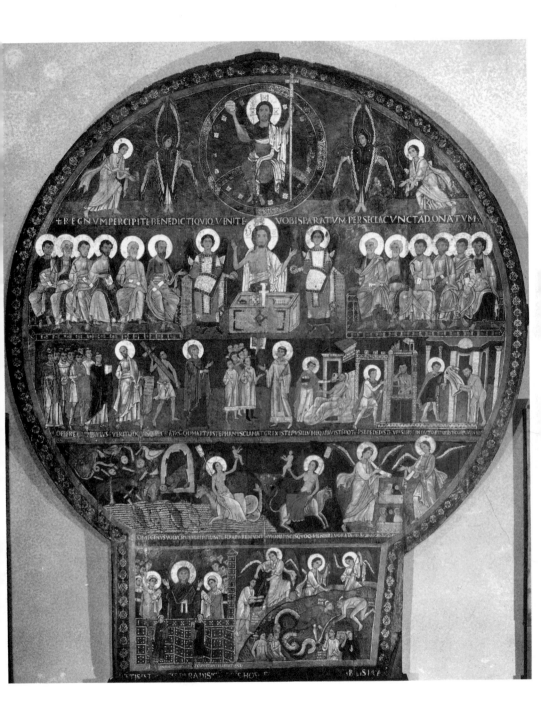

93. *Last Judgment*. Late eleventh/early twelfth century. Pinacoteca. Alinari/Art Resource, N.Y.

Present (1991) Installation of Raphael Tapestries

94. Diagram of tapestries in the Sala degli Arazzi. Author.

Mantua; the Museum, Loreto; Berlin, and Hampton Court Palace) was woven in Brussels under the direction of Pieter van Aelst (?–1536), himself supervised, or merely assisted perhaps, by Bernard van Orley (1488–1541). The present tapestries were exhibited for the first time in the Sistine Chapel in December 1519. Sixteen thousand ducats were spent on them, of which Raphael was paid 1,000 for making the cartoons. His last payment was received on December 20, 1516. Weaving began in Brussels in the following July.

Time and vandalism have wrought changes. Four tapestries were damaged when they were stolen during the Sack of Rome in 1527. In the *Blinding of Elymas* (fig. 95) only about half of the figure scene survives, and the pseudo-relief panel on the lower border is also missing. Raphael or his assistants also made interesting mistakes. It occasionally seems to have been forgotten that, in order to be made into tapestries, the designs would have to be reversed left to right. Thus some characters gesture with their left hands—e.g. Saul in *The Blinding of Elymas*.

On feast days these once-brilliant tapestries were hung along the walls below the quattrocento frescoes. It is said that, aside from their didactic purpose, they improved the acoustics when the Sistine Choir sang in the little balcony on the near right as you face the altar.

The scenes depict events in the lives of

95. Raphael, tapestry of *The Blinding of Elymas*, 1517–19. Pinacoteca. Alinari/Art Resource, N.Y.

96. Raphael, tapestry of *The Stoning of Stephen*, 1517–19, detail. Pinacoteca.
Alinari/Art Resource, N.Y.

saints Peter and Paul. The first in the Paul series, *The Stoning of St. Stephen* (in which Paul participated before his conversion; fig. 96), was hung to the left of the altar while the Peter series began on the right with *The Miraculous Draught of Fishes* (fig. 97). The other tapestries, in order, proceeded down the chapel's side walls. Unfortunately at present they are not all on exhibition, and those that are hang in the wrong order. In my text I give them in the proper chronology. The diagram in fig. 94 indicates their actual positions in the room.

1. Right: The Miraculous Draught of Fishes (Luke 5:3–10; fig. 97)

Peter is a fisherman of the Lake of Gennesaret when Christ first meets him. The Savior has promised him a miraculously abundant catch that has just materialized. Christ sits in the fish-filled boat as Peter's companions, among them James and John, sons of Zebedee, come in another boat to aid him with his windfall and haul in one of their own. This is the scene where Christ tells Peter that he will make him a fisher of men. The boat full of fish is thus

a symbol of the Church, which will be populated with Peter's converts.

2. Right: Christ Delivering the Keys of Heaven to Peter (Matt. 16:13–20; fig. 98)

Christ is with his disciples in Caesarea. He turns to Peter and says, "You are Peter, and upon this rock I will build my church. The the gates of Hell will not prevail against it. And I give to you the keys of the kingdom of heaven. That which you bind on earth shall be bound in heaven; and that which you liberate on earth, shall be liberated in heaven." This is the "key" scriptural event used to prove Peter's pre-eminence over the other apostles. The same phrases, or paraphrases of them, are inscribed around the base of the dome, and around the main interior frieze inside St. Peter's.

Again on the extreme right, Christ stands by a flock of sheep—obviously a reference to the text, frequent in other Gospel passages, "feed my sheep" (John 21:15) Christ the Good Shepherd has given the keys to Peter, who kneels to him much as he had done in the fishing boat in *The Miraculous Draught of Fishes*. Other apostles express a range of reactions— consternation, reverence, wonder, and even perhaps, in the older man on the left, anger. The faces seem inspired by the

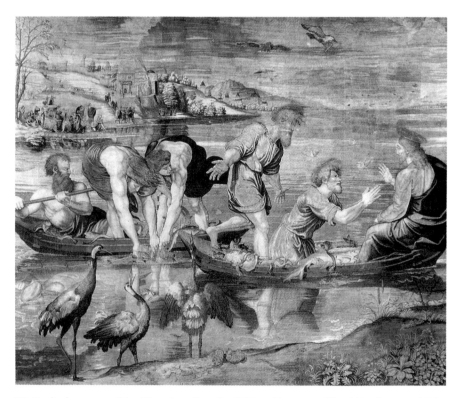

97. Raphael, tapestry of the *Miraculous Draught of Fishes*. Pinacoteca. Alinari/Art Resource, N.Y.

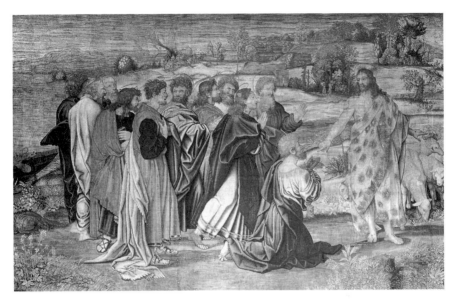

98. Raphael, tapestry of *Christ Delivering the Keys to Peter*, 1517–19. Pinacoteca. Alinari/Art Resource, N.Y.

emotionally varied group we see in Leonardo's *Last Supper* of twenty years or so earlier, which was already famous through copies and prints. (A tapestry copy of Leonardo's mural is at present hanging in the Galleria degli Arazzi.) As another link with the theme of the apostles as fishers of men, note the boat drawn up on the shore at the extreme left.

1. Left: The Stoning of St. Stephen (Acts 7:54–60; fig. 96)

These scenes from the life of St. Paul center around a hero and saint who, so far in our look at the Vatican programs, has been almost a forgotten man. Yet Paul, we should note, contributed incomparable things to the New Testament. And we saw that he was also thought to have come to Rome and to have been martyred and buried there. Some even claimed that he

shared Peter's tomb under the confessio in Old St. Peter's.

The present scene is the beginning of Paul's story. Stephen has been elected deacon along with six other men. He then preaches, but the people stone him when he tells them he is looking at a vision of the heavens opening with Jesus on God's right. One unbeliever, a certain Saul, as St. Paul was called before his conversion, approves of the killing. As his persecutors begin to beat him Stephen simply kneels and, a true Christian, prays that their sin not be laid against them.

This is naturally one of the most violent scenes. The poor deacon kneels in the right center, his gaze fixed on heaven as his arms take the form of one being crucified. Behind him two muscular thugs prepare to strike him. One holds a massive rock. In the left foreground a third leans over to collect more stones. The scene is

like an animation drawing of the act of throwing rocks. On the right, meanwhile, is one of the other deacons reaching out his hand in horrified but useless support to his fellow Christian. In the sky on the right is the vision Stephen had seen—a bevy of young angels surrounding the head and upper body of Christ and God.

3. Left: The Blinding of Elymas (Otherwise known as *The Conversion of the Proconsul*) (Acts 13:1–12; fig. 95)

Paul and Barnabas sail to Cyprus. The Roman proconsul at the town of Paphos is a man named Sergius Paulus. He wishes to hear the two Christians speak, but Elymas, a magician and false prophet, objects. Paul reviles Elymas as an enemy of justice and, the hand of the Lord being on him, he blinds the man. This is one of the few tapestries with a title: "Through the Preaching of Saul, Sergius Paulus, Proconsul of Asia, embraces the Christian Faith." The Roman official is enlightened; darkness falls on Elymas.

The proconsul is seated on a high thronelike chair backed by an exedra. Dressed in a toga, he wears a wreath of oak leaves in his hair like a Roman judge. To the right are lictors, the men who attended on magistrates. They carry fasces, bundles of rods, that are symbols of the Roman state. Behind are the vaults of the basilica or law-court. On the left, amply indicated by auxiliary figures who point him out, is the blinded magician, his hands out before him, eyes closed, as an associate leads him away. On the left, confronting Elymas, is Saul, his arm raised in salute, his finger extended in menace. Other faces glower at the villain. There is no doubt that Sergius's verdict accords with the crowd's reactions. This, by the

way, is the moment when Saul will change his name to Paul, taking the name of his convert at Paphos.

4. Left: The Sacrifice of Lystra (Acts 14: 7–17; fig. 99)

Paul goes to Lystra where he meets a cripple. The latter hears Paul preach and Paul, knowing that the man now has great faith, says, "Rise up on your feet." The cripple rises and walks. Yet the watching crowd claims that magicians can also perform such tricks. The Lystrans even identify Paul and his companion, Barnabas, with their false gods Jupiter and Mercury whose return to the town is being awaited. The priest of Jove is on hand to offer sacrifice to them: "bulls and garlands [are] being carried before the gates." Paul and Barnabas ask the people to renounce their pagan superstitions and believe in the one true God.

Once again a classical cityscape with figures of pagan gods. A statue of Mercury with his caduceus is on the right against the sky. In the foreground is an active crowd of citizens, some bringing in the white ox that is to be offered. (Note the assistant priest who kneels by the animal and holds its head: his job is to make it nod yes when the priest asks it if it wishes to be sacrificed.) On the right the executioner meanwhile raises his axe as a youth in the crowd reaches forward to stop him. He, at least, has understood what the apostles are saying. Meanwhile, behind, another sacrificial animal is led forth surrounded by a raffish multitude. In the foreground to the right is a beautifully realized pagan altar with winged lions, wreaths, and other sacrificial sculptures. Behind it stand two acolytes with the box of bran that was sprinkled on the fire before the ox was roasted. On the far right

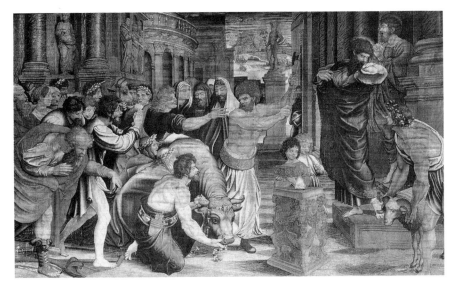

99. Raphael, tapestry of *The Sacrifice of Lystra*, 1517–19. Pinacoteca. Alinari/Art Resource, N.Y.

yet another sacrificer, head wreathed for the ceremony, stands with his own offering, a ram. The two apostles are outraged and Paul speaks, pointing to his bosom, rending his clothes (as in the text) and saying "we are humans, not gods!" On the far left is the miraculously cured cripple taking his first few tottering steps, his unneeded crutch now lying on the ground.

5. Left: St. Paul in Prison (Acts 16: 23–26; not shown on the diagram)

This narrow ribbon of a tapestry next to the exit door was designed to fill a small space between *The Sacrifice at Lystra* and the forward edge of the chancel screen. The vignette gives us an upper scene of Paul, who has been imprisoned with Silas in Macedonia, their feet bound with wood. The lower foreground is dominated by the personified earthquake that was to free the saint from prison.

Some scholars claim that ten tapestries were all that were ever planned. Thus there would have been four devoted to Peter and six to Paul. According to John Shearman, the Peter series would have stopped at the choir gallery with the Death of Ananias. On the other side of the chapel the sixth and last Paul scene, *Paul at Athens*, would have ended up approximately opposite the choir gallery. Other scholars, buttressed by an account of 1517, say there were originally to have been sixteen scenes. Such a number would equal the number of quattrocento frescoes, which originally went all the way around the four walls of the chapel, and would also have given equal play to Peter and Paul. The extra scenes, intended but apparently never designed, might have included the deaths of the apostles, which are standard in such series but are missing here.

The fictive reliefs that ornament the bases of the tapestries represent events from Leo X's career. Beneath *The Charge to Peter* is the sack of the Medici Palace in

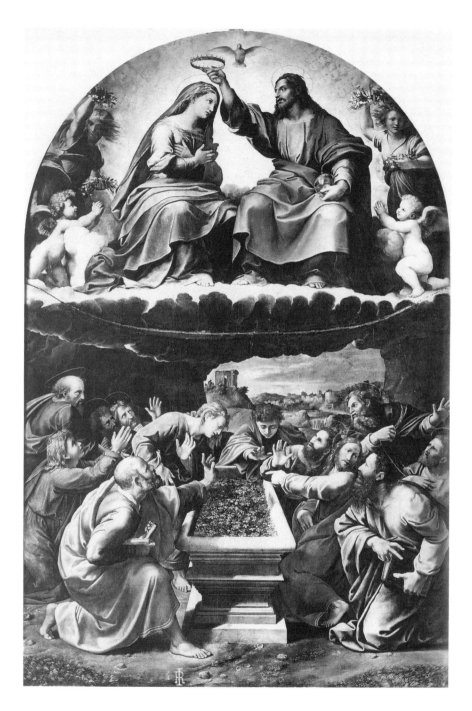

100. Raphael, *Coronation of the Virgin*, 1502–3. Pinacoteca. Alinari/Art Resource, N.Y.

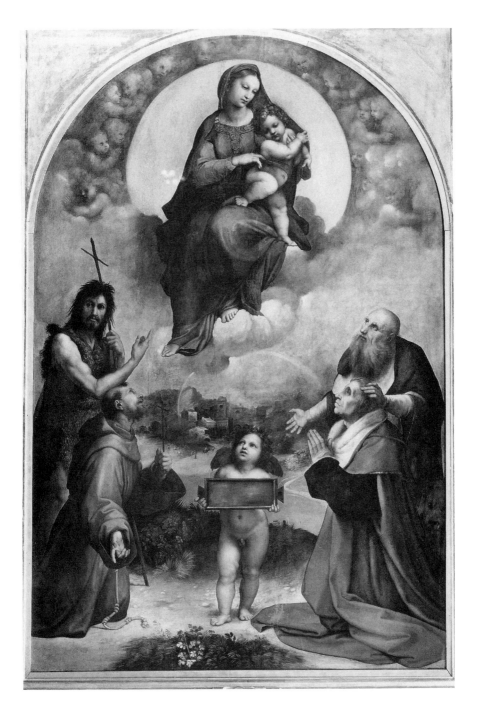

101. Raphael, *Madonna di Foligno*, 1512–13. Pinacoteca. Alinari/Art Resource, N.Y.

Florence in 1494 and beneath *The Healing of the Lame Man* Giovanni de' Medici's capture at Ravenna and his escape in 1512. The subject of the relief for *Paul in Prison* has not been deciphered. Some of the other reliefs turn from Medici history back to scripture. Under *The Sacrifice at Lystra* are Paul's discussion of circumcision at Jerusalem and the beginning of his mission to the Gentiles.

High Renaissance Painting in the Pinacoteca

The Sala degli Arazzi contains notable paintings by Raphael. His early Peruginesque style is represented by a wonderful *Coronation of the Virgin* (1502–3; fig. 100). Its predella or set of smaller scenes, originally forming a base for the main picture, is separately displayed. Note the almost complete symmetry of the upper heavenly section of the main panel, in which Mary is crowned by Christ amid music-making angels; in contrast is the lower, earthly scene dominated by the leftward-jutting empty tomb, from which Mary's body had miraculously been assumed upward so that she could be enthroned beside her son. Lilies and roses grow where her body lay as the twelve wondering apostles lift their eyes to the scene above.

In the same room is a later landmark, the *Madonna di Foligno* of 1512–13 (fig. 101). This was painted as an ex voto for Sigismondo de' Conti, chancellor of Julius II, who had survived a bomb-blast during a siege of his native city, Foligno. (We recall that Sigismondo was one of the people proposing Julius's canonization.) Below the cloud-throned Madonna and Child we see saints Francis and John the Baptist and, to the right, another, unidentified saint who introduces the kneeling red-robed donor. This picture, originally in the Church of the Aracoeli, Rome, was like Raphael's *Transfiguration* taken by Napoleon to Paris. The *Madonna di Foligno* is a *sacra conversazione*, a type of picture in which holy figures seem to converse and draw the viewer into their conversation. Thus does St. John the Baptist, as he points to the Savior, look clearly out at us. Beside him the kneeling Francis does the reverse: he points to us as he gazes at the Christ child.

The most important High Renaissance work in the Vatican Pinacoteca is Raphael's last major painting—displayed at his funeral—the *Transfiguration* (fig. 102). It was commissioned in 1517 by the future Clement VII, whose idea was that Raphael and Michelangelo should each paint a large altarpiece for his French benefice, the cathedral of Narbonne in France. The cardinal would then send the better of the two pictures to the church. (Here is another kind of Renaissance paragone.) Michelangelo, however, perhaps not liking to put himself into the ring with Raphael, subcontracted his commission to Sebastiano del Piombo, who painted a *Resurrection of Lazarus*. Raphael's picture meanwhile remained unfinished at his death in 1520. Parts of the lower half are by his heirs Giulio Romano and Gianfrancesco Penni. We will meet them again in the Stanze and the Logge. (Meanwhile Sebastiano's picture, which *was* completed, was sent on to Narbonne. It is now in the National Gallery, London [fig. 103].)

In the upper half of Raphael's scene the white-clad figure of Christ appears on Mount Tabor flanked by Moses and Elijah, with whom he converses (Matt. 17). Below, the apostles Peter, James, and John tremble beneath the brilliant emanations

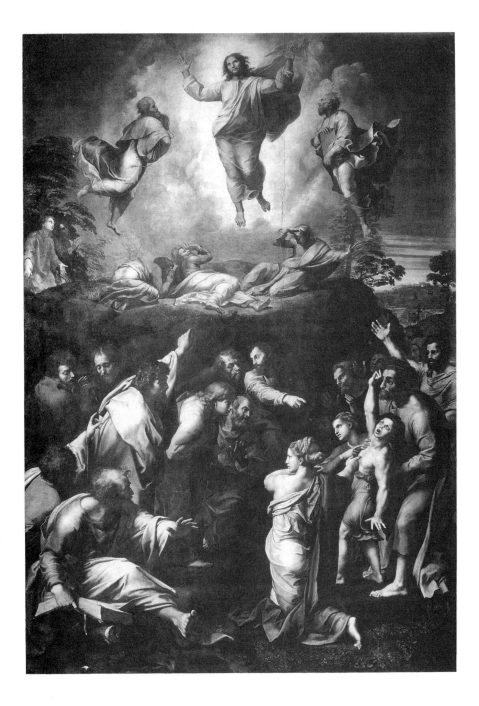

102. Raphael, *The Transfiguration*, 1519–20. Pinacoteca. Alinari/Art Resource, N.Y.

103. Sebastiano del Piombo, *The Resurrection of Lazarus*, 1517–19. National Gallery, London.

that transfigure their Lord, and which give the event its name. Far to the left of this upper scene, kneeling, are the Medici patron saints, Giuliano and Lorenzo. Below is something completely different: in a somber darkness lit by lurid highlights, a magnificent kneeling woman, back to us, indicates her son who has been infested with demons. The flailing, distracted boy howls as his father (the man in green) brings him forward. Local magicians and doctors have been unable to cure him; but the apostles, one of them in a gorgeous rose-colored mantle, do so, pointing up to the transfigured Christ. The great Baroque painter Caravaggio would establish many debts to this turbulent part of Raphael's picture. Also compare the mosaic copy of the composition in St. Peter's, left aisle, middle chapel.

Moving to the adjoining rooms we first note Leonardo's memorable *St. Jerome* of about 1480 (fig. 104). This and Raphael's *Coronation* can serve to map the growth of the powerful, magnificent High Renaissance style we have been looking at as it emerged from the more delicate art of the Early Renaissance. The *St. Jerome* consists only of sketched-in underpainting and never received its final working-up in full color. Yet its simplified unfinished state predicts the grandeur of the coming High Renaissance. It, and the many finished imitations of it that almost immediately began to appear, also had an important afterlife in the Baroque. Leonardo's image defines the desert saint as painted by Jusepe Ribera and his followers, e.g. Hendrik van Somer. But Leonardo's picture was not always treated with great respect. It belonged to the Neoclassical artist Angelika Kauffmann and after her death in 1807 was found in Rome in two parts—the head being in a shoemaker's shop.

104. Leonardo, *St. Jerome*, c1480. Pinacoteca. Alinari/Art Resource, N.Y.

Those interested in the Venetian High Renaissance should visit Sala X, devoted to Titian and his contemporaries, while Sala XI illustrates the elegant, intricate Mannerism of Giorgio Vasari and others, which in Tuscany and elsewhere followed immediately on the High Renaissance and preceded the Baroque. The greatest Baroque picture in the Vatican collection, by the way, is Caravaggio's *Deposition* of 1602–4 (Sala XII), originally in the Chiesa Nuova. Characteristically, it revises an equally great work by Raphael, the *Entombment of Christ* in the Borghese Gallery, Rome.

The Palazzi Vaticani are perhaps more important in the history of museums and

collecting than in that of residential architecture. Subsequent Roman collections of sculpture, if not displayed in open courtyards, were often exhibited in rooms frescoed to resemble such courtyards—e.g., in the Palazzo Chigi (1664–67). As to the Belvedere itself we have already noted that in 1817–22 Raffaele Stern built a second crosspiece for the Belvedere, the Braccio Nuovo. This is now full of antique sculpture. Still more recently other museums were added, e.g. the Pinacoteca (Luca Beltrami, 1932), while former offices and residential quarters, such as the Borgia Apartments and Raphael's Stanze, became museums in and of themselves. Today the official entrance to the Musei Vaticani is on the north face of the Villa Belvedere. American visitors will admire the entrance hall, erected in 1932 by Giuseppe Momo (1875–1940), which with its helical ramp and glass dome was clearly the inspiration for Frank Lloyd Wright's Guggenheim Museum in New York (1959).

5 The Stanze

I want you to know that so far only a few of the wars painted here have taken place; yet now that they have been painted, they will occur. He who painted them, prophesied them.

Ariosto, *Orlando Furioso* 33:6

odged behind the shallow apse of the Cortile del Belvedere is a series of four former papal offices and reception rooms. They comprise a sort of bridge between the Belvedere and a small interior courtyard called the Cortile del Pappagallo (fig. 105). The rooms were constructed under Nicholas V (1447–55) and were originally decorated—probably in two different campaigns—by groups of artists that included Luca Signorelli and Piero della Francesca. In 1508, however, on Bramante's advice, Julius II summoned another group to continue, but also partially to replace, this earlier decoration. Among the new men were Sodoma, Pietro Perugino, and Baldassare Peruzzi. But Bramante's further suggestion seems to have been to give his young, relatively untested fellow-countryman, Raphael, a chance. This was done. So pleased was the pope with Raphael's work that he was put in charge. The newcomer preserved some of his predecessors' work, especially on the ceilings, but also effaced much. In this respect—as a transforming High Renaissance completion of an Early Renaissance program—the Stanze parallel the Sistine Chapel.

The results, especially in the most famous of the rooms, the Stanza della Segnatura, are among Raphael's greatest masterpieces (fig. 106). They are very early monumental examples of the High Renaissance style in painting. From this moment the stately, sensuous, infinitely self-assured manner that goes by that name bears Raphael's stamp. Bramante's new basilica would be the equivalent in architecture; but that was years in the realization and in any case we have seen that the final result departs considerably from Bramante's

129

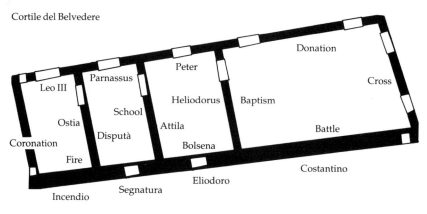

Cortile del Belvedere

Donation

Peter

Leo III — Parnassus — Cross

Heliodorus — Baptism

Ostia — School

Coronation — Disputà — Attila — Battle

Fire — Bolsena

Costantino

Eliodoro

Incendio — Segnatura

Cortile del Pappagallo

105. Diagram of the Stanze. Author.

106. (*facing page*) Stanza della Segnatura, 1509–11. Scala/Art Resource, N.Y.

original schemes. Most of the subjects in the Stanze, as subjects, are equally unprecedented. And the iconographic future of Raphael's scenes turned out to be different from their stylistic one. These imageries are as rare in earlier art as in later. Because the art in question is so site-specific, my analysis will mainly be a demographic and behavioral census. Who is painted here, what events unfold, and why were these choices made?

The Age of Julius II: The Stanza della Segnatura

The Stanza della Segnatura (1509–11) was the first of the rooms to be begun and the only one of the four to date entirely from Julius's reign. It is also the only room whose main scenes are thought to have been painted entirely by Raphael. The room takes its name from post-Julian times, when the ecclesiastical Court of the Segnatura met there. In Julius's reign it served as a library and the decoration was laid out with this in mind. Renaissance li-

braries were divided into the categories of law, theology, poetry, and philosophy, and these governed Raphael's fresco program.

The School of Athens (fig. 107)

Entering, we immediately face one of the most famous pictures in the world, a hymn to the Greek philosophers of antiquity, removed from their own epochs and arranged as colleagues in a timeless academy. The noble vaulted hall, in part open to the sky and dominated by colossal niched statues of Apollo and Minerva, is probably based on designs by Bramante and echoes some of his ideas for the new St. Peter's. The philosophers are disposed on a stepped stage in the foreground, the more important teachers surrounded by pupils. In the center, entering the stage, is Plato, his finger pointing to the heavens and his other hand holding the *Timaeus*, his treatise on Pythagorean number symbolism. Plato stands for the kind of celestial harmony and geometric mysticism celebrated by the Neoplatonists at Julius's

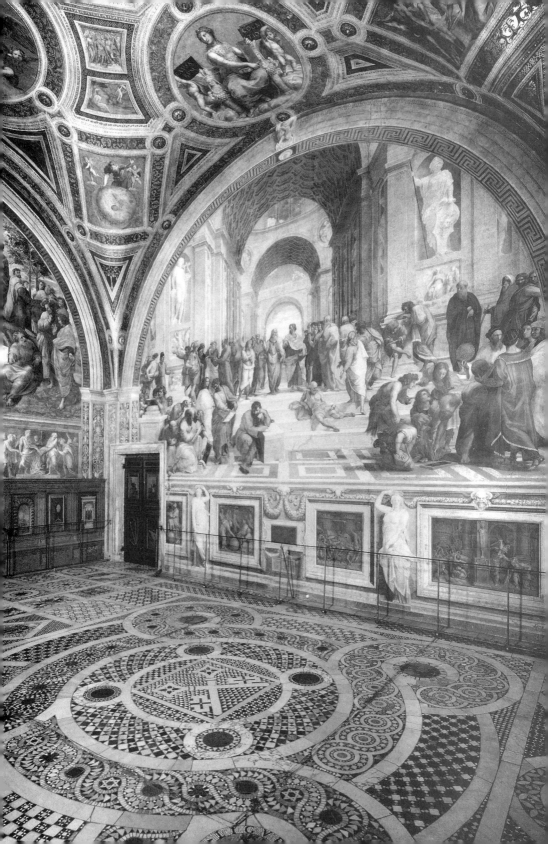

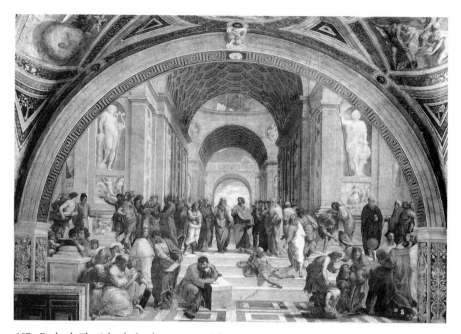

107. Raphael, *The School of Athens*, Stanza della Segnatura. Scala/Art Resource, N.Y.

court—and by Bramante's plan for the new St. Peter's. Next to him is his younger, brown-bearded pupil Aristotle, holding a copy of his *Ethics,* and with his hand extended in a horizontal gesture as he describes the earth and the wide dominion of moral teaching. If Plato represented the new currents of philosophy embodied in Italy by his revivers, Marsilio Ficino and Pico della Mirandola among others, Aristotle represents the older current of metaphysics inherited from the Middle Ages. From this double fountainhead, metaphysics and natural philosophy, flow the philosophical streams that mingle in this hall. In a way that was to prevail throughout the Stanze, Raphael has sometimes painted his contemporaries playing the roles of the philosophers. In so doing, typecasting was the order of the day. Just as Julius II played Julius Caesar on medals

and coins, so Bramante, for example, plays Euclid here. In this sense the fresco is like a humanist academy in which each member takes a classical sobriquet suited to his nature.

But here we come to a crux between style and iconography. Someone might ask: what is to be gained from the histories, analyses, and identifications that I provide for this art? Shouldn't the visitor simply take it all in on a visual level? The achievements of Michelangelo, Bramante, and Raphael are important for their beauty, not for their iconography. What is the advantage, for example, of knowing that the solemn white-cloaked young man on the far left in the *School of Athens,* who listens to Pythagoras, Empedocles, and Averroes, has been identified as Francesco Maria della Rovere?

One advantage of knowing such a thing

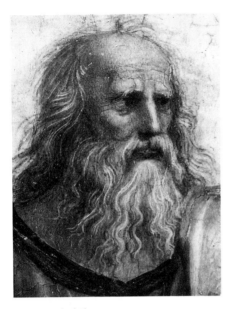

108. Detail of Plato
Alinari/Art Resource, N.Y.

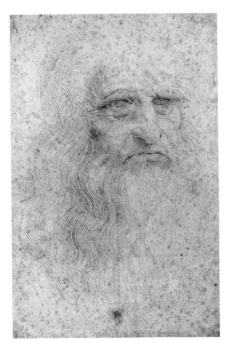

109. Leonardo, self-portrait, 1512–15. Turin, Biblioteca Nazionale, 15571.

would be to put it together with the fact that the philosophers in the fresco are mostly the authors of the books originally shelved in the room in which the painting is located. Hence Raphael would be portraying Francesco Maria, who was Julius II's nephew, as a "pupil" of the three philosophers in the sense that he would, or could, read their books. But the young man was also the pope's future heir and would inherit the library housed here. He will thus eventually receive these philosophers in the sense that he becomes the owner of their works. The Renaissance loved this kind of thinking. It would have made a typical epigram, just the sort of thing Pietro Bembo or Jacopo Sannazaro were always writing. Knowing such things about Francesco Maria della Rovere, at least to me, brings associations that frame the beauty of the *School of Athens*. The painting becomes more memorable, hence more present in and engaged with my mind. One looks again at it and sees that aside from Francesco Maria many of the other figures have the individuality, the idiosyncratic bodies and faces, the self-awareness, of portraits. Still other figures, in their generalized features and ideal mien are just as clearly anonymous—members of the crowd. And if not all the portraits are satisfactorily identified, if there are still mysteries—that only leads to renewed exploration, which is the point of going to look at works of art.

But some of the imposed identities in the *School of Athens* are odd. Plato bears a strong resemblance to Leonardo (figs. 108, 109), though Leonardo himself was in fact more of an Aristotelian. Other portrait figures do not seem to have been given extra contemporary identities. To the left of Plato is Socrates with his Silenus-face—it cannot be anyone else—telling off points

on his fingers. His companions, by tradition, are identified as Eschinus, the youth Alcibiades, and Xenophon—actors who take part in the *Dialogues*. In front of them is the elderly Zeno; behind, Chrysippus. Near Zeno, his head crowned with vine leaves, Epicurus reads a book propped on a column base and is observed by a curly-haired youth thought to represent Federigo Gonzaga, scion of the famous family that ruled Ferrara and Mantua, who was studying in Rome at the time and whose portrait Raphael painted on commission from Julius II.

We also see Pythagoras, seated in profile and inscribing the tablets that bear his tetractys, a diagram showing how ten is the sum of

<div align="center">

I

II

III

IIII

X

</div>

The Neoplatonists of the time attached enormous significance to this simple fact. Leaning over him is a turbaned figure usually identified as Averroes and, perched behind, Empedocles (see Chapter 7). We have already noted Francesco Maria della Rovere. He was not only the pope's ally in life but continued with Julius's tomb project after the latter's death in 1513. To the right stands a man with one foot on a block of marble. He has been identified variously as Anaxagoras, Xenocrates, Aristoxenus, and Parmenides; take your choice.

Nearby, seated and meditating pessimistically, a philosopher identified either as Heraclitus or Democritus writes what might be the first words of a poem (fig. 110). A block of marble is his desk. This is probably Michelangelo, who many years later was in fact to write a poem

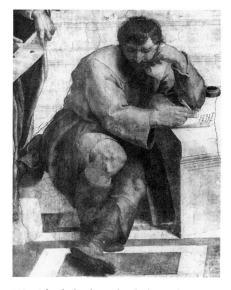

110. *School of Athens*, detail of Heraclitus or Democritus (portrayed by Michelangelo?). Alinari/Art Resource, N.Y.

about a statue imprisoned in a marble block. Michelangelo even wore a famous pair of boots like those shown here. His sulky resentment of Bramante and Raphael is readable (cf. also the Sistine Jeremiah; fig. 165); but even more isolated is the sprawling seminude figure of Diogenes, who sounds the only other note of discord in the scene's harmony.

On the right, a geometer draws on a slate. He could be Archimedes or, more likely, Euclid. In any case he is also Bramante. On the border of his gown are the golden letters RVSM: *Raphael Urbinas Sua Manu*—"Raphael of Urbino, by his hand," a tribute from the grateful pupil to his master and champion. And this is another trope or visual epigram: if Bramante made Raphael's career, Raphael made Bramante's portrait. Further right is another group of four, this one featuring Ptolemy, who holds a terrestrial sphere. (He wears a

crown, since at the time the astronomer was thought to have been one of the Ptolemaic kings of Egypt.) The man carrying a celestial sphere is Zoroaster—said to be a portrait of Castiglione. Behind, peering out directly at the viewer, is the shyly offered countenance of Raphael himself and next to him the dry brown face of his elder colleague, the painter Sodoma.

The *School of Athens*, then, is indeed an academy. It is an assemblage of the greatest philosophers of Greece (and one or two other countries; but note that Rome doesn't rate). We also see pupils in the act of learning. Thus the fresco portrays the communication of knowledge through time. But above all, for our purposes, it proclaims the visual arts as the agents of philosophy. The descriptive powers of Aristotle, the number and shape relationships of Plato, Euclid, and Pythagoras, the correspondences between man's earthly works and the cosmos, as investigated e.g., by Zoroaster, are not only portrayed but exemplified. For instance, we have noted the Renaissance discoveries and rediscoveries in geometric projection and the mapping of space. The power of geometric architectural projection is well illustrated right here. Pythagoras, Euclid, Ptolemy, Zoroaster, and Plato interpreted the cosmos as a harmonious complex of concentric spheres and other "perfect" shapes and values, moved by number-based music. Art, especially the arts of poetry, architecture, sculpture (note the statues of Apollo and Minerva, art and learning, in the background), and painting reflect cosmic perfection by imitating nature's number-structure. Thus Giles's quaternities and other groupings are echoed in the four major groups, with the Pythagoreans dominating the lower left, the Socratics above and behind them, the Eu-

clidians in the right foreground, and the group of as-yet-unidentified philosophers behind. Each of these groups, furthermore, along with the lesser groups, is made up of some other significant number. These range from the one of Diogenes to the two of Plato and Aristotle through the six of Pythagoras's group and on to the nine of Euclid.

In the dado underneath the fresco are scenes by Perino del Vaga (1501–47), one of Raphael's pupils. These represent more authors: the death of Archimedes as he attempted to defend his city of Syracuse, magi discussing the celestial sphere, and an allegorical figure of Philosophy. There are also scenes of Alexander preserving the *Iliad* in a precious chest and Augustus preventing Virgil's *Aeneid* from being burned (as the poet had wished).

The Disputa (fig. 111)

The fresco directly opposite was probably undertaken by Raphael before he painted the *School of Athens*. In imagery and meaning, however, it is subsequent. It represents Christianity's triumph over, and transformation of, the sources of thought portrayed in the *School*. Note that the latter is a vaulted nave while the *Disputa* takes the form of an apse. The church of philosophy, in other words, is approached through the aisles of Greece (pun intended) and reaches its climax and full revelation in the work of theologians gathered in their mighty apse. Their bodies actually constitute this church's architecture, and the arc they together form closes off, ends, resolves, the open-ended discussions that had begun in the *School of Athens*. This apse is centered around an altar bearing an ostensorium or holder for the sacrament—the wafer that when consecrated is,

to most Christians, literally the body of Christ. The ostensorium stands in the exact horizontal center of the fresco and marks the vanishing-point of the architectural perspectives both of the *Disputa* and of the *School of Athens*.

Surrounding the altar are rows of theologians disputing, or, better, discussing, the dogma here presented, which is almost certainly that of transubstantiation. (This was a current issue: Martin Luther was shortly to try to confute and modify it.) The lower level of authors, who comprise a more active, hence more earthly silhouette, is contrasted with the solemn heavenly rows above. At the same time all of the "heavenly" and most of the "earthly" theologians, like the pagan philosophers opposite, are gathered into a time warp, living persons from many different historical epochs, arrayed like majestic shelves of books.

In the center, uniting both levels, against an infinite blue sky and accompanied by flocks of cherubs and golden rays, is God the Father. Teams of ravishing angels accompany him. Just below, in turn, Christ is seated on clouds flanked by his precursor, John the Baptist, and the Virgin. The huge circular golden nimbus behind them functions as a sort of rose window, while the "dome" of the apse is formed of floating angels with rays spreading from its apex like ribs. At Christ's feet is the dove of the Holy Spirit, which is the form God takes when he pervades the world. Four little angels hold open the four books of the Gospels—again a reference to the room's function as a library, and to this wall in particular, where the theological books would have been shelved.

On either side of the upper group are patriarchs and prophets of the Old Testament in alternation with apostles and con-

fessors from the New. There are also saints of the early Church. From the left we see: St. Peter, Adam, St. John the Evangelist, David, St. Stephen (the first Christian martyr), and Jeremiah. On the other side, from the right: St. Paul, Abraham, St. James Major (or possibly St. James the Less, or even St. Matthew), Moses, St. Lawrence, and Judas Maccabaeus. Judas Maccabaeus restored the temple of Jerusalem in 165 B.C.E. after it had been destroyed. (Adam, St. Stephen, Abraham, and St. Lawrence are not known to have written books, though the sixteenth century may have believed in various now-forgotten apocryphal works ascribed to them.)

On the lower level there is less agreement about the characters' identities. But all who have been identified are authors (or in one case a painter). Beginning at the altar and moving left, the ecclesiastic with the papal tiara is thought to be St. Gregory the Great, who wrote a life of St. Benedict and a commentary on the Book of Job. Then comes St. Jerome, the desert saint who translated the Hebrew scriptures into Latin; then a trio of youths bowing in adoration while a standing man points to other books lying on the pavement. Then two more bishops, then four ecclesiastics in discussion. An old man, possibly Bramante making a cameo reappearance, points out a passage in a book. (Bramante is reputed to have written a treatise on perspective.)

Another artist is probably present: the saintly Fra Angelico, on the far left margin. He had painted frescoes in the nearby chapel of Nicholas V (1448–50; fig. 15), which depict the lives and martyrdoms of two of his companions here in the *Disputa*, St. Stephen and St. Lawrence. These scenes transfer the events of Stephen's life

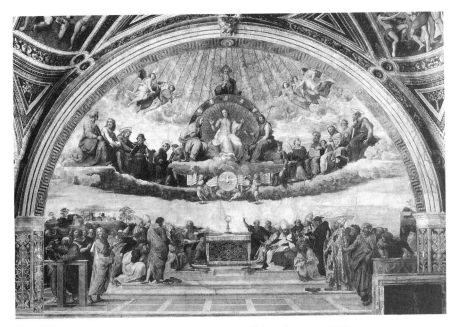

111. Raphael, the *Disputa*. Stanza della Segnatura. Scala/Art Resource, N.Y.

from Jerusalem to Rome, which is like what happens throughout the Stanze: events from various parts of the world are restaged in the papal city. The arrays of saintly authors in Fra Angelico's frescoes are another forestaste of the *Disputa*.

On the other side of the altar, meanwhile, a man gestures towards heaven as he turns to the seated St. Ambrose, marvelling at the vision they both see. Beyond him sits St. Augustine, who completes the appearance in the fresco of the four doctors of the Latin Church (Ambrose, Augustine, Gregory, Jerome). Augustine is dictating to a youthful secretary. Then come St. Thomas Aquinas, pope Sixtus IV (Julius II's uncle and the author of theological works, e.g. on the blood of Christ), and the poet-theologian Dante. The figures of pupils and followers among the lower range of authors illustrate, like their

equivalents in the *School of Athens*, the library's function as a transmitter of knowledge.

The *Disputa* pictures upper and lower worlds. Giles of Viterbo claims that our lower world is the common, sense-oriented one afflicted with death. The upper world is divine, intellect-oriented, and immortal. "The head of this world," he says, "hangs from the heavens and from universal nature. But the supreme [world], which resides in the highest citadel of things, is pure simple golden emanation that emanates gold [*aureus fulgor et fulgens aureum*]; [it is] God, most like to the sun and to the light of the sun, shining in the highest place. The central world inhabits the air appearing at the upper limit of our vision. The light from it partakes of the divine and its own light is the greater." The passage could almost be a description

of the central upper part of Raphael's fresco with its sculptural gold leaf. The rays of this upper sun, the preacher continues, penetrate outward and downward into our human intellects. Christ, then, if I may marry Giles's vision to Raphael's fresco, is here a sun, though also clad in the white robe of his crucifixion, his hands open in the gesture of the priest who consecrates the host, and with the wounds of his upper body exposed. Next to the sun of Christ, says Giles, is Christ's "queen," or moon, dressed in gilded clothes: her light is like a garment. In the fresco that moon is the Virgin, clad in blue trimmed with gold, who humbles herself before her son as a crescent moon gleams delicately within the white cloud of her throne.

Giles's sermon contains numerological speculations that at least match, if they do not perhaps explain, other aspects of Raphael's composition. In particular there is a disquisition on the sacred properties of the number twelve, a number that informs and structures the coming age of Christ and his upper world. (We have already looked at part of this discussion and at the properties of the Della Rovere oak.) So now we note that there are six saints on either side of the central trio of Christ, John, and Mary. There are then three angels on either side of the one God; and four Gospels. This harmonious, upper-world meditation on the number twelve and its constituents, four and three, is contrasted with the relative disorder below, which lacks such clear groupings. Number leads to architecture. The temple before us is reminiscent of one of Julius's schemes for St. Peter's. These had at one time included a Cappella Giulia with curved banks of benches surrounding the altar. The arrangement was not uncommon in early Christian churches. It appears again in the

younger Antonio da Sangallo's sketch for the remodeling of the chancel of Santa Maria sopra Minerva, Rome. His model there, we know, was the *confessio* in Old St. Peter's. My reading of the *Disputa*, in short, makes heaven itself an *instauracio* of Old St. Peter's.

In the very distant background we see two buildings being erected. These are thought to be the new basilica, of which Raphael was to become chief architect, and the Logge. If this is right these details must have been added later, perhaps when the room was converted from library to judicial chamber. Others think that the tiny figures are constructing the Cortile del Belvedere. Whatever the case, the little scene gives the *Disputa* a specific Roman location. And it places the altar shown in the fresco about where the altar of St. Peter's is.

In the dado proper are what might, in a book collection, be called footnote-scenes probably added after the library was removed: the Sibyl of Tibur, a town near Rome, shows the Virgin to Augustus; we see St. Augustine and a boy at the seashore who had vainly tried to drain the whole ocean into a hole in the sand—an enterprise no less futile, the legend says, than the saint's own attempt to understand the mystery of the Trinity. We also see a pagan sacrifice as the type of the Christian mass. All are by Perino del Vaga.

The Parnassus (fig. 112)

Note that this fresco is dated 1511 (AN CHRISTI MDXI) on the soffit of the architrave of the window looking out into the Cortile del Belvedere. We are on the peak of the famous Greek mountaintop, just above Delphi, which was the home of Apollo and the Muses. The god is seated

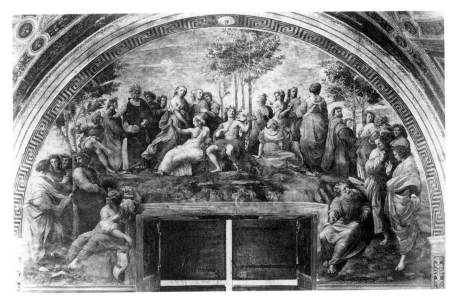

112. Raphael, *Parnassus*. Stanza della Segnatura. Alinari/Art Resource, N.Y.

on a rock playing an instrument only recently invented in Raphael's day, the *lira da braccio*, a predecessor of the violin (with the nine strings possibly standing for the nine muses). Thus again do antiquity and the modern merge. From beneath the god's seat issues the whitish stream of the fountain, Castalia, whose waters bestow poetic inspiration on those who drink them. The nearly naked god, whose pose and costume parallel those of the Christ in the *Disputa*, is shaded by a thick-fronded green grove of laurels. His rapt upward gaze responds in ecstasy to his music.

A crown-formation of muses, the female goddesses of the arts and sciences, surrounds him. On the left, seated near Apollo, is Calliope, muse of epic poetry and eloquence. She is dressed in white and carries a thyrsis. Behind are Euterpe, Clio, and Thalia. They stand respectively for music and lyric poetry, for history, and for comedy. Thalia, in green, hugs her more imposing sister Clio, who suitably seems to dream of the past. In the right-hand group we can recognize Melpomene, goddess of tragedy, by her solemn face and tragic mask. She stands with Erato, muse of love poetry. There is also Terpsichore, muse of choral song and dance. Urania, who rules astronomy, points at the sky. Next to her is Polyhymnia, goddess of sacred poetry and oratory. The fact that their leader, Apollo Musagetes ("leader of the muses"), plays a *mus*ical instrument— and, indeed, their very name, "muses"— shows that the inner principle of all their disciplines is music. Music, in short, with its harmony, number, and interval, structures the other arts. The very spheres of the cosmos, said philosophers at the time, make music.

A select group of Greek, Roman, and contemporary poets have joined Apollo and his consorts. I repeat the usual identi-

113. Raphael, *The Cardinal Virtues*. Stanza della Segnatura. Alinari/Art Resource, N.Y.

fications, a few of which are pure guesswork. On the crest of the hill to the left of the Muses, at the very acme of Parnassus, we see Homer, blind and kingly, dressed in purple and gold. His face is raised to the heavens. A seated youth with a tablet records his words. Nearby are Dante and Virgil. A third, rather worldly-looking poet just behind Virgil, with fleshy face and pleased smile, may be Statius. Lower down, still on the left, are other poets. The foremost is Sappho, who carries a scroll with her name on it in her upraised left hand. Like Apollo she is seated on a rock. She has just set down her lyre. She leads the "lyric" poets. Her companions, from the left, are Alcaeus, Corinna, Petrarch, and Anacreon. To the right of the muses on the other side of the fresco is another group of poets, who similarly rank slightly below the Homer-Virgil-Dante group; from the left are Ariosto, whose bearded Renaissance face looks directly out at us, Ovid, Catullus, Tibullus, Propertius, the Renaissance poet Tebaldeo, and, further down, Horace, the other Renaissance poet

Sannazaro, and the seated Pindar. We note that if Romans do not appear in the philosophy fresco they are well represented among the poets. And, speaking of musical ratios, note how the twenty-eight figures are divided into arrangements of ones, twos; threes, fours, fives, and the like. The three living poets in the group, Tebaldeo, Sannazaro, and Ariosto, are the only characters whose glance goes directly out to us, the living. We might add that all three were, or were to be, recipients of papal patronage. Sannazaro's *De partu virginis*, "The Birth of the Virgin," we have noted, was dedicated to Leo X who, on accepting it remarked that he liked to look at the poet's portrait. He may have meant this one.

On the window wall looking down to the Cortile del Pappagallo is a lunette of three seated cardinal virtues (fig. 113). Fortitude grasps a Della Rovere oak for strength; Prudence looks into a mirror that tells her what lies behind her. She is lighted by the torch of hope carried by a putto. We also see Temperance holding a

bridle and bit. The three putti represent the theological virtues—Charity shakes a tree to collect its fruit, Hope raises a torch, and Faith points to heaven. The fourth cardinal virtue, Justice, is in the vault.

Gregory IX Consigns the Decretals to the Consistory (fig. 114)

The event occurred in 1227. To the right of the window a venerable bearded pope, Gregory IX (played by Julius II—his first portrait with his new beard) in a golden cope, is seated on a throne. The marble niche of an ancient basilica recedes behind him. Flanked by cardinals, he hands a book to a kneeling cleric, Raimondo di Penaforte. The book contains part of the Church's canon law. The decretals, as these laws were called, are derived from letters written by the earliest popes. By turning them over to the cardinals Gregory was in essence expanding local Roman and papal rules and precedents to the Western Church as a whole—one more instance of Romanization. Not only the pope but at least two of the attending cardinals are portraits of contemporaries: note Giovanni de' Medici, the future Leo X, and Alessandro Farnese, the future Paul III.

Justinian Consigns the Pandects to Trebonian (fig. 115)

To the left of the Justice window is a similar, though somewhat narrower scene. Another landmark in legal history is observed. In an ancient basilica matching Gregory's the Byzantine emperor Justinian I receives the pandects from the legal expert Trebonian (seemingly played by none other than Raphael). This act, which

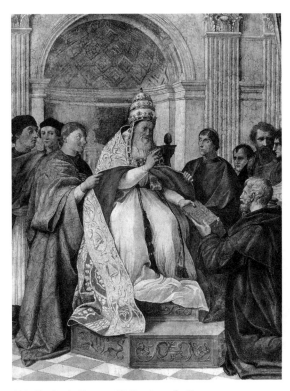

114. Raphael, *Gregory IX Consigns the Decretals to the Consistory*. Stanza della Segnatura. Alinari/Art Resource, N.Y.

took place in 533, did for civil law what Gregory's editing of the decretals did for canon law: they made a logical structure out of a mass of confused precedents. The pandects were a digest (in Greek *pandeuktai*) of some nine thousand time-honored statutes. The new version came to be known as the *corpus iuris civilis* and was influential throughout later history.

In the dado beneath, more scenes of supportive amplification: under the decretal scene Moses presents the Tablets of the Law to the Hebrews and under the pandect scene Solon the lawgiver speaks to the people of Athens. Both are by Perino del Vaga.

115. Raphael, *Justinian Consigns the Pandects to Trebonian*. Stanza della Segnatura. Alinari/ Art Resource, N.Y.

116. (*facing page*) Stanza della Segnatura, vault. Alinari/Art Resource, N.Y.

The Vault (fig. 116)

The vault consists mainly of huge fictive medallions. Between them are figures from the sciences and arts. Above the *Disputa* is the seated figure of Theology—or, as her inscription says, *divinarum rerum notitia*, "knowledge of divine things." In this part of the room color symbolism— one might even say color coding—holds. Thus theology is a noble female with a white veil, green mantle, and red gown, these being the colors of the respective theological virtues of faith, hope, and

charity. She holds a book in her left hand and, with her right, indicates the crowd of saints and theologians in the *Disputa* on the wall below her. Above the scenes of Gregory IX, Justinian, and the allegory of applied justice, we see Justice herself (*ius suum unicuique tribuit*—"she administers her law to each one"). Justice wears a blue drapery bordered and decorated with colors symbolizing the four elements. Thus, above, she is blue scattered with stars, for air, below that, red decorated with salamanders for fire, then sea-green with scattered fish for water, and light brown with plants for earth. Justice, you might say, is universal, elemental. Over the *School of Athens* we see Philosophy (*causarum cognitio*, "knowledge of the causes of things"), who holds two volumes, one entitled *moralis* and the other *naturalis*. Above the *Parnassus*, finally, we see Poetry, a book in her right hand and in her left a lyre. Her blue gown, with a girdle strewn with stars and wings, symbolizes the flight of imagination. Her inscription may be translated: "She is inspired by a god."

There are still other figures in the corners of the vault. Between Theology and Justice is Original Sin: *The Fall of Adam and Eve*, an interesting contrast to Michelangelo's version in the Sistine (fig. 153). Between Justice and Philosophy is *The Judgment of Solomon*, and between Poetry and Theology *Apollo and Marsyas*. The latter event pitted a mortal, Marsyas, against the god in a lyre-playing contest. Marsyas, who of course lost, was flayed alive as punishment. His fate ever afterward symbolized the folly of mortals' setting themselves against gods. These scenes are all by Raphael. The rest of the vault is decorated with imprese and emblems of Julius II, and is the work of the earlier artists whom Raphael supplanted. The pave

ment has similar devices, and includes emblems also of Nicholas V (who built the original room) and of Leo X.

The general themes of the Stanza della Segnatura are fairly clear. The main idea is to portray the authors of the books, using, as already noted, the categories common in libraries at the time. The four main categories were theology (*Disputa*), philosophy (*School of Athens*), jurisprudence (*Gregory* and *Justinian*), and poetry (*Parnassus*). Jurisprudence was in turn subdivided into canon and civil law— i.e., Gregory and Justinian. Theology was divided into revelation (the saints above) and reason or speculation (the thinkers below). Poetry was divided into epic (Homer, Virgil, etc.) and lyric (Anacreon, Sappho). There are also, here, the muses or poetic essences of the other arts and sciences. Philosophy was divided into moral (Plato, Socrates) and natural (Aristotle, Euclid, etc.). Where possible these categories are couched in terms of Julian imagery. Philosophy occupies a vast open-air classical basilica reminiscent of the Cortile del Belvedere or Bramante's St. Peter's. Some of the court's favorite modern poets inhabit Parnassus. And we see theology as another church, like St. Peter's, formed literally from saints and the saintly. Jurisprudence, finally, is an ancient Roman institution set in a classical basilica (the architectural form of Old St. Peter's was based on that of the Roman law court) whose laws are transmitted from empire to church.

The Age of Leo X

The next two rooms, the Stanza d'Eliodoro and the Stanza dell'Incendio, are completely different. They originally housed judicial, social, and bureaucratic functions.

Their frescoes, accordingly, depict specific historical events seen as types of the events of the early sixteenth century. Indeed the pictures may be said to have functioned, or to have been intended to function, like the battle pictures in Merlin's painted room in Ariosto's *Orlando Furioso* (1532; 33.6; see epigraph to this chapter). In an age of typology, paintings of historic victories, oaths, liturgies, and miracles were intended to predict or, following Ariosto, bring about future replays of those events. In line with this belief Julius, Leo, and Clement play the roles that point up the cyclical recurrences of papal policy in all ages. The themes of the Stanza d'Eliodoro and that of the *Incendio* are:

1. The imperial nature and destiny of a papacy that is the heir of ancient Rome and is dominant over the Holy Roman Empire;

2. The inviolability of Italy to Turkish, French, Spanish, or German penetration;

3. The purity of the priesthood, God's miraculous defense of that priesthood, and his prohibition against mortals judging popes.

The Stanza d'Eliodoro (1512–14)

The Stanza d'Eliodoro was undertaken in the last year of Julius's reign and completed in the second year of Leo's. Undoubtedly the subjects and compositions were set while Julius was still alive, except perhaps for one of the scenes, as noted below, which features his successor's namesake confronting Attila.

The Expulsion of Heliodorus (fig. 117)

This fresco, which dates from 1512–14, illustrates an event in 2 Maccabees. It took place during the reign of Seleucus Philopa-

117. Stanza d'Eliodoro, 1512–14. Raphael, *The Expulsion of Heliodorus from the Temple.*
Alinari/Art Resource, N.Y.

tor king of Syria (reigned 187–176 B.C.E.).
Heliodorus, Seleucus's tax collector, was
ordered to seize the treasures kept in the
Jerusalem temple. Arriving with a group
of soldiers he succeeded in snatching the
loot. But as a result of the prayers of the
high priest, Onias, God sent a mysterious
horseman on a white charger. He along
with two armed men threw Heliodorus to
the ground as he tried to flee.

Raphael depicts the moment when the
plunging horse is about to trample He-
liodorus beneath his hooves. The motif
comes from Leonardo's designs for eques-
trian monuments (fig. 118). Heliodorus
lies, a wounded classical warrior, vainly
beseeching God's implacable representa-
tive. One of his black-bearded and brutish
henchmen emits a yell of rage. The two
youths assisting the angelic horseman,
meanwhile, almost fly, so eager is their

attack. Most of the worshipers are amazed
at the miracle. But the real motor behind
the scene, of course, is Onias, who lifts his
aged head to the Lord. He is framed in the
recesses of a series of gilded vaulted bays.
The miraculousness of the priest's prayer is
witnessed by two other youths on the left.
One, in gold, grasps a column so as to lean
forward to see Onias while a companion
steadies him. A kneeling woman in the
foreground, her back to the viewer, has
similarly swerved from the prayer's dra-
matic outcome, enacted on the right, to re-
gard the even more powerful act of the
prayer itself, upstage center. This way of
working toward the heart of a scene, set in
the rear, via the vivid reactions to that
event as they are displayed in the fore-
ground, is something Raphael and his fol-
lowers will exploit often in the Stanze.

In contrast to the scene of thieves and

ieir punishers on the left, on the right is group of women and children—those who would have been deprived by Heliodorus's theft. Then, on the far left, in a processional calm contrasted with the atmosphere of violence, wonder, and excitement that we see everywhere else, is Julius II seated on his papal *sedia gestatoria* or sedan chair. This time he is not playing a historical role but is an interloper from the modern age. The young man in black gown and red sleeves on the far left, meanwhile, is Raphael himself, who looks on with admiring wonder at what his skill has wrought. Next to him, more princely in his self-possession, carrying one of the handles of the sedan-chair and staring out

at the viewer with serene pride, is Raphael's pupil and successor Giulio Romano, who undoubtedly assisted in the execution of this fresco and was to be in charge of the Sala di Costantino. Giulio's partly hidden companion is said to be the man who engraved and widely published so many of Raphael's subjects, Marcantonio Raimondi. That these men, who wrought the media used to project the papal message, should thus portray themselves is typical of the times. In an exactly similar way Ariosto, in the midst of the most glorious passages of *Orlando Furioso*, will stride personally onto the scene. It is sometimes said that this fresco celebrates Julius's success in reestablishing tax payments to the Vatican

118. Leonardo, design for an equestrian monument. Windsor, Royal Library 12358r, c1485. By permission of Her Majesty the Queen.

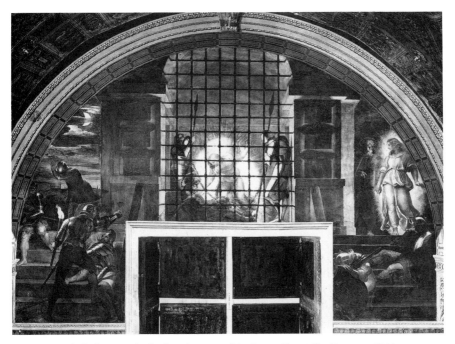

119. Stanza d'Eliodoro. Raphael, *The Liberation of St. Peter*. Alinari/Art Resource, N.Y.

from local barons who had been refusing to contribute.

The Liberation of St. Peter (fig. 119)

On the adjacent wall is a New Testament antitype to the scene we have just looked at. St. Peter was several times in prison. Two occasions count specially: when Herod put him in jail in Jerusalem so that he could not participate in his followers' Easter celebration, and when, in 69 C.E. according to legend, Nero put him in the Mammertine prison in Rome in anticipation of his crucifixion and death. On both occasions Peter prayed, like Onias before him, for relief from the wrong being committed against him. But as a Christian he also prayed for the salvation of his captors, for forgiveness and redemption for those who had punished him. On the first oc-

casion he was miraculously freed by an angel. On the second, imprisonment was followed by crucifixion.

Raphael focuses on the saint's Jerusalem imprisonment; yet the scene is full of Roman associations. In color it is a cool-toned nocturne divided into three vertical episodes. In the center is the moment of miracle itself when, in a flash of radiant reddish fire, the angel descends to loose the apostle's chains. Deep-bearded Peter, in silhouette, lies sunk in sleep, exhausted by prayer. His two armored guardians sleep too, leaning on their spears. The jail is represented by a thick masonry arch set with a metal grille. On the right we see the outcome of the angel's visit as he leads the beautiful docile old man out of the prison past more sleeping guards, who sprawl on the steps in poses reminiscent of Diogenes in *The School of Athens*. On the

right, too late, a captain rouses other soldiers to tell them of the saint's flight. All three tableaux are lit with dramatic backlighting that emanates from the angel's explosive epiphany and from the moon among the nighttime clouds.

Raphael has transcribed the incident exactly as reported in the text (Acts 12): the numerous soldiers, the iron gate, the narrow defile, the two chains, the two guards in the cell, the brilliance of the angel's flame—are all in the Bible. The notion of liberation, of course, ties in with a great theme of Julius's papacy even as it also recalls one of Leo's personal traumas. Here too the particular act of liberation would connect with Peter's subsequent rejoining of his flock and with the recommencing of his leadership of the Church. And once again the secret of Peter's success, like Onias's, was prayer.

Leo I Stops Attila's Invasion (fig. 120)

This dates from 1513–14 and is by Raphael, assisted by Giulio Romano and Giovan Francesco Penni (1488–1528). Now the popes have obtained temporal power and the glory due their universal office. Yet, once again, we see the integrity of Italy and the papacy first threatened, then miraculously preserved. Leo the Great was pope from 440 to 461. Attila, the king of the Huns (reigned 445–53), had been extorting increased tribute from the empire, at the time in a weakened state. Eventually the emperors began refusing to pay the tribute. Among the recusants was Valentinian III, emperor of the west. As a substitute for funds his sister Honoria offered herself in marriage to the Hun chieftain. But Attila demanded half the western empire as dowry. When this was refused, Attila, accompanied by a large army, marched on Rome. But he was forced to turn back long before reaching the city, probably because of supply shortages, though tradition has it that an eloquent messenger from Leo I did the trick.

In any event Raphael's scene, in which Attila and Leo confront each other outside the walls of Rome, never occurred. It is yet another translocation of a non-Roman event. Tightly framed by a heavy round arch we see the pope and his cardinals, Leo's hands raised toward the barbarians in benediction as he rides fearlessly towards them. The parallel with Julius II in the Heliodorus scene is exact. But now the pope is Leo X (Julius died as the fresco was being painted). In the background, for example, are the Colosseum and an aqueduct. In the sky is a miraculous event that, according to some of the legends, was what actually brought about Attila's decision to retreat. The flying figures of saints Peter and Paul, armed with swords, menace the invaders. As additional prodigies a hurricane fills the sky and fire blazes on the horizon. Attila, wearing an iron crown, rears back on his black horse and stares up at the apparition. Just in front of him, in the center of the fresco, a soldier indicates the pope and his courtiers in a gesture expressing the army's next action, which will be to wheel and march away. On the right a white horse plunges as its armed rider is stopped—another reference to the Heliodorus with its similar rider. Meanwhile in the rear the musicians, sounding their *cornua* or curved trumpets, have already begun the march back to their Hungarian forests. Even to Attila, then, even to the pagan horde which, it was believed, God himself had sent to punish errant Christians, Rome remained inviolable.

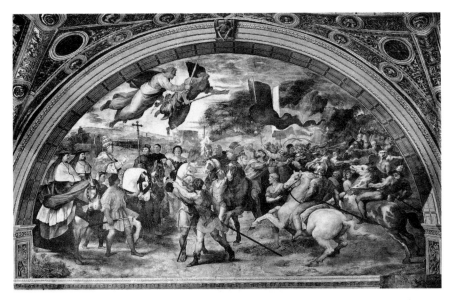

120. Stanza d'Eliodoro. Raphael, Gianfrancesco Penni, and Giulio Romano, *Leo I Stops Attila's Invasion.* Alinari/Art Resource, N.Y.

The Mass at Bolsena (fig. 121)

The fresco is succulent with Venetian color. It is possible that the Venetian artist Sebastiano del Piombo, who lived in Rome from 1510/11 on, may have displayed his secrets to Raphael. (Another possibility is Lorenzo Lotto.) But if the style is new the subject is not unexpected: once again northerners try to wrong Italy, but fail. This time the wrong is German atheism. In legend the event occurred in 1263; a German priest who had lost his faith and doubted the truth of transubstantiation was celebrating mass at the tomb of Santa Cristina in the town of Bolsena, not far from Orvieto. As he consecrated the host a miracle occurred. When the priest, in a part of the ritual symbolizing Christ's crucifixion, broke the wafer, it bled. The blood flowed down over the corporal, a cloth used in the ritual. The miracle showed that Christ's flesh truly did inhabit the

consecrated host and that his crucifixion was and is a permanent sacrifice, renewed whenever mass is said. This is so even when the priest is an unbeliever. Indeed, the miracle at Bolsena delivered the priest from his infidelity.

The fresco, which was probably completed before Julius II's death, is set into the arched wall area over a window. In the center, raised above the surrounding spectators, the priest kneels and raises the wafer over the cup of wine. Behind him are the kneeling forms of his acolytes or assistants in the mass. They have just seen the miracle and look wonderingly at each other. On the other side of the altar kneels the solemn figure of Julius II. He gazes sternly at the priest as if silently exhorting him. Curved wooden choir stalls form an apse for the scene. The pope is attended by cardinals and other dignitaries standing below and behind. Among them are Cardinal Raffaele Riario (hands crossed) and

121. Stanza d'Eliodoro. Raphael, *The Mass at Bolsena*. Alinari/Art Resource, N.Y.

Alessandro Farnese (hands clasped), the future Paul III, who was a canon of the cathedral at Orvieto where the corporal is now kept. At the lowest level kneels a group of magnificently uniformed Swiss knights, Julius's favorite soldiers. They are his *sediari*, bearers of the papal sedan chair. On the left a colorful group of men, women, and children marvel at the scene. Raphael has set the whole episode in one of those open-air basilicas he seems to have liked.

The stained corporal is still venerated in the cathedral of Orvieto, and it was here, to pray before that very relic, that Julius II stopped on his way to the siege of Bologna in 1506. The feast of Corpus Domini, still in the Roman calendar, was instituted as a result of the miracle.

The ceiling of the Stanza d'Eliodoro

(fig. 122) was decorated during Leo's reign. It is divided into four wedge-shaped scenes enacted in front of thick blue skies. In order, they are: *God Appears to Noah, The Sacrifice of Isaac, God Appears to Moses,* and *Jacob's Dream*. Creighton Gilbert points out to me that the events respectively express the elements of water, fire (i.e. that on Abraham's altar), earth (claiming the promised land), and air (angels appearing to Jacob). The frescoes, in poor condition, are attributable to Guillaume de Marcillat (1475–1529), one of the assistants working to Raphael's designs. They exhibit the influence of Michelangelo. All four of these Old Testament subjects show how God miraculously manifests himself to his people in order to guide them. Noah is instructed to build the ark that will save the virtuous remnant of the human race

122. Stanza d'Eliodoro, vault. Alinari/Art Resource, N.Y.

after the rest of it drowns; Abraham's love of God is tested when God asks him to sacrifice his beloved son Isaac. When the stricken father is about to do so God sends an angel to stay Abraham's arm. In a dream, God then commands Jacob to take ownership of the land of Israel. He later appears to Moses to summon him as the deliverer of his people out of bondage in Egypt. Let us note that after his dream Jacob was to build a shrine, Bethel, marking his people's deliverance and newfound freedom. Bethel, in turn, thus became one of the types of the church.

The dado of the Stanza d'Eliodoro consists of eleven painted caryatids and four herms (for the difference, see Chapter 8). They exhibit the instruments and works of peace and are by Raphael's assistants. Much of the dado was repainted in the eighteenth century.

The Stanza dell'Incendio

Painted by Raphael and his pupils between 1514 and 1517, this chamber was apparently used by Leo X as a private dining room. Earlier, under Julius II, both it and the room that became the Stanza d'Eliodoro had been one of the *aulae pontificae*, reception rooms for dignitaries. There are differences among the rooms in iconography as well as function. Where the Segnatura and Eliodoro chambers take subjects from many different periods the Stanza dell'Incendio takes its subjects exclusively from the half-century 800–849. Not surprisingly it features popes named Leo. Also unlike the other rooms it concentrates on relations between those popes and the emperors before reverting to the more familiar theme of Rome's inviolable primacy. This shift makes sense. In the early sixteenth century the supreme tribu-

nal of the papal curia, the Signatura, met here (and not in the adjacent one that we now so confusingly *call* the Stanza della Segnatura). The Signatura was comprised of two offices, the *signatura iustitiae*, which resolved jurisdictional disputes among the various parts of the curia, and the *signatura gratiae*, headed by the pope himself, which involved the pontiff's personal replies to appeals and supplications.

The Oath of Leo III (fig. 123)

The event depicted on the window wall occurred when, on December 23, 800, Leo III (reigned 795–816) publicly purged himself of supposedly false accusations. He did so in St. Peter's, in the presence of the Holy Roman emperor, Charlemagne. To us this somewhat ignoble episode evokes the charges levelled at Julius II by Louis XII's synod at Pisa—charges refuted, we saw, in the Lateran Council that was being held even as this fresco was in process. Some of the accusations made against Leo III were in fact the same as those with which the High Renaissance popes were confronted. Both sets of accusers denied the pope's right to rule politically in central Italy and to appoint bishops in foreign countries. In reply, under the *Oath of Leo III* are inscribed the words: "It is God, not man, who judges bishops" (the pope is a bishop). In the fresco itself, as if in further reply, Leo imitates the pose of Onias in the Heliodorus fresco, which is also that of Julius II at Orvieto. He stands at the altar that specially honors the tomb of the prince of the apostles. As chief priest of the Christian church, Leo asks God's forgiveness—not for his own sins, let us clearly note, but for those of his accusers, who have attacked the foundations of the papacy and would alienate Peter's lands,

123. Stanza dell'Incendio, 1514–17. Raphael and assistants, *The Oath of Leo III.* Alinari/Art Resource, N.Y.

treasure, and duties from his rightful successors. Charlemagne, the man in the gold chain, on the left with his back to us, witnesses the oath as one who joins in its affirmations.

The Coronation of Charlemagne (fig. 124)

This occurred just two days later, on Christmas day 800. Guicciardini well states the idea: "Pope Leo together with the Roman people, and [he] not with any authority other than being their head, elected Charlemagne as emperor of Rome." The aim was to defend the city against its enemies. The scene is the same as in the adjacent fresco of Leo III's oath: St. Peter's. As, in the previous scene, the emperor had sanctioned the pope's civil

power, so in this the pope sanctions the emperor's. Leo places the crown of empire on Charlemagne's head. A crowd of officials and ecclesiastics watches in the packed basilica. We learn that the emperor rules only with the pope's sanction, that this sanction must be delivered in Rome, and that peace in Europe is based on the alliance between pope and emperor. Underneath is written: "Charlemagne, sword and shield of the Roman church."

But once again there is a sixteenth-century antitype to the ninth-century type. The fresco is an allusion to the recent alliance between Francis I and Leo X, signed in October 1515. Francis I, in fact, plays Charlemagne in Raphael's solemn enactment, while Leo X plays Leo III. The germ of the idea may have come from Julius, who had died less than a year be-

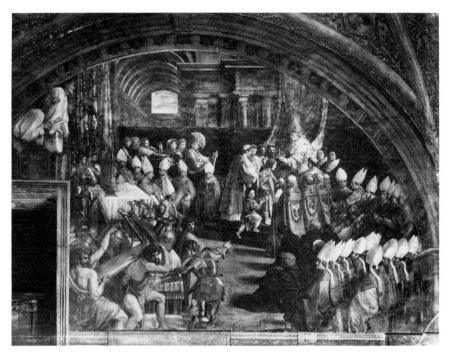

124. Stanza dell'Incendio. Raphael and assistants, *The Coronation of Charlemagne*. Alinari/Art Resource, N.Y.

fore work on this room began. We recall that as Giuliano della Rovere Julius had urged Charles VIII of France to imitate the actions of his great ninth-century predecessors, Pépin le Bref and Charlemagne. These two French kings had conquered various Italian towns and provinces and donated them to the pope. Painted in the very year of Francis's agreement, and now recently cleaned, *The Coronation of Charlemagne* adjures Francis to be another Constantine, to be worthy of his legendary predecessor. Unfortunately, the French-papal transactions of 1515 went in the opposite direction. The peace of Viterbo, we saw, deprived Leo of Parma, Piacenza, Modena, and Reggio Emilia.

The Fire in the Borgo (fig. 125)

We move forward from 800 to 847 and the reign of Leo IV (847–55). The episode is taken from a passage in the *Liber Pontificalis*, a collection of legends of the early Church. This describes a potential holocaust in the Borgo Leonino, the area around St. Peter's. When fire threatened, the pope put it out merely by making the sign of the cross. The fresco is the most vigorous of the Stanze scenes. Through the foreground arch we glimpse, on the left, a columned portico seen in sharp perspective. On the right, balancing the portico, other antique columns line a wall, and steps rise toward the right. Through the space between the two walls we see Old St. Peter's with the huge mosaic saints that decorated

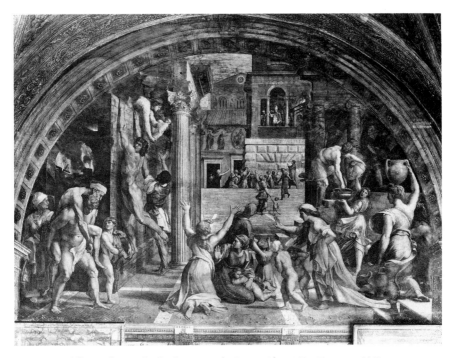

125. Stanza dell'Incendio. Raphael, *The Fire in the Borgo*. Alinari/Art Resource, N.Y.

its facade. Just in front stands an anachronism: a loggia for papal benedictions whose design borrows from Raphael's plans for the new basilica. A crowd of worshipers kneels before the loggia's arch. In that arch, far upstage again, appears the white-clad figure of Leo IV making his fire-quenching sign. In the foreground, on the right, frightened men, women and children form a bucket brigade to put out the fire still raging on the left, its flames licking out through an arched wall. In the center are frightened women and children. A mother in a saffron robe, hair all loose, hurries her babes along. A magnificent kneeling woman, also in saffron, her back to us and looking like a wildly praying maenad, joins her action to the prayers of the distant worshipers around the pope.

On the left is one of the most famous incidents Raphael ever painted: the nude man escaping from the flames with his wife and young son, and carrying his aged father on his back. The group is traditionally identified as Aeneas carrying his father Anchises from burning Troy accompanied by his son Iulus and his wife Creusa. Anchises is thought to have the features of Cosimo de'Medici, called il Vecchio, ancestor of Leo's clan. If the Trojan simile was meant, then once again, as so often in the poetry of the age, Rome is Troy. This is just: after all Aeneas went forth from the burning Ionian city to found Rome, which he himself called a second Troy. Indeed Virgil's description of the fall of Troy (*Aeneid* 2.705ff.) pictures the flaming city, Aeneas's house, and the

aged father carried on the son's shoulders as the family escapes. The poet even specifies that Creusa walks behind the main group, as Raphael shows her, and adds that Aeneas's little son Iulus walks by his father's side (2.710). On growing up in Rome Iulus gave his name to the Roman *gens* of Julius Caesar and hence is Julius II's namesake. (If all this was intended it was a compliment not to the reigning pope but to his predecessor, since the fresco was painted during Leo X's reign.) By making the Rome of Leo IV play the role of Troy vis-à-vis the Rome of Leo X, meanwhile, Raphael suggests the phoenix-like way in which the Eternal City is reborn after disaster.

The Victory of Leo IV at Ostia (fig. 126)

This occurred two years after the fire in the Borgo, in 849, when a Saracen flotilla was captured by Leo's forces. We have noted the papal fear of Islam. Giles's sermon is in part the preaching of a crusade against the Turks. Nor did the problem go away. In the reign of Paul III the Turks anchored off the Tiber estuary again, in unhappy fulfillment of this fresco's Ariostan prophecy.

The fresco itself must largely be the work of assistants, led, perhaps, by Giulio Romano. In the background we see Ostia with the famous harbor castle built for Julius II by Baccio Pontelli (1483–86). Behind it the exotic half-moon-shaped vessels of the Turks are still vainly battling the papal fleet. In the foreground, on the left, Leo IV is seated on a block of ancient marble with bits of Roman cornice beside it. He wears his tiara and a golden cope, his features being those of Leo X. Beside him a military commander raises his arm like an image of Augustus, gesturing to an

assistant who brings in the naked Turkish prisoners who must make their obeisance. (This commander is the subject of a beautiful preliminary drawing that Raphael inscribed and sent to Dürer [Vienna, Albertina].)

On the right a boatsman poles his vessel toward the shore and soldiers take more prisoners in hand. Some of them have been wrestled to the ground as they are tied up. Presiding over the whole is the gold processional cross carried by one of the pope's acolytes. On the far shore, meanwhile, a red-clad horseman dispatches the few remaining Turkish infantrymen. The cross and the Roman buildings suggest that the cause of Christ, enthroned in Rome, must prevail.

Beneath the main scenes are caryatids and reliefs, painted to resemble bronze, mostly depicting kings loyal to the Holy See. Any living kings, or their spokesmen, with business in the Stanza dell'Incendio would surely mark the messages, to wit:

1. Charlemagne.

2. Pépin le Bref; He is inscribed as "Pépin the Pious, who first opened the road to the expansion of the church with his army at Ravenna, an [opportunity?] granted to him on many other occasions."

3. Lothair I; "The emperor Lothair, asserter of papal liberty." Lothair (795–855) was Charlemagne's grandson and was crowned emperor in 823 by Paschal I at Rome.

4. Astulph, king of Britain, stands under the *Fire in the Borgo*. During the papacy of Leo IV, who was of course the hero of that event, Astulph paid taxes to the pope. Peter's citadel is sustained by the continual tribute of the nations of the earth.

5. Godfrey of Bouillon was the medieval Burgundian nobleman who refused

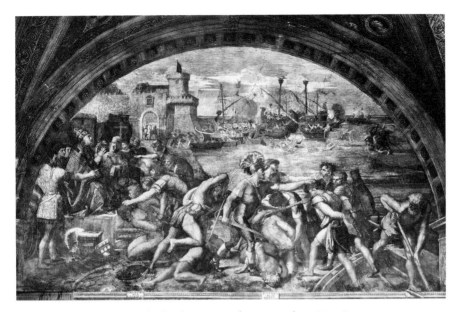

126. Stanza dell'Incendio. Raphael and assistants, *The Victory of Leo IV at Ostia.*
Alinari/Art Resource, N.Y.

the gold crown of (but not sovereignty over) Jerusalem in 1099. His inscription reads: "It is an offense against divine law to wear gold where Christ the king of kings wore a crown of thorns and redeemed Christian men." The exemplary Godfrey thus made his gold crown a form of tribute.

6. Matilda, countess of Tuscany (1046–1115) donated all her lands to the Holy See.

7. Ferdinand the Catholic (i.e., Ferdinand V of Castile and León, and II of Aragón) was still alive when the caryatids were unveiled—he died only in 1516. The inscription reads: "Ferdinand the Catholic king, propagator of the Christian empire" and refers to Ferdinand's patronage of Columbus.

These caryatids, then, like the original ones in classical legends, are admonitory and political. They inculcate lessons in religious responsibility for kings. And they also map out an increasing range of papal

territories running from Jerusalem to Italy to the New World.

The ceiling (fig. 127) dates from 1508 and was done to Perugino's designs by his pupils. Dominated by the image of Christ as the sun of justice, it supports the purposes of the *signatura iustitiae* and the *signatura gratiae.* Indeed personifications of written codes and papal grace flank Christ's figure. We also see images of God the Father among angels, Christ between angels and saints, Christ and the apostles with God the Father and the Holy Spirit, and Christ the judge.

The Sala di Costantino (1519–1525) (fig. 128)

This room is considerably larger than the other three. Like the smaller rooms next door it seems to have been used for banquets and receptions of foreign dignitaries.

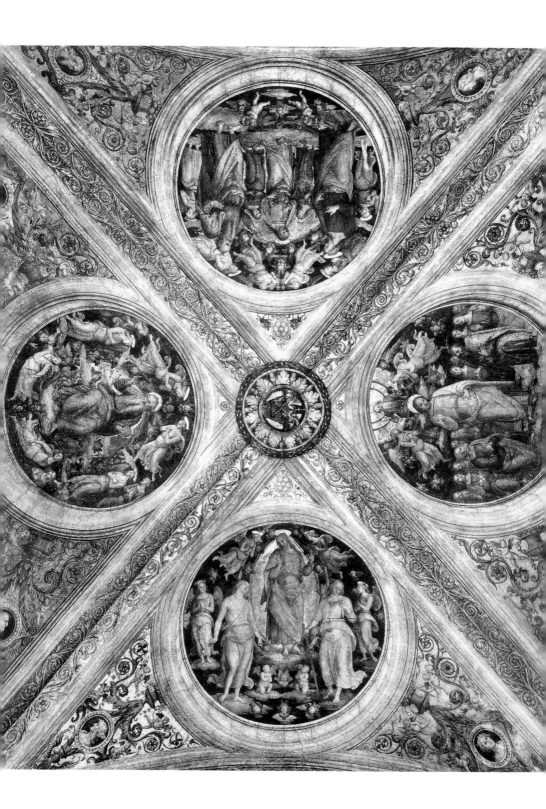

Other ceremonies, e.g., wedding receptions for papal relatives, were also held here. More important from the viewpoint of the fresco program, the pope here received foreign ambassadors and the tribute or service of his lieges. It is also possible that the College of Cardinals met in the Sala di Costantino in the days when that college was still relatively small. The most recent scholar to work on the room, Rolf Quednau, thinks the designs for most of the paintings (they are partly in oil, partly fresco) are Raphael's. The basic program was probably ordained in 1519, late in the reign of Leo X. However we know that the subjects of at least two of the main scenes were radically changed (see below). It is generally agreed that the artist in charge of execution was Raphael's assistant and, at Raphael's death in 1520, his successor, Giulio Romano. He was assisted mainly by Gian Francesco Penni and Raffaellino del Colle.

The theme is the conversion of the fourth-century Roman emperor Constantine to Christianity and his (mythical) donation to the popes of certain privileges, titles, and functions of the Roman emperors. "Constantine," writes Guicciardini, "having been converted to the Christian faith, and moved as he was by the saintly living and miracles that were seen so frequently in the lives of Christ's followers, granted them protection, which they had not had for the three hundred years previously." He continues: "It is claimed, aside from these things, that Constantine, constrained by circumstances in the eastern provinces to transfer the seat of his empire to the city of Byzantium, [which was thereafter] called, after his name, Constan-

127. Stanza dell'Incendio, vault. Alinari/Art Resource, N.Y.

128. Sala di Costantino, 1519–25. Layout. Author.

tinople, gave to the popes the rule of Rome and many other cities and regions of Italy." All this was firmly supported by the Church, though Lorenzo Valla in the fifteenth century, as we have noted, and others earlier, had rightly claimed that the donation document was a forgery.

Guicciardini takes it as authentic. But even though nowadays no one believes that there ever was such an official delegation of power, Guicciardini is right when he goes on to say that "the transfer of the seat of empire to Constantinople was the first origin of the popes' powers, since over time it weakened the power of the emperors in Italy." He also properly cites the invasions of the Goths, Vandals, and other northern nations as reasons why the popes had to exert secular rule and military defense. Similarly in the northeast, after the peninsular-wide pretensions of the Byzantine exarchs in Ravenna were diminished by Longobard pillage, Rome turned more and more to the counsels and authority of the locally resident popes.

Constantine was the illegitimate son of the emperor Constantius I and was raised

in the eastern empire. After rising rapidly in court and military circles he helped his father in a victorious battle with the British in 306. In the battle Constantius met his death and the son was acclaimed emperor by his army. Later the defeat of Constantine's rival, Maxentius, just outside Rome on October 28, 312, would remove the last roadblock to Constantine's assuming the full imperial office.

Like other emperors Constantine ruled via the adoption of not one but several different traditional offices—Augustus, Consul, Caesar, etc. The title "imperator," emperor, was one of these. The situation was not unlike that of Renaissance ecclesiastics who gathered into their hands as many benefices as possible. One should also note that at the height of his powers Constantine obtained a degree of absolutism for the imperial office that it had rarely possessed. The builder of Old St. Peter's, then, who decreed Christianity as the state religion and thereby made all of paganism a mere *superstitio*—the "leftover" of various older cults—Constantine, as a role- model for Renaissance popes, was little short of ideal. Add to this that in his later years he was an avid builder, and that, like Julius and Leo, he was frequently accused of emptying the public purse in the cause of artistic glory.

We noted earlier that Raphael's seated portrait of Julius II was the first such painted image of a pope ever made. The notion, I implied, would catch on. The Sala di Costantino contains an impressive array of similar portraits, images that vie in grandeur and scale with the historical events they frame. Flanking each main episode from Constantine's life—these latter, be it noted, painted as imitation tapestries—the popes all date from from the first six hundred years of Church his-

tory. Iconographically, then, they relate to the early popes in the Sistine Chapel. But stylistically and psychologically they owe more of a debt to the Sistine seers, and indeed mark the first introduction into the Stanze of strong influence from that quarter.

The popes themselves are most of them powerful old men, heroically enthroned, instinct with Michelangelesque passion and engagement. Their golden copes and pleated vestments ripple and stir almost like layers of muscular flesh. Though varied in physique and face they all sit in the same chair. It is the chair of Peter, revered to this day (and represented by an eighteenth-century container for it designed by Luigi Vanvitelli) in Bernini's great sunburst behind the high altar of the basilica. These enthroned pontiffs, all of them haloed saints, in a way replace the emperors, kings, and caryatids of the earlier rooms. They are further pillars of the church, whose majesty is drawn from, and continues, the gifts of Constantine. They are arranged chronologically except for Silvester I, who was thought to have received the original Donation, and who is therefore placed on the wall depicting that event.

Another Michelangelesque element in these flanking scenes is the sensuous allegorical figures—not just males, this time, but lightly clad, sometimes seminude females. Some represent the moral qualities of the popes they accompany. Others stand above the papal thrones and function as herms or caryatids, carrying banderoles that speak of papal and Medici qualities. Note, too, that the caryatids on the inner sides of the papal thrones seem to help support the tapestries portraying the Constantinian episodes, as if they were holding them up for our inspection. So the popes

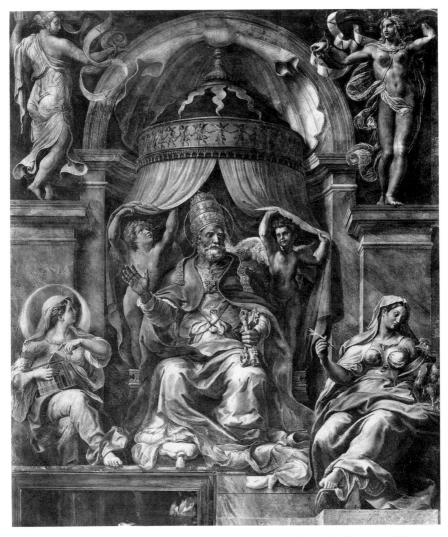

129. Sala di Costantino. Giulio Romano and assistants, *St. Peter*. Alinari/Art Resource, N.Y.

who write, pray, and expound in the corners of the room are in effect interpreting the central scenes for us.

As to the nudity, I will speak of this subject more fully in the next chapter. But here the unclothed body moves beyond innocence into sensuality. Yet there was and is theological justification even for this.

Defenders of pornography in the sixteenth century maintained that it could actually have what we call "redeeming social value" and indeed a full, admirable moral purpose and effect. Thus did Daniele Barbaro, patriarch-elect of Aquileia, praise Pietro Aretino's lewd tales and letters as inspirations to the moral life. It was even said—

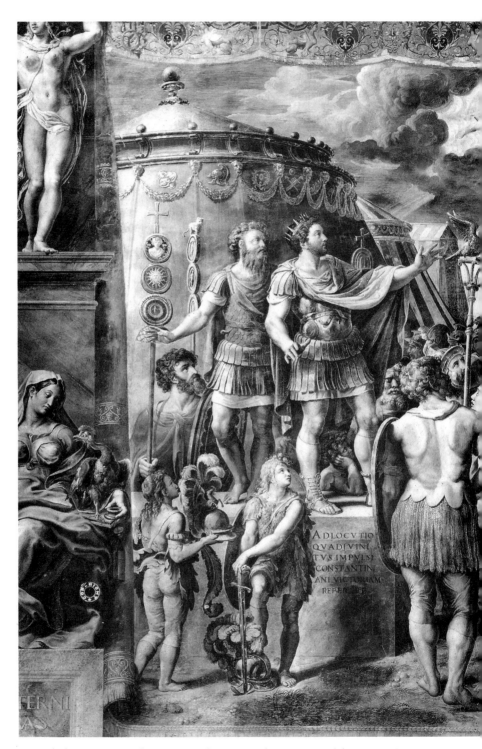

Within the fresco, the inscription reads:

ADLOCVTIO
QVADIVINI
TVS IMPVLSI
CONSTANTINI
ANI VICTORIAM
REPER...

130. Sala di Costantino. Giulio Romano and assistants, *The Apparition of the Cross to Constantine.* Alinari/Art Resource, N.Y.

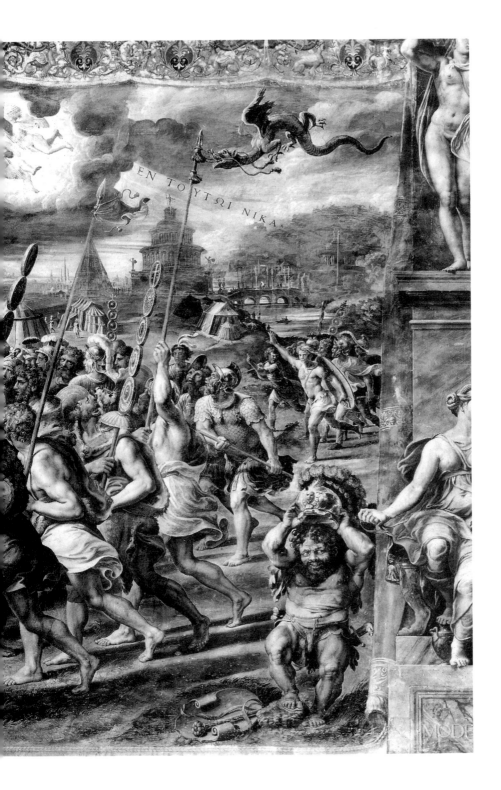

and by theologians—that we ordinary mortals can best understand a saint's love of virtue by analogy with our own feelings of sexual attraction. That the latter are base and the former sublime, it was said, is only a measure of the difference between common humanity and the exalted world of the saints. Michelangelesque popes, surrounded and worshiped by sensuous allegories, showed up later in many papal monuments—sculptured as well as painted. We have admired Della Porta's beautiful, originally nude *Justice* on Paul III's tomb (fig. 40). Bernini's tombs for Urban VIII and Alexander VII, also in St. Peter's, are further cases in point.

Beneath the main scenes, all around the room, are fictive bronze and marble caryatids. Each of the papal portraits is labeled, but due to inaccurate restorations over the years some of the labels we see today are wrong. The correct ones are given in the diagram (fig. 128).

East Wall

Peter (fig. 129) is a tough white-bearded man in papal tiara and vestments. In his left hand he grasps the keys to the kingdom of heaven, his right hand being raised in a gesture of invocation. He sits beneath a thickly draped baldacchino whose curtains are lifted by two naked angels. On his left, holding a model building (which represents the *tegurio* or temporary shelter Bramante built over St. Peter's tomb while the old basilica was being torn down [fig. 59]), is a woman representing Ecclesia. A crescent moon haloes her head: the Church is to Christ as the moon is to the sun (cf. the *Disputa*). On the other side of Peter, turning away from him toward his successor, showing how the Church depends on the succession of the apostles, is

Eternity clad in white and gold. In her right hand she holds a quill and in her left an inkpot and book. Eternity, then, is achieved through history, through fame. A phoenix, symbol of rebirth—the "eternity" of rebirth—is by her side.

The Apparition of the Cross to Constantine (fig. 130). Eusebius in his *Life of Constantine* relates, as a story he had heard from the protagonist himself, that at noon on the day before his battle with Maxentius for possession of Rome there appeared in the sky a flaming cross with the legend, in Greek, *"en touto nika,"* "by this, victory." On winning the battle Constantine vowed to become Christian and adopted the image as his personal device.

The composition of the scene repeats formulas we see on Roman monuments such as the Column of Trajan and the Arch of Constantine. On the left is the emperor's elaborate round campaign tent, the edge of its conical roof hung with garlands. Constantine, wearing the iron crown, stands with the prefect of the Praetorian Guard (said to be a portrait of Giulio's assistant, Penni) on a platform called a *suggestum* that is surrounded by praetorians and other military men. The emperor extends his arm towards his army, preparing for action on the right. His gesture is called the *allocutio*, the pre-battle pep talk of a general to his men, familiar from many Roman reliefs. It is at least possible that Raphael, who probably designed the present scene, was also influenced by the relief episodes from Constantine's career on the Arch of Constantine, erected by that emperor to commemorate this very event and still standing near the Colosseum (fig. 131).

In the immediate foreground various arms-bearers carry the emperor's helmet, shield, sword, etc. We recall the inscription

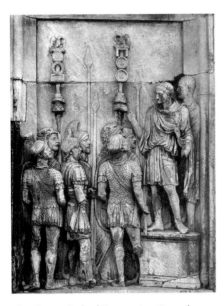

131. Rome, Arch of Constantine. Scene from Constantine's life, *Rex Datus* (or *Discourse of Marcus Aurelius to His Troops*). Aurelian Relief. Alinari/Art Resource, N.Y.

scene, the viewer is standing on the future site of St. Peter's. If so, this justifies the imagery of the flanking portrait of St. Peter. And the famous vision of the cross is occurring on the future site of the saint's tomb; "ecclesia" exists for "eternity" on this holy *mons vaticanus*. Finally, in the sky, is the miracle itself. Dramatically backed by brilliant bursts of golden light, the visionary cross is carried triumphantly by putti.

Clement I (fig. 132) holds a book and has the features, not very attractively rendered, of Leo X. Like Peter he has a halo and raises his hand in invocation. This frequent pose in the Vatican programs comes originally from Michelangelo's destroyed bronze statue of Julius II. (Let us note that this too was a full-length seated image.) Clement I is a crucial pope in that he was second in the succession—the tradition being that Peter named him as his successor. Clement's letters were revered as being of apostolic authority. In addition he produced a work known as the *Constitutions of the Apostles* whose propositions were held to have been dictated by saints Peter and Paul. The zodiac painted on the fringe of Clement's baldacchino has the sign of Leo in its center. On the left is *Moderatio*. One breast is revealed and her thick blond hair, set with pearls, is artfully arranged. The wine jug at her feet is borrowed from the iconography of a sister virtue, Temperance, who stands for moderation in drinking—and in all things. Moderatio's partner, meanwhile, is identified as *Comitas*—"friendliness, courtesy, graciousness." She too is attractive, even bedizened. Where Moderatio accords the pope a more distant attention, Comitas regards him with a sultry stare. Her sumptuous clothes are slipping off, her hair and body set with gems, and her gesture imi-

under *The Coronation of Charlemagne* in the Stanza dell'Incendio, to the effect that that emperor was the "sword and shield of the Church." On the far right, in the foreground, one of the emperor's pet dwarves plays with a helmet and smiles impishly at the viewer. Military standards bear the totems of the different kinds of troops (in particular the *vexillum*, eagle, and dragon) that Constantine commands.

In the background we see the Tiber and the *meta Romuli*, which was thought to be the tomb of the city's founder-namesake, Romulus (and which, according to some, was the inspiration for the general shape of the Julius tomb; see Chapter 8). Other Roman monuments appear, as does the Milvian Bridge where, the next day, the actual battle would take place. Quednau thinks that, with respect to the painted

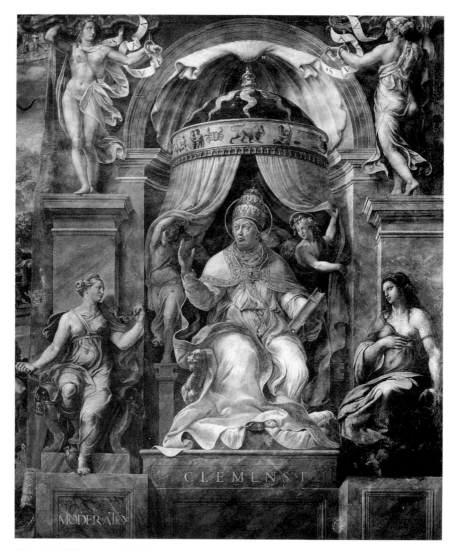

132. Sala di Costantino. Giulio Romano and assistants, *Clement I*. Alinari/Art Resource, N.Y.

tates classical Venuses. At her feet is a lamb, symbol of acquiescence. Comitas seems to embody the spirit of benevolent compromise in politics. Final touches are the nude caryatids above who present themselves attractively in a flutter of banderoles inscribed *suave*—one of Leo's Medici mottoes. (*Jugum enim meum*

suave est, et onum meus leve—"My yoke is easy and my burden is light" [Matt. 11:30]; Jesus is speaking.)

South Wall

Alexander I (currently misidentified as Sylvester I), who ruled from 105 to 110,

was St. Peter's fifth successor. As is appropriate to a pope identified with the city of Rome Alexander I frames one side of the fresco of the *Battle of the Milvian Bridge*. A relatively youthful pontiff, he raises his eyes to heaven and with a reverent left hand holds a richly bound book against his golden cope. His face is pale and passionate, his lips full and slightly open. Quednau thinks the face may be that of some young member of the Medici family, since the pope also wears a Medici ring. Two solemnly beautiful angels accompany him. To the left, a much-repainted *Fides*, in white, humbles herself and offers the communion chalice. According to legend, Alexander particularly honored this cup. To the right *Religio* holds two wooden tablets, one inscribed with the first words of the Old Testament in Hebrew, the other with the beginning of the New Testament in Latin. She does not wear the timeless draperies of the other allegories but a sixteenth-century skirt and bodice with puffed sleeves. Does this indicate that these ancient texts are always modern? The caryatids, female on the left and male on the right, bear banderoles again inscribed *suave* as, with raised arms, they support their entablature.

The Battle of the Milvian Bridge (fig. 133). This event, legends aside, was crucial to early Christianity. Constantine and Maxentius, we saw, were rivals for the *imperium*. The decisive engagement occurred when Constantine sought to cross the Tiber at the Milvian Bridge, now known as the Ponte Molle (via Flaminia near the Palazzetto dello Sport). Maxentius marched out from Rome with an army considerably larger than Constantine's. To assist his men in crossing the river quickly, so as to cut off Constantine's army, he built a supplementary bridge of

boats. The crucial moment came when Constantine's cavalry (ironically made up of Gauls) drove the left flank of Maxentius's forces into the river. The pontoon bridge collapsed and Maxentius himself perished in the water. This site near the Milvian Bridge is also one of the places where it was thought St. Peter was crucified.

The scene is a vast battle in full career with swordsmen and other warriors, nude or nearly so, wildly thrusting in the midst of plunging horses. The palette is close to that of the Sistine ceiling, though here there is also the constant flash of gold. Note that now most of the military standards are topped with crosses. Those with the old pagan images have been dashed to earth (lower left center). We can also discern the gilded members of the emperor's train of trumpeters, arms-bearers, and the like. In the center, leading them, and giving a fulcrum to the whole action, Constantine is about to spear a foe cowering beneath his plunging horse. Ultimately drawn from Roman battle sarcophagi, the scene owes a good deal also to Leonardo's pioneering *Battle of Anghiari*, now lost but sketched by Rubens (fig. 134), and which once decorated the walls of a council room in the Palazzo Vecchio, Florence. The equestrian emperor derives equally from another Leonardo scheme for colossal bronze equestrian tomb sculptures in Milan (fig. 118). We saw an earlier spinoff from his conception in the *Heliodorus*.

A vast hilly landscape, the Tiber Valley, stretches beyond the battle. In the sky angelic messengers soar above the emperor. They are angels but also victory goddesses, and at the same time reflect the two flying saints, Peter and Paul, in the *Attila*. They surround the miraculous sign showing Constantine that his victory will occur under Christianity's aegis. On

133. Sala di Costantino. Giulio Romano and assistants, *The Battle of the Milvian Bridge.*
Alinari/Art Resource, N.Y.

the left, meanwhile, we see Maxentius's
drowning cavalry swimming away from
the wreckage of the bridge and Maxentius
himself grasping his horse as he goes
down no doubt for the third time. Euse-
bius, commenting, evokes the drowning of
Pharaoh's army as it pursued Moses and
the Israelites through the Red Sea. The
Egyptians, he says, "sink to the bottom
like stones." But if the fresco contains al-
lusions to the remoter past it also invokes
the future. In the background on the right-
hand hill is the Villa Madama, (fig. 61),
begun by Raphael for the future Clement

VII when he was still Giulio de' Medici.

Urban I, who reigned from 222 to 330,
frames the scene on the right. His very
name (from *urbs*, city) expresses his Ro-
manness. He is supposed to have con-
verted St. Cecilia's fiancé, St. Valerian, to
the faith. After several miracles in which
he humiliated paganism Urban was de-
capitated. A long-bearded, deep-eyed,
venerable pontiff (whose face has been re-
painted) he has some of Michelangelo's
angry force, though he spreads his hands
in what is probably a peaceful gesture, his
left finger pointing to the figure of Charity

168 *The Stanze*

on his left as his right hand indicates his other attribute, Justice. The two diminutive female angels with him in the niche draw back his cope to reveal the white cascading filaments of his stola. On the left, Justice's hand gracefully rises as it holds the balance symbolizing evenhandedness. In her right hand she grasps the neck of an ostrich—a traditional symbol of justice because, it was said, all its feathers are the same length. Painted in oil rather than in the fresco used elsewhere, the Justice is one of the most beautiful figures in the room. Meanwhile three infants cling to

Charity; they seek her breast as she turns her tender Leonardesque head to them.

West Wall

At this point in the series, Quednau thinks, the direct influence of Raphael and Leo X leaves off and that of Giulio Romano and Clement VII comes into play.

Damasus I, who reigned from 366 to 384, is seated on the left of the next scene in Constantine's career, the Baptism. He is an old man with a rich moustache and beard, his legs crossed beneath his stola

and his cope folded back from his clasped hands. Of the two angels behind his throne, one, on the left, holds the triple crown and gazes up to the female caryatid on the right while the pope's angel-companion points in the same direction. Both caryatids sport banderoles with the Medici motto *candor illesus*, "unsoiled purity." On Damasus's left sits the armed figure of Prudence, gowned in violet and gold, accompanied by her usual serpent (of legendary wisdom). She looks into her mirror (to see what lies behind as well as before her; that idea is reflected also in her helmet with its two faces looking in two directions). On the other side is Peace, dressed in white, cross-legged, eyes demurely cast down, holding a palm frond. Her hair is intricately braided and enriched with olive leaves. Meanwhile in a departure

from the previous papal portraits two putti kneel and arrange the pontiff's garments.

Damasus was indeed a man of peace and prudence. But he was also a fighter. He withstood attempts to impose the rule of two antipopes, Felix II and Ursinus. He purged the church of the Arian heresy, which held that Christ was subordinate to the Father rather than being one with him. (The heresy first arose in Constantine's reign.) In addition Damasus was much praised for industriously refurbishing the tombs of the Roman martyrs with marble decoration.

The Baptism of Constantine (fig. 135). According to Michelangelo's friend Sebastiano del Piombo the original scheme for this wall, in 1520, was to have shown prisoners being brought before Constantine— a sign that the theme of imprisonment/

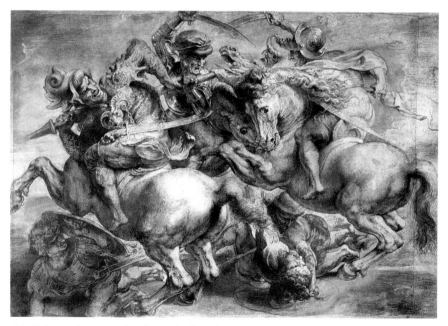

134. Rubens, after Leonardo, *The Battle of Anghiari*. Paris, Louvre, c1606 [?]. Alinari/Art Resource, N.Y.

liberation was still alive. This is especially so, as Quednau notes, in that there is no mention of such an incident in the Constantinian legends. Presumably the prisoners would be those taken after Maxentius's defeat. (There is a scene of prisoners before an emperor painted in one of the dado panels on the south wall.) In the end, however, the present more germane incident was chosen. Yet Constantine's baptism is not totally wrapped in innocence. In his later career he fell prey to the habit, common among Roman emperors, of murdering relatives he suspected of treachery. Because he murdered Crispus and Fausta, respectively his son and wife, God afflicted him with leprosy. When Constantine acknowledged his sins the pope, Sylvester I, absolved him; it was only then—long after the Battle of the Milvian Bridge—that he was baptized.

The scene is enacted in the octagonal baptistry of the Lateran (newly restored in the early sixteenth century). The space is dominated by four great Ionic columns forming a hemicycle. Behind them is a niche flanked by tall doors. In the foreground a half-ring of steps leads down to a center half-circle forming part of the baptismal piscina or pool. The architecture is thoroughly integrated into that of the enthroned popes on either side. In the very center is the kneeling emperor, arms crossed in humility over his chest, wearing only a loincloth. Sylvester (played by Clement VII, who now appears for the first time in the series) is in full pontifical vestments. From a dish he pours the water of baptism on the emperor while a deacon, subdeacons, and acolytes hold a larger bowl, a water jug, other vessels used in the service, and the written liturgy. The book is inscribed: "Today the salvation of the city and of the empire is accomplished." A

long-haired youth, on the left, holds the emperor's armor. Those in the respective trains of pope and emperor, right and left—clergy, acolytes bearing candles and a cross, and another candidate for baptism, an older man—stand among the columns. To the left and right are two of those handsome, self-confident ancillary figures one sees so often in High Renaissance painting. One, on the left, in contemporary dress and wearing a dark gray cloak, is said to be the banker Anton Fugger. He imperiously points out the scene to us. A beardless youthful man on the right, dressed all'antica and wearing arms and a crown, is probably Constantine's son (one that he didn't murder), who became Constantine II.

Leo I (reigned 440–61) flanks the baptism on the right. He is enthroned between Innocence and Truth as he looks downward and to the right toward the adjacent baptism. Leo, who like Sylvester has the features of Clement VII, puts his arm around an angel as he points to a scroll. On his other side are two other angels, one in a heavy robe and the other kneeling to kiss the pope's feet. The caryatids above flourish banderoles with the motto *candor illesus*. The white-clad figure of Innocence, on the left, is based on one of Michelangelo's Sistine ignudi. She wears an intricate and revealing webbed bodice and carries a dove. Truth, as is traditional, is a nude unveiling herself. She too recalls the ignudi. Above, instead of the more anonymous male and female caryatids of the other papal scenes, are Apollo and Diana (the latter with her crescent moon in her hair while the head of Apollo, the sun-god, is surrounded by a blaze of light). These gods were favorites of Clement's. Note that Apollo takes the pose of the Apollo Belvedere (fig. 82).

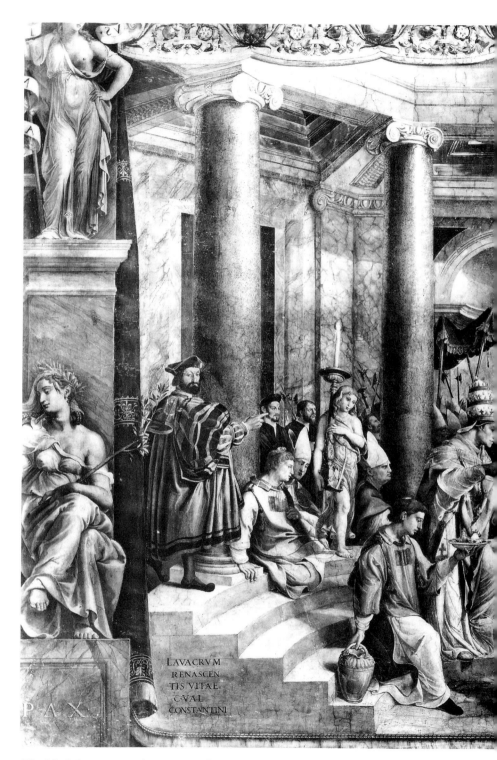

Text within the image: LAVACRVM RENASCEN TIS VITAE. C.VAL CONSTANTINI

PAX

135. Sala di Costantino. Giulio Romano and assistants, after Raphael, *The Baptism of Constantine*. Alinari/Art Resource, N.Y.

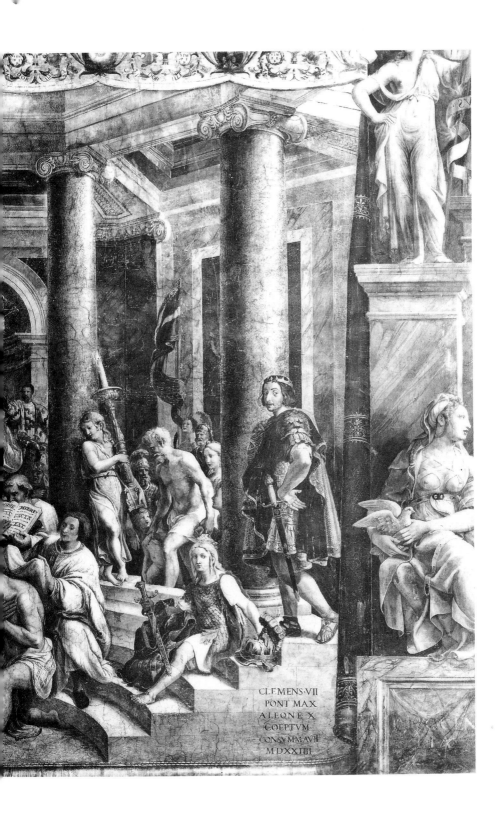

CLEMENS·VII
PONT MAX
A LEONE X
COEPTVM
CONSVMMAVIT
MDXXIIII

North Wall

Sylvester I, the pope who received Constantine's Donation, is enthroned on the left-hand side of the scene. There is no painted architectural niche. The venerable bearded figure is simply set against the wall, his attitude more vigorous and asymmetrical than those of the other popes. Sylvester is in the process of writing in one book something he has read in another, the books each being supported on the shoulders of a putto before him, while two other putti look on, one holding a bottle of ink and the other flattening one of the book's pages. The pope's pose is similar to those of Temperance in the Stanza della Segnatura and of the Sistine ceiling's Daniel. Other putti raise the curtains of the baldacchino—one of them sporting a colossal Medici ring—while, above, the caryatids revert to the male and female types we have seen in most of the other papal portraits. For reasons of space Sylvester is accompanied by only one virtue, Fortitude, who is seated below and to the left. She sits on a lion, as is traditional, and the lion's rear leg in turn governs a globe meaning the universality of Fortitude's rule. She is armed and helmeted and gazes fiercely but protectively at the pope. (Above the group is a terracotta relief of Sylvester and Constantine meeting at the Tiber. A drawing now at Windsor Castle shows a different relief, displaying Bramante's facade for St. Peter's. The subject was changed in the final version of the fresco, no doubt because the exact nature of that facade was still in doubt. But the intention, clearly, was to show Sylvester as pope when old St. Peter's was erected.)

Sylvester I was not only Constantine's converter but the author of several miracles. For one thing he rid Rome of a dragon that had been slaughtering the citizens with its poison breath (depicted in a dado scene). Sylvester writes in one book and reads another because he confirmed some of the conclusions of the Council of Nicaea, 325 C.E., but corrected others. To later generations this proved that papal decrees outranked those of church councils. The council's condemnation of Arianism is relevant to 1520 because Luther was frequently accused of this heresy.

The Donation of Constantine (fig. 136). Sebastiano del Piombo, who speaks in a letter about an earlier plan for painting a *Reception of the Prisoners* on the west wall, also tells us that the original idea had been to paint a still different episode here on the north wall. There is a legend that when Constantine was struck with leprosy his pagan doctors said he could be cured by bathing in the blood of male babies. This third scene in the series would consequently have shown the emperor confronted with the chosen babies and their mothers gathered before the Capitol. On seeing this piteous sight the emperor, it is said, repented of the advice he was about to take and punished the pagan doctors.

The Donation of Constantine is the work of Gianfrancesco Penni. As in the Baptism we are in a solemn ecclesiastical interior dominated by soaring columns. The scene is old St. Peter's. We see the nave and crossing, and the apse fronted by the four twisted columns said to have stood in the temple of Jerusalem. An animated foreground is filled with spectators, some praying, others pointing out details of the scene to their companions. Several figures are lifted from frescoes in the other Stanze. An elderly pilgrim, on the left, looks yearningly toward the tableau of pope and emperor. In the center a putto plays with a dog. Other spectators stand

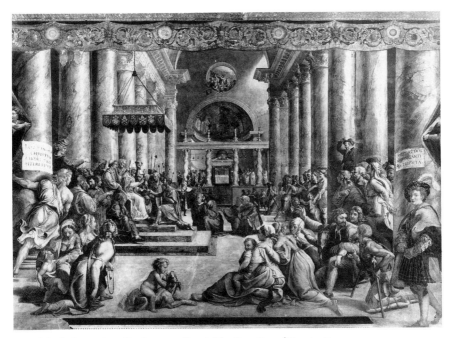

136. Sala di Costantino. Gianfrancesco Penni, *The Donation of Constantine*.
Alinari/Art Resource, N.Y.

between the retreating columns on the right. The actual event, then, is upstage, to the left, and seen in profile. In an almost direct repetition from the *Baptism*, the emperor kneels before the pope. Once again Sylvester has Clement VII's features. He receives not a document but a statuette of the goddess Roma (or she could be the goddess Ops [dominion, resources], since the inscription on the *Battle of the Milvian Bridge* specifies that Ops was transferred from pagans to Christians in that battle).

Anyway, it is this pagan divinity, believe it or not, that symbolizes the actual transfer of powers. This is the place to note that, among these powers, was the popes' spiritual supremacy in matters of faith and worship over the whole of the Church, east and west, and, as well, tem-

poral rule over Rome, all of Italy, and "the provinces, places and *civitates* of the western regions." In other words the text of Constantine's Donation endowed the popes with temporal rule over nothing less than the western Roman empire. No wonder the Holy See was loath to see the document as a fake.

Gregory I, also known as Gregory the Great, is seated to the right of this key event. He is in many respects Sylvester's twin and, once more, an author. Four putti, some with additional writing materials, assist him. Other books are seen. Beside him the figure of Fulmination (much repainted), right arm raised, grasps an arrow that bursts with lightning. She is preparing to strike down heretics and sinners. So the Constantinian sequence begins and ends with celestial flashes (if we

may so describe the blazing cross in Constantine's vision). On Fulmination's lap is the open book of papal bulls that constitute the pope's thunderbolts. Here again we recognize that the doctrine that papal power outranks the conclusions of the councils. As the last in the series of popes, as the greatest of them after Peter, and as the final image in the room as a whole, Gregory owes much to Michelangelo's angrier prophets. And he well embodies one of his own sayings: "*Quisquis ergo aliud sapit anathema sit;*" "whoever thinks otherwise [than what is here taught], let anathema be upon him." But then, that sentiment belongs to the whole program.

In the dado all around the Sala di Costantino are smaller scenes from the careers of Constantine and the popes portrayed above. The vault is decorated with an elaborate *Triumph of Christianity* wherein a crucifix symbolically replaces a broken idol. There are also figures of the regions of Italy (another reference to Constantine's donation) by Tommaso Laureti. The pavement mosaic is antique, dating from the second century, and has human heads representing the four seasons. It comes from the Lateran.

The sites of the four major scenes in this room—the vision, the Milvian Bridge, the baptism in the newly reconstructed Lateran baptistry and, of course, the Donation in old St. Peter's itself—all refer to the original Julian artistic and architectural programs. The apparition of the cross takes place (we suppose) on the future site of St. Peter's, which is also the site of Peter's tomb and of the Donation. The battle of the Milvian Bridge takes place at one of the sites where St. Peter was thought to have been crucified. The theme of Rome as the center, Rome as the unchanged, unchanging stage for all those ritual successions of type and antitype that here pass for historic events, could not be plainer.

6 The Sistine Chapel and the *Last Judgment*

The Sistine Chapel

uilt in 1475–81, the Sistine Chapel stands over the foundations of an earlier papal chapel. The architect of the new structure (figs. 137, 138) was probably Baccio Pontelli, who later designed the castle Julius II built at Ostia before his election as pope (fig. 4)—though some scholars give both buildings to Michelangelo's friend Giuliano da Sangallo. It is worth noting that the exterior of the Sistine is fortified, and that thick-walled rooms over the vaults were designed for military purposes. As to the chapel itself guidebooks call it "the most beautiful hall in the world." Not only does it contain Michelangelo's epic ceiling depiction of creation, fall, and redemption (1508–12); there is a brilliant series of earlier Renaissance frescoes by Botticelli, Ghirlandaio, and others (1481–83; figs. 140, 141), and of course Michelangelo's later masterpiece, *The Last Judgment* (1535–41; fig. 181).

These formed the backdrop for the chapel's ceremonial events. During the rebuilding of St. Peter's papal ceremonies normally conducted in the basilica were transferred next door to the Sistine. Still today the Chapel houses the conclaves of cardinals that elect the pontiff. It was here that Julius II, Leo X, and Clement VII were voted into office.

The chapel itself, as an architectural container, is plain in form. Instead of having the volumetrically distinct elements of nave, choir, and apse which one might expect, and, especially, rather than having the upper west gallery that was almost de rigueur in palace chapels, the Sistine is a single rectangular volume. A row of six great win-

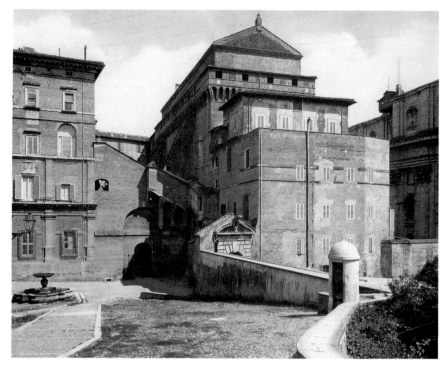

137. Baccio Pontelli, the Sistine Chapel, 1475–81, exterior. Alinari/Art Resource, N.Y.

138. (*facing page*) The Sistine Chapel, interior looking west. Alinari/Art Resource, N.Y.

dows is set along the summit of each side wall. On the east is the chapel's central entrance, and on the west its altar on a set of broad steps within a screened choir area.

Here we might note that the finest and most memorable of the great halls in the New Palace of the Popes at Avignon is the Great Chapel of Clement VI (before 1354; fig. 139). Its height and width almost exactly match those of the Sistine (20.7m high and 13.2m wide) though the Avignon chapel is twelve meters longer. Because of these similarities it is worth noting that Giuliano della Rovere was archbishop of Avignon from 1474 to 1503 and papal legate there in 1476. He in fact built the bishop's palace in that city. It may be no

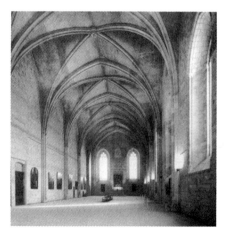

139. Avignon. Chapel in the New Palace of the Popes, before 1354, interior. Courtesy Silvain Gagnìere.

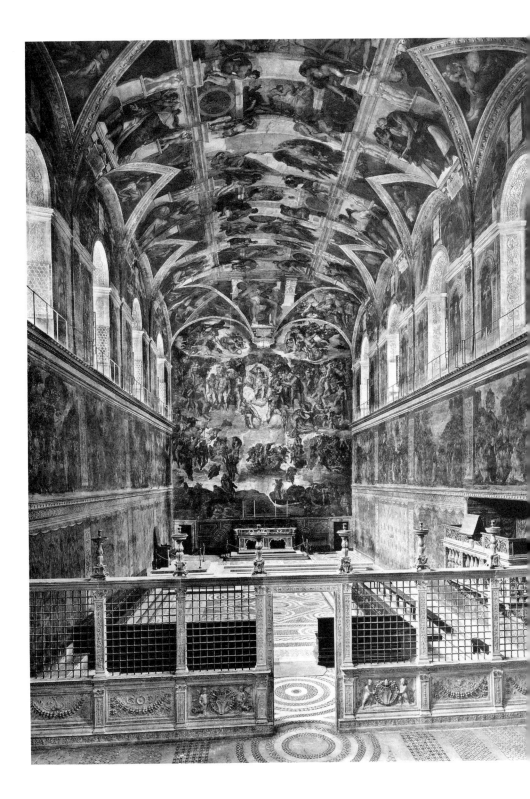

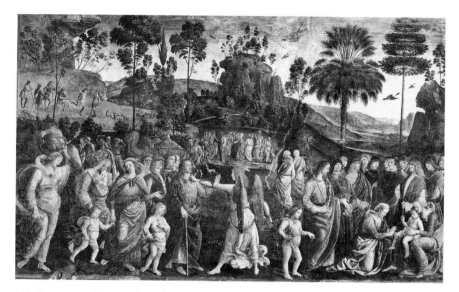

140. Perugino and Pinturicchio, *The Circumcision of Moses' Sons*, 1481–83. Sistine Chapel. Alinari/Art Resource, N.Y.

coincidence that Sixtus began the Sistine Chapel in the very years when his nephew was active at Avignon.

We return for the moment to the world of biblical typology. It has been pointed out that the proportions of the Sistine Chapel (like those of the chapel at Avignon for that matter), are roughly those dictated by Jehovah for Solomon's Temple, as described in 3 Kings 6: 60 cubits long, 20 wide, 30 high. In other words the approximate ratio of length to height is 2:1, length to width is 3:1, and width to height is 3:2 in both buildings. Though these similarities have been contested as being too approximate, Julius II might well have been thinking of them when he declared his intention to complete the chapel's decoration with Michelangelo's ceiling fresco, for he himself compared the Sistine Chapel decorations with Solomon's sacrifices (of energy, money, and precious materials) for the temple at Jerusalem.

Nonetheless it has to be said that similar proportions were normal in Renaissance buildings.

The floor dates from the fifteenth century and is mosaic of a type known as *opus alexandrinum*, imitating the mosaics of early Christian times. The elegant marble transenna dividing the choir from the rest of the chapel was carved by Mino da Fiesole, Andrea Bregno, and Giovanni Dalmata. Its pilasters and candelabra are decorated with putti, festoons, and the arms of Sixtus IV. The same artists did the marble cantoria or choir loft above, in which the celebrated Sistine choir sang. All this forms part of Sixtus's original commission.

After the structure was completed, a team of artists, as noted, came to Rome to fresco the side walls with two series of scenes. Looking towards the altar, on the left, are events in the life of Moses. On the right are corresponding events in the

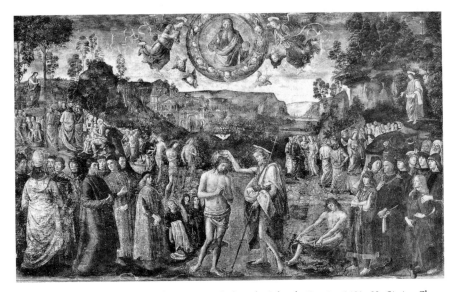

141. Perugino and Pinturicchio, *The Baptism of Christ by John the Baptist*, 1481–83. Sistine Chapel. Alinari/Art Resource, N.Y.

life of Christ. The two series illustrate a mode of thought that will reappear in Michelangelo's ceiling. As the recently uncovered *titoli* or Latin inscriptions for the scenes—though they may not be contemporary with the paintings themselves—make clear, each event from the Old Testament is the type of a New Testament antitype. Where Perugino and Pinturicchio paint *The Circumcision of Moses' Sons*, the same artists paint, opposite it, *The Baptism of Christ by John the Baptist* (figs. 140, 141). Circumcision and baptism are both key childhood purification rites. Indeed baptism was at first conceived as a replacement for circumcision. Similar typologies will appear in Michelangelo's ceiling. But here let us note that typology is not just a question of making one event predict or repeat another. It is a way of seeing a vast pattern slowly revealing itself over the centuries, knitting biblical events, and ancient and modern history, into an overwhelming meaning.

Above these scenes, between the windows, are paired portraits of papal saints, twenty-four in all. They were probably executed by some of the artists of the lower frescoes, including Ghirlandaio, Botticelli, and Rosselli. The popes are mostly very early, so like the pavement designs they emphasize the Church's life in Rome during its first centuries.

The play of typologies may explain why, though the Sistine Chapel is dedicated to the Assumption of the Virgin, and while it was begun in the year that Sixtus wrote his treatise on the Immaculate Conception (the belief did not become dogma until the 1850s), there is now no major reference to these things in the chapel's artistic program (though it is true that there was an *Assumption* by Perugino over the altar, replaced by Michelangelo's *Last Judgment*). Instead, the chapel's program now emphasizes the founder of the He-

Michelangelo

In 1506, then, as a pendant to his great scheme for a new St. Peter's, Julius determined to add to the chapel's decoration. Michelangelo was commissioned to paint a further set of biblical scenes on the upper walls and ceiling. The artist began work on May 10, 1508, and completed it on October 31, 1512. The vault is huge. At 2,400 square feet it constitutes one of the largest frescoes ever painted. And with a sublime self-assertion that looks forward to Romanticism, Michelangelo claimed to have done it without assistance.

Visually if not typologically the ceiling's basic scheme is quite different from what the quattrocento artists had painted below. Instead of a series of charming dramatic scenes set in rich landscapes, accompanied by awed spectators, and with trees, flowers, and rocky outcroppings in the middle ground, Michelangelo conceived of a single architectural frame, a kind of temple interior peopled with mostly solitary figures, some seeming to be statues or reliefs, others seeming real. Landscape is reduced almost to nothing. The recent cleaning has made the fictive stone background very white, which emphasizes the figures' isolation.

Also in distinction to the frescoes below—and indeed to almost all earlier Renaissance art—Michelangelo's personages move and struggle as with inner enemies. In place of the quattrocento Florentine decorum of, say, Signorelli's figures, with their placid stances and the decent intervals between them, Michelangelo's men and women seem filled with a menacing urgency. Some writhe in turmoil, their colossal forms crowding their thrones and niches. And where the quattrocento frescoes are self-contained, here the figures create a network of strong, ac-

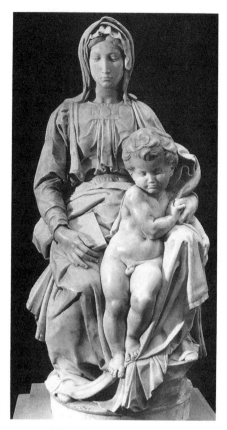

142. Michelangelo, the Bruges Madonna, c1501. Notre-Dame, Bruges. Alinari/Art Resource, N.Y.

brew oak/ark, Moses: his own life, its parallels with that of Christ, and his account, in Michelangelo's ceiling, of the creation and fall of man at the beginning of the Book of Genesis (known as the first book of Moses in the Latin Vulgate). Michelangelo's final achievement in the chapel, the *Last Judgment*, would meanwhile map the transformation of the oak/ark into a vision of Christ. It is painted on a wall that, as it happens, is itself shaped like the tablets of the Law. Christ judges the resurrected dead as his cross, the final form of the Mosaic oak, is carried upward by angels (fig. 181).

tive linking gestures and gazes that criss-cross the ceiling. Finally, instead of the stiff Renaissance clothes of the lower frescoes, rich with jewels and embroidered fabrics, Michelangelo's figures are either nude, as in the central scenes of the Creation and Fall of Man, and as in the *ignudi*—the nude balletic men who surround those central scenes—or else wear generalized, often exiguous draperies. Only exceptionally, e.g. in the Libyan sibyl (fig. 167), do we see the rich, fantastic dress beloved by earlier generations of artists.

Michelangelo's earlier works—notably his sculptures—are good introductions to the achievements of the Sistine. The Bruges Madonna (c1501, Notre-Dame, Bruges; fig. 142), contributes its gently squirming Christ child, an infant, yet solid and godlike. He becomes the prototype for the Sistine's infant caryatids, while the withdrawn yet sublime and subtly sorrowful Bruges Virgin will reappear, in more generous and powerful form, in some of the sibyls. As to Michelangelo's earlier paintings, the way in which the Madonna in the Doni Madonna (Uffizi; fig. 143) twists to reach round behind her exactly foretells the gestures of several of the sibyls, though the Doni Madonna is thinner, more sinewy, and smoother than her Roman sisters.

The Fictive Architecture (fig. 144)

The architectural framework is a departure from what one sees in earlier comparable frescoes. It is true that, in earlier art, frescoes had been painted with similar handsome moldings, niches, and frames. And there had been what is called fictive architecture—the painted imitation of columns, pilasters, vaults, and the like.

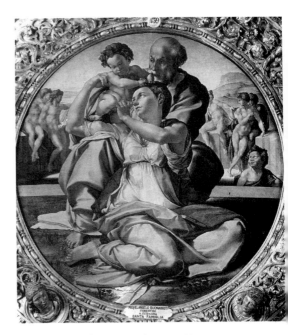

143. Michelangelo, Doni Madonna, c1504. Florence, Uffizi.

But Michelangelo has created a curious structure in the Sistine Chapel. It defies the logic of perspective. It is a ceiling that attempts to be no ceiling, but rather a towering latticed space rising to heaven. (One recalls that the very word "ceiling" is derived from the Italian word for heaven: *cielo*.) The side walls move upward through stories containing the niched thrones of the prophets and sibyls to the level of the ignudi, where the notional ceiling would normally cross the vault horizontally. But here it doesn't. Or, rather, it both crosses horizontally, allowing us to look through to the scenes from Genesis, and continues vertically. This architectural contradiction in Michelangelo's ceiling has not had much influence on later art. But the more general idea of a vault that opens fictive windows or courtyards upward into a heaven seen from down here on earth—this had

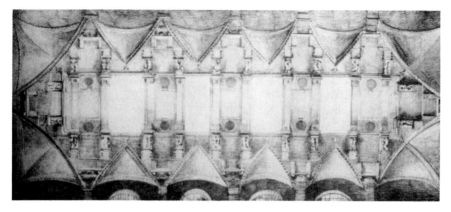

144. Sistine Chapel, scheme of the fictive architecture in Michelangelo's ceiling, 1508–12. From V. Fasolo, *Michelangelo*, Genoa, 1965, p. 111.

many later reflections (though at least two earlier artists, Masolino in the earlier fifteenth century and Mantegna in the later, had done something comparable).

The Erotes

The purely architectural parts of the framework are mostly painted to look like marble. But much of the edifice Michelangelo has imagined is an architecture of supporting or assisting human bodies (fig. 145). Infant caryatids hold aloft panels carrying the names of each prophet and sibyl. Rising from behind the triangular panels in which Christ's ancestors appear are marble pedestals supporting other infant caryatids, in pairs, and represented as being carved in marble relief. These children in fact support the whole of the heavy entablature running around the spine of central scenes. The caryatids stand, sometimes calmly, sometimes wriggling with what seems the urge to escape their task.

Architecture thus involving interwoven human bodies—a sort of permanent "human pyramid"—may seem novel. Yet of course we are all familiar with caryatids.

That tradition is the key to Michelangelo's design. According to legends preserved by Vitruvius, the original caryatids were people who had been set into stocks, or a pillory, that was also a building. The weight of the entablature they supported

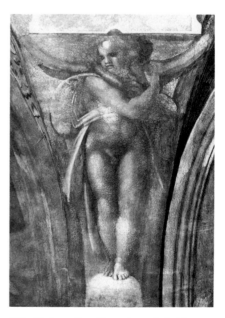

145. Sistine ceiling, Erotes beneath Isaiah. Alinari/Art Resource, N.Y.

146. Sistine ceiling, *Ancestors of Christ: David and Solomon*. Alinari/Art Resource, N.Y.

symbolized the weight of their sins. The image was taken up by Dante. Similarly the caryatids of the Sistine are doomed to spend eternity supporting the temple in which mankind's salvation is acted out. They are, quite literally, pillars of the Church.

But why are they children? And what was their sin? They are what the Italians call putti—young or infant boys, allied to the cherubs of the Bible and also identified with angels. Still another name for these young beings was *erotes* (from eros, love, personified as a young boy familiar today as Cupid). As erotes Michelangelo's infants would be embodiments of the divine love that is the most powerful of all the emotions governing men and women. In classical times and in the Renaissance the spaces of the universe were thought to be filled with invisible erotes who ruled the movements of the heavenly spheres and of earth and who also governed the "motions,"

i.e. the emotions, of people. Michelangelo's visual conceit, in which erotes are confined like prisoners and help hold up the painted temple's framework suggests, to my way of thinking, how human passions may serve God's plan for redemption. As to the erotes' sin, they had after all once been pagan divinities. Now they are entering the Christian world. Their punishment is to support a great Christian temple. The infant erotes, in short, are happily undergoing bondage to him "whose burden is easy and whose yoke is light"—to invoke the Medici motto. In them, as in the sibyls they attend, paganism becomes the pillar, the caryatid, of Christ.

The Israelites

In a mood of entirely contrasting bondage, more desolate and despairing, male nudes inhabit the triangles side by side with the caryatid putti (figs. 146, 172). Some of

these nudes are recumbent, others brace their legs against the heavily molded frames that contain them. They are sometimes identified as the Israelites languishing in Nebuchadnezzar's prisons during the Babylonian Captivity. They certainly look like prisoners. Sidney Freedberg writes that they seem "unillumined captives of ancient ignorance . . . caged beasts," which might even imply that they are souls in limbo (the Israelites of the Babylonian Captivity would be in limbo.) Or they could be in purgatory. Let us recall that purgatory was important at the time. The indulgences that helped pay for the new St. Peter's earned time off from that unhappy place.

I myself would offer, as a possible text for these benighted souls, Ezekiel's description of Jehovah's punishment of Tyre. This describes an appropriately purgatorial state: "And then all the princes of the sea shall come down from their thrones, and lay away their robes, and put off their broidered garments; they shall clothe themselves with trembling; they shall sit upon the ground, and shall tremble at every moment, and be astonished at thee [Tyre]" (Ezek. 26:16). This would explain the figures' nudity, the way most of them cling like dying men to their supports, and the bare settings in which they mourn.

Let us now look at the events along the vault crest in their textual chronology. Before doing so, however, we should note that in all probability they were executed in reverse order. One could suppose that Michelangelo laid out the work so that by the time he reached the earliest and holiest scenes, those depicting God alone, he would as much as possible have mastered his technique (he did not consider himself a professional fresco painter) and program. According to his favorite philosophy,

Neoplatonism, such an approach would make sense: the artist began by painting the most earthly and human of the events, the episodes from Noah's career, at the entrance to the chapel, and ended with God in the heavens. Through the "windows" opening upward to these heavens, then, we see nine scenes, eight of them horizontal in format, and alternating between larger and smaller. The difference in size is considerable: the small scenes are only about a quarter the size of the large. They are oriented so that one sees them by standing as the priest stands, facing the al-

147. Sketch by Michelangelo from a sonnet describing himself painting the Sistine ceiling, c1510 Florence, Casa Buonarroti.

tar and moving his head back, back, and further back until he resembles Michelangelo in his comic self-portrayal, bent like a bow as he was painting the scenes (fig. 147).

The Three Scenes of the Creation of the World

1. God Separates the Light from the Darkness (Gen. 1:5; small scene; fig. 148). Jehovah is clad in flowing purplish robes animated with powerful highlights. He is seen sharply from below, his arms raised over his head, his body straining across the space of the void, his chin and neck straining upward as, on the left, clouds of darkness are swept into being and, on the other side—towards the altar—clouds of light appear. God's posture is odd. He seems to be kneeling on the cornice. (Vasari notes that Titian adapted this pose in order to depict a general falling from his horse in battle. He may have meant the falling horseman in the Sala del Maggior Consiglio, Venice, 1537–38; but cf. also Raphael's use of the pose for *Joshua Defeating the Amorites* in the Logge; fig. 204). Note, too, how the ignudo just below, to the right, writhes in a pool of shadow, as if overwhelmed by the universe's first experience of light.

3. God Separates the Waters and Brings Forth Earth's Vegetation (Gen. 1:9–12; small scene; fig. 150). The second event in the biblical sequence comes *after* the third, so as to make the separation of light from darkness, and the creation of seas and green lands, into subsidiaries that flank this, the principal scene. (To understand, one might think of the composition of ornamental monograms. If your initials are WED a monogrammist might put the D in the center, as wDE, in order to give it the primacy of the central place.) We now see

148. Michelangelo, *God Separates the Light from the Darkness.* Alinari/Art Resource, N.Y.

another view, as it were, of God's first appearance, this time rotated toward us, and with more angels tucked behind his windblown purple robes as he floats over the seas like a great airship. In this appearance God is a solider, more weighty form than in the first scene. His purple robe is enlivened by the cool gray masses of his hair and beard. Some authorities identify this scene as God creating the creatures of land and sea.

2. God Creates the Sun, Moon, and Earth (Gen. 1:16, 17; large central scene; fig. 149). This is the first of the larger scenes. God appears twice, once on the right, looking towards us, his arms aloft and spread in wide-flung motions of command. The pose is a variant, a successive motion perhaps, to that portrayed in the flanking scene we just looked at. Behind God's flapping robe angels cluster, infants and a youth, one shielding his eyes as he gazes at the fierce-browed bearded face of Jehovah whose long beard swings in the

vehemence of his gesture. The angels are wrapped in Jehovah's abundant purplish garment. On the left God appears a second time, having swung off from his previous position. As Freedberg observes, he is like a personified rotating planet. He courses through the firmament scattering new-made heavenly bodies in his wake. In the center is the dusky golden disk of the sun, on the far right the pallid moon, and in the lower left-hand corner a few fronds of vegetation. The earth now awaits the first humans.

The Three Scenes of the Creation and Fall of Humankind

4. God Creates Adam (Gen. 1:26; large scene; fig. 151). The first three scenes formed a triad. So do the second three. In the first of these, probably the most famous of all the Sistine scenes, God reaches from an enormous cloudlike cloak that has blown out from his body and become a kind of shell for a troop of angels. One of the angels is clearly a woman—possibly the uncreated Eve looking out warily at

her future husband. Adam, meanwhile, is a magnificent classical nude reclining on the very earth from which God had made his body. Just as God's figure is filled with energy, Adam's is filled with the languor of unsouled flesh. He is just able to raise his hand to meet Jehovah's massive driving finger. Yet he gazes at the terrible face of his creator with innocent longing. Note also that the positions of the two figures are almost exact mirrorings—left leg, right leg, left arm, right arm, twist of torso, twist of neck. (Note also the influence of the Belvedere Torso, fig. 90.) The postures of the two figures form a kind of horizontal dance. It is a way of stating that God has created man in his own image, a point made twice in the passage (Gen. 1:26, 27).

5. God Creates Eve (Gen. 2:18ff.; small scene; fig. 152). Feeling that Adam must have a partner, God puts him to sleep and extracts a rib from his body. This bone he transforms into the image of the woman who becomes Eve. Michelangelo shows her issuing from Adam's sleeping form. She kneels in thanks to her maker

149. Michelangelo, *The Creation of the Sun, Moon, and Earth.* Alinari/Art Resource, N.Y.

150. Michelangelo, *The Separation of Land from Water*. Alinari/Art Resource, N.Y.

as God, a deep-bearded magus, invites her forth. She steps with awkward innocence from her husband-father's sleeping body. Eve was regarded as the type of the Church just as Christ, husband-father to the Church, was the second Adam. The desert landscape of the scene of Adam's creation has turned green and the sleeping Adam embraces the trunk of a tree whose branches have been sawn off (though there are signs in the fresco that originally Michelangelo had painted it with leafy branches).

6. *The Temptation and Expulsion from Eden* (Gen. 3:1ff.; large scene; fig. 153). Now it is Eve's turn to recline, imitating the sleeping Adam of the previous scene. She lies back on what could be the stump Adam had lain against when she was brought out of his body. Another tree, meanwhile, bushy and abundant. which produces the fruit of knowledge, serves as Adam's background. Eve intently reaches up and takes one of the fruits from the serpent who challenges her to break God's command and eat. She gets Adam to do so as well. Adam, now a towheaded peasant, rather gross, very different from the sublime if sleepy hero he was when he was created in God's image, betrays his curiosity. He reaches eagerly to grasp the fruit (in the text it is Eve who picks it and then gives it to Adam), which is nothing less than the knowledge of good and evil. Indeed his gaze moves directly on toward the serpent. That serpent, the tempter, is wound around the tree trunk, making a Faustian visual trope that equates temptation and knowledge.

When they have eaten, the woman and man lose their innocence. They are ashamed of their nakedness. And when Adam reveals to God what he has done, God will cause the couple to put on clothes, which symbolize the suffering they will henceforth endure. He then exiles the couple from Eden. On the right an angel in a gown with crimson highlights flourishes his sword and sends the fallen couple

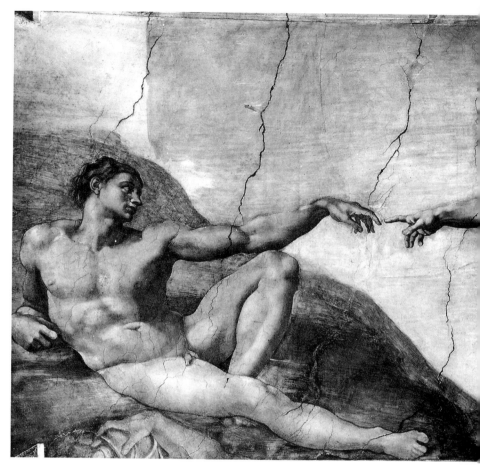

151. Michelangelo, *The Creation of Adam*. Alinari/Art Resource, N.Y.

forth. His figure provides the tree with a branchlike shape symmetrical to the serpent, pointing in the opposite direction. As a sign for the whole series of events depicted we can think of the tree with its two creaturely "branches" as the chiasmus between goodness and obedience and their opposites, evil and betrayal.

The Three Scenes of Noah's Fall

8. The Flood [Note that the final triad, like the first, is out of linear order, 8, 7, 9]

(Gen. 6:1ff.; small scene; fig. 154). According to Giles of Viterbo the career of Noah represents a crucial break in the cycles of time. Noah initiated the third of history's four golden ages. This does a lot to explain his presence in the creation cycle. Yet Noah's most famous attribute, the ark, is played down in Michelangelo's scene. In Christian preaching the ark had come to represent the Church, carrying God's congregation, at sea in a hostile world. In a break with that tradition Michelangelo here once more focuses atten-

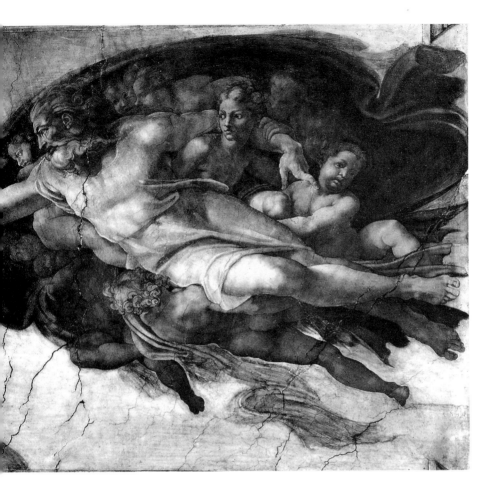

tion on the human beings involved and on their sin. He emphasizes not Noah's salvation but the loss of the remainder of humanity. The river of naked figures, young men, old men carried by their sons, a beautiful mother with her infant and young child (the Bible says the human race was fair but fallen), all doomed to drown at God's command, make their way in vain to higher ground, or shelter in a tent pitched on a rock that juts from the surrounding waters. Those in the tent reach out to a grieving old man who carries the dead body of his son. All wait for the sea that will rise to make the earth as empty as it was on the day before God separated it from the waters.

On the far left a woman, her garments whipping in the wind, clings to a blasted tree reminiscent of that against which Adam and Eve reclined. In the central part of the scene we see a small rounded skiff making for the ark floating in the background. A white dove is visible against the upper roof—the dove, perhaps, that will return to the ark with a branch in its beak

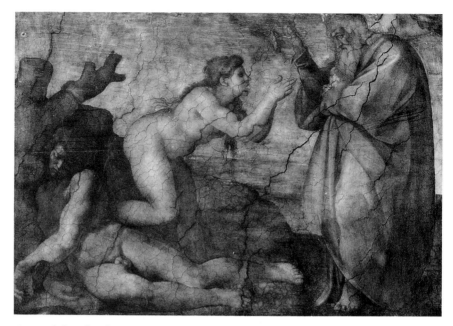

152. Michelangelo, *The Creation of Eve*. Alinari/Art Resource, N.Y.

showing that the waters have begun to recede.

This scene, we noted earlier, with its relatively small figures, sharply outlined and round-featured, is probably the first that Michelangelo executed. Its stylistic parallels with his earlier paintings—the Doni Madonna (fig. 143) and his *Battle of Cascina*, a huge fresco cartoon (preliminary full-scale drawing) that also depicts

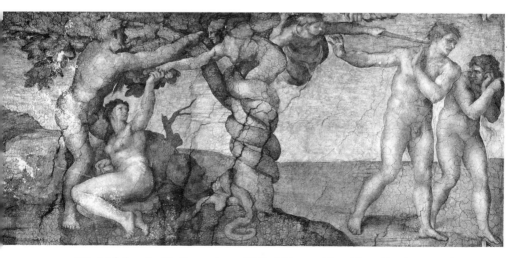

153. Michelangelo, *The Temptation and Fall of Adam and Eve*. Alinari/Art Resource, N.Y.

192 *The Sistine Chapel*

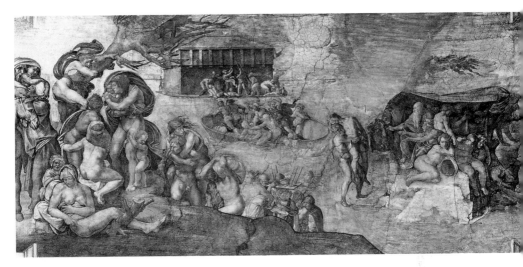

154. Michelangelo, *The Flood*. Alinari/Art Resource, N.Y.

people escaping from the water—are clear. The scene also owes something to the close-packed reliefs filled with sinuous figures of the late medieval sculptor Jacopo della Quercia (fig. 155). Heinrich Wölfflin has surmised that the figures in this scene, when Michelangelo inspected them from floor level, proved too small. The artist therefore had to abandon his original idea, which was to make the figures progressively smaller as they were supposedly further from the observer's eye. Instead, he transformed the other central scenes into a world of giants.

7. *The Sacrifice of Noah* (Gen. 8:20ff.; large scene; fig. 156). After the flood has subsided, Noah, as the leader of humanity's saved remnant, gives thanks to God. In a tightly composed scene the patriarch in a red gown stands behind the altar whose fires already crackle in readiness for the sacrifice. He is accompanied on the right by his wife, Zipporah, dressed in a saffron gown and white veil, and by a more youthful figure in lime green, whom I take to be

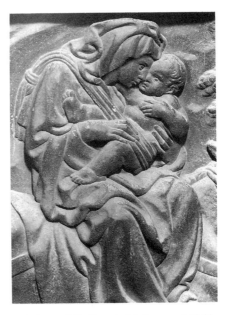

155. Jacopo della Quercia, Madonna and Child. Detail from relief of the *Flight Into Egypt*. Main Portal, San Petronio, Bologna. Alinari/ Art Resource, N.Y.

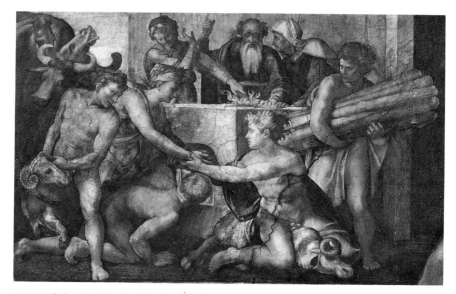

156. Michelangelo, *The Sacrifice of Noah*. Alinari/Art Resource, N.Y.

the Erythraean Sibyl (see below, s.v.). In the foreground the sons of Noah, among them Ham, Shem, and Japheth along with two of their wives, deal with the sacrifice. One son kneels and blows on the fire in the altar. Another brings an armload of wood. Another deals with the sacrificial rams. The animal on the right, indeed, has already had its throat slit, and its slaughterer hands one of its organs to another son dressed in white robes. This sacrifice is to be a veritable hecatomb: on the far left we glimpse the heads of a horse, an ox, and a donkey awaiting their destiny.

9. The Drunkenness of Noah (Gen. 9:18ff.; small scene; fig. 157). In the last of the series the red-garbed Noah digs his land, much as God had condemned Adam to do generations before. Noah has made the wine that fills the vat in the center, has gotten drunk, and now lies naked in his tent. Given the emphasis, in these scenes, on the Incarnation—the doctrine that says God assumed human flesh as Christ—the

wine can be taken for that of the eucharist.

But for the moment Noah's involvement with wine is humiliating. One son, Ham, derisively points out the naked old man to his brothers. They, mindful of the taboo that children may not look upon their fathers' virilia (Gen. 9:23; Lev. 18:7), cover Noah's nudity. Ham is thereafter condemned to father a race of servants. On this note, a second Fall, the final triad, and the Genesis sequence, end. According to the theological writer Lactantius, Noah's drunkenness and Ham's disgrace marked the first separation of humanity into different races, the Jews being descended from Shem (whence the word semite) and Japheth, and the Gentiles from Ham.

Why end with the Noah series? Why skip over the stories of Cain and Abel, Enoch, Seth, Methusaleh, etc.—i.e., from the end of Genesis 3 to Genesis 6.1? Our cicerone, Giles of Viterbo, can explain: Noah is the founder of the second golden

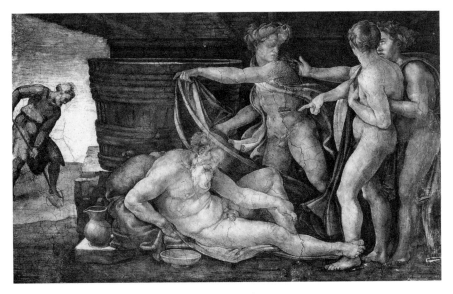

157. Michelangelo, *The Drunkenness of Noah*. Alinari/Art Resource, N.Y.

age, and hence a direct prototype of Julius II, who in turn founds the fourth golden age. Noah is also Adam's direct continuator. He is the one just man remaining after Adam's other issue had brought moral ruin to the world. As Giles puts it, God therefore called on Noah "to make the ark, he submerged all things in the flood, rendered desolate the earth, and killed off the human race. After the flood, Noah, despite his fall from grace, served as the guide to reinstruct humanity in rectitude, modesty, and the proper worship of God." Thus Noah, unlike Cain, Abel, Seth, etc., predicts the continual cyclical falls, followed by God's continual offers of salvation, that have marked subsequent human history.

There remains one further and more far-reaching puzzle, and for this Giles is no help. Michelangelo, quite against the text, has Adam and Eve go forth into the world as nudes. Why are they expelled in the nude when, as the King James version puts it, God himself made them wear "coats of skins"? One can answer that there was an established artistic tradition showing them so; but then it simply becomes the tradition that needs explanation. Also, why should Ham, Shem, and Japheth react so strongly to their father's nudity when, in Michelangelo (fig. 157), they themselves are wearing the ultimate in see-through garments? It is true that the Bible only says it was taboo for a child to look on its father's virilia, and not vice versa. But surely it is a little perverse to paint the three sons thus.

In partial answer, one can point out that there is a tradition in ancient art that scenes of sacrifice such as battles, funerals, sports, and certain kinds of dance take place in the nude or near-nude. In a similar spirit the ancients often depicted gods and goddesses, and lesser divinities, without clothes. The early twentieth-century art historian Bernard Berenson, echoing Vasari, adds that nudity is also the most

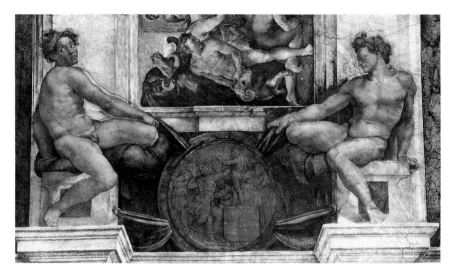

158. Michelangelo, Ignudi around *The Sacrifice of Noah*. Alinari/Art Resource, N.Y.

expressive way in which to present the human body: "[Michelangelo] saw clearly what before him had been felt only dimly, that there was no other such instrument for conveying material significance as the human nude." And he adds later: "there is no visible object of such artistic possibilities as the human body; nothing, therefore, in which we can so rapidly perceive changes; nothing, then, which if represented so as to be realized more quickly and vividly than in life, will produce its effect with such velocity and power, and so strongly confirm our sense of capacity for living."

To this day people wear clothes not merely for warmth and decency but (to state Berenson's proposition in reverse) because their naked bodies would reveal too much about themselves. Or let us say that decency is a another word for secrecy, for the suppression of truths we wish to remain unknown. Berenson also believed that when we look at great figure art we instinctively feel, in our own bodies, the

stresses, positionings, tensions and therefore moods and even thoughts of the figure represented. If Michelangelo believed something like this, and I think he did, then Adam and Eve and Noah and his sons, nude rather than clothed, would express their fates incomparably more fully.

But there is another, supplementary, answer to these questions, a theological one. For Michelangelo's age the good people of the Bible all still existed, in heaven, in a state of grace. Though, like Adam, Eve, and Noah, they may have lived fallen earthly lives (and worn clothes to prove it), they were afterward redeemed by Christ's sacrifice. They have achieved, or re-achieved, the primal innocence of paradise. And, as the Counter-Reformation theologian (and cardinal and saint) Roberto Bellarmino was to put it, for such people nudity was the ideal and only possible state. He explains that the sight of beautiful forms is the greatest joy of the senses. And the most beautiful of all forms is the human body as created of virginal flesh by

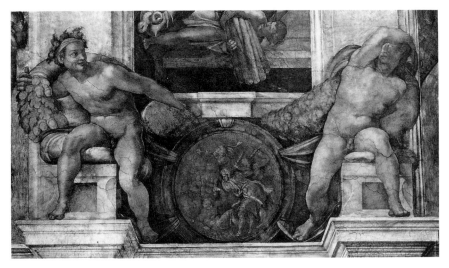

159. Michelangelo, Ignudi around *The Sacrifice of Noah*. Alinari/Art Resource, N.Y.

the Holy Spirit. When the saved soul gains the kingdoms of the blessed, says Bellarmino, "it will rejoice first in the splendor and pulchritude of its own body," and later in the sight of the bodies of the martyrs. Their very wounds, he says, will become as jewels. The supreme joy of the newly arrived soul will be the beauty of the body of Christ, unclothed on the cross. The nudity of primal innocence is in fact an imitation of Christ. That, I believe, is Michelangelo's point when he shows us Adam and Eve, and Noah and his sons, re-enacting the events of their earthly lives. They reenact them, but do so in heaven, in a painted *cielo*, and hence in a state of innocence.

The Ignudi

And that brings us neatly to the ignudi who support the huge medallions in the smaller vault scenes (figs. 158, 159). Like the caryatids, and like most of the figures throughout the central scenes, these young men are without clothes. But their nudity, in contrast to that of the caryatids and "Babylonian prisoners," is unquestionably sensual. Some of them also seem strangely turbulent: impatient, moody, sometimes convulsed, full of sulky longing. Their eyes flash as they engage the eyes of the prophets and sibyls, or even those of some of the actors from Genesis. Could they, too, exemplify contemporary views about innocent nudity? At any rate they show off their handsome bronze limbs like acrobats or dancers. We may liken their mutinous magnetism to that of the caryatids. In fact, both sets of creatures serve, willingly or not, to keep God's temple erect and beautiful. This conjecture is strengthened when we note that Michelangelo specifically stated (through his self-appointed mouthpiece Ascanio Condivi) that the ignudi are in the act of decorating the seers' thrones with Della Rovere oak-leaf festoons.

Despite their male sex organs and lack of wings the ignudi may be angels.

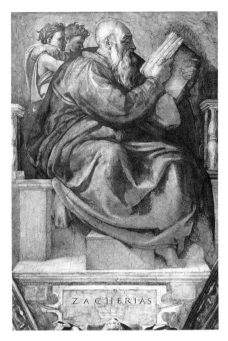

160. Michelangelo, *The Prophet Zechariah*.
Alinari/Art Resource, N.Y.

Michelangelo almost always portrayed angels in this wingless state. We have also noted that cherubs, erotes, and putti are subclasses of angels. According to some extra-scriptural Jewish traditions, furthermore, angels are young men with powerful physiques who may indeed be sexy. Even in the Bible itself the men of Sodom, who gave their name to sodomy, were aroused by the sight of angels (Gen. 19:5ff.). And if adult angels are not normally nude in art there is one type, the cherub, who is. And note too that despite their similarity to putti cherubs are not necessarily children. The most famous of all Hebrew cherubs were those "graved on the walls" of the temple of Solomon, and the text makes it clear that they were full-grown males (Ezek. 40:15). My conclusion is that Michelangelo's ignudi may represent

edited versions of these ornaments from Solomon's temple, the building itself being a possible type for the Sistine.

In yet another conceit the artist shows the cherubs not only as ornaments but in acts of ornamenting, lifting into place the giant medallions that depict the heroes of Solomon's succession (1 Kings 6ff., 2 Sam.).* Perhaps the weight of all this royal greatness wearies them; in any event they are among the most memorable and personal of Michelangelo's ceiling figures. Let us recall that the artist himself was named after an archangel. Each pair of ignudi, finally, is separated by a ram's skull with sharply twisted horns. These are probably the remains of Jewish sacrifices and precursors to Christ's sacrifice on the cross.

The Prophets and Sibyls

Among the most famous figures ever painted are the immense, vigorous Hebrew prophets and pagan sibyls enthroned just below the level of the ignudi. This mingling of pagan and Jew emphasizes that the two sorts of seers performed overlap-

*Beginning with the ignudi nearest the *Last Judgment* over the prophet Joel, we have:
1. King Joram, son of Ahab, who is thrown from his chariot by a rival for kingship, Jehu;
2. King Jehu has an idol of the false god Baal destroyed (over the Erythraean sibyl); 3. the slaying of Nikanor, general of Antiochus IV, in a battle against Judas Macchabaeus (over Ezekiel); 4. a ruined tondo (over the Persian Sibyl); 5. the ascension of Elijah (over Jeremiah). Then, beginning again near the *Last Judgment* but on the other side of the chapel we have: 6. Abraham about to sacrifice Isaac (over the Libyan Sibyl); 7. the death of Absalom, son of King David (over Daniel); 8. David and Nathan (over the Cumaean Sibyl); 9. the slaying of Heliodorus (Isaiah); 10. the slaying of Abner (over the Delphic Sibyl).

ping and symmetrical functions. In the Church's view they prophesied to their respective audiences the coming of Christ, salvation in the Roman Church, and the ultimate conversion of the world.

In antiquity, sibyls were priestesses who sat in shrines or temples inhaling fumes that filled them with the presence of the god. They then uttered prophecies, often in the form of riddles (hence the word "sibylline"). There are traditions to the effect that the sibyls traveled to Rome where their writings were preserved in the Capitol as prophecies about the city's future. It is as the authors of these books, clearly, that Michelangelo shows them, since all are engaged in writing or reading. The particular works they consult are probably the writings gathered under the title *Oracula Sibyllina*. These claimed that the sibyls, though priestesses of Apollo, preached that the Hebrew Messiah would come in the form of Jesus Christ. The experts who interpreted these utterances also discerned in them predictions of Armageddon, the Millennium, and the Last Judgment.

Zechariah (fig. 160) sits over the chapel's entrance in majestic profile, an old, angular bearded man in a skullcap leafing through the pages of a thick book as two cherubs watch from behind. His lower mantle is lime green, his upper one saffron. Zechariah is traditionally known as the prophet of the branch ("In that day [of Christ's coming] shall ye call every man his neighbour under the vine" [Zech. 3:10]). But in the Sistine Chapel all the prophets and sibyls are in fact summoned under the vine, or at least branch—the Della Rovere oak-leaf garlands being hung in place, by the ignudi, over each prophetic throne. Biblical interpreters have added that Zechariah's

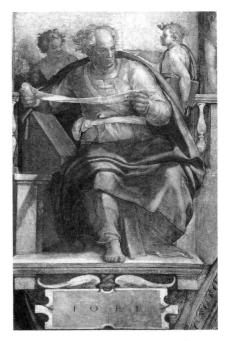

161. Michelangelo, *The Prophet Joel*. Alinari/ Art Resource, N.Y.

vine is also the constantly reappearing tree, or wood, of Adam, Noah, Solomon, and Christ.

Like some of the other prophets, Zechariah is also a type of Christ. In 8.4, 5, the prophet describes the happiness of a Jerusalem restored to the Jews. Christians interpreted this as one more prediction of Christ's return to rule mankind after Armageddon. Like many of the other Sistine prophets, Zechariah also spoke of the c520 B.C.E.. rebuilding of the temple (and cf. Ezra 4:24, 6:15). This theme, the rebuilt temple as preparation for the Messiah, is one of the main messages delivered by the sibyls and prophets.

Joel (fig. 161), a white-haired balding man with a deep-lined, serious, handsome face, wears a light lavender Oriental tunic with green-banded collar and a narrow

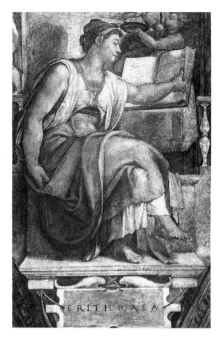

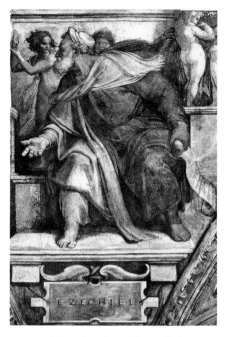

162. Michelangelo, *The Erythraean Sibyl.*
Alinari/Art Resource, N.Y.

163. Michelangelo, *The Prophet Ezekiel.*
Alinari/Art Resource, N.Y.

blue sash over one shoulder. He is enveloped in a copious wine-colored cape as he reads from a scroll. Behind his left shoulder a putto with a book at his side gives a command to a companion. Joel was interpreted by the Church as another herald of Armageddon. His scroll may thus portray the "valley of decision" when the sun and moon shall darken and the "Lord shall also roar out of Sion and utter his voice from Jerusalem; and the heavens and the earth shall shake" (Joel 3.14ff.).

The Erythraean Sibyl (fig. 162), in yellow and lime green, takes a pose Michelangelo probably adopted from a Greek coin. A young woman, she sits sidewise, legs tightly crossed, and studies a tome. Behind her is a putto with a lighted torch and scales: the light to lighten the Gentiles, perhaps, and the justice of the com-

ing day of judgment. Indeed the Erythraean Sibyl had more direct links with Christianity than this. It was said that she was Noah's daughter-in-law and that she performed an open-air sacrifice by the ark. The *Oracula Sibyllina* quote the Erythraean Sibyl's description of Noah's flood. Thus we have identified the figure to the left of Noah in *Noah's Sacrifice*, directly over her head, as a second appearance of this sibyl. The two look much alike.

Ezekiel (fig. 163), who appears directly under the *Creation of Eve*, is vehement, almost angry. He is dressed in a russet cloak partly covered by a pale purple robe and white shawl. On his elderly white-bearded head he wears a turban. He has set aside his scroll and turns his body, in profile, directly back to the Erythraean Sibyl and Joel, who returns his gaze as he

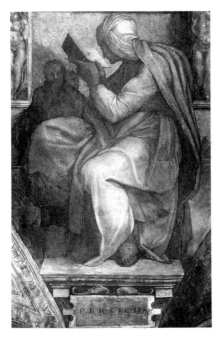

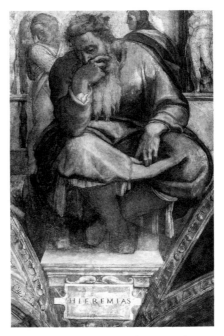

164. Michelangelo, *The Persian Sibyl.*
Alinari/Art Resource, N.Y.

165. Michelangelo, *The Prophet Jeremiah.*
Alinari/Art Resource, N.Y.

expostulates. In the scriptures Ezekiel has the most vivid trances of all the prophets and is among the bitterest in his denunciations of his countrymen's sins. He rejoiced when Jerusalem fell in 586 B.C.E., for it was God's just punishment on the unrighteous Jews. Ezekiel describes the Babylonian Captivity from personal experience. Only after this, which was another justified punishment, and whose victims included himself, can rebuilding, salvation, begin (36, 37). His description of the new temple marks this reconstruction of Jewish identity (40, 41, 42). Ezekiel's words are crucial to our knowledge of that structure, by the way. The final verses of the prophecy also describe in detail the city of the New Jerusalem to which Julius's plans for Rome were frequently likened.

The Persian Sibyl (fig. 164) like Zecha-

riah is viewed from the side. Her feet arch upward from the toes, her legs full beneath her pale green robe. A delicate, ancient, gnarled face turns with gentle absorption to a redbound book, the veiled head a shadowed profile. A reddish cloak covers her back. A youthful servant or genius stares directly out from behind the sibyl's knee. More than any of the other sibyls the Persian is linked to pagan predications of the Jews' redemptive mission among the great nations of the East. That, at least conceivably, is why her throne is set across from Daniel's: both prophesied in this easternmost part of the Jewish world. Noah's ark, furthermore, made its landfall in Persia, so it was there also that Noah's sacrifice and drunkenness occurred.

Jeremiah (fig. 165) is plunged in gloom, his dark bearded face partly covered by his

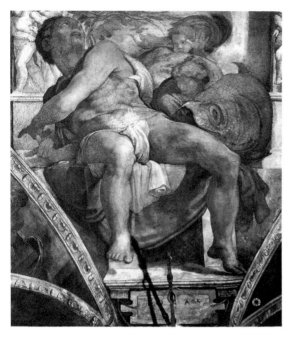

166. Michelangelo, *The Prophet Jonah*.
Alinari/Art Resource, N.Y.

hand as he leans on his arm, his eyes cast down, his gray hair awry, his feet encased in boots that, some have thought, make him a portrait of the artist himself, who looked and dressed a bit like this. Behind are two disciples respectively in green and white and green and red. One may be the scribe Baruch. Jeremiah was the last great prophet before the Exile. He lived at a time when the whole of western Asia was laid waste by barbarian invasions. The Battle of Megiddo (608 B.C.E.) was fought in his lifetime ("Armageddon" is a corruption of "Megiddo"). The Jewish historian Josephus tells us that Jeremiah was punished for the pessimism of his prophecies. Like Ezekiel Jeremiah predicted the Babylonian Captivity.

Jonah (fig. 166) is directly over the altar at the chapel's western end, oppo-

site Zechariah on the east. Unlike the other prophets and sibyls, who are decorously enthroned among their books and meditations, Jonah, clad only in a kind of breech-cloth and white cloak, rears back thunderstruck, mouth open and eyes rolling, his left arm across his body as if fending off some fearful spectacle. Jonah himself claims "fear of the lord" as one of his attributes (Jon. 1:9). Lost in the swirl of the white cloak behind him are the faces of a putto and a young angel in golden robes. The great fish shimmers on the right. Jonah is the last of the prophet figures Michelangelo painted, and different from the others. His is the only figure on the ceiling observed in perspective from below—the others being presented dead on or from only slightly above the viewer's eye. Though this is not the first instance of painting what the Italians call *da sotto in sù*, "from underneath upward," Michelangelo's Jonah foretells the virtuoso exercises in multifigure scenes, shown from below, that would characterize Italian ceiling paintings in later centuries.

Jonah, furthermore, like Jeremiah, is in the presence of the most stupendous of the central scenes: God's first appearance in visible form. No wonder the prophet seems overwhelmed. He had been sailing out on a mission to convert Nineveh to Judaism; a storm overtook his ship and he volunteered to jump into the sea as a sacrifice so that God would quiet the tempest (Jon. 1:1ff.). He did so and the storm ceased. But by God's command Jonah was then swallowed by a whale. He remained inside it for three days, after which he was miraculously disgorged and resumed his mission. Jonah's self-sacrifice and three-day sojourn were seen as types of Christ's crucifixion and three-day stay in hell.

The Libyan Sibyl (fig. 167), in a mem-

orable gesture, reaches back behind her
throne to lift out a huge open volume. She
wears a curious strapless gown and her
golden hair is wound with an elaborate
veil. She is just across from Jeremiah.
Jeremiah, Jonah, and the Libyan Sibyl, as
adjacent seers, map out three reactions to
God's act of creation: amazement at its mi-
raculous nature (Jonah), reverent acknowl-
edgment of its inevitable penetration of
paganism (the Libyan Sibyl), and despair
at humankind's failure to be worthy of it
(Jeremiah).

 Daniel (fig. 168) is a golden-haired
youth reflectively pursing his lips as he
casts his eyes on the tablet or scroll onto
which he copies words from the broad co-
dex on his lap. Between his legs a putto
struggles to hold the great book aloft.
Daniel's garments are white, gold, and pale
crimson. With Noah and Job, Daniel was
one of the great saints of ancient Israel.
Like so many of them he proselytized in
foreign lands, preaching in Babylonia dur-
ing the Hebrews' captivity there and con-
verting prominent non-Jews, among them
Nebuchadnezzar, king of Babylon. And
when, in Persia, the emperor Darius cast
the prophet into a lions' den for breaking a
prohibition against prayer, Daniel brought
even Darius under Jehovah's sway. He
was, finally, an annotator and interpreter
as well as a prophet, and embedded his
own prophecy in his reading of the Book
of Jeremiah (Dan. 9:2), much as Michel-
angelo shows him—reading from a scroll
as he writes in a codex.

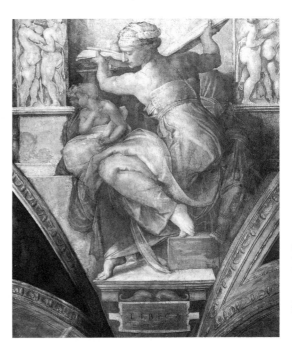

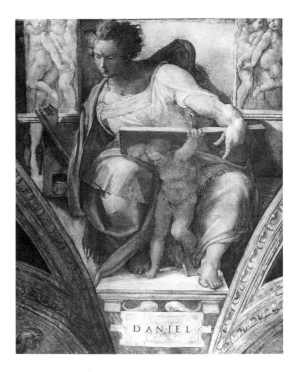

167. (*above, right*) Michelangelo, *The Libyan
Sibyl*. Alinari/ Art Resource, N.Y.

168. (*right*) Michelangelo, *The Prophet Daniel*.
Alinari/Art Resource, N.Y.

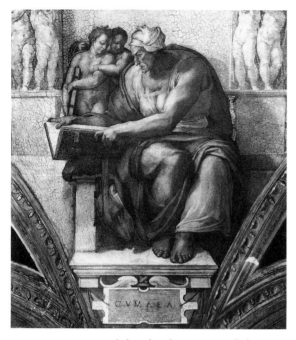

169. Michelangelo, *The Cumaean Sibyl.*
Alinari/Art Resource, N.Y.

The Cumaean Sibyl (fig. 169), Apollo's priestess at Cumae, near Naples, is pictured as a fearsome, powerful, dark-skinned old woman uncomfortably seated on her throne. She bitterly resented her great age: she had asked the god for eternal life and had been granted it, but had forgotten to ask for eternal youth (Apollo is apparently something of a bureaucrat). She was associated with the prediction by Virgil in his Fourth Eclogue: "And now a virgin shall give birth, and the kingdoms of Saturn [i.e. the Golden Age] return." This was thought to be Apollo's prediction of the coming of Christ, though more likely Virgil meant Astraea, goddess of Justice. The Cumaean Sibyl sits beneath the *Creation of Eve*, which is appropriate, since Virgil's virgin, as interpreted, was "the

second Eve" whose son's passion would rectify the first Eve's fall.

Isaiah (fig. 170), who appears under the sacrifice of Noah and opposite the Erythraean Sibyl, addresses himself to the fall and to the destruction and punishment that must occur before true penitence is possible. The Old Jerusalem dies to make way for the New. Isaiah also describes the coming of the messianic king (8:18–9:6) and pictures a future golden age that, Christians hold, was to be the Millennium (40:1–9). Isaiah's book was appropriate to Julius's papacy because it portrayed, like Jonah's, a small embattled country, Israel, beset by powerful neighbors who nonetheless fall by the wayside. Isaiah also dwells on another papal theme, the gathering in of the exiles from over the earth. Thus if the Erythraean Sibyl's participation in Noah's sacrifice symbolizes Christian theology's cordiality to paganism, Isaiah's appearance in this same bay marks that sacrifice as the covenant between God and Noah's offspring—a covenant that leads on through history to the Millennium.

The Delphic Sibyl (fig. 171), a young and beautiful woman, holds a scroll as she gazes outward with brilliant eyes. She was the most inspired of the ancient priestesses and was gifted with extraordinary poetic powers (she was thought to have composed many of the lines in Homer's poems). She may stand for the fact that artistic inspiration is a mark of divine presence.

The Ancestors of Christ

On the upper walls of the chapel, in the lunettes or surrounds of the windows and between each throne in triangular pendentives, are the ancestors of St. Joseph, known as the ancestors of Christ (figs. 146, 172). Just as the saintly popes below form a pat-

rimony of priests and are Christ's *successors* carrying his Gospel onward from the founding of the Church, Christ's *ancestors* form a procession going back to Abraham, the next Hebrew hero after Noah. The lunettes contain the male ancestors named in the Gospel account plus their wives and children. As Creighton Gilbert points out to me, the lunette figures are stylistically quite different from those in the rest of the ceiling. In their slimmer bodies, bizarre colors and wilful gestures the people of the lunettes predict the mannerism of Rosso Fiorentino and Pontormo. They were probably executed towards 1511, after a long break in the work on the main parts of the ceiling.

More family members dwell in the pendentives above the lunettes. Several of these ancestors are kings, e.g., David and Solomon (fig. 146). (Michelangelo had originally included Joseph's seven earlier ancestors—Abraham, Isaac, Jacob, Judah, Phares, Esron, and Aram—on the altar wall. They were covered up when the artist painted the *Last Judgment* there in 1536ff.) We might also note that the ancestors take up more space than any other group on the ceiling and are far more numerous—some forty forefathers plus a total of twenty collateral relatives. In line with Matthew 1:1ff., Christ's ancestors are traditionally divided into three groups of fourteen (fourteen generations from Abraham to David, another fourteen from David to the Babylonian Captivity, fourteen more from then until Christ's birth; the last of one set being also the first of

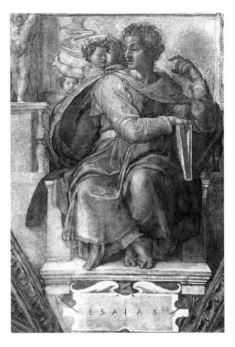

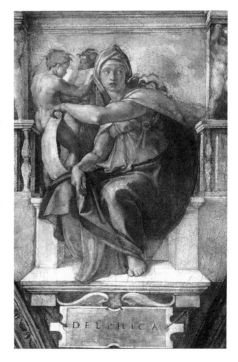

170. (*above, right*) Michelangelo, *The Prophet Isaiah*. Alinari/Art Resource, N.Y.

171. (*right*) Michelangelo, *The Delphic Sibyl*. Alinari/Art Resource, N.Y.

172. Michelangelo, *Ancestors of Christ: Nason and His Wife*. Alinari/Art Resource, N.Y.

the next). Michelangelo observes this division. David appears in the first bay in from the west, on the south side. Jechonias and Josiah, the two ancestors born during the Babylonian Captivity (Matt. 1:11, 12) appear symmetrically with David in the first bay in from the east.

The ancestors themselves are curiously baleful. We might also ask: why call these people Christ's ancestors? What is the blood-tie? Christ's begetter was after all not Joseph but the Holy Spirit. It is only the ancestry of his mortal mother that should count. Theologians answer the question by saying that Joseph's tribe, that of Judah, was also Mary's. Anyway, the menfolk sit in their encampments, at work, or with their children, or glumly meditating, and, uniquely in art it seems, with their wives present. Their mood belies their brilliant costumes, and the fact that many of them, fathers and mothers, play with restless babies. A few even have the slightly menacing majesty of the sibyls

and prophets. Some bend down from their seats, their arms trailing on the ground in histrionic despair. Others clutch their infants and huddle into pathetic pyramids like homeless families sitting on the ground.

One might interpret these expressions of woe and apparent dread as prophecies of Christ's Passion. It is as if, for all its generations, his human family had been filled with the foretaste of tragedy. Yet the mood of the genre scene often prevails: one husband will write on a sheet of paper while his wife is overwhelmed by affectionate babies. Aminadab stares straight ahead in moody reflection as, on the other side of the window, his wife intently combs her long blond hair. Nason's wife, dressed in a brilliant green cloak, regards herself in a mirror as her husband sprawls with by no means full decorum before his reading desk (fig. 172). The same elements—brilliant clothing, babies, moody husbands and wives—also dominate the ancestors in

the pendentives. Indeed the feeling is of a further hopelessness expressed by despairing women. Some people lie on the ground; others hide their faces in their hands.

Sidney Freedberg notes that the ancestors of Christ are in limbo, that unhappy intermediate state between the terrors of hell and the bliss of heaven to which all good but unbaptized persons are consigned. The word comes from *limbus*, edge or border (e.g. of hell), which suits the placement of these personages in the chapel scheme. Limbus could also mean prison, and was usually described as a dark confining place like those occupied by Michelangelo's figures. I would propose, provisionally, that the pendentive families, in representing Christ's ancestors, may also represent all good persons who have died unbaptized. Others have interpreted the figures as victims of the Babylonian Captivity, though as noted the scriptures are quite clear that of all Christ's ancestors only Jechonias and Josiah were born during that period. Nonetheless, describing the captivity Jeremiah (25:9ff.) paints pictures much like Michelangelo's:

I will send and take all the families of the north . . . and make them an astonishment, and an hissing, and perpetual desolations. . . . I will take from them the voice of mirth, and the voice of gladness, the voice of the bridegroom, and the voice of the bride, the sound of the millstones, and the light of the candle. And this whole land shall be a desolation, and an astonishment; and all these nations shall serve the king of Babylon seventy years.

The Four Corner Scenes

Four scenes in the corners of the vault occupy much larger pendentive areas. Indeed they are by far the largest scenes in the ceiling and more than any of the others are filled with violent action. As we might expect by this time the theme is exile and sacrifice. In the southwest corner, flanking the altar, is the *Worship of the Brazen Serpent* (fig. 173). This depicts the rain of burning snakes who with poisoned jaws fell upon the people of Israel when they spoke against God (Num. 21:5ff.). Moses, at God's command, made a fiery serpent of his own, of brass, and hung it on a pole. Those who had been bitten by the real serpents were cured by looking at this talisman. In the center, distantly silhouetted against the sky and exactly like a crucifixion, we see that sculptured serpent coiled around its tree. It is also a bit like the serpent in the *Temptation and Fall of Adam and Eve* (fig. 153). On the left an eager huddled group looks toward it as relief and healing flow through them. Those who have not yet looked at it writhe on the right, the living serpents still wrapping them in Laocoön-like agonies. Note that Michelangelo uses the same compositional device Raphael was using in the *Heliodorus* and the *Fire in the Borgo*: an outer frame of victims around an inner funnel of space leading to the central act of salvation.

In the northwest corner, also flanking the altar, is the *Punishment of Haman* (Esther 7.10; fig. 174). Haman was the grand vizier of Ahasuerus, king of Persia. On the left, in a dim yellow garment, he plans with the king and a prince to murder all Jews who are captive in Persia. But later on Ahasuerus learns, from an account read to him as he lies in bed, that a Jew named Mordecai has scotched a coup that Haman was planning. Michelangelo shows the grateful Ahasuerus rising to countermand the pogrom. A servant rushes out the door to do the royal bid-

173. Michelangelo, *The Worship of the Brazen Serpent*. Alinari/Art Resource, N.Y.

174. Michelangelo, *The Punishment of Haman*. Alinari/Art Resource, N.Y.

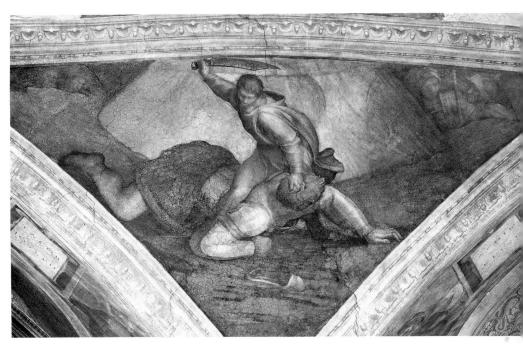

175. Michelangelo, *David and Goliath*. Alinari/Art Resource, N.Y.

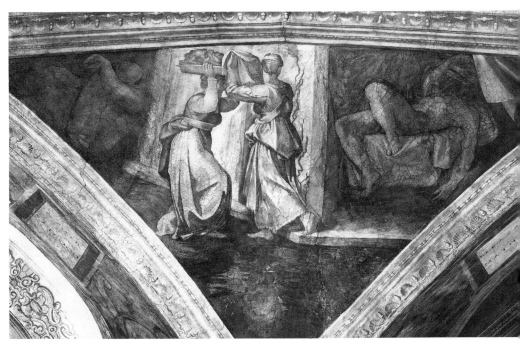

176. Michelangelo, *Judith and Holofernes*. Alinari/Art Resource, N.Y.

ding. In the center, ferociously foreshortened, Haman is crucified (this is not in the biblical text but follows Dante's *Purgatorio*), his left arm toward us. From these events the feast of Purim took shape. But given his role in the story, Haman-as-the-crucified can exist only as what theologians call an *exemplum a contrario*, a kind of counter-Christ, a man who is as evil as Christ is good, his crucifixion being as just as Christ's was unjust.

In the northeast corner are David and Goliath (1 Sam. 17; fig. 175). In 1501–4 Michelangelo had already provided an unforgettable interpretation of this event in his marble David now in the Accademia, Florence (fig. 177). There the triumphant youth stands in relaxed but wary *sprezzatura* (gracefully managed difficulty). The paradox here is that the normal-sized youth who slew the giant actually *is* a giant. How different is the scene in the Sistine Chapel, where Goliath is a true giant and David a true boy. Having felled the Philistine with his sling David now takes Goliath's own sword and, grasping him by the hair, swings the sword back (1 Sam. 17:51). We see the giant's fellow soldiers fearfully withdrawing in the distance. In terms of the chapel's program David's victory is that of "the God of the armies of Israel, whom [Goliath] has defied" (1 Sam. 17:45). Once again "Israel" would be the Church, whose strength in its political struggles against the superpowers is drawn, like Israel's, not from its size but from its faith.

In the southeast corner are Judith and Holofernes (fig. 176). Here is yet another tale of Hebrew heroism against Israel's enemies. The Assyrian general's naked form lies on the bed he had wished to share with the Jewish woman. Instead, she has decapitated him and now hurries out of his tent, her servant helping her with the head which, on the morrow, will be displayed to Holofernes' troops and send them packing. Their confusion and flight are foretold by the bewildered soldier on the far left.

The four corner scenes are divided into pairs—two decapitations marking Hebrew military victories (Goliath and Holofernes) and two crucifixions marking the survival of Israel (Haman and the brass serpent). The crucifixions are on the altar end of the chapel and are therefore connected with that other Christ figure, Jonah. They stand

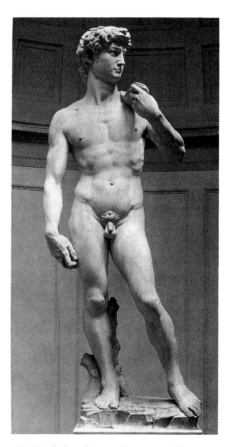

177. Michelangelo, *David*, 1501–4. Florence, Accademia. Alinari/Art Resource, N.Y.

above the living priest who, saying mass in the chapel, re-presents Christ's own crucifixion. They recall the fact that Christ's cross was flanked by those of two thieves—Haman and the bronze serpent doing duty for the latter.

Having looked at all four of these scenes we can note, finally, a practice that Michelangelo uses throughout the ceiling: a figure in a given pose is reemployed in four different events, playing four different roles, his body meanwhile being rotated or reversed into different positions (figs. 173, 174, 175, 176). Thus the recumbent Goliath, left arm extended, right arm folded next to the body, right leg slightly drawn up, is also the crucified Haman (though with right arm now further back), the recumbent and headless Holofernes, and finally the large male nude in the foreground of the brazen serpent. This was not an unknown form of repetition. Artists have often taught themselves by drawing the figure in difficult or violent poses, and from many viewpoints. But here the practice also makes narrative sense. Let us call this figure in its four different roles "the victim." As he progresses through the four stages he is captured by the serpent, crucified as Haman, about to be beheaded as Goliath, and then actually is beheaded as Holofernes.

The Last Judgment

The *Last Judgment*, most awesome and powerful of works, fills its chapel, the other programs we have been discussing, and indeed the subsequent history of art, with a tragic challenge. Ascanio Condivi, whose biography of Michelangelo is the testimony of a friend and confidant, tells us that Clement VII's original intention was to have the artist paint a *Resurrection*

of Christ on the Sistine Chapel's altar wall and, at the other end, a *Fall of the Rebel Angels*. All records of the latter are lost, though some scholars think Rubens's painting of the subject in the Alte Pinakothek, Munich, reflects the composition (fig. 178). As to the planned *Resurrection*, however, Michelangelo made a number of drawings (fig. 179) of this subject. The belief that our bodies will be physically resurrected, rising from their graves and reclothed in the flesh they wore in life, is in the Apostles' Creed and had been reaffirmed by the 1513 bull *Apostolici Regiminis*. Paul III's enthusiasm for the dogma probably suggested changing the subject from Christ's own resurrection to that of humankind.

The altar wall of the Sistine Chapel, we have seen, was already decorated when Michelangelo began to think about the new commission. I have mentioned the upper lunettes with the ancestors of Christ by Michelangelo himself. Below these were two windows flanked by portraits of Popes Peter, Linus, and Cletus, along with a portrayal of Christ himself as a pope. Two frescoes by Perugino, a *Nativity* on the right and the *Finding of Moses* on the left, also decorated this western wall. These were the beginning episodes in the two side-wall sequences. There was also, we have seen, a third Perugino work, serving as an altarpiece, *The Assumption of the Virgin*. Michelangelo's earlier sketches imply that he may once have wanted to preserve some of this work—though we are also told that the Perugino frescoes had been ruined in a 1525 fire. In the end, however, he covered the entire wall, thus decapitating three of the chapel's four lateral programs. The prophecy of humanity's end came to overwhelm these earlier beginnings.

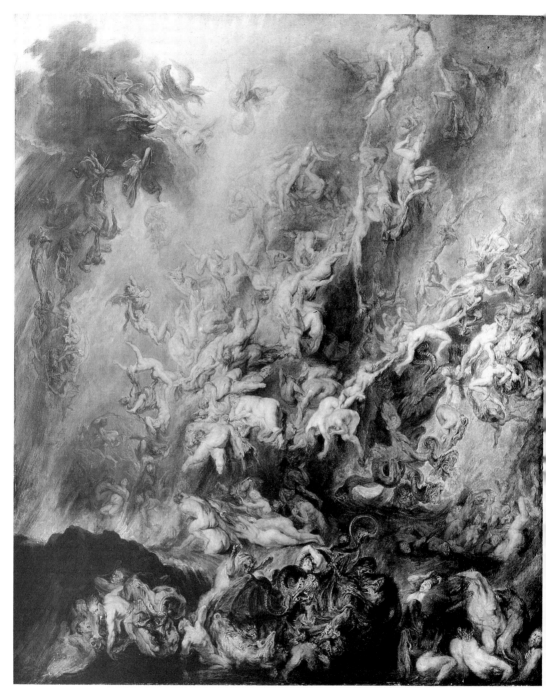

178. Rubens, *The Fall of the Rebel Angels*. Munich, Pinakothek. Giraudon/Art Resource, N.Y.

On Michelangelo's orders the chapel's western wall was lined with bricks so that the whole surface sloped gradually outward as it rose, thus preventing dust from settling on its surface. By April 16, 1535, the scaffolding was in place but various delays put off further work until April 1536. As was his wont the artist worked alone except for a servant who ground the colors and so on. On February 4, 1537, Pope Paul inspected progress. On December 15, 1540, the scaffolding for the upper half was removed. The finished fresco was unveiled on October 31, 1541—the vigil of All Saints Day, which celebrates the sojourn of the blessed in heaven. (The offertory for that day's mass says: "The souls of the just are in the hand of God and the torment of evil shall not touch them. . . . They are in peace, alleluia.")

A Note on the Cleaning

At this writing (1992) the *Last Judgment* is in the process of being cleaned, while the ceiling has only recently revealed its original brilliancy. The restorers were able to find out precisely what pigments Michelangelo used. This made it possible to distinguish Michelangelo's own paint from everything later. On top of their repaintings, moreover, earlier restorers had applied coats of glue and other bonding agents. These had to be removed without affecting the original layers underneath.

In the ceiling Michelangelo's original silken yellows, apple greens, and orange-reds are startling revelations. If similar things happen to the *Last Judgment* we will have to revise the rather sombre impressions it has made on generations of visitors. Already, for example, under the direction of Gianluigi Colalucci the team has discovered that much of the sky is a

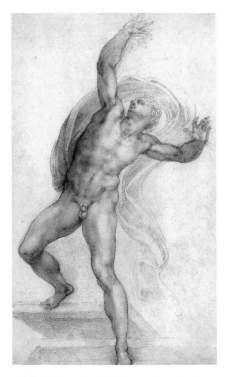

179. Michelangelo, *The Resurrection*, drawing, c1532. Possibly for planned Sistine fresco. Windsor, Royal Library, inv. 12768. By permission of Her Majesty the Queen.

brilliant lapis lazuli blue. The job is planned for completion in 1994. It will be more complex than restoring the ceiling, since the wall has always been more accessible and thus has a lot more paint and varnish on it. It is also more heavily caked with dirt, lamp-black, soot, and candle-smoke than was the ceiling.

Some critics have claimed that the ceiling has been cleaned too aggressively, and that Michelangelo himself applied shadings and darkenings to some of his brilliant base-colors, alterations which have now been wrongly removed. Colalucci admits that in a few instances this in-

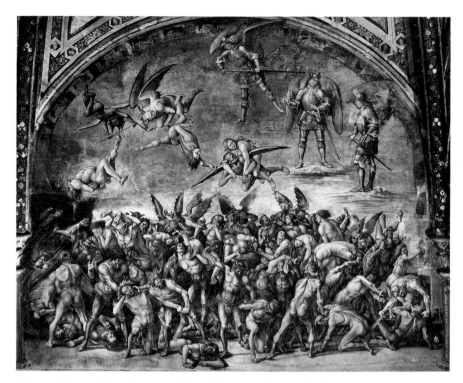

180. Luca Signorelli, *Last Judgment*, 1500–1505. Orvieto Cathedral. Alinari/Art Resource, N.Y.

deed happened. But on the whole the expert reaction has been highly favorable.

Fresco, or *buon fresco* as Michelangelo's technique is called, consists of painting in water-soluble colors directly into fresh plaster. The color thus bonds with the substance of the wall itself. (That is why the red underpants added to some figures after Michelangelo's death, by Daniele da Volterra, cannot be removed.) The fresco surface is divided into areas that can be completed in a day's work (called *giornate*, "days") "He moved very rapidly," says Colalucci, quoted in the *New York Times* of June 19, 1991 in an article by Marlise Simons, "with very solid techniques. It's possible to see what he did in a day. Sometimes he used many very thin coats of paint, sometimes he applied very little pigment to make sure the light of the plaster would shine through."

The *Last Judgment*'s Predecessors

Michelangelo's scene departs from earlier *Last Judgments*. It abandons their marked and orderly layers of cosmic deities who flank a central blazing portrayal of Christ the King. On either side of Christ, in this tradition, were the apostles and other members of the elect, the Virgin Mary interceding for sinful humankind, John the Baptist, important martyrs, allegorical figures such as Ecclesia, and trumpeting angels. Below, the damned occupied one side and the blessed the other. The groups are

moving parts in a cosmic equilibrium. A good example, one that Michelangelo admired, is by Luca Signorelli in the cathedral at Orvieto (fig. 180; 1500–1505). A comparable High Renaissance arrangement of heavenly figures is the *Disputa* (fig. 111).

Michelangelo keeps this traditional cast of characters but, probably inspired by Signorelli's great Judgment scenes, imposes on them a tragic turmoil (fig. 181). He stresses the dreadfulness of judgment, the undeservedness of acceptance, the rage and horror of damnation. With one powerful all-pervading gesture Christ raises his right hand to draw the blessed upward as he lowers his left to signal the descent of the damned. The whole population of four-hundred-odd bodies surges into motion. This *concetto* seems to have been Michelangelo's invention. More traditional is the fighting that goes on in the lower right-hand corner, as the damned struggle with their tormentors and with the angels who cast them down. All this was not wholly unannounced in earlier art. There is for example the river of flame in Giotto's *Last Judgment* in the Arena Chapel, Padua, which with similar ferocity sweeps the damned into the abyss (fig. 182). And in Francesco Traini's frescoes in the Camposanto, Pisa, the Christ is proto-Michelangelesque, a punishing judge angrily displaying his wounds.

We can't linger over every one of the more than four hundred figures. But Catherine is specially interesting (see diagram, fig. 183, and fig. 184). Kneeling and leaning forward she raises a piece of the spiked wheel on which she was tortured. (Her drapery is an addition by another hand; Michelangelo painted her nude.) Catherine is supposed to have lived in the reign of Maxentius—he of the Milvian Bridge—in the fourth century C.E. As a

Christian professor of philosophy she protested the emperor's persecutions of her co-religionists. In response Maxentius set up a group of fifty scholars to defeat her in a debate. But Catherine, though only eighteen, was possessed of phenomenal eloquence and learning. She won the debate and converted all present to Christ. Charmed by her brains and beauty, Maxentius proposed that she become his (bigamous) mate. At her angry refusal—she announced that she was already engaged to Christ—she was condemned to the wheel. When, miraculously, not she but the wheel broke, she was beheaded.

Or look at St. Bartholomew, center-right just below Christ (fig. 185). He has been flayed alive. He holds his skin in one hand (note Michelangelo's self-portrait in the skin's face) and with the other the knife that did the work—a gesture more than tinged with menace. (The saint's face resembles Aretino's, some have noted [fig. 186], and Aretino was famous for verbally flaying his enemies. Indeed in 1545, after the fresco was complete and perhaps seeing the image as an unflattering portrait of himself, Aretino bitterly attacked Michelangelo's work.)

In any event the fact that Bartholomew, a balding bearded man, should hold the skin of a man with hair and no beard, continues to puzzle. A pair of psychoanalysts, Richard and Edith Sterba, see Bartholomew as Christ's own super-ego, threatening his mother with the knife "as if he indicted her for all the martyrdom and injustice which he had to suffer from her in his childhood. . . . The intensity of his reproaches has struck her so hard that she moves nearer to the Savior and half hides behind him for protection." Leo Steinberg points out, in contrast, that the Bartholomew incident involves the fresco's theme

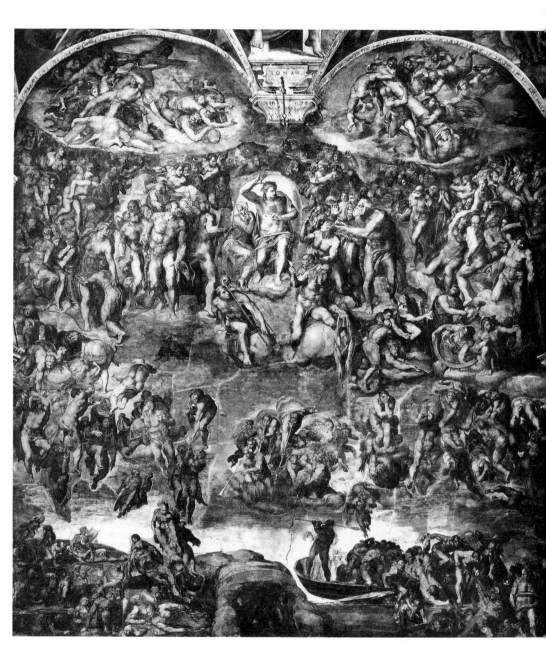

181. Michelangelo, *Last Judgment*, 1535–41. Sistine Chapel. Alinari/Art Resource, N.Y.

of bodily resurrection and the flesh as
clothing for paradise: "On the last day I
shall dress myself in my skin and in my
flesh shall see my God" (Job 19:25–6).
Steinberg thinks the saint is holding the
skin as if to ask whether it should be kept
or dropped into the abyss. He also sees a
"line of fate" descending from Christ's
gesture down to the right through Bar-
tholomew and Michelangelo's skin, and on
to the memorably desperate figure who
hugs himself and stares out, eyes blazing
with horror, having realized only now that
he is doomed.

And then we see Andrew with his
cross, Lawrence with the grate on which
he was burned, and Blaise with the iron
combs that were used to torture him.

182. Giotto, *Last Judgment*, Scrovegni Chapel,
Padua. Alinari/Art Resource, N.Y.

183. Diagram of main characters and groups in
Michelangelo's *Last Judgment*. Author.

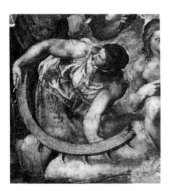

184. Detail of St. Catherine.
Alinari/Art Resource, N.Y.

Angels
Bearing
Cross

Angels
Bearing
Column

Eve

Adam

Jewish
Heroines?

John the
Baptist

Saints

Christ

Jewish
Heroes?

Ecclesia

Mary

Peter

Catherine

Sebastian

Lawrence

Bartolomew

Martyrs

Trumpeters

Blessed Arising

Angels Casting
Out Damned

Virtues

Couple with
Rosary

Charon

Dead Resurrected

Vices

Minos

Limbo

Altar

185. Detail of St. Bartholomew. Alinari/Art Resource, N.Y.

186. Titian, portrait of Aretino, 1545. Detail. Florence, Pitti Palace. Alinari/Art Resource, N.Y.

Angels are particularly numerous. In the lunettes, on the right, a group of them carry the instruments of the Passion including the cross and the thorns that crowned Christ. Opposite, a similar group has flown aloft with the column against which he was beaten.

Scholars have supposed that Michelangelo had in mind still further identities. Unfortunately there is little agreement about them since so few of the people have any attributes. At the outer edges of the scene, on the right, are naked seated athletic men and, on the left, seated clothed women. They seem to be debating. The men may be Old Testament prophets or heroes of Israel. The women could be sibyls or Israelite heroines. Behind the two groups, on each side, are what seem to be the first humans. As a frame for these, in turn, on the right, is the huge figure of the aged Adam holding one of his even older sons. On the left is another ancient, Eve, whose giant breasts show she is the mother of us all. Other individuals, equally ancient, represent Abraham, Isaac, Sarah, etc. All are gigantic. Old age infests them with its grotesqueries. Their bones and joints are huge, their noses and chins prognathous. (We recall that in this heroic age people lived to be hundreds of years old.) On the right, between Adam and Abraham, are several mysterious couples who embrace but not in joy. They could, it is thought, be unbaptized Jews.

On the right, again, we see a giant carrying a cross assisted by another figure. The mighty cross-carrier may be the Christian who daily bears Christ's cross. Or he may be Dismas, one of the two

thieves between whom Christ was crucified, and who repented and converted at the moment of death. The enormous standing woman mid-left, who succors a girl kneeling before her, may be the Church, Ecclesia. The two resemble a famous classical statue-type, Niobe succoring one of her children (fig. 188). Below the saints people exemplifying the Vices deal with their charges, the damned. We recognize Greed with his moneybag and Avarice with his keys. Surrounding Charon are more condemned souls. They howl and glare as they tumble, slide, and dive to hell.

187. Leonardo, *Last Supper*, 1494–97. Milan, Santa Maria delle Grazie. Detail of St. Peter. Alinari/Art Resource, N.Y.

In depicting all these angry, expostulating, even threatening people—especially the major saints and the damned—Michelangelo was borrowing from Leonardo's *Last Supper* in Milan. This had been the first great portrayal of the apostles remonstrating with each other—and with Christ himself, as happens in the texts. Especially important here is Leonardo's Peter who, like Michelangelo's Bartholomew, gestures with a knife as he turns an angry profile toward Christ (figs. 185, 187).

Michelangelo's drawings record his decision to make Christ (fig. 189) an active nude athlete, a young Zeus, hurling a thunderbolt or gathering war clouds. De Tolnay traces the artist's first conception of Christ to drawings for a projected *Zeus and the Fall of Phaethon* (fig. 190). Michelangelo's Christ, though more deliberate and less violent than his Zeus, has the same arm gestures and twist of torso. It is this gestural memory, this descent from a Zeus, I believe, that gives this Christ his propulsion, the sense that he is not simply gesturing but casting something forth. The Phaethon subtext also contributes light symbolism. Phaethon, son of Helios the sun, had tried to drive his father's chariot through the sky but failed to con-

188. Niobe and her child. Hellenistic. Florence, Uffizi. (This group was not rediscovered until 1583, but similar ancient versions of the group may have been known to Michelangelo.) Alinari/Art Resource, N.Y.

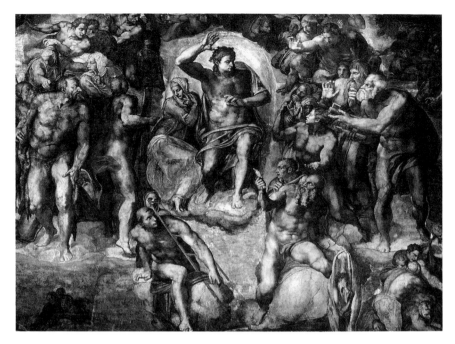

189. Christ, the Madonna, and St. John the Baptist in the *Last Judgment*.
Alinari/Art Resource, N.Y.

trol its mighty horses. When they plunged out of control the existence of the sun itself was threatened, so Zeus killed Phaethon, whose name means "ray." Phaethon makes an excellent emblem for a disobedient humankind unconsciously willing its own immolation, its derivative light extinguished to preserve the source of all light, namely Christ the sun. As to other figures, many of the classical sculptures in the Statue Court were laid under tribute: the Apollo Belvedere (fig. 82), the Belvedere torso (fig. 90), the two Venuses (figs. 86, 89) and the two river gods (figs. 83, 92), in particular, are re-seen, rotated, reversed, and revised throughout.

Yet despite these forms of classicism, and what some have seen as paganism, the Christian significance of the *Last Judgment* flows powerfully forth. It portrays the last days when the dead will awaken and the secrets of all hearts be opened. In the lower left-hand corner we see the first bleak beginnings of the resurrection of the buried dead. They crawl like primeval creatures through caked mud (fig. 191). Skeletons begin to be reclothed with flesh, and even with the winding-sheets in which they had been buried. Angels try to lift their bodies up; demons of the earth try to hold them fast. But soon the force of gravity diminishes. The dead begin slowly to soar. Virtues haul them further into Christ's presence. Note the man and woman who have seized a long rosary offered by an angel, and who hold tightly to it as they are raised to heaven like a half-drowned pair pulled from the sea.

Perhaps it was the self-punishing spirit of Rome after the Sack that made Michel-

angelo renounce so many High Renaissance discoveries and rediscoveries in this picture. For example he refuses the perspective space, the architecture and landscape, that Renaissance painters so loved to construct. Normative Renaissance pictures create measurable volumes within which the painted personages stand and move. A good example is the *School of Athens* (fig. 107). One could imagine, in Raphael's spirit, a *Last Judgment* set into a deep palatial hall painted to look like an ennobled continuation of the Sistine Chapel. Instead, the artist has constructed this towering plane of floating bodies. There is no sense of a distance, only immediate confrontation. The renunciation of perspective and of enframement was more than a simple omission. The upper figures are larger than the lower ones. This not only negates the progressive shrinkage that would normally occur as the figures stand and move further and further from the observer's eye, it endows these more distant beings with gigantic stature. Meanwhile Christ himself, curiously enough, is smaller than those around him. Yet even he is no man but a huge divinity. Gloria Kury has suggested to me that Michelangelo's renunciation of perspective and foreshortening helps to set the whole scene outside of history—perspective space being that of earthly events, of mappable reality—while the Day of Judgment transcends history and concludes it.

Finally—and here I return to a theme mentioned earlier—the most striking of all Michelangelo's renunciations, that of clothes. When he began the *Last Judgment* he had heard the criticisms of the ceiling figures' nudity. He was not affected. For that nudity is as nothing to the sea of legs, arms, thighs, chests, and genitalia that greeted the first viewers of the *Last Judg-*

190. Michelangelo, *The Fall of Phaethon*, drawing, 1533. Detail. Windsor, Royal Library. By permission of Her Majesty the Queen.

ment. For a later, more prudish generation it was too much. In 1565, just after Michelangelo's death, Pius IV commissioned Daniele da Volterra to paint red underpants on all the more uninhibited figures. (Afterward, it is said, he was known as Daniele delle Brache, Daniel of the Britches.) But the nudity in the *Last Judgment* is hardly sensuous. It is the nudity of desolation, of renunciation, of Christ's own body during the Passion, of the desert saint who hates his own human flesh. Michelangelo firmly believed in this kind of nudity, as well as all other kinds. When Paul III's Master of Ceremonies, Biagio da Cesena, objected to it, according to Vasari the artist punished him by painting him as Minos, himself nude and with a notably ugly body, admitting sinners to hell (fig. 192, far right).

De Tolnay prints a list of the literary sources Michelangelo seems to have used. The artist surely knew Matthew 24:30–31, where the evangelist speaks of day being darkened over as fear and tribulation spread among the tribes of the earth. Humanity weeps, says Matthew, as it sees the

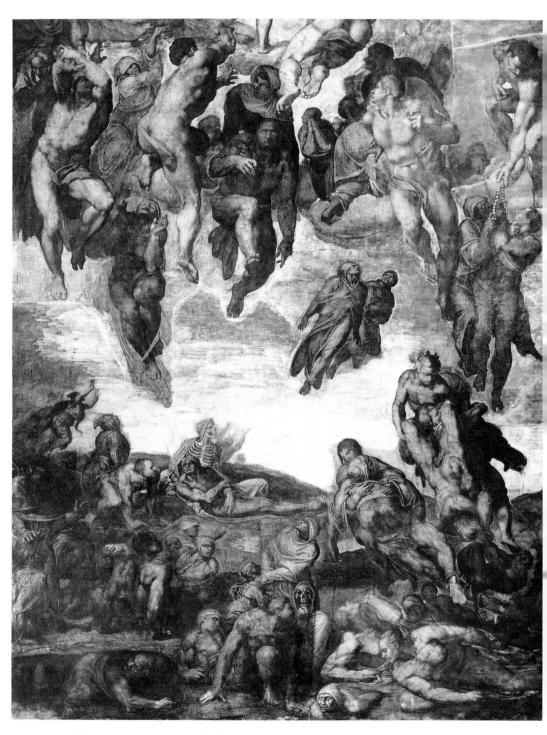

191. *Last Judgment*, detail of the dead arising. Alinari/Art Resource, N.Y.

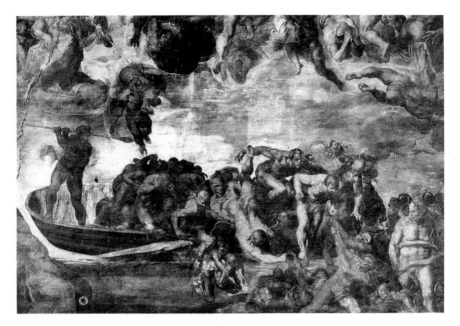

192. *Last Judgment*, detail of the scene in Hell. Alinari/Art Resource, N.Y.

Son of Man come forth among the clouds in all his virtue and majesty. "And he sent his angels with trumpet and great voice, and his elect congregated from the four winds and from the summit of the heavens to their depths." That's a good text for Michelangelo's picture. It helps us see it as a night scene.

Another good text is John 3:19 which speaks of Christ as the light of the world, the sun of day, but laments that humankind takes more pleasure in shadow than in light. We have seen Christ as Zeus and can see the plunging damned as Phaethons— as rays broken from the sun. The theme of disobedience, meanwhile, is re-expressed, among the trumpeters, where two angels are holding books. They are probably inspired by Apocalypse 20.12ff: "And books were opened, and another book which is the book of life, and the dead are judged

by what is written in this book according to their deeds. . . . And he who is not found written in the book of life is sent into the swamp of fire."

Dante is also present. We look at the angels pulling the blessed to heaven while these latter assist those below them. They seem to reflect the *Divine Comedy*: "They come from up above so that all are pulled up to God, and all [those who are pulled] pull also" (*Purgatorio* 28:127–29). More certainly the figures of Charon and Minos (fig. 192, far left, far right) come respectively from *Inferno* 3:109–11 and 5:4–15. "Charon the demon, his eyes burning coals, collects [the damned] all together and beats with his oar those who linger." Minos, meanwhile, snarls and indicates by the number of times his tail wraps around his body the circle in hell that waits for the sinner who comes before

him. In the present case the second level is called for, which Dante devotes to the lustful. If Minos is the puritanical Biagio da Cesena his prurience is displayed in his tail, which turns into a snake gorging itself on the gatekeeper's penis.

Minos has been given a pair of asses' ears, which has led some to identify him as the legendary king, Midas, who earned this punishment. Michelangelo has not painted Midas, but if this Minos is really Biagio, asses' ears are appropriate. Midas had objected to Apollo's being declared a better musician than the mortal, Marsyas. In revenge Apollo gave Midas asses' ears, making them the sign of foolish artistic judgment. Biagio also deserved asses' ears for so misjudging the *Last Judgment*.

Finally, just over the altar is the cave of limbo. Good people could be there, as Dante says, but this limbo is dominated by a fearful, grinning skull-face. And it is this vision that stares directly out at the priest saying mass! It emphasizes how terribly, how profoundly, the *Last Judgment* differs from normal altarpieces.

7 The Logge

The Logge and the Vatican

ramante began the three stories of arched balconies known as the Logge di Rafaello, adjacent to the Stanze on the east, just before his death in 1514 (fig. 193). Shortly afterward, we have seen, Leo X appointed Raphael as principal papal artist and architect. Raphael continued with the Logge and also designed the ramp leading up to them. As built, the lower storey is treated with arches set between engaged columns supporting an entablature. The middle storey, with the famous painted and stucco scenes, is a second row of arches and engaged columns with a balustrade on the outer side. The upper storey is a simple open colonnade. The sixteenth century artist Marten van Heemskerck has recorded the original look (fig. 194). The middle-storey loggia measures about 200 feet by 15 and its decoration was mostly done between 1514 and 1516.

In Italy loggias are domestic conveniences affording breezes in summer and, in winter, protection from the rain. Vitruvius calls them *ambulationes*, places for walking. But loggias also had, or could have, a ceremonial role. The word loggia itself is possibly derived from the Greek *logeion*, speaking-place. The Benediction Loggia erected on the facade of Old St. Peter's, visible in Heemskerck's drawing, is an Early Renaissance example of the logeion-loggia. Renaissance loggias can play other civic roles. Thus in Florence the Loggia dei Lanzi is an open arched porch (now filled with some of the city's totems—frescoed or sculptured heroes such as Cellini's *Perseus*). And not long after the Vatican Logge comes the Loggetta in Venice, built as a civic structure not dissimilar in function to the Loggia dei Lanzi.

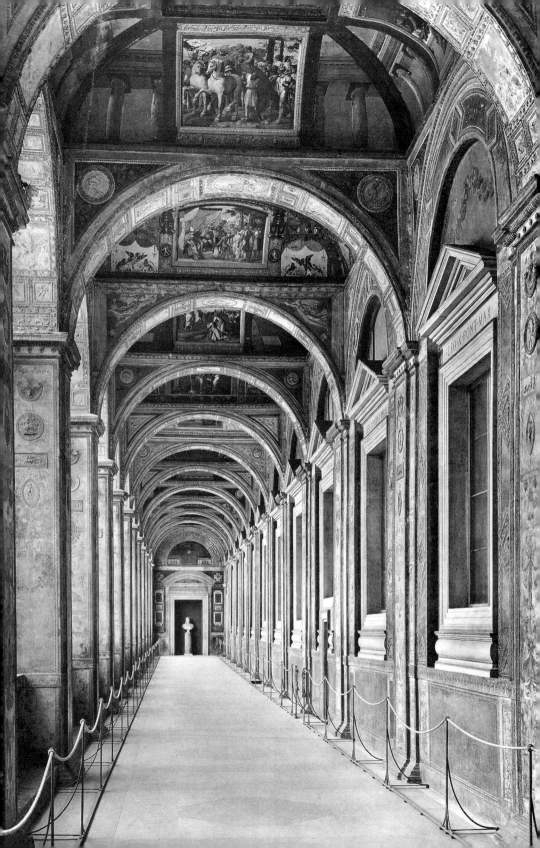

In a roughly comparable sense the Vatican Logge formed part of the itinerary of important visitors to Rome. They afforded a magnificent panorama of the city and, as well, a view of a private garden (since removed). Their main function, however, was to provide access to the Sala di Costantino, which in Leo's reign was his main audience chamber (fig. 105).

In Vitruvius an ambulatio may exist in a garden, and he adds that *ambulationes* were often painted or carved with garden motifs (*De architectura* 7. 5. 2). He gives a long list of such features, and includes harbors, headlands, shores, rivers, springs, straits, temples, groves, hills, cattle, and shepherds. He also speaks of gods, legends, and the like. Much of this squares with the garden view once to be had from the Vatican Logge. And we can still admire the painted flowers, fruits, trellises, and hedges with which Raphael's team filled the vaults and piers.

The great Renaissance humanist Leone Battista Alberti, who in the mid-quattrocento is thought to have made a project for rebuilding the Vatican area, takes up Vitruvius's term *ambulationes* in his architectural treatise of c1450. He too speaks of loggias particularly as garden features. But he also calls the naves and aisles of churches by this name (somewhat as in the Medieval Latin *ambulatorium*, ambulatory). This more medieval and ecclesiastical sense of a loggia will also be reflected in Raphael's program, which presents a sequence of religious scenes as in the nave of a church. One final inspiration for the look of the Logge is probably the Roman vault known as the Tabularium, the city archive of ancient Rome under the

194. The Logge di Raffaello from the exterior. From a drawing by Marten van Heemskerck. Vienna, Albertina, inv. 31681.

193. Raphael and assistants, The Vatican Logge, 1514–16. Alinari/Art Resource, N.Y.

195. The Tabularium, Rome. Alinari/Art Resource, N.Y.

The Logge 227

Capitoline Hill (fig. 195). Its architecture is similar to that of the Logge; and I note that the Tabularium, tucked just beneath the present Senate Palace, afforded a fine view.

One's first impression, walking into the Logge, is of bewildering richness. But the dazzle of this apparent disorder can eventually be resolved. Doing so is part of the fun. Thus as Bernice Davidson writes, the visitor is:

> dazzled by the galaxy of images represented in the stucco cameos studding every pier and pilaster the length of the Logge. It may be a long time before one realizes that on each pilaster surface there are four such reliefs, and that although each of these four is composed of a different shape—cartouche, roundel, rectangle, mandorla—the same four shapes are repeated in the same sequence and position throughout the Logge.

There are many such threads of meaning and order to be followed. The choices are simply optional ways of "doing" this painted garden of amazement where, to paraphrase Vitruvius, temples sprout from blossoms and gods from flowers. Perhaps the only mistake is to think that only a single message lurks behind the riot of possibilities. If a loggia is a "corridor" in a garden, or a way of looking out onto a garden, this particular loggia partakes of that other garden fantasy-structure so dear to the Renaissance, the labyrinth. Losing one's way, discovering unforeseen attractions, entertaining vain hopes, and a final release—these are some of the pleasures to be had.

The Logge as an Academy of Art

The Logge are not only full of charm, they represent the flowering of a tendency found more in Early than in High Renaissance art. This is the desire to re-create, or preserve, the collaborative workshop tradition of the Middle Ages. Then, it was less often the individual master than the joint work of master and assistants that defined a school and created its representative "masterpieces." Even the word masterpiece, as Walter Cahn has shown, changed its meaning with the advent of the Renaissance. In the Middle Ages a masterpiece was a demonstration by a journeyman that he was skilful enough to be called a master. Let us look at the Logge, then, as a neo-medieval masterpiece, with Raphael and his team producing an abundant, complex, and joyous testament to their collective talents.

The idea suits Raphael. Modest in bearing, we are told, a charming man with many friends, lionized by the papal court, he is said to have traveled through the streets of Rome with an entourage almost like that of a modern show-business celebrity. He seems to have loved his assistants as friends and companions. And he was not "social" only in this sense but was a wonderful teacher. The more important workers in his studio—Giulio Romano, Gianfrancesco Penni, Perino del Vaga, Giovanni da Udine, and others—became significant in their own right. Vasari says that Raphael's total entourage consisted of about fifty persons, not a few of them—perhaps the majority—being artist-assistants. His Vatican projects, and particularly the Logge, thus constituted a kind of academy before true academies of art began to be founded.

In the Logge as planned by Raphael there were many media and genres to master: *finti* or painted-imitation bronze reliefs, imitation marble panels, and the like—the sort of thing we find in the dadoes

of the Stanze. A number of the vaults have what are called *trompe l'oeil* (fools the eye) architecture in which painted openings seem to rise into a blue sky. We also see early appearances of a phenomenon that became common during the age of the Baroque—*quadri riportati*—frescoes painted to look as if framed easel paintings had been attached to the ceiling. Aside from the trompe-l'oeil specialists, others specialized in painting fruit and flower festoons, in modeling stuccoes, or in landscapes. Still other specialties included making or designing the marble frames for the windows, doors, and niches (those in the Logge at one time contained statues), the carved wooden shutters for the windows and the wooden pediments for the doorways, and setting the colorfully patterned glazed tiles of the pavement, which came from the Florentine shop of the Della Robbia family.

The Logge, in short, are an encyclopedia of genres and techniques. In this mood of serious frivolity, of play between real and unreal, *finto* (fictive) and *vero* (true), not only were scenes from antiquity restaged, so were the very anecdotes of ancient painters. Everyone knew the stories of painters like Zeuxis who painted fruit so realistic that birds were fooled into trying to eat it. Vasari accordingly writes that during the painting of the Logge Giovanni da Udine painted a fictive balustrade with a rug hanging over it in one of the window embrasures. One day one of the palafrenieri, in a rush to prepare for some ceremony, vainly tried to flip the rug off the balustrade.

Raphael's very style has been an academy. It has taught generations of later painters right down almost to our own time. Indeed, since the Logge themselves are now partly ruinous, we have to thank the generations of careful copyists who went there all during the sixteenth, seventeenth, and eighteenth centuries, for their bright, meticulous portrayals of what Raphael and his shop accomplished (fig. 196). The Logge were not only a "lodge" or academy for its creators, they have served similarly for later artists.

The Chronology and Personnel

We noted that the decorative painting of the Logge dates mainly from between 1515 and 1518. Work was finished at the latest by May 1519. At this time, however, Giovanni da Udine had not yet decorated the loggia underneath Raphael's, while the ornament of the upper loggia was to wait till the reign of Pius IV. People generally agree that while Raphael composed most of the figure scenes for the main loggia, the chief of operations was Giulio Romano, who was also about to take up his demanding role as chief executant in the Sala di Costantino. Giovanni, meanwhile, a specialist in animals and plants, was responsible for the grotesques (for which see below).

There are thirteen vaults. Each has four biblical scenes placed at the compass points, oriented so that the bottoms of the four scenes are all set toward the vault's outer margins. (In most bays, as shown on the chart in figure 197, a fifth biblical scene is located in the dado.) Since this means that the viewer has to reorient him or herself for each scene in each vault (a total of fifty-two reorientings for the whole series), viewer convenience is clearly not the aim. Rather, that aim must have been the associational logic of each bay. The elaborate frames of the pictures meet in the center of the bay in a square panel, itself heavily framed with creatures, blos-

196. Watercolor copy of part of Raphael's Logge. Vienna, Österreichisches Nationalbibliothek, Codex Miniatus 33, fol. 16.

soms, feathers, and the like. In the center of each panel is a Medici diamond ring with three feathers (one of Leo X's imprese) or, alternatively, Leo's more personal impresa of a yoke, seen also in the Sala di Costantino, with or without the word *suave*, easy. All the considerable variations among vaults are mirrored symmetrically. In other words vault 1 has the same decoration as vault 13, vault 2 = vault 12, etc., until you reach vaults 6—8, which flank vault 7, exactly in the middle, and whose

decoration is unique. Each symmetrical pairing of bays also has its own color scheme.

Order is sustained in other ways. The biblical scenes are at the same human scale—unlike those in Michelangelo's Sistine Chapel, be it noted. The horizon line is always about two-thirds up the height of the whole. This again differs from Michelangelo. A standard scale, though smaller, also holds for the figures in the vault corners and for those placed along the

walls and pilasters. Such uniformities help make the whole continuous surface, as Sydney Freedberg says, "like a living skin upon the body of the architecture, mobile and porous, giving respiration to the underlying form."

The Biblical Scenes

I shall not go through every scene and every bay in detail; a sampling is sufficient. The biblical scenes, considered in their context of all'antica decorative detail, function like the illustrations in a magnificent Bible—one thinks of the manuscript

197. Plan of the Logge with arrangement of scenes. Author.

198. Page from the Hamilton Bible, mid-fifteenth century, folio 400v. Kupferstichkabinett, Staatliche Museen zu Berlin, Preussischer Kulturbesitz. Photo Jörg P. Anders.

shown in Raphael's portrait of Leo X (Pitti Palace, Florence; figs. 28, 198). In that painting the Hamilton Bible appears as a treasure belonging to the man who commissioned "Raphael's Bible," as the Logge are often called. And indeed the Logge decorations do look like enlarged pages from illustrated books (fig. 201). As with the typical illuminated manuscript of the period, too, the grotesques and arabesques below the Bible scenes are a forest of hidden symbols and allusions to the pope's family, status, interests, and identity, a way of weaving his name and attributes into a tapestry.

The first thought that comes to mind, looking at the biblical scenes themselves, is: "how like Michelangelo's Sistine!" The second thought is: "How unlike it!" Both ceilings concentrate on the Old Testament. But Michelangelo's nine bays are divided, we saw, into three groups of interlocked episodes. The actors in these main scenes, moreover, interact with the ignudi, the prophets, the sibyls, even with the ancestors below them. It is a system of reinforcement. And the emphasis is overwhelmingly on human perdition. The garden labyrinth of the Logge, in contrast, is almost joyful. One is not surprised that in the eighteenth century, when Haydn's charming oratorio The Creation (1799) was published, its cover displayed not Michelangelo's God Separating Light from Darkness, but the much more cheerful Raphaelesque recension of that event from the Logge. Raphael's Bible does try to challenge or at least meet Michelangelo on his own ground, we shall see; but it also does very different things. The painted Bible is in fact a sequence of genre scenes filled with incident, landscape details, groups. Raphael and Michelangelo, we might say, were in art as they were in life.

Raphael liked groups, companions, attendants. Michelangelo's heroes, like the man himself, act alone.

The diagram in figure 197 gives all the subjects (one must imagine all thirteen bays in a single line, of course, running from south to north). The extra subjects in separate panels, such as God Establishes the Sabbath in the first vault, belong to the vault series but are painted in the basamento or lower panel of each bay.

The First Bay (figs. 199, 200)

As we see on the diagram this selects events from the very beginning of Genesis, three of them the same as those in the Sistine. The fourth is God's creation of the animals. (Leo had a great liking for animals and established a zoo in the Belvedere.) Giovanni da Udine, we have seen, was meanwhile the Logge's animalier. Exotic animals (and plants) symbolized the expanding papal empire. Thus the Portuguese explorer Tristan da Cunha brought American specimens, some of which appear in the Creation of the Animals, e.g., the Colinus californicus (bobwhite).

For all its differences of mood and style the indebtedness of several of the Logge's Creation scenes to those in the Sistine is apparent. The two flying figures of God silhouetted against a bright cloudy sky as he creates the sun and the moon, or separates the sea from land, verge on parody. The same may be said of the Separation of Light from Darkness (fig. 199; compare fig. 148) "Here, pupil, mate the Sistine God with the Moses" (that statue was begun in 1515, just at this time; see Chapter 8). And look at the result: God, a great blimp, runs amok in the cosmos. By contrast The Creation of the Animals, which doesn't depend on Michelangelo but is

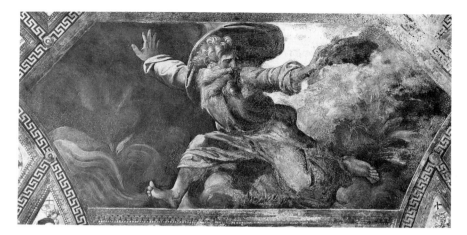

199. Logge, bay 1, *The Separation of Light from Darkness*. Alinari/Art Resource, N.Y.

more of a traditional Peacable Kingdom episode, is more successful (fig. 200).

The Creation of the Animals

This features a lion who is of course Leo X. Lions, indeed, like diamond rings and easy yokes, thickly dot the Logge's walls and pilasters. One reason Leo chose that name, aside from the kinship he felt with earlier popes named Leo, was that, when she was pregnant with him, his mother dreamed of giving birth to a lion "of great size and marvellous humanity." That may be why Giovanni's lions look so kindly. Next to the lion is a bear: this too is emblematic and personal. It represents Leo's Roman side through his mother, Clarice Orsini, daughter of a powerful Roman family whose name means "little bears." The vault against which these quadri are riportati, meanwhile, consists of a fictive woven arbor with diagonal openings through which one discerns brilliant legions of angels, their wings spread, their faces joyful. The garden motif—a garden of Eden?—is apparent once more. In the center, framed in a Greek-key pattern, is an angel bearing the SUAVE yoke.

Other Bays

The vault of the second bay is much more of a closed and paneled ceiling than that of the first. There is a play of squares, rectangles, and beveled corners. At the center in a large square skylight set with lozenges, a graceful angel carries a diamond ring. The four corner panels, meanwhile, contain grotesques with tiny jewel-like figures against dark backgrounds. The Bible scenes of this second bay depict the tale of Adam. No attempt is made to echo Michelangelo's *Creation of Adam*. But we do get replays of his *Creation of Eve* (as a presentation of Eve to Adam), *Temptation*, and *Expulsion*. The fourth scene is *Adam and Eve Laboring*.

The same general ideas hold for the third bay, devoted to Noah. Three of the scenes revise Michelangelo, though subjects and poses are differently divided, with the *Construction of the Ark* and the *Exit from the Ark* as two separate episodes. But

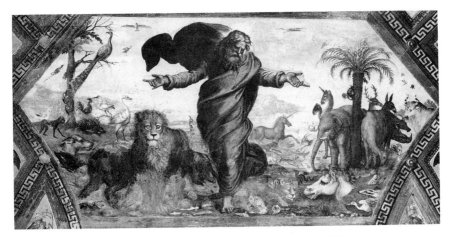

200. Logge, bay 1, *The Creation of the Animals.* Alinari/Art Resource, N.Y.

the *Construction* hews to Michelangelo in another way, for two of the sons of Noah constructing the boat are nude. The *Exit* allows Giovanni da Udine to paint more of his exotic plants and animals.

But now we begin to sense that the underlying iconography of the Logge is really different from that of the Sistine. As in Giotto's upper church at Assisi each bay will be devoted to an Old Testament hero: Abraham, Isaac, Jacob, Joseph, Moses (who gets two bays, the eighth and ninth), Joshua, David, and Solomon. The last bay, the thirteenth, as noted, portrays the life of Christ. In such a sequence the Old Testament heroes become types of Christ, and all thirteen then become types of Leo X. Let us recall from the Introduction that this was exactly the scheme Giles of Viterbo had proposed for Julius II. That pope, like Leo here, was seen as a sort of *summa* of specific biblical predecessors.

The Seventh Bay (fig. 201)

The central seventh bay is the only one in which generalized papal symbolism joins

that of the Medici and of Leo as an individual. We have also seen that in terms of color this bay functions as the axis of mirror symmetry for the whole. These scenes tell the story of Joseph, favored son of Jacob and Rachel, who was sold into slavery by his brothers, they being jealous of his prophetic dreams and of the many-colored coat Jacob had given him. Joseph's life had several parallels with that of the young Giovanni de' Medici. Both were famed for their chastity. Both were imprisoned. Joseph was released and became governor of Egypt. Giovanni, on his release from prison, became pope.

If Joseph's career is a type for Leo's youth, his type as pope is mapped in the next two bays, devoted to Moses. The main Old Testament type for any Renaissance pope would be Moses. He, after all, both priest and prince, had received the law directly from God and sealed it in the ark of the covenant. That ark, in turn, was the kernel of all successive Jewish and Christian temples and ecclesiastical jurisdictions down to and including St. Peter's and the Vatican. One can add that Moses,

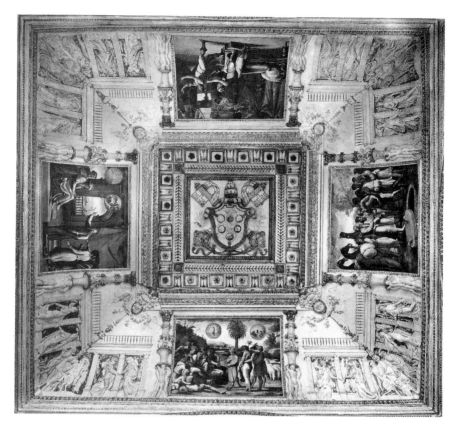

201. Logge, bay 7, four scenes from the life of Joseph. Alinari/Art Resource, N.Y.

like Noah before him, urged his people into foreign-settlement enterprises just as the popes were doing.

The Tenth Bay
(figs. 202, 203, 204, 205)

We might look at the career of Joshua as mapped out in the tenth bay. Joshua was Moses' anointed successor; a book of the Bible is named after him. After Moses' death Joshua marched with his people to the land of Canaan, flowing with milk and honey, which had been promised him by Jehovah as the Jews' new home. Joshua obtained the land by driving out, slaughtering, or enslaving the native Canaanites. To us, perhaps, his behavior may recall the present struggle, in roughly this same piece of country, between the Israelis and the Palestinians. But the court of Leo X would have thought of the constantly preached crusade to wrest the Holy Land—again, in part that same Canaan—from Islam.

The exploration and occupation of the Western Hemisphere and the exploits and reversals of the papal armies would have come to mind as well. After papal arms were defeated at Ravenna in 1512 by the

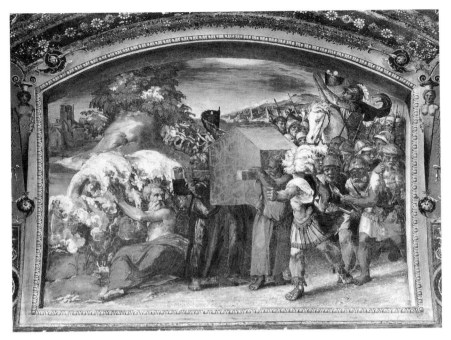

202. Logge, bay 10, *Joshua Crosses the Jordan*. Alinari/Art Resource, N.Y.

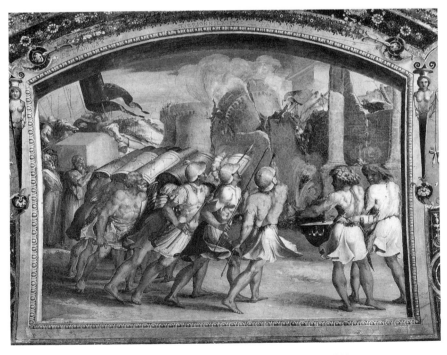

203. Logge, bay 10, *Joshua at the Battle of Jericho*. Alinari/Art Resource, N.Y.

French, Giles of Viterbo explicitly evoked Joshua, noting that his victories were accomplished through prayer rather than superior arms. Meanwhile God's speech to Joshua in Joshua 1:3 directly recalls the language with which Alexander VI had divided up the lands of the Western Hemisphere between Spain and Portugal. So do chapters thirteen through twenty-one, which give a detailed account of the division of Canaan and adjacent lands among the tribes of Israel. God's assurances to Joshua that nothing on earth can prevent the takeover, and that the courage of the indigenes would melt before Israel's might (Josh. 2:11), are also to the point.

The first event shown is Joshua's nighttime crossing of the Jordan (Josh. 3; fig. 202), whose waters miraculously rolled away from the Jews' path allowing unhindered passage for ark and people. In the painted scene the Jordan is a hoary river god, reclining on the left as he prevents a foaming wave from breaking over the army. The ark at the center is borne by priests, while Joshua, plumed like a classical warrior, exhorts the troops who march menacingly behind him, eyes hot and spears forward. At Sechem Joshua installed the ark of the covenant. It was marked by a stone beneath an oak and was the sanctuary of Jehovah, to whom Israel swore eternal obedience. We also see the fall of Jericho (fig. 203), its towers (reminiscent of the fortresses at Ostia and Civitavecchia, by the way) cracking and falling in flames, the hapless defenders tumbling from them, while the victorious Israelites march round and round. Their drums have thundered the city into collapse.

After having sacked many other cities Joshua fights against another native community, the Amorites (fig. 204). Things go badly for Israel but then God rains stones on the enemy. On the final day of battle Joshua commands the sun and the moon to stand still while he delivers the final blow. In a vigorous battle scene Joshua, on a white horse, flings out his arms as the sun and moon stop dead in their courses (Josh. 10:13). The echo of the first bay of the Logge, and of Michelangelo's *God Creating the Sun and Moon* (fig. 149), is patent.

In the last scene the aged Joshua divides up the conquered lands among the tribes and sub-tribes of Israel (Josh. 13: 1ff.; fig. 205). He is helped by the priest Eleazar in accordance with orders left by Moses. There is no doubt of the typological play here, for Eleazar's garb resembles that of a bishop. Before the two of them, seated side by side beneath an honorific altar hanging—another modern touch—a putto brings land deeds out of a large vessel and hands them to the settlers' families. One thinks of the many such benefactions by Leo X to his Medici relatives—or for that matter of Alexander VI's division of the New World between Spain and Portugal.

The Thirteenth Bay (fig. 206)

The four main scenes of the thirteenth and last bay are the only ones devoted to Christ: *The Adoration of the Shepherds, The Adoration of the Kings, Christ's Baptism* (fig. 207), and the *Last Supper*. The *Adoration of the Shepherds* combines two images, one of the Virgin reverencing the child, delicately touching its feet in an act of obeisance as the babe reaches out to her, and secondly the adoration of the shepherds who bring gifts of game and garlands. In the neighboring scene the kings perform this same ceremony of foot-touching.

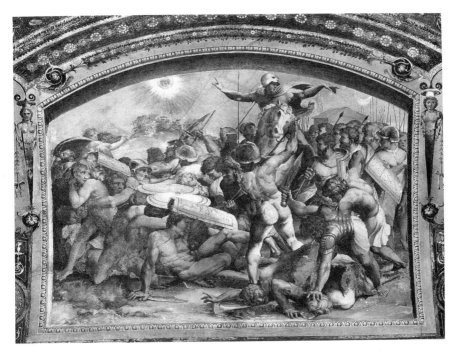

204. Logge, bay 10, *Joshua Fights the Amorites*. Alinari/Art Resource, N.Y.

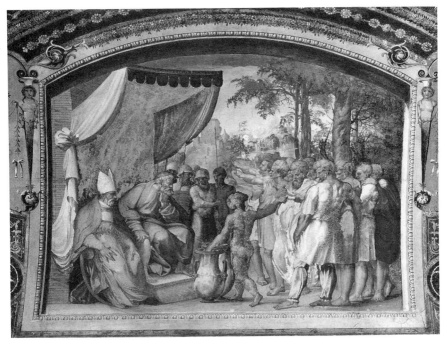

205. Logge, bay 10, *Joshua Divides His Lands among the Tribes of Israel*. Alinari/Art Resource, N.Y.

In the next event John the Baptist, dressed in tawny fur, stands on a rocky place in a river's curling currents and sprinkles the Redeemer with the water of grace. It is a traditional version of the event and we recall the importance of John the Baptist for Leo and the Medici. Meanwhile it was at the Last Supper that the New Testament was promulgated. That new testament, or covenant, is what binds the Christian to take Christ's body and blood into his own body at the mass. In the Logge the scene also expresses the apostles' terror at Christ's announcement that he will soon die, betrayed by one of them. In emphasizing this terror Raphael, as would Michelangelo in the *Last Judgment*, pays a debt to Leonardo's picture. Compare, for example, Cosimo Rosselli's sedate and uneventful version in the Sistine. In the Logge, in contrast, the apostles forsake decorum. They are bewildered and angry. They accuse each other, they argue, and one rises from his bench in anger (Luke 22:24).

Below in the basamento is the epilogue: *The Resurrection*, when Christ's body emerges from its tomb and is about to ascend to heaven, completing the earthly cycle that had begun with the creation of

206. Logge, bay 13, vault. Alinari/Art Resource, N.Y.

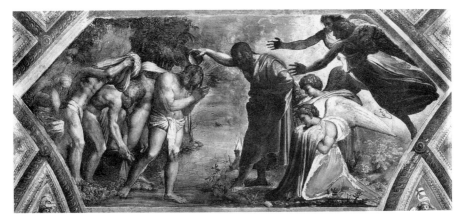

207. Logge, bay 13, *The Baptism of Christ*. Alinari/Art Resource, N.Y.

the cosmos. We recall that this last bay leads directly into the Sala di Costantino where the official visitor would come into the pope's presence. Thus the Logge are a decorated waiting room provided with the inspirational illustrated reading matter such rooms so often offer.

The heroes of Raphael's Bible, then, are a succession of divinely appointed rulers of the Hebrews. They function as the founders of the tribes of Israel, as the keepers and continuators of God's covenant, as kings and high priests. In a manner that, we now see, is remarkably *unlike* the Sistine ceiling, but is like the Stanze, Raphael's Bible buttresses the Renaissance papacy's claims to extensive temporal and universal spiritual rule. It justifies the existence of warrior-popes, of lawgiver-popes, of conquest and colonization.

If we compare the scenes in the Logge to the pre-Michelangelo episodes on the Sistine walls we immediately sense how Michelangelo's enormous influence looms between the Quattrocento art and that of Raphael's "academy." In contrast to the earlier glittering panoramas, full of land-

scape, architecture, and clouds, with their graceful courtiers and solemn heroes, we have in the Logge a close focus on a few figures usually embroiled in powerful emotions. They rush, they battle, they quail, they swoon, they bristle. Strong horizontal compositions replace the decorous layerings of the earlier work. God creates violently, and the same vehemence pervades the Deluge, the story of Lot, Joshua's passage across the Jordan, the fall of Jericho, the frantic stopping of the sun and moon, David and Goliath. Even scenes that one might think would be calm, such as Moses receiving the tablets of the law from Jehovah, are pervaded with vertiginous terror.

Renaissance Paganism

Now we look at the pagan underpinnings of some of these Christian scenes. The non-Christian episodes decorate the walls and pilasters and in fact cover more territory than do the biblical events. The pagan figures, furthermore, are more evident and visible. And indeed through the centuries

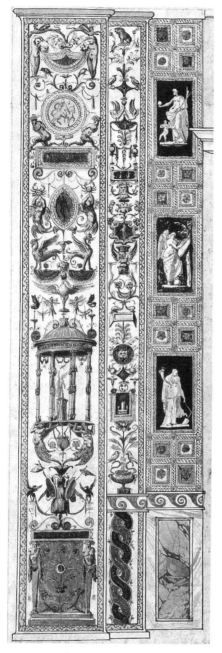

since the Logge were created it is these episodes that have garnered the lion's share of praise and blame. Why blame? Because Greek and Roman gods are depicted, and other pagan characters as well, and because some of them are dressed, or are behaving, indecently. Indeed, Bernice Davidson's book is in part an attempt to justify the presence of the pagans in this papal context. Thus, she claims, a Medea in the bay devoted to the creation of the sun and moon is there because Medea was called the daughter of the sun. Nicole Dacos, the other main expert on the Logge, takes exception to these interpretations but I myself do not see what's so wrong with them. They are the very stuff of Renaissance symbolism. But the differing views of Davidson and Dacos do highlight a controversy we have already looked at in discussing the Statue Court: is paganism a welcome anticipation of Christ or is it a satanic substitute?

For the most part, and particularly in regard to ancient art with its gods and goddesses, the Reformation took the satanic view. In the decades immediately following the completion of the Logge, positive, so-called "syncretic" interpretations of antiquity came to seem heretical. That attitude is presaged by Erasmus who, in his *Ciceronianus*, bitterly criticizes the Latin poets of his time for treating holy writ with the same *disinvoltura* they used for pagan myths. Today, still, we are so used to the idea of an essential conflict between paganism and Christianity that it takes a special effort to put ourselves into the syncretic mood of Leo's court.

Let us turn back the *Baptism of Christ* in Bay 13 (fig. 207). On the left are nude youths who move in a dense crowd toward Christ, stripping off their clothes. In terms of the narrative they represent others who

208. Watercolor copy of part of Raphael's Logge. Pilaster with grotesques. Vienna, Österreichisches Nationalbibliothek, Codex Miniatus 33, fol. 3.

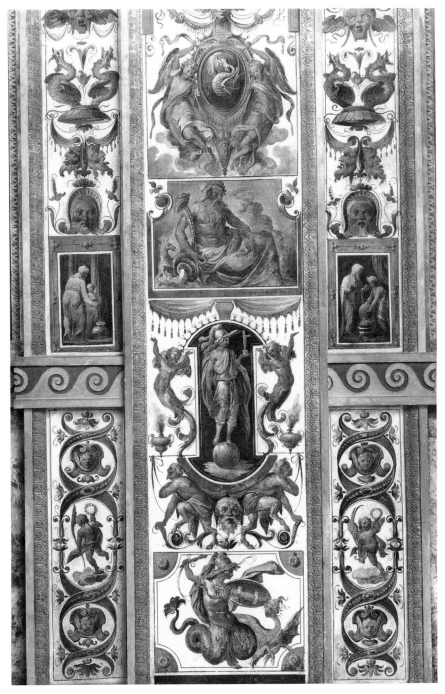

209. Logge, grotesques on pilaster. Alinari/Art Resource, N.Y.

are to be baptized. But in terms of the picture's formal sources they are clearly imported from some antique, hence pagan context. Why should pagan heroes migrate to a Christian context and line up to be baptized?

Well, why not? Christ was, after all, himself an ancient. And we can provide a less obvious, supplementary answer by looking at a poem. A number of important Renaissance Latin poems, such as Jacopo Sannazaro's *De Partu virginis* (1521), support Davidson's position and show us how pagan images and personalities can augment events in scripture. The *De Partu* was written as a Christian completion of Virgil's *Aeneid* (which is unfinished). Thus in Sannazaro's poem the tale of Troy's end and Aeneas's long pilgrimage to found the city of Rome is given a new climax dealing with the birth of the Virgin Mary (supposedly predicted by Virgil) and with the prospect of Christ's own birth, ministry, and passion. Accordingly not only the style and meter but even the subject matter of Sannazaro's work are almost as pagan and antique as Virgil himself.

Here is Sannazaro describing the baptism of Christ. It is a monologue recited by the River Jordan and addressed to the Baptist: "There gods forget their pride, rush out to you,/And bare their holy bodies as they sing,/ While naked in the river you accept/The author of all things, of angels and of men. . . . "(*De Partu virginis* 1.401). This could almost be a description of Raphael's composition. It is paganism's obeisance to Christ. Nor is the obeisance merely implicit. Thus in line 477 of this same book Neptune casts aside his trident and, together with his female companions, "kisses impetuously the sacred feet" of Christ. The point is not that paganism is expunged but that it is sub-

dued and redeemed. And, once redeemed, it continues to exist and flourish. As Joseph and the pregnant Mary approach Bethlehem Joseph exclaims:

Country of kings to whom a king shall come,
Whom Sol and his twin twisting axes serve,
Hail! The infant Jove in his Cretan cradle
Trembles and forswears his empty cult;
Thebes shakes, and Latona's twins
Are loath to praise Apollo. . . .

(2.254ff.)

Book III, the last, is as much a hymn to Jupiter as to the Christian God: in fact the two divinities more or less swear eternal friendship, though with Jupiter in a slightly lesser role. And the landscape, the atmosphere of the poem, remains that of a freshly minted antiquity. When God gives the sign that indeed the child in the Virgin's womb is his son, this is done "That all may hear who are surrounded by/Great Ocean, Tethys, and raucous Amphitrite" (1.201–2).

It is in a similar mood that Sannazaro stages the two adoration scenes, of the shepherds and the kings, so that they mean the earth's acknowledgment of the rule of Christ. One notes that the shepherds are attended by Virgilian folk:

Lycidas stood near
The child, and noble Aegon whose large herds
Graze Gaetula's fields and in their hundreds
Roam Massyla; Aegon, leader at
Bagrada, where on Cyniphia's rolling sands
The triton sports. . . .

Still later we see nymphs paying court to the holy child.

Glauce, the beautiful Lampothroe,
Doto, Proto, and Galena swell
The attendant train with joyful faces, and,
Breasts and shoulders nude, clothes undone,
Callirhoe, Byro, Pherusa, and

Dinamene, and fluid Asphaltis;
And perfumed Anthis, better than the rest
At colors and at forming painted crowns
To decorate their hair

 (248–93)

This is pretty bold. One doesn't see visual images, in the Renaissance or any other period, of pagan nymphs attending the Christ child—though there can be angels in dishabille, e.g., in Correggio and Caravaggio, that can come pretty close. Yet Sannazaro is among the most visual of poets. Sometimes he seems simply to be writing descriptions of imaginary Renaissance pictures. A painter or *stuccatore*, in this same mood, could very well link a scene of Joseph and Mary with one of Apollo and Latona, stage a birth of Zeus as a preamble to that of Christ, or at least introduce nymphs into a neighboring cartouche. And in fact this is precisely what we see all throughout the Logge.

The Stucchi

Many of the pagan ornaments in the lower parts of the Logge are executed in stucco. These in turn were inspired by the discovery of antique specimens of the art form in Capitoline Hill excavations. They are called grotesques—*grotteschi*—because they were found in the cellars, or grottoes, of the ancient palaces. In them nature has gone charmingly berserk. They consist of hosts of tiny ornaments, of flowers, plants, beasties, gods, and mini-scenes, often seeming to grow one out of the other and comprising an underground world, an ancient Middle Earth (figs. 208, 209). The fact that grotesques were found in the grottoes of the infamous Nero and that they depicted activities such as bestiality, pagan sacrifice, and so on, often enacted by nude infants—all this contributed to

the sense of a nature unredeemed and uncontrolled and gave its modern meaning to the word "grotesque."

Earlier I quoted Vitruvius's description of this art. What I did not say was that it was part of an attack. He castigates particularly the representation of monsters, plants, animals, and people made up of disparate parts—human torsos with foliage legs, for example. Raphael's decision to cover the Logge with just such things is thus an anti-Vitruvian move, which, despite the "Vitruvian" architecture of his latter days, matches his disappointment with that author when he finally got to read Fabio Calvo's translation of the Latin text. In any event the artist clearly wished to exercise himself in recreating, like some second maker of the natural world, "such things [as] neither are, nor can be, nor have been," as Vitruvius puts it.

Empedocles

What else might have inspired Raphael? Do grotteschi have any substantive meaning? Empedocles, the Sicilian philosopher of the fifth century B.C.E., preserves a creation myth that throws light on these questions. He pictures humanity's creating goddess as Aphrodite, who is originally not a goddess of love and beauty but a sculptress. First, as the basic substance from which all life will be created, she makes clay. The water she uses for it is the "glue" or *harmonē*, harmony, that binds the earth together. Aphrodite's genius, in fact, is her ability to make disparate substances and entities blend and bond, which of course foretells her role as the love-goddess. Empedocles then speaks of Aphrodite pouring her clay into "eight broad-breasted melting-pots" in accordance with set proportions of earth and

water. She adds other fluids, some from her own body. The clay is then set in molds, one of which is her own womb. On removal the newly formed plants and creatures are hardened by the two other elements of creation, air and fire (i.e. wind and sun). Nor does Aphrodite rest here; she is also a painter. She colors her creations with the four humors—presumably blood, phlegm, and black and yellow bile—that Empedocles describes as "the four colors of art." She uses them, he says, "as painters. . . . decorate temple offerings with pigments and produce the semblances of all. . . . things."

Most of these early beings, however, are incomplete or monstrous. Heads are without necks, arms without shoulders. There are men who have the heads of animals, animals with human heads, androgynes. Other creatures have human heads that turn into leaves and fruit. It is only later on, after this false start, that the goddess manages to produce the normal animals and plants we see today, including men and women with their "beautiful bodies."

I believe that the grotesques executed in stucco all over the lower parts of the Logge similarly represent the odd creatures of Aphrodite's first creation—or something very similar. Empedocles' poems were well known to the Renaissance since most of the fragments we have exist today only because Aristotle quoted them. Moreover, one of the artists involved in the Logge, Pirro Ligorio, defended the grotesques in an Empedoclean phrase as "depictions of the fragile, weak beginnings of our actions." In other words Pirro, like Empedocles, saw monsters, men with plants emerging from their heads, and the like, not simply as odd bits of fancy but as an early stage of creation. It is also inter-

esting to notice that the bay in the Logge devoted to the creation of humans and animals displays not only Empedoclean monsters but, in the biblical paintings, exotic animals such as elephants and giraffes—and we have noted the California bobwhite—as well as mythical ones like the unicorn and the basilisk (a large lizard with fatal breath and glance).

In this same Empedoclean sense we can see, among the grotteschi in the Creation bay, scenes of students and assistants mixing colors, pouncing cartoons, and the like. They are of course the "students" at the "academy"; but like the creator-goddess Aphrodite they are also makers of images peopling a world.

The "Fortuna Critica" of the Logge

The other monuments discussed in this book have always been so famous that it is pointless to list all the later art they inspired. But the Logge, though once equally famous, are today little known. It is therefore worth pointing out that they too became an important model for later decorative programs in public buildings. Almost as soon as they were finished, Cardinal Giulio de' Medici was commissioning similar grotesques for the Villa Madama (fig. 61). We see important reflections of them in the papal apartments in the Castel Sant' Angelo (fig. 12). Correggio in the Camera di San Paolo, Parma, Parmigianino in the cathedral also at Parma, and at Fontanellato, Beccafumi in the Palazzo Bindi Segrardi, and many other artists, were similarly inspired. The same may be said for the private suites in the Castel Sant' Angelo and for Pirro Ligorio at the Casino of Pius IV. The designs were also diffused in drawings and prints throughout Europe. Sisto Badalocchio and Giovanni Lanfranco

210. Costantino Brumidi, grotesques and scenes in the Capitol, Washington, D.C.

produced the earliest set. Louis XIV personally directed Poussin to supervise the making of another, executed by Nicolas Chapron, which was widely known and used in France.

In 1778 Catherine the Great, empress of Russia, determined to have a full-scale replica of the Logge erected in her St. Petersburg palace, the Hermitage. Having seen a bound volume of prints of the scenes she wrote to a French correspondent, Baron Grimm, in language that establishes the monument's rapturous reception in the eighteenth century:

I could die, I could die, certainly; [I experience] a great sea-tempest, worse than can be imagined; I was this morning in the bath, which made the blood rush to my head, and this after-

noon the vaults of Raphael's Logge fell into my hands [i.e. she looked at the prints]. The only thing that sustains me is hope: I pray you, save me. Write immediately to Reiffenstein [an agent], I beg of you, to have these vaults copied at full scale, and the same for the walls, and I vow to St. Raphael to have these Logge built, whatever it costs, and there to install the copies, for it is an absolute necessity that I have them just as they are. I have such a veneration for the Logge, the vaults, that I promise the funds for this structure, vowing that I will have neither peace nor repose until it is under way.

The replica was indeed made and can still be seen in the Hermitage. Something approaching another replica adorns the salon in the Château de Bagatelle, by Béranger, 1777–87; indeed Dacos attributes the origins of the Louis XVI style in part to

the example of the Logge. Thus too did Stendhal in 1830 quote French visitors to the Logge exclaiming: "Quel genre Pompadour, quel rococo!" The prestige continued. In the nineteenth century, under Ingres' supervision, a replica of the Vatican masterpiece was installed in the Paris Ecole des Beaux-Arts.

There is an American chapter to the tale. In the latter half of the nineteenth century the dome, corridors, and other spaces of the newly enlarged Capitol in Washington were decorated with patriotic scenes by the Greek-Italian artist Costantino Brumidi (1805–80). Brumidi, born in Rome, and whose work may still be seen

there (frescoes in the Cappella della Madonna dell'Archetto, via di San Marcello near Santi Apostoli) was an Italian patriot who participated in the founding of the short-lived Italian Republic that saw the light in 1849ff. Subsequently he emigrated to America, anxious to place his services at the disposal of the country he most admired in the world. Brumidi's prior experience as a decorative painter had consisted, among other things, of restoring Raphael's Logge. In adapting them for the Capitol he exploited both the grotteschi and the biblical scenes, the latter being transposed into events in American history, which Brumidi saw as a bible of freedom (fig. 210).

8 The Tragedy of the Tomb

ichelangelo's biographer, Ascanio Condivi, refers to the long story of the artist's involvement with Julius's funeral monument as "the tragedy of the tomb." And Michelangelo meanwhile saw himself almost as one of the marble captives he planned for the tomb's pilasters: "I find I have lost my entire youth tied to this tomb." The tragedy of the tomb includes noble moments as well as ignoble ones. And it is not the final result that teaches, but the story itself, which speaks eloquently of Renaissance visions of history, scripture, and the meaning of death. It maps the final fate of Julius's dream. And it exposes, as does almost nothing else, the age's controlling concern with complicated artistic programs.

Michelangelo was commissioned to begin work on a tomb for Julius II in March 1505, thirteen months before the cornerstone of the new basilica was laid. The two projects were soon temporarily united. In one scheme Michelangelo's monument was to go directly under the basilica's central dome. In another it would occupy the apse built on Rossellino's foundations (fig. 17), which was to be known as the Cappella Giulia.

But whatever plans there once were to put the tomb inside the church, in the end the destinies of the two monuments were separate and opposed. The church rose slowly but gloriously. The tomb, despite equally glorious intentions, was ultimately a disappointment, even an embarrassment. Had it been completed according to any of various earlier designs, and had Michelangelo been its sole executant, it would have constituted the artist's most ambitious and

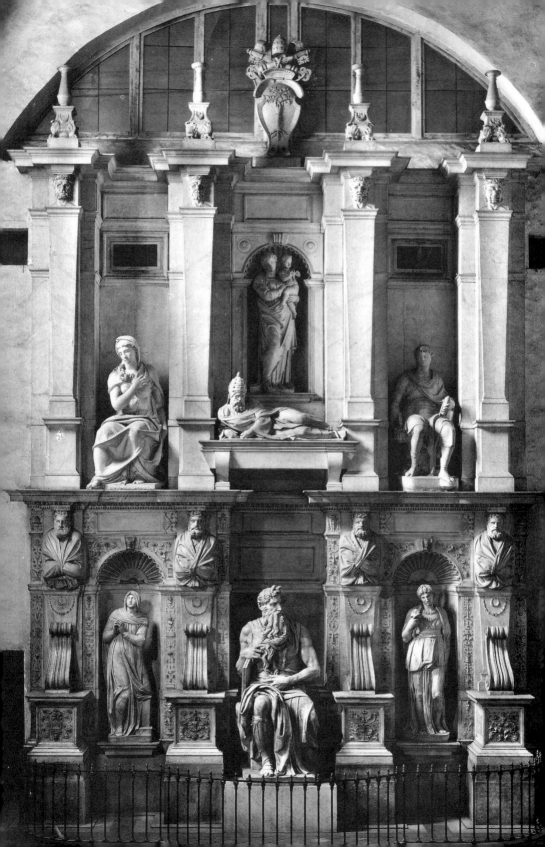

probably greatest work of sculpture. Today, however, it exists only as a dismembered captive, stripped and immured, in Julius's old church of San Pietro in Vincoli (fig. 211). Even so, the many vicissitudes, compromises, and defeats that led from the grand beginning to the abortive end produced some marvellous statues.

Was Julius guilty of hubris in contemplating his own tomb as a centerpiece in the new basilica? And there is, indeed, evidence that amid its many variations in size and sculptural population the monument was at one point conceived as being dedicated to Peter and Julius both. Such a double monument would have been perfectly proper in a building whose main purpose was to memorialize the burial place of the prince of the apostles. It would also partly have relieved Julius of the charge of egotism.

But let us look also at Christ's own tomb, so frequently evoked by Giles. The tomb of Christ in the Church of the Holy Sepulchre, Jerusalem, throughout many changes and remodelings, has always been a good-sized marble *arca* or mini-building. The church itself was one of the models, we recall, for the new St. Peter's. The sepulchre, meanwhile, had inspired one of the most important Renaissance tombs in Italy, in Leone Battista Alberti's Rucellai Chapel in San Pancrazio, Florence, dating from 1467 (fig. 212). From there its influence proceeded to Michelangelo and the tomb of Julius.

In the diagram (fig. 213) we see on the top line the dates of the six different designs for the tomb. Underneath are boxes,

211. Rome, San Pietro in Vincoli. Michelangelo and others, Cenotaph of Julius II, 1514–45. Alinari/Art Resource, N.Y.

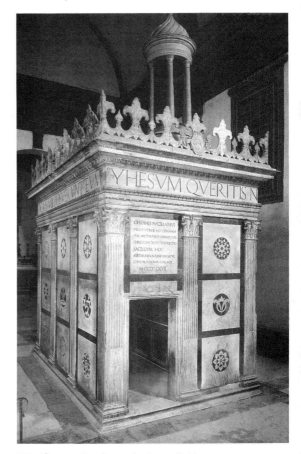

212. Florence, San Pancrazio. Leone Battista Alberti, Rucellai Chapel, 1467. Alinari/Art Resource, N.Y.

alternating gray and white, for the reigns of the popes (the slender rectangle after Leo X is Adrian VI), The various elements for the tomb that Michelangelo made are noted above the horizontal line. Below it are his other main projects during these years (see also the Chronology at the end of this book). We know from Michelangelo himself that at the outset, in 1505, he made several designs, one of which the pope then chose. These variants, along with the five later contract designs, explain

the variety of projects found in surviving drawings by Michelangelo and his copyists. Work on the six contract versions of the tomb is spread, in distinct intervals, from 1505 to 1545—that is, from the artist's thirtieth to his seventieth year. So all during his work in Rome and Florence on the Sistine chapel ceiling, the Medici chapel, the *Last Judgment*, and the frescoes in the Cappella Paolina, Michelangelo was haunted by thoughts of the tomb.

Michelangelo's Earlier Work in Rome

When Julius first summoned Michelangelo to Rome the artist already had two notable works there. One was the *Bacchus* of 1496 (now Florence, Bargello; fig. 214), a neo-antique vision of the young god drunk and staggering, carrying a large jewelled winecup in his right hand and a bunch of grapes in his left. These in turn are nibbled by a smiling infant satyr who snuggles against the god's leg. We will see

a comparable idea in one, and perhaps two, of the captives made for the Julius tomb (figs. 221, 222). The second of the two works was more famous—the *Pietà* of 1498ff. now in St. Peter's, already discussed (fig. 22).

There are qualities in these earlier works that reappear in the tomb. They record the thirty-year-old artist's developing concern with nudes of a high degree of luminous and even reflective polish. Michelangelo also replaces the normal hieratic solemnity of Renaissance sculpture with a relatively new emphasis on expressions of altered mental states like drunkenness and rapture, anguish and yearning. This will lead in the work for Julius to statues that embody despair, anger, and other moods hitherto uncommon (though not unknown) in the lexicon of monumental sculpture. Perhaps the artist's greatest achievement in his work on the tomb was to vivify funeral sculpture with these powerful emotions.

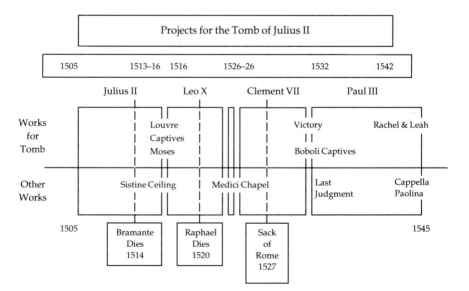

213. Diagram of dates for the tomb of Julius II. Author.

But the closest connection between the tomb and Michelangelo's other work lies in the slightly later *St. Matthew* of c1506, now in the Accademia, Florence (fig. 215). The *St. Matthew* is a marble block well over eight feet high, an unfinished statue in the round, commissioned by the Arte della Lana, the Florentine guild of wool merchants. It was to be part of a set of twelve marble apostles for the choir chapels of the cathedral, the contract specifying that each would take about a year to complete. Yet (because the commission for the Julius tomb interfered) Michelangelo in

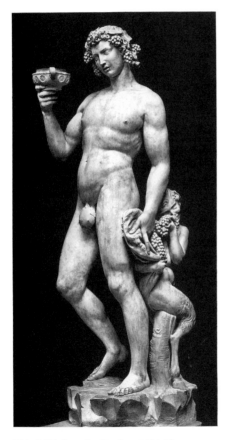

214. Michelangelo, *Bacchus*, 1496. Florence, Bargello. Alinari/Art Resource, N.Y.

the end left only this one unfinished statue and several drawings for this and other apostles. But it is the look of the figure, and even its unfinished state, not its date and contract, that most link it to the tomb. Matthew, a broad muscular man, is one of the first of a type that will mark much of Michelangelo's mature work. He writhes as one bound in chains, his noble bearded face twisted sidewise in what seems an agonized desire to escape. The pose, and the exiguous drapery, comprise an extraordinary concept for an evangelist. Normally, in earlier art, such sacred authors were sternly upright, abundantly robed, carrying the volume of their writings.

By this time the artist had already begun work on the similarly conceived *Captives* for the Julius tomb (see below). Scholars say he was applying his concept for the tomb's *Captives* to this Matthew; that is clearly so. But why? Why show an apostle struggling and bound? We have seen that the idea of captivity, particularly of the Church as the bound prisoner of evil forces, was strong in Julius's thought. But did the Arte della Lana share this obsession? And yet the notion of monumental apostles imprisoned in their niches has as much theological appropriateness in Florence as in papal Rome. It was St. Paul who declared that bondage to Christ was perfect freedom and Matthew himself who said (in what became a Medici motto) that it was a joy to bear Christ's yoke. That the apostles saw themselves literally but happily chained to their mission, and to their savior, was a commonplace. We shall return to these ideas.

The Project of 1505 (fig. 216)

The first act of the story may seem more of a fencing-match or ballet than a tragedy.

After Michelangelo had been working
for thirteen months—an effort mainly
concerned with inspecting and acquiring
marble—the pope suddenly discharged
him. Usually this is linked to the selection
of Bramante's design for the new St. Peter's,
and it is certainly true that Michelangelo
saw Bramante as a dangerous rival. But I
find no reason to think that Michelangelo's
tomb would "not have fitted into the new
church" as some have claimed, and there-
fore that Bramante's appointment automati-
cally meant that Michelangelo's project
was being abandoned. It is true, though,
that Michelangelo may have felt that funds
for the tomb were to be sacrificed in favor
of Bramante's project. Anyway, when Mi-
chelangelo sought redress he was literally
thrown out of the papal court. It was this,
in turn, that led to his dramatic departure.

Yet, perversely, Julius was incensed at
Michelangelo's flight. And, in a turnabout
symmetrical with Julius's, the sculptor
soon made it known that he would be
willing to continue with the tomb if he
could do so in Florence. By this time,
however, in yet another twist, Julius had
decided to have Michelangelo return to
Rome and paint the Sistine ceiling. (This
was in 1506, two years before that work
was actually begun.) Some have claimed
that the suffering Matthew portrays the
artist's vision of himself imprisoned by
Julius's unpredictable will. Others have
even suggested, with some reason, that
with its fictive sculpture and monumental
seated seers and ignudi, which so corre-
spond to figures being planned for the
tomb, the Sistine Ceiling is a kind of la-
ment for Julius's temporarily aborted
monument.

We have descriptions of this 1505
scheme in Condivi and Vasari, plus draw-
ings, and the elements from it that are

preserved in later versions of the tomb.
Needless to say scholars disagree about
details. From it all we do learn, however,
that it was to be a freestanding edifice,

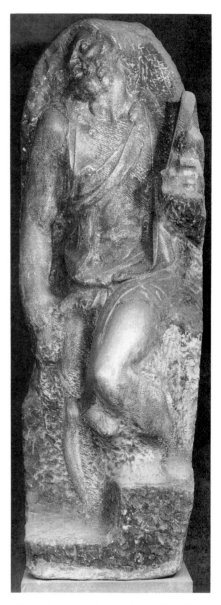

215. Michelangelo, *St. Matthew*, c1506. Flor-
ence, Accademia. Alinari/Art Resource, N.Y.

rectangular in plan, measuring 12 by 18 Roman braccia (23'7" by 35'4"). Inside was to be a small chapel, oval in plan, entered by a door or doors on the shrine's narrow axis. The sarcophagus was to stand in this chapel.

On the exterior were to be pilasters carved as termini or herms rising out of tall pedestals. In antiquity such figures presided over boundaries—for example those of provinces and cities. When employed in shrines and temples they marked the border between the divine and the secular. The word *terminus* makes that point. Herms, on the other hand, which in function and appearance are practically interchangeable with termini, were originally images of Hermes. But Hermes also has to do with borders. He controls them in general and, in particular, conducts souls beyond the confines of the land of the living to Hades.

In front of each of the herms, bound to the boundary gods, was to be a naked captive. The captives, like the herms, belong to classical tradition. Such statues were displayed as pillars on buildings. Vitruvius mentions a Persian Portico in Sparta in which images of captured enemies were displayed, though these were bound not to herms but to columns. In the early sixteenth century caryatid figures of a different type were common on tombs, most often as bearers of the sarcophagus. Voluminously draped, representing virtues, they bore the bier along in a marble re-creation of an earthly funeral procession. Eugene J. Johnson has shown that Michelangelo's herms with struggling bound men are very much a novelty for their time.

Above the tomb's main story were to be seated figures, one of them an early form of the *Moses* that now appears on

216. 1505 project for the tomb of Julius II. From Charles de Tolnay, *Michelangelo*.

the existing tomb. Infant caryatids, much like the ones we saw in the Sistine ceiling, support the ends of parapets separating these seated statues and providing them with thronelike settings. In the center of the main narrow end, between the seated personages, the pope's sarcophagus appears (a dummy; the real one, we saw, was to be inside) seen end-on. Two winged nude angels set the body in cope and the triple crown, into the sarcophagus. (At least one surviving study shows the pope nude, except for the crown—and with no attempt to heroicize his plumpness.) Putti perched on the cornice completed the tableau.

All this probably gives a falsely consistent idea of conceptions that were actually in flux. Not only the basic architecture and arrangement, but the personages chosen seem to have been subject to alteration. One constant figure, however, is the *Moses*. Aside from him, according to Vasari and Condivi, the other people in the upper

217. 1513–16 project for same. From Tolnay.

zone were the *Active Life* and the *Contemplative Life*—these could well have been seated versions of the *Rachel* and *Leah* we see in the finished tomb—and *St. Paul.* Vasari had said, meanwhile, that the two figures associated with the coffin were one of them *Heaven*, who smiled with happiness as she welcomed the pope, and the other *Cybele*, Earth, weeping at her loss. It is notable that a drawing in Milan of the catafalque or temporary funeral structure for Michelangelo's own funeral, years later, shows two seated angels or allegories (one perhaps weeping, the other perhaps smiling) on either side of an end-on sarcophagus in which the body of the artist half-lies, half-sits, just as in the drawing for Julius's tomb. An inscription on this design says, moreover, that the design is based on the 1505 scheme for the tomb of Julius. If the catafalque was a re-

flection of Michelangelo's requests about his funeral, he saw himself not only chained to Julius's tomb but in a sense as its occupant.

I have said that at one point the tomb might have been intended to memorialize St. Peter as well as Julius. Later documents speak of an unfinished statue, by Michelangelo, of St. Peter dressed as a pope. The work is now lost. I believe it was intended for the Julius tomb during that period, namely from 1505 to 1513, when, we have supposed, the monument was contemplated for the new St. Peter's. The statue of St. Peter could appropriately have been placed at the summit above the pope's sarcophagus. It was traditional, on Renaissance tombs, to set at this point a statue of the Virgin as the "mediatrix" who intervened on behalf of the sinner's soul and besought Christ to accept it into heaven. But a seated St. Peter, replacing the Virgin, could have played that same mediating role. St. Peter, after all, was Julius's principal scriptural and historical type and, as well, keeper of the keys to heaven. But in the end, we shall see, it was decided to conform to tradition and put an image of the Virgin over the sarcophagus.

The 1513–16 Project (figs. 217, 218)

When he began the Sistine ceiling Michelangelo temporarily abandoned work on the tomb. The frescoes were duly completed the year before Julius's death. That event then became the occasion for the second main tomb project. Yet to the very last Julius opposed Michelangelo's returning to the tomb—and this though his will contained a provision of 10,000 ducats for completing it! Instead, it was Leo X who provided the artist with time to work on

Julius's monument. Yet from this moment on, it becomes clear, it was no longer destined for St. Peter's. Perhaps in compensation for this the executors of Julius's estate decided to make the new version grander than ever. And it was also in these years, 1513–16, that Michelangelo created three of the proposed tomb's most memorable existing components—the two Louvre *Captives* and the *Moses*.

An old and presumably reliable copy of a Michelangelo drawing for the next version of the project (though some scholars think the drawing represents the 1505 program; fig. 218) confirms all this and, as well, fills the niches with figures of Victories—classically draped women with raised arms trampling their enemies underfoot. We also see from the drawing that the herms and captives were to continue around the tomb's long sides. By putting these ideas together, therefore, Michelangelo was linking the separate notions of geographical boundaries, military victory, and the afterlife. As iconography it was a bit unusual for its time but was well fitted to the warrior-pope who restored lands to the Holy See.

The new scheme preserved the lower zone of 1505 with its herms, captives, and victories. But the tomb was no longer freestanding. One of the narrow facades was to be attached to the wall of the as-yet-unspecified church where it was to be built. The inner chamber was also abandoned. But among other expansions there were to be six rather than four large seated statues above the cornice, and the effigy was now accompanied by four rather than two figures. Since St. Peter's was no longer the intended setting, the seated St. Peter was replaced by the Virgin. Her image was framed by what was called the *cappelletta*, a towering arched element whose gable

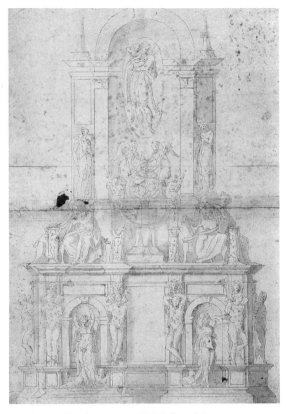

218. Jacomo Rocchetti, copy of Michelangelo's sketch for the 1505 project for tomb of Julius II. Berlin, Kupferstichkabinett.

was flanked by miniature obelisks. Within it, in an oval or mandorla, stood the Virgin carrying the Christ child. (Michelangelo's sketches for this, by the way, were apparently inspired by Raphael's *Sistine Madonna* now in Dresden; fig. 219.) At the cappelletta's base were allegorical females, probably Virtues, beside framing pilasters.

Moses

The *Moses* was probably begun in 1515 (fig. 220). The colossal figure is bare-armed, his long-locked beard descending to

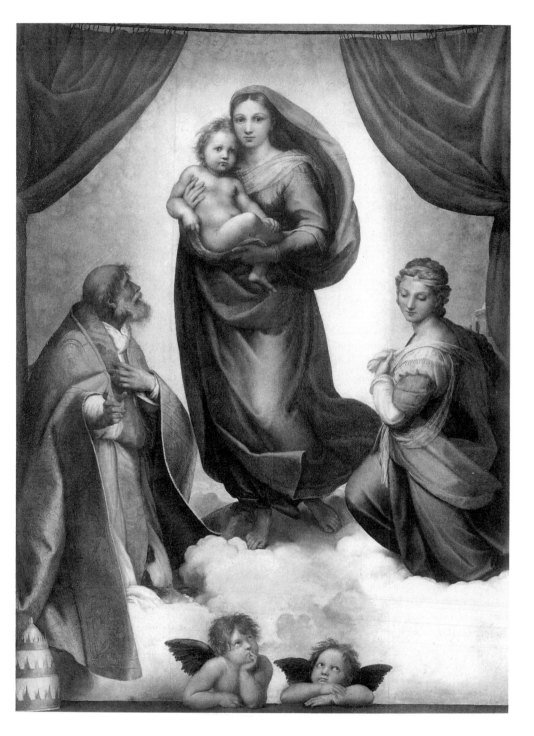

219. Raphael, *Sistine Madonna*, 1513–14. Dresden, Gemäldegalerie. Alinari/Art Resource, N.Y.

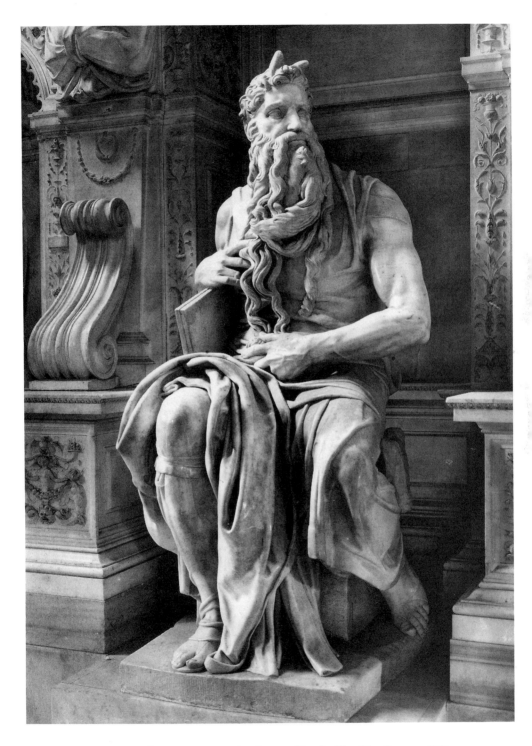

220. Michelangelo, *Moses*, begun 1515. Rome, San Pietro in Vincoli. Alinari/Art Resource, N.Y.

his waist, a deeply draped robe filling his lap. He wears leggings belted at the knee and foot with other straps around his shoulder. His face is like a furrowed mountainside. In his anger and formidableness he is Zeus-like, a storm-bringer. The horns on his brow (there because of St. Jerome's mistranslation of the Hebrew for "light upon his head") only emphasize this ferocity; yet the ferocity is contained. Freud describes Moses' mood as "not the beginning of a violent action, but the aftermath of a spent emotion: he wishes at once to unleash his anger and take vengeance, but he has overcome the temptation." Like Freud, other interpreters have thought that Moses has just come down from Mount Sinai after receiving the tablets of the law, which he now holds, and has found the Jews worshiping the golden calf (Exod. 32:19: "And Moses' anger waxed hot"). The sense of controlled fury in the statue also reflects the artist's own famous terribilità, not to mention Julius's.

The Della Rovere Oak

There is another way in which Moses appears on the tomb. The plinths and entablatures of the present monument, some of them made for earlier versions, are carved with the Della Rovere oak (fig. 211). Its branches, which often frame or support satyrs, rustic divinities, and mascherons, twine in symmetrical arabesques throughout the tomb's architecture. They act like the recurring tropes of *robur* (oak) and *corroborare* (strengthen) in Giles's 1507 sermon. But *the* man of oak is Moses. To Virgil's image of the oak tree rising from hell to heaven Giles adds another cosmic oak, which grows when Moses places the tablets of the law beneath the oak that grew in, or perhaps was, the Jews' ori-

ginal sanctuary in the centuries before the building of Solomon's temple (Josephus 24.26). This oak-ark now flourishes around the tomb.

The Louvre Captives

The oak links the *Moses* and the captives. The so-called *Dying Slave* in the Louvre, one assumes from its pose, was intended for the left center pilaster (fig. 221). Seeming more asleep than dead, he is bound with a heavy band around his chest while his left wrist is strapped to the back of his neck. A partly-carved monkey embraces his left shin. We saw a similar beastie, a satyr, at the *Bacchus's* leg (fig. 214). This monkey has been identified as "art the ape [or, in Latin, monkey] of nature" in an attempt to show that the captives represent the arts as they mourn, and are bound by, their great patron's death. It is an attractive idea, but in a moment I will incorporate it into something fuller.

The other Louvre captive, known as the *Rebellious Slave*, is wide awake (fig. 222). His arms are tied behind his back, his right foot rests on a step or platform, and his head turns in contrapposto as his yearning gaze goes to heaven. If the earlier figure sleeps the sleep of mute imprisonment, this one wakes to the realization of useless energies, his distended muscles an expression of deadened power. Both figures are indirectly influenced by the Laocoön (fig. 84). Some think the unfinished marble support around the Louvre statue's left leg was destined to be another monkey. (There is a diagonal break in the marble through the head and left shoulder of this statue, which may be why Michelangelo abandoned it.)

A sketch at the Ashmolean Museum, Oxford, depicts a captive in a similar pose,

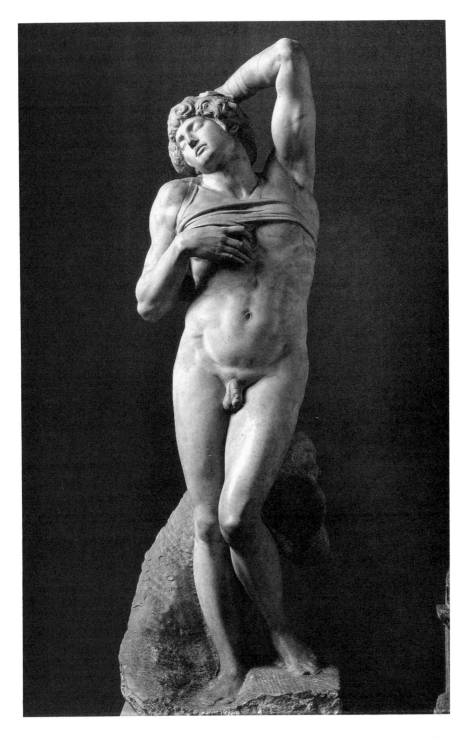

221. Michelangelo, *Captive (Dying Slave)*, begun 1513. Paris, Louvre. Giraudon/Art Resource, N.Y.

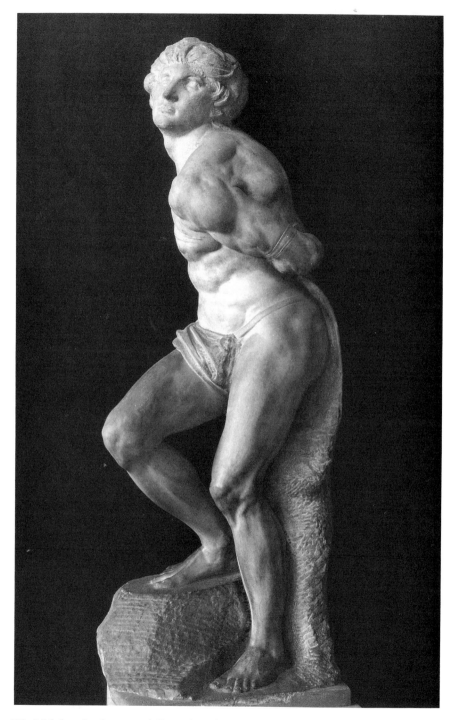

222. Michelangelo, *Captive (Rebellious Slave)*, begun 1513. Paris, Louvre.
Alinari/Art Resource, N.Y.

223. Michelangelo, sketch for a captive, c1513. Ashmolean Museum, Oxford.

but with a beard (somewhat like the one Laocoön wears) and with pieces of what appear to be armor behind him (fig. 223). The armor relates to that worn by the trophy herms and continues my suggestion that these, and the prisoners, had some military meaning. Vasari, we saw, claims that the captives represented the states Julius had brought back to the rule of the Church. Against this it has been argued that, as of 1505, Julius had not yet in fact "liberated" any territories. But we have seen that on his accession in 1503 all papal lands seized by the the Borgia reverted to the Holy See, so that two years before the tomb was first commissioned Julius's dominions were supplemented by important cities like Cesena, Piombino, and Mantua.

Anyway, propaganda doesn't require real accomplishments.

There are other views as to what these statues represent, but given that one of Julius's main purposes in life was to restore provinces, and that he went on to "liberate" Perugia and Bologna in 1506 and Faenza and Rimini in 1509, Vasari's explanation is certainly not, on its face, unlikely. In this sense we would read Michelangelo's statues as struggling lands attaining their longed-for freedom due to the papal victories—the *Victories* in the niches—that were to stand between them. The monkey or monkeys, meanwhile, might even stand for the new discoveries in Africa and Ceylon. And the trophies and the *Victories'* trampled enemies would represent defeated usurpers such as Cesare Borgia. One theme of the tomb, then, at least at this particular stage, echoes Virgil as quoted by Giles when he summed up the "arts" Julius exercised in reassembling the papal states: "Remember thou, O Roman, these shall be your arts, to reign over your peoples, impose the rule of peace, raise the lowly and subdue the proud" (*Aeneid* 6.851ff.).

The presence of Moses on the tomb's upper zone is now more eloquent than ever. Not only was Moses responsible for the Hebrews' primal temple, he was even more famously the liberator of the Hebrew people. He led Israel from bondage as Julius leads Italy. And Giles adds a more global touch when he evokes this fact: as Moses reclaimed the Holy Land to the east so the pope will "in the future possess the churches of Asia." These churches, the preacher explains, are antitypes to the Persians of scripture who succored Israel in her servitude. Now at the dawn of humankind's ultimate golden age these same "Persians" will come forth in

The Tragedy of the Tomb 263

turn to be saved in the rebuilt temple at Rome (here again we recall Vitruvius's Persian captives in Sparta). Indeed, says Giles, Julius will free all the peoples of the earth who have been captives—captives to heresy, schism, ignorance, and barbarism.

Yet it is also true, as noted earlier, that Condivi and others since have said that the captives are not cities or provinces at all, nor the arts of government, but the liberal arts and sciences imprisoned by the pope's death. Some, with a leap of the imagination, have added that the *Rebellious Slave* (fig. 222) is a symbol of architecture or sculpture (the unfinished block on which he rests his foot would be a planned column capital). Erwin Panofsky, on the other hand, thinks the *Captives* represent souls yearning to free themselves from the prison of the body—a Neoplatonic idea that Michelangelo often evokes in his poetry.

Giles offers a way of understanding how the captives may represent not one but all of these options. We have already seen that he equates the four branches of the Rovere oak with various quartets ("quaternities") of things that structure life and the universe—the four seasons, the four golden ages of history, the four temperaments, etc. These quartets, he says (without naming them) also match the four arts and sciences—which he in fact portrays as victories conquering their four opposite evils. (So much for quartets; but Giles also compiles groups of other qualities, entities, institutions, and materials, these being grouped into sixes, eights, tens, and twelves.) The various explanations of the *Captives*, when considered as being mutually exclusive, fail to take account of this kind of thinking. To the Neoplatonist these causes and representations are not single but multiple. It is

224. 1516 project for the tomb. From Tolnay.

not a question of arts *or* provinces *or* souls, but of arts that are provinces that are souls; provinces that have souls and exercise, or are expressed by, arts.

The Project of 1516 (fig. 224)

We have seen that in 1515 Julius's most important heir, Francesco Maria della Rovere, duke of Urbino, lost his duchy—to a Medici—and ceased for a time to enjoy Leo X's support. As a result Michelangelo turned from the tomb to a new project, for the Medici: designing a facade for their family church of San Lorenzo in Florence. This was in turn aborted in 1520 but was immediately replaced by another—the Medici Chapel within that church. Work on that would occupy Michelangelo's main energies as a sculptor for the next few years.

In line with the artist's responsibilities to the Medici a new contract for the Julius tomb was drawn up in 1516. This greatly reduced its size and complexity. Now the

idea was to create a simple wall tomb. Only one facade of the old project, the narrow one, was retained. The herms were still there but the *Victories* were abolished and, in all probability, their niches—there would now be only two—were to be filled with the Louvre *Captives*—or more precisely with the *Dying Slave* plus a second version of the *Rebellious Slave*, carved from an unflawed block. There was meanwhile to be a bronze narrative relief in the center of the lower storey. Above an upper storey decorated with half-columns was to be a figure of the pope supported by two figures, probably the mourning Earth and rejoicing Heaven of the earlier schemes. Above this once again was the standing Virgin and child.

This upper storey also contained niches for the *Moses* and other three seated statues—two across the front and two others on the returns or edges of the tomb. No doubt the three other statues were still to be St. Paul, Leah, and Rachel. Above these, in turn, were to be large bronze medallions, similar, probably, to those above the seated sibyls and prophets of the Sistine. In his correspondence about the tomb Michelangelo, who had again moved back to Florence, now for the first time broaches the idea that some of the work might be done by assistants in Rome.

The 1525–26 Project

In the short reign of Adrian VI, Della Rovere fortunes rose again. Francesco Maria was restored to his duchy and the new pope demanded that Michelangelo finish the tomb or else return part of the money he had received. He replied that he could not return to the Julius tomb unless Giulio de' Medici freed him from his work on the Medici Chapel. For a moment it

225. Michelangelo, sketch for 1525 tomb (?). London, British Museum.

looked as if the tomb would be resumed with full vigor. But then came Adrian's death and Giulio's election as Clement VII. Once more the situation was reversed. With Clement it was clear that Michelangelo's major efforts would continue to go into Medici work in Florence and that the Julius tomb would probably be completed, as earlier planned, by others. Things stood at this point over the next few years until the Sack of Rome in 1527. That, and Clement's resulting impoverishment, changed everything yet again and freed Michelangelo from Medici obligations.

So for the third time he returned to the tomb. Tolnay interprets certain sketches now in London, based on a Roman honorific arch, as ideas for this 1525 project (fig. 225). The scheme is also close in feeling to the tombs in the Medici Chapel (fig. 226). Michelangelo often reinterpreted a new or revisited project under the influence of one he was finishing or abandoning. Thus does the Sistine ceiling realize ideas from the earlier versions of the Julius tomb, and thus now does this later

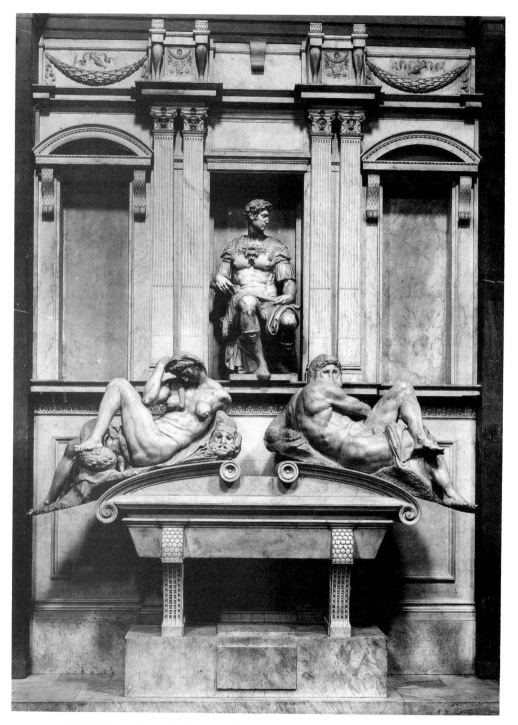

226. Michelangelo, tomb of Giuliano de'Medici, begun 1520. Florence, Medici Chapel.
Alinari/Art Resource, N.Y.

Julius tomb borrow from the Medici projects. The latter, in turn, had meanwhile been influenced by the artist's ideas for the facade of San Lorenzo.

The 1532 Project (fig. 227)

As the 1525–26 project precedes one military event, the Sack of Rome, so its successor comes in the wake of another—the siege of Florence of 1529–30. On this occasion the armies of Clement VII and the Holy Roman Empire sought to drive out the republican forces that since 1527 had ruled Florence and exiled the Medici from their city. Michelangelo turned republican in these years and was giving his attention to the town's defenses. But after the republican surrender on August 12, 1530, Clement VII pardoned the artist for fighting against him. Michelangelo turned back to the Medici tombs.

But now the Rovere heirs, restored to power, could renew their demands. Not for the first time Michelangelo felt forced to return some of the 8,000 ducats he had received over the years with little to show for it except for three statues, namely the *Moses* and the Louvre captives, two of which were patently incomplete. It was arranged that, except for a group of four captives and one or possibly more victories, the rest of the tomb's sculpture, including the statue of the pope, would be executed in Rome by Michelangelo's fellow-Tuscan Raffaello da Montelupo. A schedule for the next three years, 1532–34, was drawn up. In it the artist would work on the Julius tomb in Rome for three months each year and spend the other nine in Florence on the Medici Chapel. As to the Julius tomb's proposed architectural setting, the Roman arch was abandoned in favor of the earlier wall tomb.

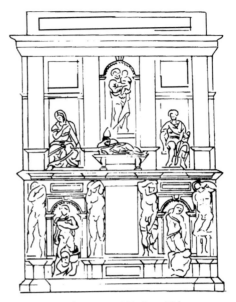

227. Project for same, 1532. From Tolnay.

The Four Unfinished Captives (figs. 228–31)

It may be that Michelangelo had planned the unfinished *Captives* now in the Accademia, Florence, for the 1525–26 project. Work, however, does not seem to have been begun until 1532, which would make them a common factor in two otherwise rather different conceptions for the monument. With their powerful bodies, their arms and legs striving as if to emerge from a dense mist, the Accademia figures also reflect qualities of the Louvre *Captives* (figs. 221, 222). And, though these unfinished *Captives* were never included in a tomb, they had an interesting afterlife. After Michelangelo's death in 1564 Cosimo I, duke of Tuscany, had the architect Bernardo Buontalenti set them into a grotto in the Boboli Gardens behind the Pitti Palace (fig. 232). A sixteenth-century writer, Francesco Bocchi, describes them there:

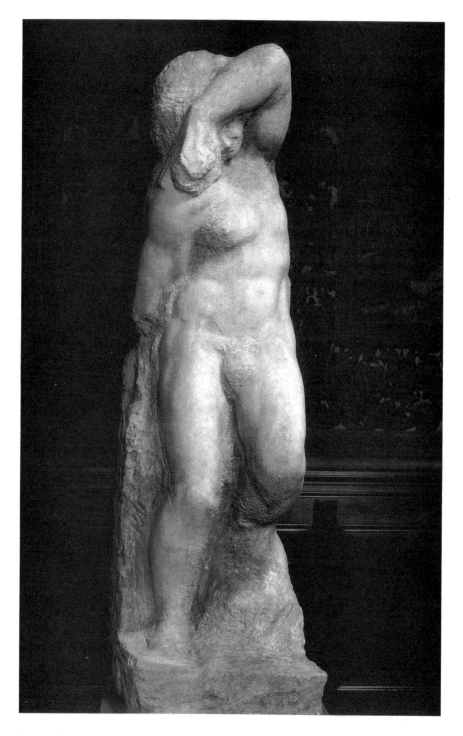

228. Michelangelo, *Captive*, 1532. Florence, Accademia. Alinari/Art Resource, N.Y.

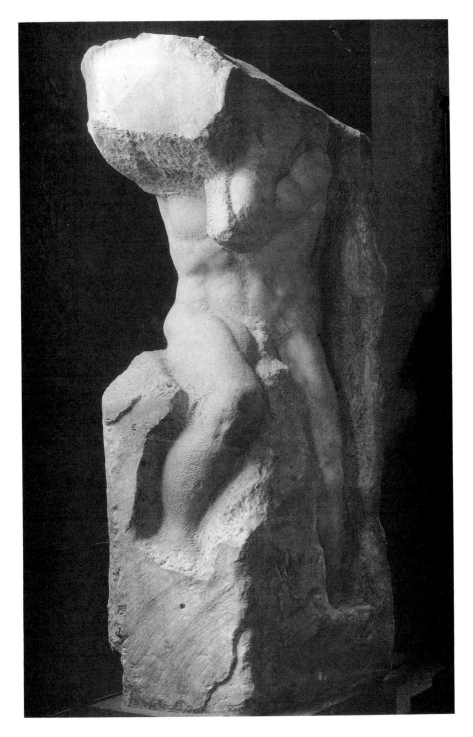

229. Michelangelo, *Captive*, 1532. Florence, Accademia. Alinari/Art Resource, N.Y.

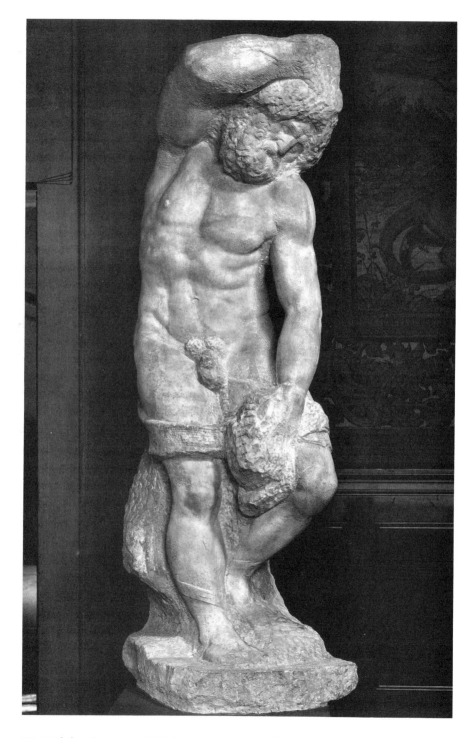

230. Michelangelo, *Captive*, 1532. Florence, Accademia. Alinari/Art Resource, N.Y.

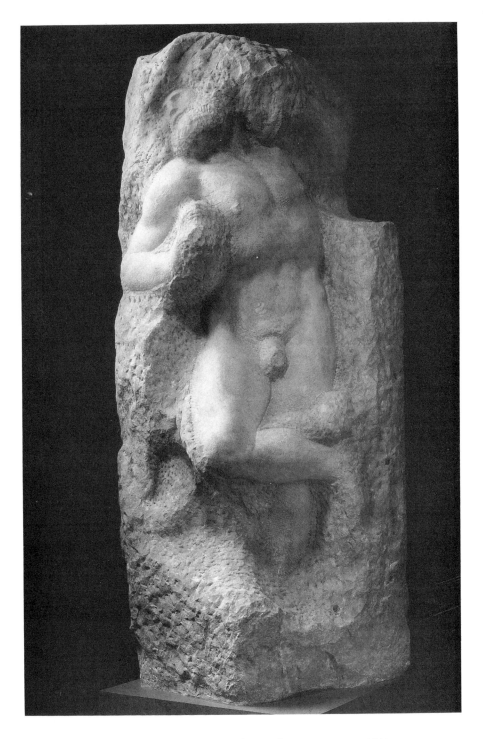

231. Michelangelo, *Captive*, 1532. Florence, Accademia. Alinari/Art Resource, N.Y.

232. Bernardo Buontalenti, interior of Grotta Grande, Boboli Gardens, Palazzo Pitti, Florence, with copies of Michelangelo's *Captives* now in the Accademia. After 1564. Alinari/Art Resource, N.Y.

Four marble statues by Buonarroto, made earlier for the tomb of pope Julius II, are located in this place, not without effect and subtle understanding: because, sketched out with incredible and marvellous skill, these figures show themselves to be desiring with every effort to extricate themselves from the marble so as to escape the ruin above them in the form of blocks of stone [supplied by Buontalenti] that menace collapse. They lead one to recall that, according to the poets, when men were extinguished by the Flood, Deucalion, carving [new] men out of stones, restored the world. Artists are amazed and amateurs put to confusion as to how a man might possess such wisdom that he could, with chisel, hand, and rasp, roughly carve human bodies from stone, bodies that are not finished and yet are unequivocal, natural and true. And verily these statues are more marvelous in this guise than had they been completely finished, and are more admired by the best artists, and contemplated and studied, than if they had received Buonarroto's ultimate polish.

The passage expresses an important aspect of the later sixteenth-century taste for grottoes and the grotesque. We have already looked at its origins (Chapter 7); in the later sixteenth century the new taste branched out to create rocky artificial caves dotted with chthonic half-human sculptured creatures. It is as if the stucchi of the Raphael Logge were being reproduced at human or superhuman scale. Bocchi also hints at the aesthetic of the *nonfinito* that grew up around these and other unfinished Michelangelo sculptures—the notion of the artist as a titan, a conceiver of works so filled with wild and mighty possibilities that actual completion would only dim them. Finally, having looked so often at the role of caryatids, herms, and the like, we note that Buontalenti seems to have been adding his own twist to that concetto: the prisoners, having sensed that the

structure they were holding up is collapsing, seek to free themselves.

The Male Victory (fig. 233)

Another new statue for the 1532 project was a male *Victory* (Florence, Palazzo Vecchio) probably intended to replace one of the female Victories in the earlier sketches. Instead of a robed woman we see here an almost completely naked youth, long-limbed, with muscular chest and abdomen and Della Rovere oak-leaves in his hair. He rests his left knee on the back of a defeated foe who has been crushed to earth. With an absent gesture he seems to be about to rearrange his cloak, which had been thrust aside in the struggle. The foe is a bearded old barbarian warrior, his muscles straining, his heavy cuirass crushed beneath him: a pathetic contrast to his self-absorbed but vigilant conqueror. Similarly, the old man's armor plays off against the youth's nudity—the conquest by unarmed righteousness of armed unrighteousness. Some scholars think the statue, quite apart from its official meanings, is a personal allegory of the relatively aged (fifty-seven) Michelangelo and the young man he loved, Tommaso de' Cavalieri. And it is true that the old man does have some resemblance to Michelangelo—but then so did those being trampled by the female Victories in the drawing of twenty or more years earlier (fig. 218).

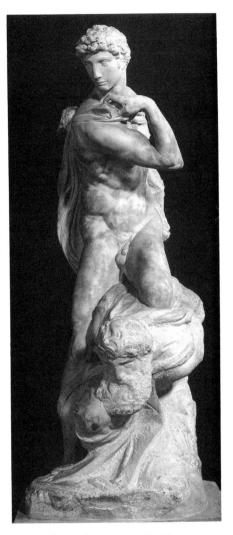

233. Michelangelo, *Victory*, 1532. Florence, Palazzo Vecchio. Alinari/Art Resource, N.Y.

The 1542 Project (fig. 211)

The death of Clement VII once more severed Michelangelo—and this time definitively—from his main Medici projects. But Clement's death did not mean that Michelangelo would now at last fully devote himself to the tomb of Julius II. Paul

III, we have seen, was as anxious as his predecessors had been—or more so—to give Michelangelo new commissions. Thus the *Last Judgment* was one barrier to finishing the tomb; another was the memorable frescoes of the Cappella Paolina (1542–49; fig. 1); a third, after 1546, was the artist's appointment as architect of St.

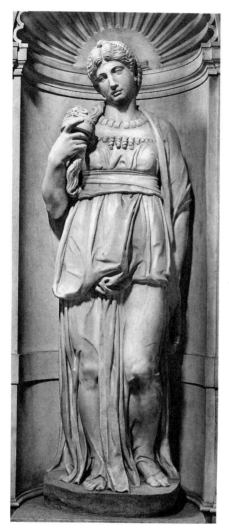

234. Michelangelo, *Leah*, from tomb in San Pietro in Vincoli. Alinari/Art Resource, N.Y.

flanked by a seated prophet and sibyl—were already commenced. In the event, seven of the most beautiful existing statues for the tomb—the captives and the male Victory—were being eliminated from the final version of the monument. Tolnay attributes this to the Counter-Reformation's distaste for nudity.

Michelangelo's two new statues were the *Leah* and the *Rachel* (figs. 234, 235). We recall that these may have been planned from the first, though then they would have been seated. The present statues were installed in February 1545 and are among Michelangelo's most disappointing works. To me it seems possible that he designed and began them but that they were finished, or finished off, by Raffaello da Montelupo. They are stiff and cold. The volumes of the Hebrew heroines' faces shrink away from their features and the draperies are excessively ridged.

Nonetheless the statues are worth looking at iconographically. They amplify the meanings of such masterpieces as the *Moses*, the *Victory*, and the *Captives*. Leah and Rachel, two sisters who were simultaneous wives to Jacob in that polygamous era (Gen. 29:31), had long been symbols of the active and the contemplative life. Dante describes them thus in a passage Michelangelo almost certainly knew:

I seemed to see in a dream a lady young and beautiful going through a meadow gathering flowers and, singing, she was saying, 'whoso asks my name, let him know that I am Leah, and I go moving my fair hands around to make myself a garland. To please me at the glass I adorn me here, but my sister Rachel never leaves her mirror and sits all day. She is fain to behold her fair eyes, as I am to deck me with my hands: she with seeing, I with doing am satisfied'. *(Purgatory* 27, 95ff., trans. Charles L. Singleton)

Peter's. It was therefore decided that the new version of the Julius tomb would be minimal. It would contain the *Moses* and two other unnamed figures by Michelangelo. The remaining sculptures would be done by others under Michelangelo's supervision. Indeed the documents state that these latter figures—now to be the Virgin

274 *The Tragedy of the Tomb*

This may sound a bit narcissistic, but Dante means that the hands of the active person are beautiful through their activity, and the eyes of the contemplator beautiful as she contemplates the mirror that is her conscience. Michelangelo, then, shows Leah with her handiwork—the garland in her left hand and, in her right, a decorated diadem. Her hair and dress are "worked," respectively with braids and an elaborate necklace. Rachel, in contrast, in a simple robe, head veiled as for sacrifice or prayer, kneels, clasps her hands, and raises her searching gaze to heaven. She adopts the pose of an allegory of Faith or Hope. But at the same time her true mirror, her conscience, is heaven itself. One might ask if Dante's graceful girlish Leah and Rachel are apposite allegories for the martial Julius. Giles of Viterbo apparently thought so. He ends his 1507 sermon with this very parallel. Alluding to Julius's liberation of Perugia and Bologna the year before, he says the pope's peaceful behavior on these occasions brings out the side of his personality represented by Rachel. He in fact reveals that at Bologna he had delivered a whole oration, the pope in attendance, on her.

Meanwhile early in 1545 Raffaello da Montelupo's Virgin, sibyl, and prophet were placed in the tomb's upper story (fig. 211). These are in fact partly the work of Raffaello's shop, he himself having been ill during some of the crucial months. The prophet and sibyl are late ideas borrowed from the Sistine ceiling. They also relate to the seated figures that in earlier versions were to be set alongside the *Moses* (fig. 220). The prophet's pose, meanwhile, is practically a mirror image of the Medici Chapel's Duke Giuliano (fig. 226). Tommaso di Pietro Boscoli's statue of the pope is particularly odd. The portly Julius lies

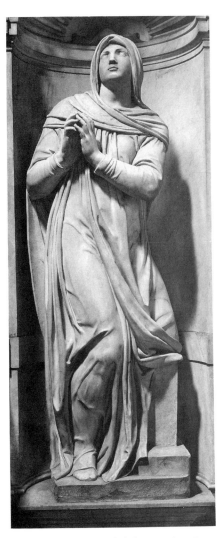

235. Michelangelo, *Rachel*, from tomb in San Pietro in Vincoli. Alinari/Art Resource, N.Y.

on his sarcophagus clad in cope and triple crown, his head and chest bolt upright as he forces his head erect and leans on his elbow. It is a parody of the "Etruscan" pose (figs. 31, 32). But throughout all its changes, compressions, and degradations the tomb of Julius II continued to make certain statements. Above the earthly

freed captives and boundary gods of the lower section were enthroned images of the biblical types who most shaped the pope's personality and role: St. Paul, Moses, Leah, and Rachel. Above them the Virgin (or in one version St. Peter) introduced the pope's soul into paradise.

There is a humiliating epilogue to the tragedy of the tomb. When Julius died in 1513 the completed structure lay some thirty years in the future. The pope's body was therefore taken to a temporary resting place in a chapel in Old St. Peter's that had been built by Sixtus IV. Paul III, in whose reign the tomb in San Pietro in Vincoli was erected, razed Sixtus's chapel but failed to send Julius's body on to its intended new resting place. In the end, in fact, the body of the man who has been called the greatest patron in the history of European art, a man obsessed with building himself a magnificent tomb embodying the acme of Michelangelo's genius, and which would stand at the center of the greatest church in the world—that body wound up in a mass tomb in the sacristy of the new St. Peter's. This was provided for all the popes who had been dislodged from their individual resting-places as the old basilica was gradually torn down. Here Julius's name appears in a list of 145 other defunct pontiffs. Perhaps this is the revenge of the many souls he disturbed when he embarked on his great enterprise—to be placed, eventually, among them.

Chronology

Most Important Rulers

Popes	France	Spain	Holy Roman Empire	England
Sixtus V 1471–84 Innocent VIII 1481–92 Alexander VI 1492–1503 Pius III 1503	Louis XII 1498–1515 Francis I 1515–47	Ferdinand & Isabella 1479–1504 Ferdinand 1504–16	Maximilian I 1493–1519	Henry VII 1485–1509
Julius II 1503–13		Charles I 1516–56 (same as Charles V)	Charles V 1519–56	Henry VIII 1509–47
Leo X 1513–21 Adrian VI 1522–23 Clement VII 1523–32 Paul II 1534–49				

N.B. Dates refer to year in which works of art were begun or in which books were published.

Year	Public Events	History of Art
1476, 1480–82	Giuliano della Rovere is legate in France	
1492	Lorenzo the Magnificent dies; Charles VIII enters Florence, Medici flee	
1494	Florentine Republic; Giuliano della Rovere flees to France	
1495		Leonardo, *Last Supper*; Michelangelo, *Pietà*
1496		Michelangelo, *Bacchus*
1498		Michelangelo, St. Peter's *Pietà* finished
1500		Bramante, Santa Maria della Pace

1501		Michelangelo, *David* begun—completed 1504 Bramante Tempietto begun
1503		Leonardo, *Mona Lisa* begun Bramante, Belvedere
1505		First Julius tomb project; Santa Maria del Popolo tombs
1506	Perugia, Bologna to Papal States; Columbus dies	Cornerstone of St. Peter's Michelangelo, Statue of Julius II; *St. Matthew*
1507	Giles of Viterbo's sermon	
1508		Sistine ceiling begun
1509	Pope, Empire, France vs. Venice; Faenza and Rimini to pope; Erasmus visits Rome	Raphael, Stanza della Segnatura begun
1510	League of Cambrai defeats Venice	
1511	Venice, Spain vs. France; Council of Pisa; Lateran Council	Raphael, Portrait of Julius II
1512	Battle of Ravenna; Medici in Florence; Holy League	Sistine ceiling completed; Sala d'Eliodoro begun
1513	Julius II dies; Piacenza to Spanish; *Apostolici regiminis* (bodily resurrection)	Second Julius tomb project; *Moses*, Louvre slaves begun; Raphael, *Galatea*
1514		Stanza dell'Incendio begun; Bramante dies
1515	Papacy takes Parma, Piacenza; Francis I marches south; Peace of Viterbo; Leo X's triumphal entry into Florence	Fra Giocondo dies; Raphael: tapestry cartoons begun; Castiglione portrait; becomes architect of St. Peter's
1516	Concordat, Bologna; Ferdinand the Catholic dies	Third Julius tomb project; San Lorenzo facade; Giuliano da Sangallo dies
1517	Luther's 95 Theses	Raphael, Farnesina Loggia
1519		Sala di Costantino begun; Santa Maria sopra Minerva tombs
1520		Medici Chapel begun; Raphael dies
1521	Luther excommunicated; Diet of Worms; Parma, Piacenza, and Ferrara to Empire; Sannazaro's *De Partu Virginis*	
1523	Piero Soderini surrenders	
1524		South transept walls of St. Peter's
1525	Francis I defeated at Pavia	Fourth Julius tomb project

1526ff.	League of Cognac; France and Empire at peace	Michelangelo, Florence *Captives*
1527	Sack of Rome; Medici expelled from Florence	
1529–30	Siege of Florence; Medici return; Charles V proposes international peace; Alessandro de' Medici m. Margherita, Charles's daughter	
1532	Alessandro de' Medici first duke of Florence	Fifth Julius tomb project; Florence *Captives*; Palazzo Vecchio *Victory*
1533	Archbishop of Canterbury annuls marriage of Henry VIII and Catherine of Aragon	
1535	Tunis taken by Charles V	Michelangelo named chief Vatican artist
1536		*Last Judgment* begun
1538	Henry VIII excommunicated	
1541		*Last Judgment* unveiled
1542		Sixth Julius tomb project; Frescoes in Cappella Paolina begun; Titian, portrait of Paul III
1543–44		Nave of St. Peter's vaulted
1545–46	Council of Trent begins	South transept of St. Peter's vaulted; Aretino attacks the "licentiousness" of the *Last Judgment*
1546–47		Michelangelo appointed architect of St. Peter's
1563	Council of Trent ends	
1564		Michelangelo dies
1607–14		St. Peter's facade, Carlo Maderno

Further Reading

Ackerman, J. S. "Architectural Practice in the Italian Renaissance." *Journal of the Society of Architectural Historians*, 13 (1954).

———. *The Architecture of Michelangelo*. London, 1961.

———. *The Cortile del Belvedere*. Rome, 1954.

Armstrong, Lilian. *Renaissance Miniature Painters and Classical Imagery*. London, 1981.

Battisti, Eugenio. "Il Significato simbolico della cappella Sistina." *Commentari 8.2*. April-June, 1957.

Becle, James H. *Michelangelo: a Lesson in Anatomy*, New York, 1975.

Bevan, Edwyn. *Holy Images. An Inquiry into Idolatry and Image-Worship in Ancient Paganism and in Christianity*. London, 1940.

Bieber, Margarete. *The Laocoön*. Exhibition catalogue. Detroit, 1967.

Bober, Phyllis Pray, and Ruth Rubenstein. *Renaissance Artists and Antique Sculpture: A Handbook of Sources*. Oxford, 1986.

Braudel, Fernand. *The Mediterranean and the Mediterranean World in the Age of Philip II*. New York, 1973.

Brilliant, Richard. "Intellectual Giants: A Classical Topos and the School of Athens." *Source: Notes in the History of Art*, 3, no. 4 (1984):1 ff.

Brown, George K. *Italy and the Reformation to 1550*. Oxford, 1933.

Bruschi, Arnaldo. *Bramante*. London, 1973.

Bull, Malcolm. "The Iconography of the Sistine Chapel Ceiling. *Burlington Magazine*, 130 (1988):597ff.

Buonarroti, Michelangelo. *The Complete Poems and Selected Letters of Michelangelo*. Edited and translated by Creighton Gilbert. Princeton, 1980.

Buonarroti, Michelangelo. *The Poetry of Michelangelo*. Edited and annotated by James Saslow. New Haven, 1991.

Burckhardt, Jacob. *The Civilization of the Renaissance in Italy*. New York, 1958.

Burke, Peter. *Culture and Society in Renaissance Italy, 1420–1540*. New York, 1972.

Cahn, Walter. *Masterpieces: Chapters in the History of an Idea*. Princeton, 1979.

Camporesi, Piero. "The Consecrated Host: A Wondrous Excess," *Zone 3*, Part 1 (1989):221ff.

Cast, David. "Finishing the Sistine," *Art Bulletin*, 73 (1991):669ff.

Castiglione, Baldassare. *The Book of the Courtier*. Many eds.

Cellini, Benvenuto. *The Autobiography*. Trans. George Bull. Harmondsworth, 1956.

Chastel, André. "Les 'idoles' à la renaissance." In Silvia Danesi Squarzina, ed., *Roma, centro ideale della cultura dell'antico nei secoli xv e xvi*. Milan, 1989, 468ff.

———. *The Sack of Rome, 1527*. Princeton, 1983.

Clark, Kenneth. *A Failure of Nerve: Italian Painting, 1520–1535*. Oxford, 1967.

———. "Michelangelo Pittore." *Apollo*, 80, 437ff.

———. *The Nude: A Study in Ideal Form*. Princeton, 1956.

Clements, R. J. *The Poetry of Michelangelo*. New York, 1965.

Clerc, Charly. *Les Théories relatives au culte des images chez les auteurs grecs du ii. me siècle après Jésus-Christ*, Paris, 1915.

Colonna, G. and M. Donati. *I Musei Vaticani*. Novara, 1972.

Condivi, Ascanio. *The Life of Michelangelo*. Baton Rouge, [1553] 1975.

Cox-Rearick, Janet. *Dynasty and Destiny in Medici Art*. Princeton, 1984.

Cuzin, Jean-Pierre. *Raphael, His Life and Works*. Secaucus, 1985.

D'Achiardi, P. *La Pinacoteca Vaticana*. Bergamo, n.d.

Dacos, Nicole. *Le Logge di Raffaello. Maestro e Bottega di fronte all'antico*, 2d ed. [Rome] 1986.

D'Amico, John F. *Renaissance Humanism in Papal Rome: Humanists and Churchmen on the Eve of the Reformation*. Baltimore, 1990.

D'Ancona, Mirella Levi. *The Garden of the Renaissance: Botanical Symbolism in Italian Painting*. Florence, 1977.

Davidson, Bernice F. "The Landscapes of the Vatican Logge from the Reign of Pope Julius III." *Art Bulletin*, 65: (1983).

———. "Pope Paul III's Additions to Raphael's Logge." *Art Bulletin*, 61 (1979):385ff.

———. *Raphael's Bible: A Study of the Vatican Logge*, University Park, 1985.

De Tolnay, Charles. *Michelangelo*. 5 vols., Princeton, 1950–71.

Delumeau, Jean. *Catholicism between Luther and Voltaire: a New View of the Counter-Reformation*. London, 1977.

D'Onofrio, C. *Castel Sant'Angelo e Borgo tra Roma e Papato*. Rome, 1978.

Dorez, L. "La Bibliothèque privée du pape Jules II." *Revue des Bibliothèques*, 6 (1896):97ff.

Dotson, Esther. "An Augustinian Interpretation of Michelangelo's Sistine Ceiling." *Art Bulletin*, 61 (1979): 223 ff.; 405ff.

Dussler, L. *Raphael. A Critical Catalogue of His Pictures, Wall-Paintings, and Tapestries*. London, 1971.

Fehl, Philipp. "Raphael's Reconstruction of the Throne of St. Gregory." *Art Bulletin*, 53 (1973):373ff.

Freedberg, Sydney J. *Painting of the High Renaissance in Rome and Florence*. Cambridge, Mass., 1961.

———. *Painting in Italy: 1500 to 1600*, Harmondsworth, 1971.

Freud, Sigmund, "The Moses of Michelangelo" [1914]. In Freud, *Collected Works*, vol. 13, 211ff.

Frommel Christoph L. "Eine Darstellung der 'Loggien' in Raffaels 'Disputà'?" *Festschrift für Eduard Trier zum 60. Geburtstag*. Berlin, 1981, 103ff.

———. *Der römische Palastbau der Hochrenaissance*. Tübingen, 1973.

———. "'Capella Iulia:' Die Grabkapelle Papst Julius II in Neu-St. Peter," *Zeitschrift für Kunstgeschichte*, 40 (1977): 26 ff.

———. "Die Peterskirche unter Papst Julius II im Licht neuer Dokumente." *Römisches Jahrbuch für Kunstgeschichte*, 16 (1976):57 ff.

Galassi Paluzzi, C. *La Basilica di San Pietro*. Bologna, 1975.

Gere, J. A., et al. *Drawings by Michelangelo in the British Museum*. New York, 1979.

Gilbert, Creighton, ed. *Italian Art: Sources and Documents*, Englewood Cliffs, 1980.

———. *History of Renaissance Art: Painting, Sculpture, and Architecture Throughout Europe*. Englewood Cliffs, 1973.

———. "On the Absolute Dates of the

Parts of the Sistine Ceiling." *Art History*, 3 (1980):158ff.

Gilbert, Felix. *The Pope, His Bankers, and Venice*. Cambridge, Mass., 1980.

Gilmore, Myron. *The World of Humanism*. New York, 1952.

Goldberg, Victoria L. "Leo X, Clement VII, and the Immortality of the Soul." *Simiolus*, 8 (1975–76).

Gould, Cecil. *Raphael's Portrait of Julius II*. London, 1970.

Greenstein, Jack M. "'How Glorious was the Second Coming of Christ:' Michelangelo's *Last Judgment* and the *Transfiguration*." *Artibus et Historiae* no. 20 (1989):33ff.

Guglia, E. "Die Türkenfrage auf dem Laterankonzil." *Mitteilungen der Instituts der österreichischen Geschichte*, 21 (1900):684ff.

Guicciardini, Francesco. *The History of Italy*. New York, 1969.

Hall, Marcia B. "Michelangelo's 'Last Judgment:' Resurrection of the Body and Predestination." *Art Bulletin*, 58 (1976):85ff.

Hallman, Barbara McClung. *Italian Cardinals, Reform, and the Church as Property, 1492–1563*. Berkeley–Los Angeles, 1985.

Hartt, Frederick. *Giulio Romano*. New Haven, 1958.

———. "*Lignum Vitae in Medio Paradisi*: The Stanza d'Eliodoro and the Sistine Ceiling." *Art Bulletin*, 32 (1950):115ff.; 181ff.

———. *Michelangelo Buonarroti*. New York, 1984.

———. *The Complete Sculpture of Michelangelo*. New York, 1968.

———. *The Sistine Chapel*. New York, 1991 (complete photographs of the recent cleaning of the ceiling).

Haskell, Francis, and Nicholas Penny. *Taste and the Antique. The Lure of Classical Sculpture, 1500–1900*. New Haven, 1981.

Helbig, W. *Führer durch die öffentliche Sammlungen klassischer Altertümer in Rom*. 4th ed. Tübingen, 1963–69.

Hess, J. "On Raphael and Giulio Romano." *Gazette des Beaux-Arts*, 32 (1947):73ff.

———. "On Some Celestial Maps and Globes of the Sixteenth Century." *Journal of the Warburg and Courtauld Institutes*, 30 (1967):406ff.

Hibbard, Howard. *Michelangelo*. 2d ed. Harmondsworth, 1985.

Hill, G. F. *A Corpus of Italian Renaissance Medals Before Cellini*. London, 1931.

Hirst, Michael. *Michelangelo and His Drawings*, New Haven, 1988.

———. *Sebastiano del Piombo*. Oxford, 1981.

Hollanda, Francisco de. *Michael Angelo Buonarroti*. London, [1548] 1903.

Ingersoll, Richard J. *The Ritual Use of Public Space in Renaissance Rome*. Berkeley, 1985.

Jacks, Philip. "A Sacred Meta for Pilgrims in the Holy Year 1575." *Architectura*, 1989.2, 137ff.

———. "Alexander VI's Ceiling for Santa Maria Maggiore." *Römisches Jahrbuch für Kunstgeschichte*, 22 (1985):75A.

Jones, Roger, and Nicholas Penny. *Raphael*. New Haven, 1983.

Klazcko, Julian. *Rome in the Renaissance: The Pontificate of Julius II*. New York, 1903.

Krautheimer, Richard. *St. Peter's and Medieval Rome*. Rome, 1985.

Lanciani, Rodolfo. *The Golden Days of the Renaissance in Rome*. Boston/New York, 1906.

Lavin, Irving. *Bernini and the Crossing of St. Peter's*. New York, 1968.

Lees-Milne, James. *Saint Peter's: The Story of Saint Peter's Basilica in Rome*. Boston, 1967.

Lewine, Carol, F. "Aries, Taurus, and Gemini in Raphael's *Sacrifice at Lystra*." *Art Bulletin*, 72 (1990):271ff.

Liebert, Robert S. *Michelangelo: A Psychoanalytic Study of his Life and Images.* New Haven, 1983.

Lippold, G. *Die Skulpturen des Vatikanischen Museums.* Berlin, 1956.

Lohuizen-Mulder, Mab van. *Raphael's Images of Justice, Humanity, Friendship: A Mirror of Princes for Scipione Borghese.* Wassenaar, 1970.

Longrigg, James. "The 'Roots of All Things.'" *Isis,* 67 (1976): 420ff.

MacDougall, Elisabeth B. "The Sleeping Nymph: Origins of a Humanist Fountain Type." *Art Bulletin,* 57 (1975): 357ff.

MacMullen, Ramsay. *Christianizing the Roman Empire (AD 100–400).* New Haven, 1984.

Masson, Georgina. *Companion Guide to Rome.* London, 1965.

Middeldorf, Ulrich. *Renaissance Medals and Plaquettes.* Florence, 1983.

Miglio, Massimo. "Roma dopo Avignone. La rinascita politica dell'antico." In Salvatore Settis, ed., *Memoria dell'antico nella'arte italiana.* Turin, 1984, 1, 73ff.

———, ed. *Un Pontificio ed una città: Sisto IV (1471–1484). Atti del Convegno.* Rome, 1986.

Millon, Henry, and Craig Hugh Smyth. *Michelangelo Architect: The Facade of San Lorenzo and the Drum of the Dome of St. Peter's.* Exhibition catalogue. Washington, D.C., 1988.

Mitchell, Bonner. *Rome in the Renaissance: The Age of Leo X.* Norman, 1973.

Murray, Linda. *Michelangelo, His Life, Work, and Times.* New York, 1984.

Murray, Peter. *Architecture of the Italian Renaissance.* London, 1986.

———. "Leonardo and Bramante." *Architectural Review,* 134 (1963): 346ff.

———. "Menicantonio, du Cerceau, and the Towers of St. Peter's. " In *Studies in the Renaissance and Baroque Dedicated to Anthony Blunt.* London, 1967, 5ff.

———. "Observations on Bramante's St. Peter's." In *Essays in the History of Architecture presented to Rudolf Wittkower.* London, 1967, 53ff.

Nesselrath, A., and G. Morello. *Raffaello in Vaticano.* Exhibition catalogue. Milan, 1984.

Nova, Alessandro. *The Art Patronage of Pope Julius III (1550–1555).* New York, 1988.

Oberhuber, K. "Raphael and the State Portrait—I. The Portrait of Julius II." *Burlington Magazine,* 113 (1971): 124ff.

———. "Die Fresken der Stanza dell'Incendio." *Jahrbuch der Kunsthistorischen Sammlungen in Wien,* 58 (1962): 24ff.

O'Malley, John W. "Fulfillment of the Christian Golden Age under Pope Julius II: Text of a Discourse of Giles of Viterbo, 1507." *Traditio,* 25 (1969): 265ff.

———. *Praise and Blame in Renaissance Rome: Rhetoric, Doctrine and Reform in the Sacred Orators of the Papal Court, c1450–1521.* Durham, N.C., 1979.

———. *Giles of Viterbo on Church and Reform.* Durham, N.C., 1968.

———. *Rome and the Renaissance. Studies in Culture and Religion.* London, 1981.

Panofsky, Erwin. *Meaning in the Visual Arts.* New York, 1955.

———. "The Neoplatonic Movement and Michelangelo." *Studies in Iconology.* New York [1939], 1962.

———. *Tomb Sculpture: Four Lectures on Its Changing Aspects from Ancient Egypt to Bernini.* New York, 1964.

———. "The First Two Projects of Michelangelo's Tomb of Julius II." *Art Bulletin,* 19 (1937): 561ff.

Partner, Peter. *Renaissance Rome: A Portrait of a Society.* Berkeley, 1976.

———. *The Lands of St. Peter,* 1972.

———. *The Pope's Men: The Papal Civil Service in the Renaissance.* Oxford, 1990.

Partridge, Loren, and Randolph Starn. *A*

Renaissance Likeness: Art and Culture in Raphael's Julius II. Berkeley, 1980.

Pastor, Ludwig. *The History of the Popes from the Close of the Middle Ages.* 36 volumes. London, 1950.

Patrides, C. A. "'The Bloody and Cruel Turke:' the Background of a Renaissance Commonplace." *Studies in the Renaissance,* 10 (1963):126ff.

Pedretti, Carlo. *Raphael: His Life and Work in the Splendors of the Italian Renaissance.* Florence, 1989.

Perry, M. "'*Candor illaesus.*' The Impresa of Clement VII and other Medici Devices in the Vatican Stanze." *Burlington Magazine,* 119 (1977):676ff.

Pfeiffer, H. "Zur Ikonographie des Raphaels Disputà. Egidio da Viterbo und die christlich-platonische Konzeption der Stanza della Segnatura." *Miscellanea historiae pontificiae,* 37. Rome, 1975.

Pietrangeli, Carlo. *The Sistine Chapel: the Art, the History, and the Restoration.* New York, 1986.

Pope-Hennessy, John. *Benvenuto Cellini.* New York, 1985.

———. *Italian High Renaissance and Baroque Sculpture.* London, 1970.

———. "Storm over the Sistine Ceiling." *New York Review of Books.* October 8, 1987, 16ff.

———. *The Portrait in the Renaissance,* Princeton, 1966.

Portoghesi, Paolo. *Rome of the Renaissance.* London, 1972.

Pouncey, Philip, and John Gere. *Raphael and His Circle.* London, 1962.

Quando gli dei si spogliano. il Bagno di Clemente VII a Castel Sant'Angelo. Exhibition catalogue. Rome, 1984.

Quednau, Rolf. *Die Sala di Costantino im Vatikanischen Palast.* Hildesheim, 1979.

Raffaello architetto. Exhibition catalogue. Milan, 1984.

Raffaello in Vaticano. Exhibition catalogue. Rome, 1985, with articles (in Italian) by Christoph Luitpold Frommel,

Maurizio Calvesi, Matthias Winner, Kathleen Weil-Garris Brandt, John Shearman, and Konrad Oberhuber.

Ramirez, Juan Antonio. *Construcciones ilusorias.* Madrid, 1983.

Ramsden, E. H. *The Letters of Michelangelo.* London, 1963.

Rash-Fabbri, Nancy. "A Note on the Stanza della Segnatura." *Gazette des Beaux-Arts,* 94 (October 1979):97ff.

Redig de Campos, D. *I Palazzi Vaticani.* Bologna, 1967.

———. *Le Stanze di Raffaello.* Milan, 1965.

———, and B. Biagetti. *Il Giudizio Universale di Michelangelo.* Rome, 1944.

Robertson, Charles. "Bramante, Michelangelo, and the Sistine Ceiling." *Journal of the Warburg and Courtauld Institutes,* 49 (1986):91 ff.

Rodocanacchi, Emmanuel. *La première Renaissance: Rome au temps de Jules II et de Léon X.* Paris, 1912.

Ruysschaert, José, and Ennia Francia. *The Vatican Spirit and the Art of Christian Rome.* New York, 1975.

Salvini, Roberto. *The Hidden Michelangelo.* Chicago, 1978.

Schröter, E. "Raffael's Parnasse: Eine Ikonographische Untersuchung." *Actas del XXIII Congreso Internacional de Historia del Arte,* 3. Granada, 1978: 593ff.

Schwoebel, Robert H. "Coexistence, Conversion, and the Crusade against the Turks." *Studies in the Renaissance,* 12 (1965):164ff.

Seymour, Charles, Jr. *Michelangelo: The Sistine Chapel Ceiling.* New York, 1972.

Shearman, John, and John White. "Raphael's Tapestries and Their Cartoons." *Art Bulletin,* 40 (1958):193ff.

———. *Raphael's Cartoons in the Collection of Her Majesty the Queen and the Tapestries for the Sistine Chapel.* London, 1972.

———. "Raphael's Unexecuted Projects for the Stanze." *Walter Friedlaender*

zum 90. Geburtstag. Berlin, 1965, 158ff.

———. "The Vatican Stanze: Functions and Decoration." *Proceedings of the British Academy* 57 (1971): 369ff.

———. "The 'Expulsion of Heliodorus'." In *Atti del Convegno internazionale sull'istoria dell'arte*, Rome, 1986.

———. *The Organization of Raphael's Workshop*. In *Art Institute of Chicago Centennial Lectures*. Chicago, 1983.

———. *The Vatican Stanze: Functions and Decoration*. London, 1971.

Sinding-Larsen, S. "A Re-reading of the Sistine Ceiling." *Institutum Romanum Norvegiae. Acta ad archaeologiam et artium historiam pertinentia*, 4, 1969

Steinberg, Leo. "A Corner of Michelangelo's 'Last Judgment'." *Daedalus*, 109 (1980): 207ff.

———. "Michelangelo's 'Last Judgment' as Merciful Heresy." *Art in America*, 63 (1975): 48ff.

———. "The Line of Fate in Michelangelo's Painting." in W. J. T. Mitchell, ed. *The Language of Images*. Chicago, 1980.

Steinmann, Ernst. *Das Grabmal Pauls III in St. Peter in Rom*. Leipzig, 1912.

———. *Die Sixtinische Kappelle*. Munich, 1905.

Sterba, Richard, and Edith Sterba. "The Personality of Michelangelo Buonarroti. Some Reflections." *American Imago* 35 (1978): 156ff.

Stinger, Charles L. *The Renaissance in Rome*. Bloomington, 1985.

Summers, David. *Michelangelo and the Language of Art*. Princeton, 1981.

———. "Michelangelo on Architecture." *Art Bulletin*, 54 (1972): 146ff.

Symonds, J. A. *The Life of Michelangelo Buonarroti*. 3d ed. London, 1901.

Toynbee, Jocelyn, and J. Ward-Perkins. *The Shrine of St. Peter*. London, 1956.

Vasari, Giorgio. Lives of Bramante, Raphael, and Michelangelo, in *The Lives of the Painters, Sculptors, and Architects*. Many eds.

Vatican Collections, the Papacy and Art. Exhibition catalogue. New York, 1983.

Weil-Garris Brandt, Kathleen. "The Self-Created Bandinelli." In Irving Lavin, ed., *World Art: Themes of Unity in Diversity*. University Park, 1989, 497ff.

———. "Bandinelli and Michelangelo: A Problem of Artistic Identity." In Moshe Barasch, Lucy Freeman Sandler, and Patricia Egan, eds., *Art the Ape of Nature: Studies in Honor of H. W. Janson*. New York, 1981, 223ff.

———. "Michelangelo's *Pietà* for the Cappella del Re di Francia." In *'Il se rendit en Italie:' Etudes offerts à André Chastel*. Paris, 1987, 77ff.

———. *The Santa Casa di Loreto: Problems in Cinquecento Sculpture*. New York, 1977

———. "Twenty-five Questions about Michelangelo's Sistine Ceiling." *Apollo* (1987): 392ff.

Weiss, Roberto. "The Medals of Pope Julius II, (1503–13)." *Journal of the Warburg and Courtauld Institutes*, 23 (1965): 163ff.

———. *The Renaissance Rediscovery of Classical Antiquity*. Oxford, 1969

Westfall, C. William. *In This Most Perfect Paradise. Alberti, Nicholas V, and the Invention of Conscious Urban Planning, 1447–1455*. University Park, 1974.

———. "Purpose and Form in the Renaissance Palace." In Silvia Danesi Squarzina, ed., *Roma, centro ideale della cultura dell'antico nei secoli xv e xvi*. Milan, 1989, 316ff.

Wilde, Johannes. *Michelangelo's "Victory."* London, 1954.

Wind, Edgar. "Michelangelo's Prophets and Sibyls." *Proceedings of the British Academy* 51 (1960).

———. "The Four Elements in Raphael's Stanza della Segnatura." *Journal of*

Renaissance Likeness: Art and Culture in Raphael's Julius II. Berkeley, 1980.

Pastor, Ludwig. *The History of the Popes from the Close of the Middle Ages.* 36 volumes. London, 1950.

Patrides, C. A. "'The Bloody and Cruel Turke:' the Background of a Renaissance Commonplace." *Studies in the Renaissance,* 10 (1963): 126ff.

Pedretti, Carlo. *Raphael: His Life and Work in the Splendors of the Italian Renaissance.* Florence, 1989.

Perry, M. "'Candor illaesus.' The Impresa of Clement VII and other Medici Devices in the Vatican Stanze." *Burlington Magazine,* 119 (1977): 676ff.

Pfeiffer, H. "Zur Ikonographie des Raphaels Disputà. Egidio da Viterbo und die christlich-platonische Konzeption der Stanza della Segnatura." *Miscellanea historiae pontificiae,* 37. Rome, 1975.

Pietrangeli, Carlo. *The Sistine Chapel: the Art, the History, and the Restoration.* New York, 1986.

Pope-Hennessy, John. *Benvenuto Cellini.* New York, 1985.

———. *Italian High Renaissance and Baroque Sculpture.* London, 1970.

———. "Storm over the Sistine Ceiling." *New York Review of Books.* October 8, 1987, 16ff.

———. *The Portrait in the Renaissance,* Princeton, 1966.

Portoghesi, Paolo. *Rome of the Renaissance.* London, 1972.

Pouncey, Philip, and John Gere. *Raphael and His Circle.* London, 1962.

Quando gli dei si spogliano. il Bagno di Clemente VII a Castel Sant'Angelo. Exhibition catalogue. Rome, 1984.

Quednau, Rolf. *Die Sala di Costantino im Vatikanischen Palast.* Hildesheim, 1979.

Raffaello architetto. Exhibition catalogue. Milan, 1984.

Raffaello in Vaticano. Exhibition catalogue. Rome, 1985, with articles (in Italian) by Christoph Luitpold Frommel, Maurizio Calvesi, Matthias Winner, Kathleen Weil-Garris Brandt, John Shearman, and Konrad Oberhuber.

Ramirez, Juan Antonio. *Construcciones ilusorias.* Madrid, 1983.

Ramsden, E. H. *The Letters of Michelangelo.* London, 1963.

Rash-Fabbri, Nancy. "A Note on the Stanza della Segnatura." *Gazette des Beaux-Arts,* 94 (October 1979): 97ff.

Redig de Campos, D. *I Palazzi Vaticani.* Bologna, 1967.

———. *Le Stanze di Raffaello.* Milan, 1965.

———, and B. Biagetti. *Il Giudizio Universale di Michelangelo.* Rome, 1944.

Robertson, Charles. "Bramante, Michelangelo, and the Sistine Ceiling." *Journal of the Warburg and Courtauld Institutes,* 49 (1986): 91 ff.

Rodocanacchi, Emmanuel. *La première Renaissance: Rome au temps de Jules II et de Léon X.* Paris, 1912.

Ruysschaert, José, and Ennia Francia. *The Vatican Spirit and the Art of Christian Rome.* New York, 1975.

Salvini, Roberto. *The Hidden Michelangelo.* Chicago, 1978.

Schröter, E. "Raffael's Parnasse: Eine Ikonographische Untersuchung." *Actas del XXIII Congreso Internacional de Historia del Arte,* 3. Granada, 1978: 593ff.

Schwoebel, Robert H. "Coexistence, Conversion, and the Crusade against the Turks." *Studies in the Renaissance,* 12 (1965): 164ff.

Seymour, Charles, Jr. *Michelangelo: The Sistine Chapel Ceiling.* New York, 1972.

Shearman, John, and John White. "Raphael's Tapestries and Their Cartoons." *Art Bulletin,* 40 (1958): 193ff.

———. *Raphael's Cartoons in the Collection of Her Majesty the Queen and the Tapestries for the Sistine Chapel.* London, 1972.

———. "Raphael's Unexecuted Projects for the Stanze." *Walter Friedlaender*

zum 90. Geburtstag. Berlin, 1965, 158ff.

———. "The Vatican Stanze: Functions and Decoration." *Proceedings of the British Academy* 57 (1971): 369ff.

———. "The 'Expulsion of Heliodorus'." In *Atti del Convegno internazionale sull'istoria dell'arte*, Rome, 1986.

———. *The Organization of Raphael's Workshop*. In *Art Institute of Chicago Centennial Lectures*. Chicago, 1983.

———. *The Vatican Stanze: Functions and Decoration*. London, 1971.

Sinding-Larsen, S. "A Re-reading of the Sistine Ceiling." *Institutum Romanum Norvegiae. Acta ad archaeologiam et artium historiam pertinentia*, 4, 1969

Steinberg, Leo. "A Corner of Michelangelo's 'Last Judgment'." *Daedalus*, 109 (1980): 207ff.

———. "Michelangelo's 'Last Judgment' as Merciful Heresy." *Art in America*, 63 (1975): 48ff.

———. "The Line of Fate in Michelangelo's Painting." in W. J. T. Mitchell, ed. *The Language of Images*. Chicago, 1980.

Steinmann, Ernst. *Das Grabmal Pauls III in St. Peter in Rom*. Leipzig, 1912.

———. *Die Sixtinische Kappelle*. Munich, 1905.

Sterba, Richard, and Edith Sterba. "The Personality of Michelangelo Buonarroti. Some Reflections." *American Imago* 35 (1978): 156ff.

Stinger, Charles L. *The Renaissance in Rome*. Bloomington, 1985.

Summers, David. *Michelangelo and the Language of Art*. Princeton, 1981.

———. "Michelangelo on Architecture." *Art Bulletin*, 54 (1972): 146ff.

Symonds, J. A. *The Life of Michelangelo Buonarroti*. 3d ed. London, 1901.

Toynbee, Jocelyn, and J. Ward-Perkins. *The Shrine of St. Peter*. London, 1956.

Vasari, Giorgio. Lives of Bramante, Raphael, and Michelangelo, in *The Lives of the Painters, Sculptors, and Architects*. Many eds.

Vatican Collections, the Papacy and Art. Exhibition catalogue. New York, 1983.

Weil-Garris Brandt, Kathleen. "The Self-Created Bandinelli." In Irving Lavin, ed., *World Art: Themes of Unity in Diversity*. University Park, 1989, 497ff.

———. "Bandinelli and Michelangelo: A Problem of Artistic Identity." In Moshe Barasch, Lucy Freeman Sandler, and Patricia Egan, eds., *Art the Ape of Nature: Studies in Honor of H. W. Janson*. New York, 1981, 223ff.

———. "Michelangelo's *Pietà* for the Cappella del Re di Francia." In *'Il se rendit en Italie:' Etudes offerts à André Chastel*. Paris, 1987, 77ff.

———. *The Santa Casa di Loreto: Problems in Cinquecento Sculpture*. New York, 1977

———. "Twenty-five Questions about Michelangelo's Sistine Ceiling." *Apollo* (1987): 392ff.

Weiss, Roberto. "The Medals of Pope Julius II, (1503–13)." *Journal of the Warburg and Courtauld Institutes*, 23 (1965): 163ff.

———. *The Renaissance Rediscovery of Classical Antiquity*. Oxford, 1969

Westfall, C. William. *In This Most Perfect Paradise. Alberti, Nicholas V, and the Invention of Conscious Urban Planning, 1447–1455*. University Park, 1974.

———. "Purpose and Form in the Renaissance Palace." In Silvia Danesi Squarzina, ed., *Roma, centro ideale della cultura dell'antico nei secoli xv e xvi*. Milan, 1989, 316ff.

Wilde, Johannes. *Michelangelo's "Victory."* London, 1954.

Wind, Edgar. "Michelangelo's Prophets and Sibyls." *Proceedings of the British Academy* 51 (1960).

———. "The Four Elements in Raphael's Stanza della Segnatura." *Journal of*

the *Warburg and Courtauld Institutes* (1938/9): 75ff.

Winternitz, E. "The Lira da Braccio: Musical Archaeology of the Renaissance in Raphael's 'Parnassus.'" In *Musical Instruments and Their Symbolism in Western Art*. New Haven, 1979.

Wittkower, Rudolf. *Architectural Principles in the Age of Humanism*, London, 1949.

————. "Michelangelo's Dome of St. Peter's." In Wittkower, *Idea and Image*. London, 1978, 73ff.

Wolf von Metternich, Franz, Graf. "Über die Massgrundlagen des Kuppelentwürfes Bramantes für die Peterskirche in Rom." In *Essays in the History of Architecture Presented to Rudolf Wittkower*. London, 1967, 40ff.

Wright, M. R. *Empedocles: The Extant Fragments*. New Haven, 1981.

Zucker, M. "Raphael and the Beard of Pope Julius II." *Art Bulletin*, 59 (1977): 524ff.

Analytical Index

The purpose of this index is not to duplicate facts in the text but to help the reader find them there. One exception: biographical dates on artists and major rulers are included here but not in the text. (An exception to the exception: the Medici dates are all on page 17 above.)

Monuments for which locations are not given are in Rome.

Names are listed in accordance with the accepted but frequently irrational usage. Thus Perino del Vaga is under "Perino," not "Del Vaga" or "Vaga, del." However, Giuliano della Rovere is under "Della Rovere." St. Peter's is called just that; but other churches dedicated to that saint are under "San Pietro." This is the normative way to do it, and readers in the know will not put up with anything else. Besides, given the complications of Italian Renaissance names, there is no system that is both consistent and usable.

Anglicanism, 32
Antichrist, 11, 13
Antinous, Vatican Museums, 107
Apennines, 14
Aphrodite, 105, 244. *See also* Venus
Apocalypse, Book of, 11, 12
Apollo: Stanze, *School of Athens*, 130, 135; Stanze, *Parnassus*, 138; Stanza della Segnatura, vault, 142; Stanze, Sala di Costantino, 171
Apollo Belvedere, 102–3, 171
Apollonius the Athenian (1st century B.C.E., sculptor), 111
Apostolici Regiminis, 211
Apparition of the Cross to Constantine, Stanze, 164 ff.
Aragon, Catherine of (1485–1536, queen of England), 28
Aragonese, in Naples, 7, 9. *See also* Naples, Kingdom of
Aram, Sistine Chapel, 205
Arch of Constantine, 164
Archimedes, Stanze, 134, 135
Ares, 111
Aretino, Pietro, 33, 161, 215
Argan, Giulio Claudio, 67
Ariadne (formerly *Cleopatra*), Vatican Museums, 105, 108, 109
Arian heresy, 170, 174
Ariosto, Ludovico, 23, 146, 156; *Orlando Furioso*, 32, 129; in *Parnassus*, 140
Aristotle, 132, 245
Ark of the Covenant, 74, 238
Ark of Noah, 190. *See also* Noah
Armageddon, 11, 12, 199
Armies, papal, 12
Arno, Vatican Museums, 105
Arnobius Afer (theologian), 102
Artillery, in Renaissance, 5, 7
Assisi, 34
Assumption of the Virgin, Sistine Chapel, 181, 211
Astraea, 204
Astulph (9th-century king of Britain), Stanze, 156
Athene, 105
Athenodoros (Hellenistic Rhodian sculptor), 105
Athens, 105
Atrio del Torso, Vatican Museums, 111
Attila (king of the Huns, reigned 445–53), 148
Augustine, St., 137, 138

Augustus (63 B.C.E.–14 C.E., Roman emperor), 135
Aulae pontificae, 152
Averroes, Stanze, 132, 134
Avignon, 7, 9, 30, 97; archbishop's palace at, 1, 178; Great Chapel of Clement VI, 178. *See also* Della Rovere, Giuliano

Babylon, 8, 10, 27, 43
"Babylonian Captivity," 46, 47, 201, 205, 207; in Avignon, 97
Bacchus (Michelangelo), Florence, Bargello, 252, 260
Badalocchio, Sisto (1585–1647, from Parma, painter and engraver), 246
Bagatelle, Château, 247
Baglione, Gian Paolo (lord of Perugia to 1506), 14
Baldacchino, 174
Baldi, Bernardino, 109, 110
Banderoles, 171
Bandinelli, Baccio (1488–1560, Florentine sculptor); copy of *Laocoön*, 107; scheme for papal tomb, Rhode Island School of Design, 57; tomb of Clement VII, portrait of Bandinelli, 61; tombs in Santa Maria sopra Minerva, 29, 56 ff.
Baptism of Christ by St. John the Baptist, Sistine Chapel, 181
Baptism of Christ, Logge, 238, 241
Baptism of Constantine, Stanze, 170 ff.
Baptism, in New World, 13
Barbaro, Daniele, 161
Bardoni, Girolamo, 8, 10
Barnabas, St., 120
Bartholomew, St., 215
Basamento, Logge, 233
Battle of Cascina (Michelangelo), Florence, Palazzo Vecchio, 192
Battle of the Milvian Bridge, Stanze, 171
Bear, symbol of the Orsini, 234
Beccafumi, Domenico (1480–1551, Sienese painter and sculptor), 245
Bellarmino, Roberto, 196
Belli, Valerio (15th-century medalist), 52
Beltrami, Luca (1854–1933, Milanese architect), 114
Belvedere torso, Vatican Museums, 111, 188, 220
Belvedere, Apollo. See *Apollo Belvedere*
Belvedere, Cortile. See Cortile; Vatican Museums
Belvedere, Villa. See Villa, Belvedere

Castel Sant'Angelo (*continued*)
VII's bathroom, 29; papal apartments, 246
Castiglione, Baldassare, 22, 109, 135
Catherine of Alexandria, St., 215
Catherine the Great, 246
Catullus, 140
Cecilia, St., 168
Cellini, Benvenuto (1500–1571, Florentine sculptor and medallion-maker), 27, 58; *Perseus*, 225
Cesariano, Cesare (1483–1543, Milanese architect), 68
Cesena, 13, 263
Ceylon, 12
Charity, Stanze, 168
Charlemagne (742–814, emperor of the West), 8, 10, 20, 152–56; coronation, 97
Charles V (1500–1558, Holy Roman emperor), 3, 5, 21, 22, 26, 27, 30; drives Turks to Tunis, 32; lands at Genoa, 28; proposes peace, 28; visits Rome, 34
Charles VIII (1470–98, king of France), 7–9, 10, 11
Charon, 219, 223
Chastel, André, 102
Cherubim, 198
Chigi Palace, 128
Chlamys, 102
Christ Delivering the Keys of Heaven to Peter, tapestry, 117, 118
Christ, 136–39, 199; ancestors of, 184; armies of, 12; as sun, 13, as Zeus, 219, 223; Good Shepherd, 118; joy to bear his yoke, 252; life of, 181 ff.; portrayed as pope, 211
Chrysippus, Stanze, 134
Church: as prisoner, 252; general councils of, 5, 16. See also Lateran Council, Fifth; Nicaea, Council of; Trent, Council of
Church fathers, 102; in *Disputa*, 135 ff.
Circumcision of Moses' Sons, Sistine Chapel, 181
Città di Castello, 23
Civitavecchia, 1, 28, 238
Clement I (saint, pope, reigned 88?–97?), 165
Clement V (Bertrand de Goth, pope, reigned 1305–14), 97
Clement VI (Pierre Roger de Rosières, pope, reigned 1342–52), 97
Clement VII (Giulio de 'Medici, pope,

reigned 1523–34), 6, 8, 23, 100, 124, 140; advised by Alessandro Farnese, 30; artistic patronage, 29 ff., death, 29, 273; early life, 23–25; elected in Sistine Chapel, 177, 265; escapes Rome, 28; medallic persona was Christ, 52; reforms, 28; relief of meeting with Charles V, 59; relish for déshabille, 64; renounces Parma, Piacenza, Modena, 28; timidity of, 26; was to commission a Michelangelo *Resurrection*, 211; would rout Lutherans by growing beard, 49
Cleopatra. See *Ariadne*
Clio, Stanze, 139
Cognac, League of, 3, 5, 26
Coins and medals, papal, 42 ff.
Colalucci, Gianluigi, 213
Colinus californicus (bobwhite), 233, 246
Colonna: family, 13, 28; Pompeo, 27
Color, "mannerist," in Sistine ceiling, 213
Colosseum, 75, 164
Columbus, Christopher, 12
Column of Trajan, 164
Comitas, Stanze, 165
Commodus (161–92, Roman emperor), 113; Vatican Museums, 101, 112
Concetto, 215
Condivi, Ascanio, 197, 211, 249, 254, 255, 264
Condottieri, 5, 7
Constantine and Maxentius, Basilica of, 84
Constantine I (288?–337, Roman emperor): donation of, 16, 26, 159, 174, 175; as role-model for popes, 160; and site of St. Peter's, 176; vision of, 176
Constantine II (316–40, Roman emperor), 171
Constantine's Reception of the Prisoners, Stanze, 174
Constantinople, 159
Constantius I (c250–306, Roman emperor), 159
Construction of the Ark, Logge, 245
Contrapposto, 57, 260
Conversion of the Proconsul, tapestry, Vatican Museums, 120
Copernicus, Nicholas, 33
Corbinelli altar (Andrea Sansovino), Florence, Santo Spirito, 56
Coronation of Charlemagne, Stanze, 153, 165
Coronation of the Virgin, Vatican Museums, 124, 127

Corpus Domini, feast of, 150
Corpus iuris civilis, 141
Correggio (Antonio Allegri 1489–1534,
 from the Emilia), 244, 246
Cortile: del Belvedere, 97 ff., 129, 138; and
 Palestrina, 99; del Pappagallo, 98, 129,
 140; della Pigna, 99; delle Statue, 101 ff.
Councils, Church. *See* Church
Counter-Reformation, 32
Court of the Signatura, 130
Cranmer, Thomas, 28
Cranston, Jodi, 109
Creation of Adam, Sistine Chapel, 190
Creation of Eve, Sistine Chapel, 192
Creation of the Animals, Logge, 233
Creusa, Stanze, 155
Crispus (son of Constantine I), 171
Crucifixion of St. Peter, Capella Paolina, xi
Crusade against Turks, proposed, 19, 156
Cumaean Sibyl, Sistine Chapel, 204
Cupid, 107, 185
Cybele, 256
Cybo, family tombs, 54
Cyclical history, 6, 8, 12. *See also* Golden Age

D'Albret tomb, Santa Maria di Aracoeli, 111
D'Arpino, Cavalier (Giuseppe Cesari,
 1568–1640, painter, from Frosinone), 74
Da sotto in sù, 202
Dacos, Nicole, 241
Dalmata, Giovanni (Ivan Duknovich,
 sculptor, from Trogir, Croatia), 180
Damasus (pope, reigned 366–384), 169
Daniel, Sistine Chapel, 174, 203
Daniele da Volterra (Daniele Ricciarelli,
 1509–66, painter and sculptor, 214, 221
Dante, 140, 223, 274, 275; *Inferno*, 31, 100;
 Purgatorio, 210
Darius (d. 486 B.C.E., emperor of Persians),
 203
David (Michelangelo), Florence, Accade-
 mia, 210
David and Goliath: Logge, 241; Sistine
 Chapel, 210
Davidson, Bernice, 228, 241, 244
De Bilhères, Cardinal Jean, 41
De' Conti, Sigismondo, 2, 17
De Foix, Gaston and Odet, 18
Della Porta, Giacomo (1540–1602, Flor-
 entine architect), 94; and dome of St.
 Peter's, 94
Della Porta, Guglielmo (1500–1577, Floren-

tine sculptor), *Abundance* and *Peace*, 64;
 Cesi tombs (Santa Maria Maggiore), 61;
 Justice, 164; tomb of Paul III, 61, 63
Della Robbia (Florentine family of sculp-
 tors in terracotta), 229, 267
Della Rovere oak, 12, 43, 260; festoons
 from, 197, 199; as Jews' original sanctu-
 ary, 260; meanings of, 42, 43, 140
Della Rovere, Francesco Maria (duke of
 Urbino), 5, 132, 134, 264, 265
Della Rovere, Girolamo Basso, 55
Della Rovere, Giuliano (Julius II), 2, 4, 8,
 10, 18, 103; as archbishop of Bologna, 9,
 14; as bishop of Grottaferrata, 1, 9;
 builds Archbishop's Palace at Avignon,
 1, 178; cardinal priest of Santi Apostoli,
 cardinal archbishop of Ostia, 9; and Ce-
 sare Borgia, 11; character of, 2; educa-
 tion of, 8; elected pope, 11; flees to
 France, 9; 1487 campaign in Marches, 9;
 and French bishops, 10; and Innocent
 VIII, 9; legate to France, 9; medal of
 Church, 10; military policies of, 2, 3; ob-
 session with imprisonment, 9; policy for
 the Italian peninsula, 10; refuge at Ostia,
 9; sees Italy in chains, 10; sinecures of,
 9. *See also* Julius II
Della Rovere, Luchina, 55
Delphi, 138
Delphic Sibyl, Sistine Chapel, 204
Deluge, Logge, 241
De Marcillat, Guillaume (c1475–1529,
 French painter and stained-glass worker),
 150
De' Medici: Alessandro, 17, 28; Alfonsina
 Orsini, 24; Caterina, 17, 28; Clarice, 24;
 Cosimo I (duke of Tuscany), 267; Gio-
 vanni (*see* Leo X); Giuliano I, 23; Giuli-
 ano II (duke of Nemours), 17, 19, 24;
 Giulio (*see* Clement VII); Ippolito, 17;
 Lorenzo (the Magnificent), 17, 18, 30;
 Lorenzo II, 5, 19, 24, 29; Piero II, 24
Democritus, Stanze, 134
Demonic idols, considered as art, 102
Deucalion, 272
Diana, 171
Dido, 108. *See also* Virgil
Diocletian: baths of, 67; palace of, at Split,
 77
Diogenes, Stanze, 134
Dionysos (2nd century B.C.E.), Greek
 sculptor, 110

Francis I (1494–1547, king of France), 3, 5, 19, 20, 21, 26, 30, 103, 113, 153; defeat at Pavia, 26; invades Italy, 24; threatens schism, 25
Frascati, 34
Freedberg, Sydney, 186, 188, 207, 231
Fresco, *buon fresco*, 214
Freud, Sigmund, 260
Frick, Henry Clay, 8
Frommel, C. L., 81
Frundsberg, duke of, 27
Fugger, Anton, 171
Fulmination, Stanze, 175

Gabinetto delle Maschere, Vatican Museums, 110
Galleria Chiaromonti, Vatican Museums, 112
Galleria degli Arazzi, Vatican Museums, 114, 119
Gambello, Vettor di Antonio (1455/60–1537, Venetian medalist), 50
Gattinara, Bartolomeo, 28
Gennesaret, Lake, 117
Gentile da Fabriano (1370–1427, painter from Ancona), 35
Géricault, J.-L.-A.-T. (1791–1824, French painter), 107
German atheism, 149
Ghibelline (imperial) party, 20
Ghiberti, Lorenzo (1378–1455, Florentine sculptor and architect), 35
Ghirlandaio, (Domenico Bigordi 1449–94, Florentine painter), 177, 181
Gianiculum, 65
Gilbert, Creighton, 150, 205
Giles of Viterbo (1469–1532), 1, 8, 12, 13, 27, 29, 42, 74, 137, 190; and Etruscan Janus, 14; evokes Joshua, 238; on Julius as high priest and architect, 45; on Julius' family as Hebrew church, 56; likens Julius II to Rachel, 275; Noah and Golden Age, 194; quaternities, 78, 135, 264
Giocondo da Verona, Fra (1433–1515, architect), 80, 83, 84
Giotto da Bondone (1267?–1337, Florentine painter, architect, and sculptor), at Assisi, 235; *Last Judgment*, Arena Chapel, Padua, 215; Stefaneschi Polyptych, 114
Giovanni da Udine (1487–1564, painter, *stuccatore*, and architect), 228, 229, 233, 235

Giovanni delle Bande Nere, 27
Giovanni di Paolo (c1403–c1482, Sienese painter), 114
Giovio, Paolo, *Dialogo delle imprese*, 46
Giraffes, 247
Giuliano, St., 127
Giulio Romano (Giulio Pippi, 1499–1546, painter and architect), 146, 148, 156, 159, 228. *See also* Sala di Costantino
Golden calf, worship of, 260
God: Appears to Moses, Stanze, 150; *Appears to Noah*, Stanze, 150; *Creates Adam*, Sistine Chapel, 188; *Createes Eve*, Sistine Chapel, 188; *Creates the Sun, Moon, and Earth*, Sistine Chapel, 187; *Establishes the Sabbath*, Logge, 233; *Separates the Light from the Darkness*, Sistine Chapel, 187; Logge, 233; *Separates the Waters and Brings Forth Earth's Vegetation*, Sistine Chapel, 187
Godfrey of Bouillon (c1060–1100, crusader and duke of Lower Lorraine), 156
Goethe, Johann Wolfgang von, 107
Golden Age, 12, 42 ff.; of Lucifer, Adam, Janus, and the Christ, 43; as Millennium, 204. *See also* Giles of Viterbo
Goliath, Sistine Chapel, 211
Gonzaga: Federigo, 134; Ferrante, 32
Greece, 12
Gregory I, "the Great" (saint, pope, 590–604), 136, 137, 175
Gregory IX Consigns the Decretals to the Consistory, Stanze, 141
Gregory XVI (Bartolommeo Capellari, pope, reigned 1831–1846), 110
Grimm, Friedrich Melchior, Baron, 247
Grotesques (*grotteschi*), 245, 246, 272
Grottaferrata, 1
Guelph (papal) party, 20
Guicciardini, Francesco, 153, 159; *Historia d'Italia*, 2, 8, 10, 13, 17, 19, 20, 22, 25, 26, 43

Hades, 255
Hadrian, (76–138, Roman emperor), 107
Hagesandros (Rhodian Hellenistic sculptor), 105
Hagia Sophia, 77, 78
Ham, Sistine Chapel, 194, 195
Haman, Sistine Chapel, 210, 211
Hartt, Frederick, 61
Haydn, Franz Joseph, *The Creation*, 233
Healing of the Lame Man, tapestry, 124

Loreto, Santa Casa of, 1, 55
Lothair I (795–855, Holy Roman emperor), 156
Louis XII (1462–1515, king of France), 11, 14; desires papacy, 16
Louis XIV (1638–1715, king of France), 113
Luther, Martin, 13, 22, 28, 45, 136; and Arianism, 174; calls Julius's papacy a Babylonian captivity, 47; Lutheranism, 26, 32

Machiavelli, Niccolò, 19, 43
Madama, Palazzo, 18
Madama, Villa. *See* Villa Madama
Maderno, Carlo (1556–1629, Lombard architect), 94
Madonna di Foligno (Raphael), Vatican Museums, 124
Madrid, Peace of, 26
Magico-religious power of statues, 110
Makarios of Perinthos, 111
Mala medica, Medici healing apples, 49. *See also* Medici arms and emblems
Mandorla, 57, 228
Manetti, Gianozzo, 36
Mantegna, Andrea (1431–1506, Paduan painter), 184
Mantua, 13, 32, 134, 263; ducal castle, 114
Manuel I (1469–1521, king of Portugal), 12
Manutius, Aldus, 22
Mappa, 47
Marches of Italy, 9
Marcus Aurelius (121–80, Roman emperor), 113
Marignano, Battle of, 19
Marsyas, Stanze, 142, 224
Martini, Simone (1285–1344, Sienese painter), 114
Martyrium, 75
Masaccio (Tommaso di ser Giovanni, 1401–1428/9, Florentine painter), 35
Masolino da Panicale (Tommaso di Cristoforo Fini, 1383–1440/7, Florentine painter), frescoes in San Clemente, 35, 184
Mass of Bolsena, Stanze, 149 ff.
"Masterpiece," meaning of, 228
Matilda, "the Great" (1046–1115, countess of Tuscany), 157
Matthew, St., 136, 252
Maxentius (d. 312, Roman emperor), 164; basilica of, 113; defeat of, 171; and St. Catherine, 215

Maximilian I (1455–1519, Holy Roman emperor), 14, 20
Medallions, in Sistine Chapel, 197
Medals, Renaissance papal, 6, 41 ff.
Medea, 242
Medici arms and emblems, 49, 105, 174, 230
Medici geneaology, 17. *See also under de' Medici individuals—Lorenzo, Giuliano, etc.*
Medici patron saints, Giuliano and Lorenzo, 127
Megiddo, Battle of, 202
Meleager, Vatican Museums, 108
Melozzo da Forlì (1438–94, painter), 114
Mercator, Gerhard, 77
Mercury, 120. *See also* Hermes
Merlin, 144
Meta Romuli, 165
Methusaleh, 194
Michelangelo (Michelangelo Buonarroti, 1475–1564, Florentine painter, sculptor, and architect), 8, 17, 25; acquires marble for Julius tomb, 254; appointed architect of St. Peter's, 88, 89 ff., 273; Biblioteca Laurenziana, Florence, 23, 84; borrows from Leonardo, 219; caricatures himself, 187; *Christ*, Santa Maria sopra Minerva, 58; claims to have worked without assistance, 182; *Creation of Adam*, 234; *Creation of Eve*, 234; dome, St. Peter's, 99 ff.; early work in Rome, 251 ff.; facade for San Lorenzo, Florence, 23, 84; and Florence defenses, 267; 1525 project for tomb of Julius II, 56; funeral, 256; *God Creating the Sun and Moon*, 236; house at Macel de'Corvi, 34; ill will against Guglielmo della Porta, 61; incomplete statue of St. Peter as pope, 256; influence on Logge, 241; influenced by Belvedere Torso, 106; *Last Judgment*, 114, 211 ff., 240, 251; Medici Chapel, Florence, 23, 84; Medici tombs, allegories, 64; *Moses*, 47, 257 ff; and nude Adam and Eve, 195; as "occupant" of Julius tomb, 256; order of Sistine Ceiling execution, 186; *Pietà* in St. Peter's, 41, 251; *Pietàs* in Florence and Milan, 41; projected piazza for St. Peter's, 82, 114; resentment of Bramante and Raphael, 134, 254; *Resurrection of Christ*, 211; Sistine Chapel ceiling, 177 ff.; 230; Sistine ignudi, 171; St. Bartholomew in *Last Judgment*, 219; *St. Matthew*, in Ac-

cademia, 254; statue of Julius II for Bologna, 1, 36, 59, 165; supposed copy of Belvedere Torso, 111; tomb for Julius II, 66, 249 ff.; Vatican artistic dictator, 61; was to paint a *Fall of the Rebel Angels*, 27

Milan, Duchy of, 2, 9, 30; San Lorenzo Maggiore, 77; Santa Maria delle Grazie and Santa Maria presso San Satiro, 56

Millennium, 11, 34, 199

Milo, Vatican Museums, 108

Milvian Bridge, Battle of, 165, 167, 175

Minerva, Stanze, 130, 135

Mino da Fiesole (c1430–84, Florentine sculptor), 180

Minos, Sistine Chapel, 224

Miraculous Draught of Fishes, Vatican Museums, 117

Modena, 19, 28, 154

Moderatio, Stanze, 165

Mohawk warrior, 103

Momo, Giuseppe (1875–1940, architect from Vercelli), 128

Monaco, Lorenzo. *See* Lorenzo Monaco

Mons vaticanus, 165

Monte Mario, 65

Montecassino, Giovanni de' Medici abbot of, 18

Montefiascone, 30

Mordecai, Sistine Chapel, 207

Morgan, J. Pierpont, 8

Moses, 12, 43, 124, 135, 168, 207, 235; as Hebrew oak, 182; life of, 181 ff.; reclaims Holy Land, 263

Moses, tomb, 255, 257, 263, 265, 267, 274–76; interpretations of, 260; *Receiving the Tablets*, Logge, 241

Mount Tabor, 124

Mozzetta, 47

Muses, Stanze, 138

Museum of Modern Religious Art, 36

Nagonius, Johannes Michael, 10

Nanni di Baccio Bigio (active c1530–1565, Florentine architect and sculptor), statue of Clement VII, 59

Naples, Kingdom of, 2, 7, 9, 30; as papal vassal state, 14; Spanish occupation of, 14

Napoleon (Napoleon Buonaparte, 1769–1821, emperor of the French), 103

Nason, Sistine Chapel, 206

National movements in the Church, 28

Navona, Piazza di, 34

Nebuchadnezzar, and Babylonian Captivity, 186

Nemean Lion, 111

Neoattic style, 111

Neoplatonism, 130, 134, 186

Nepi, 32

Nero, Circus of, 95, 99

New World, 11, 12, 32

New York: Guggenheim Museum, 128; Statue of Liberty, 94

Nicaea, Council of, 174

Nicholas V (Tommaso Parentucelli, pope, reigned 1447–55), 35, 36, 98, 129, 144

Nile, 113

Niobe, as *Ecclesia*, Sistine Chapel, 219

Noah, Sistine Chapel, 186, 199, 201

Nogari, Paris (1536–1601, Roman painter), 82, 114

Nonfinito, 272

Nudity, 189; and Adam and Eve, 195; in *Last Judgment*, 221; in sacrifice, 195; and theology, 161

Oath of Leo III, Stanze, 152 ff.

Obelisk, from Circus of Nero, 95

Olympia, 113

Onias, 145

Ops, Stanze, 175

Opus alexandrinum, 180

Oracula Sibyllina, 199, 200

Orsini, Cardinal, 26

Orsini, family, 9, 13, 25

Orvieto, cathedral, 150

Ostensorium, 136

Ostia, 1, 28, 30, 238; architect of fort, 177; fort, 34, 156; Giuliano della Rovere as cardinal-bishop of, 9

Ostrich, symbol of justice, 169

Ovid, 140

Oxford, Ashmolean Museum, 260

Paganism, and Christianity, 242

Palafrenieri, 229

Palazzi Vaticani, 97 ff., 127

Palazzo Venezia, 41

Palestinians, 236

Palestrina, Temple of Fortuna, 99

Palladio, Andrea (1508–80, Vicentine architect), 33

Pandeuktai, 141

Panofsky, Erwin, 264

Pantheon, 56, 83
Paolo Romano (d. 1477? Roman sculptor), 36
Papal States, 1 ff., 3, 5, 27
Papal primacy, 16; sanction over new lands, 3, 5, 16
Paragone, 106, 107
Paris: Ecole des Beaux-Arts, 249; Eiffel Tower, 94; Louvre, 109, 257, 260. See also *Dying Slave*; *Rebellious Slave*
Parma, 17, 19, 22, 28 ff., 154; Camera di San Paolo, 247; cathedral, 246
Parmigianino (1503–40, Francesco Mazzola, painter), 247
Parnassus, Stanze, 138 ff.
Paros, 105
Paul, St., 30, 46, 119, 120, 121, 136, 252, 256, 276
Paul I (pope, reigned 757–67), 30
Paul II (Pietro Barbo, pope, reigned 1464–71), 30, 41
Paul III (Alessandro Farnese, pope, reigned 1534–49), 14, 26, 29, 30, 61, 101, 108, 273, 276; appoints son governor of Milan, 32; civil policies, 30; commissions new design for St. Peter's, 86; elected pope, 30; and *Last Judgment*, 28; and Michelangelo, 29, 34; and Palazzo Farnese, 88; as a patron, 32 ff.; and reform, 30; resumes Belvedere construction, 100; Titian portrait of (1543), 61; tomb by Guglielmo della Porta in St. Peter's, 61
Paul IV (Gian Pietro Carafa, pope, reigned 1559–65), 94
Paul V (Camillo Borghese, pope, reigned 1605–21), 94
Pazzi conspiracy, 23
Peace, Stanze, 170
Peacocks, bronze, from Hadrian's Mausoleum, Vatican Museums, 101
Penni, Gian Francesco (c1488–1528, Florentine painter), 148, 159, 164, 174, 228
Pentelic marble, 105
Pépin le Bref, (c714–68, king of the Franks), 10, 154, 156
Pergamon, 105
Perino del Vaga (1501–47, Florentine painter), 135, 138, 228
Perrier, François, (1590–1650, French painter and printmaker), 103, 107, 112, 114
Perseus (Canova), Vatican Museums, 103

Persian Sibyl, Sistine Chapel, 201
Persians, 10
Perugia, 13, 14; liberated, 263; Rocca Paolina, 34
Perugino, Pietro (1450–1523, Perugian painter), 36, 101, 129; and ceiling of Stanza dell'Incendio, 15; *Nativity* and *Finding of Moses*, 211
Peruzzi, Baldassare (1481–1536, Sienese painter and architect), 34, 84, 100, 101, 129
Peter, St., 1, 12, 14, 117, 136, 164, 276; in the *Attila*, Stanze, 167; captivities of, 9, 10, 16, 46, 54; *Liberation of*, Stanze, 147 ff.; martyrdom, 67, 68; and Paul, 148; tomb of, 72, 73
Petrarch, 140
Petrucci, Alfonso, 20
Pharaoh's army, and Red Sea, 168
Phares, Sistine Chapel, 205
Pheidias, statue of Zeus at Olympia, 23
Philosophy, Stanze, 142
Piacenza, 17, 19, 22, 28 ff., 154
Pico della Mirandola, 132
Piero della Francesca (c1428–92, painter from Arezzo), 129
Pieter van Aelst (?–1536, Flemish artist), 116
Pinacoteca Vaticana, 114 ff. See also Vatican
Pindar, 140
Pinecone, Cortile, Vatican Museums, 100
Pinturicchio (Perugian painter, 1492–95, Bernardo di Betto), 39, 55
Piombino, 13, 263
Pisa, Council of, 16, 24, 152
Pisani, Alvise, 14
Pius III (Francesco Todeschini-Piccolomini, pope in 1503), 11
Pius IV (Giovanni Angelo Medici, pope, reigned 1559–65), 221, 229
Pius VI (Giovan Angelo Braschi, pope, reigned 1775–99), 111, 114
Plato, 130; as Leonardo, 133
Pliny, 114
Poetry, Stanze, 142
Poliziano, Angelo, 17
Pollaiuolo, Antonio (1431/2–98, Florentine painter and sculptor), 36
Polydoros (Rhodian Hellenistic sculptor), 105
Polyhymnia, Stanze, 139
Ponte Molle, 167
Pontelli, Baccio (c1450–c1495, Florentine

architect), 9. *See also* Ostia, fort; Sistine Chapel

Pontormo (Jacopo Carrucci, 1494–1556, Florentine painter), 205

Pope, Alexander, 110

Popolo, Piazza del, 23; Porta del, 29

Praetorian Guard, 164

Pragmatic Sanction, 16

Praxiteles (fl. c370–330 B.C.E., Greek sculptor), 108, 110

Presentation of Eve to Adam, Logge, 234

Primaticcio, Francesco (1504–70, Bolognese painter), 109

Propertius, 140

Prophets and Sibyls, Sistine Chapel, 160, 198 ff.

Prudence, Stanze, 170

Pseudo-Lucian, 111

Ptolemy, 134

Punishment of Haman, Sistine Chapel, 207

Purgatory, 13, 186

Putti, 180, 185. *See also* Angels; Ignudi

Pythagoras, 132, 134

Quadri riportati, 229

Quednau, Rolf, 159, 165, 167, 169, 171

Quercia, Jacopo della (c1374–1438, Sienese sculptor), 193

Rachel, tomb, 235, 256, 265, 274, 276

Raffaellino del Colle (fl. 1550–78, Emilian sculptor), 159

Raffaello da Montelupo (1505–1566/7, Florentine sculptor and architect), 267, 274, 275; Leo X's portrait, 59

Raft of the Medusa (Géricault), Paris, Louvre, 107

Raimondi, Marcantonio (c 1480–before 1534, Bolognese engraver), 146

Raimondo di Cardona, 17

Ramirez, J. A., 76

Raphael (Raffaello Sanzio, 1483–1520, painter and architect from Urbino), 6, 18, 25, 36, 68, 129, 148; architect of Cortile, 100; architect of Logge, 99, 114, 225 ff.; character, 228; *Coronation of Charlemagne*, Stanze, 83; *Coronation of the Virgin*, Vatican Museums, 124, 127; death of, 84, 100; *Entombment of Christ*, Vatican Museums, 127; *Expulsion of Heliodorus*, Stanze, 83; *Mass at Bolsena*, Stanze, 83; *Nativity*, for Santa Maria del Popolo, 55;

Oath of Leo III, Stanze, 83; planned piazza for St. Peter's, 82; planned *Westwerk* for St. Peter's, 89; portrait of Julius II, 47 ff., 160; portrait of Leo X, 50 ff., 233; project for St. Peter's in Sala di Costantino, 8; "Raphael's Bible," Logge, 233; schemes for St. Peter's, 80; in *School of Athens*, Stanze, 135; *Sistine Madonna*, Dresden, 257; Stanza dell'Incendio, 97, 154 ff.; Stanza della Segnatura, 5, 8, 12, 130 ff.; Stanze, 5, 9, 12, 55, 98, 129 ff.; theme of gold in *Disputa*, 138; *Transfiguration*, 124; as Vitruvian, 83

Ravenna, Battle of, 18, 236; exarchs, 159

Rebellious Slave, Louvre, 260, 264, 265

Reform, ecclesiastical, 16

Reformation, 13, 242

Reggio Emilia, 17, 19, 154

Religio, Stanze, 167

Renaissance libraries, 130

Renaissance paganism, 241

Resurrection of Christ, Logge, 241; planned for Sistine Chapel, 211

Resurrection of the flesh, 211

Revelation, Book of, 11

Reynolds, Sir Joshua (1723–92, English painter), 103

Riario, Cardinal Raffaele, 41, 114, 149

Riario, Palazzo, 26

Ribera, Jusepe (1590–1652, Spanish painter), 127

Rimini, 14, 263

Romano, Giulio. See Giulio Romano

Rome, 9, 11, 12, et passim; Sack of, 27 ff., 116, 220, 265, 267

Rosselli Cosimo (1439–1507, Florentine painter), 181, *Last Supper*, 241

Rossellino, Bernardo (1409–64, Florentine architect), 36, 66; apse for Old St. Peter's, 72, 249

Rosso Fiorentino (1494–1540, Giovanni Battista di Jacopo de'Rossi, painter), 205

Rubens, Peter Paul (1577–1640, Flemish painter and architect), 167, *Fall of Rebel Angels*, 211

Sabina, 9

Sacra conversazione, 124

Sacrifice of Isaac, Stanze, 150

Sacrifice of Lystra, tapestry, Vatican Museums, 120

Sacrifice of Noah, Stanze, 193

Sadoleto, Jacopo, 2, 22, 106; on *Laocoön*, 109 ff.
St. Peter's, New, 10, 13, 65 ff.; colonnades, 71, 95; confessio, 72, 74, 76, 80; consecrated, 95; cornerstone laid, 78, 249; dome, 88, 90, 91 ff.; as a history of architectural thought, 65; justification for expense, 74; main altar, 73; medals, 43; after Michelangelo's death, 95; Michelangelo as architect, 88, 89 ff.; and Moses' offerings, 74; as a "mundus," 77 ff.; as oak, 43; and Pantheon and Basilica of Constantine, 83; projects, parchment plan, 71 ff.; after Raphael's death, 85; "quaternities," 78; sacristy, 276; and St. Peter's tomb, 67; Sangallo model, 86; tegurio, 80; tesoro, 36, 42, 43; and theme of gold, 76; as a tomb, 74; as a "work," 73 ff.
St. Peter's, Old, 97; atrium, 100; benediction loggia, 72, 225; built by Constantine, 72; Chapel of Santa Petronilla, 73; chapel built by Sixtus IV, 276; confessio, 114, 119, 138; and Nicholas V, 66; site, and Constantine's cross, 176
Sala delle Muse, Atrio del Torso, Vatican Museums, 111
Sala di Costantino, 64, 146, 157 ff., 176, 227, 229, 230, 241
Sallustia (Barbia Orbana), 107
Salvation by faith, 13
Salvius, Publius Cincius (3rd century C.E., Roman sculptor), 100
San: Clemente, 24; Giovanni dei Fiorentini, 23; Giovanni in Laterano, 97, 171; Lorenzo in Damaso, 97; Martino ai Monti, 108; Paolo fuori le Mura, 72; Pietro in Montorio, 41, 71; Pietro in Vincoli, 9, 103, 251
Sanctity, and sexual attraction, 164
Sangallo, Antonio the Younger (1483– 1546, Florentine architect), 57, 84; Cappella Paolina and Sala Regia, 99; fortifications at Ancona, Ostia, Assisi, Agnani, 34; model of St. Peter's, 86; sketch-plan for Santa Maria sopra Minerva, 138
Sangallo, Giuliano da (1443/5–1516, Florentine architect), 66, 80, 83, 84
Sannazaro, Jacopo, 22, 133, *Du partu virginis*, 140, 245
Sansovino, Andrea (1460/67–1529, Florentine architect and sculptor), 56

Sansovino, Jacopo (1486–1570, Florentine architect and sculptor), 107
Sant'Apollinare, Piazza, 34
Santa: Maria del Popolo, 39, 54, 55, 56, 57; Chigi Chapel, 80; Sforza and Rovere tombs, 54 ff.; Maria della Pace, 41; Maria di Aracoeli, 111, 124; Maria in Domnica, 18, 24; Maria Maggiore, 57, 72; Maria sopra Minerva, tombs of Leo X and Clement VII, 56 ff.
Santo: Spirito in Sassia, 34; Stefano Rotondo, 75
Savona, 8, 17
Savonarola, Girolamo, 18
Schiller, Friedrich, 107
School of Athens, Stanze, 130 ff., 221
Sebastiano del Piombo (1485–1547, Venetian painter), 54, 149, 170; portraits of Clement VII, 59; *Resurrection of Lazarus*, 124
Sechem, 238
Sedia gestatoria, 146
Sediari, 150
Seitz, Ludwig (1844–1908, German painter), 39
Seleucus Philopator (king of Syria, reigned 187–176 B.C.E.), 144
Senate Palace, 228
Separation of Light from Darkness: Logge, 233, Sistine Chapel, 187
Serbaldi, Pier Maria (c1455–after 1525, medalist from Pescia), 46
Sergius Paulus, 120
Serlio, Sebastiano (1475–1554, Bolognese architect), 68
Seth, 194
Sforza, Cardinal Ascanio, 55. *See also* Santa Maria del Popolo
Shearman, John, 121
Shem, 194, 195
Sibylline writings, 199
Sibyls, 160, 185, 199, 233; Sistine Ceiling, 198 ff.; Tiburtine, 138
Sicily, 2
Siena, 27, 32
Sigismondo de' Conti, 124
Signatura gratiae, iustitiae, 152
Signorelli, Luca (1441?–1523, painter from Cortona), 129, 182, 215
Simmachus (pope, reigned 498–514), 97
Simonetti, Michelangelo (1724–87, Roman architect), 101

Simons, Marlise, 214
Singleton, Charles L., 274
Sion, 12
Sistine ceiling, 182 ff., 251, 254; fictive architecture, 183; medallions and Solomon's succession, 198; order of scenes, 190; portraits of papal saints, 160, 181; sibyls and prophets, 198 ff., 265; theme, 215. *See also under titles of individual works*
Sistine Chapel, 177 ff.; 221; dedicated to Assumption, 181; designed by Giuliano da Sangallo or Baccio Pontelli, 177; papal ceremonies in, 177; proportions, and Solomon's Temple, 180. See also *Last Judgment*
Sistine Madonna (Raphael), Dresden, 257
Sixtus IV (Francesco della Rovere, pope, reigned 1471–84), 8, 9, 98, 137; begins Sistine Chapel, 180; tomb of, by Ghirlandaio, 1493, 36; treatise on the Immaculate Conception, 181
Socrates, 12, 133
Soderini, Piero, 24, 25, 26
Sodoma (Giovanni Antonio Bazzi, 1477–1549, painter from Vercelli), 129, 135
Sodomites, 198
Solomon (c972–c932 B.C.E., king of the Hebrews), 199, 205, 235. *See also* Jerusalem
Somer, Hendrik van (1615–84, Dutch painter), 127
Soothsayers or *vati*, 65
Spain, 2, 8, 10; enemy of France, 14; faction in College of Cardinals, 11
Sparta, 255
Sperandio di Bartolommeo Savelli (c1430–c1500, Mantuan medalist), 46
Split, Palace of Diocletian at, 77
Sprezzatura, 210
Stanza: d'Eliodoro, 114, 144 ff.; caryatids, 152; ceiling, 150; ceiling by Perugino, 157; della Segnatura, 129 ff., dell'Incendio, 144, 152 ff., 165. *See also under titles of individual works*
Statius, 140
Statue Court, 25, 101 ff., 220; and paganism, 242
Steinberg, Leo, 217
Stendhal (Marie-Henri Beyle), 248
Stephen, St., 136
Sterba, Richard and Edith, 215
Stern, Raffaele (1774–1820, Roman architect), 128

Stoning of St. Stephen, tapestry, Vatican Museums, 117, 119
Story of Lot, Logge, 241
Strozzi, Filippo, 24
Stuccatore, stucchi, 245, 272
Styx and Acheron, rivers, 109
SUAVE, Medici motto, 166, 185, 234
Subdeacon, 171
Suggestum, 164
Swiss guards, 7
Sylvester I (pope, reigned 314–335), 72, 171, 174, 175

Tabularium, 227
Tapestries (Raphael), 114 ff.; exhibited in Sistine Chapel, 116
Tebaldeo, Antonio, 140
Tegurio, 164
Telefos, 113
Temperance, Stanze, 174
Temptation and Expulsion from Eden, Sistine Chapel, 189–90
Temptation of Adam and Eve, Logge, 234
Termini, or herms, 255
Terpsichore, Stanze, 139
Tetractys, 134
Tetzel, Johann, 13
Thalia, Stanze, 139
Thebes, 246
Theology, Stanze, 142
Theseus, 108
Tiber, 14, 167; and the Meta Romuli, 165; *Tiber*, Vatican Museums, 109, 113
Tibullus, 140
Tigris, Vatican Museums, 105
Timaeus, 130
Titian (Tiziano Vecellio, 1487/8–1576, Venetian painter), 127, 187
Titoli, 181
Titus, Palace of, 105
Tivoli, temple of Vesta, 90
Tolentino, Treaty of, 103
Tolnay, Charles de, 221, 265, 274
Tomb by Michelangelo for Julius II: 1505 project, 249 ff.; 1513–16 project, 256 ff.; 1525–26 project, 265 ff.; 1532 project, 267; 1542 project, 273 ff.; *Active and Contemplative Life*, 256; as dedicated to Peter and Julius, 251; borrows from the Medici Chapel projects, 267; *cappelletta*, 257; *Captives*, 252, 255; represent arts, 264; souls, 264; heresy, schism, etc., 264; Mi-

Tomb by Michaelangelo for Julius (cont'd) chelangelo commissioned for, 249; monkeys in, 263; no longer destined for St. Peter's, 257; to go under basilica's dome, 249. See also Michelangelo
Tommaso de' Cavalieri, 273
Toulouse-Lautrec, Henri de (1864–1901, French painter), 18
Traini, Francesco (14th-century Pisan painter), 215
Transenna, 180
Transfiguration (Raphael), copy in St. Peter's, 127
Transubstantiation, 136
Trent, Council of, 31, 32; against nudity, 59
Trissino, Giangiorgio, 23, 33
Triumph of Christianity, Stanze, 176
Trompe l'oeil, 229
Troy, 155. *See also* Virgil
Truth, Stanze, 171
Turks, 9, 16, 30; in Stanze, 32
Tuscany, 3, 5. *See also* Florence
Typology, 43 ff., 180, 181

Umbria, 9
Unicorn, 245
Urania Sphaera, 77
Urania, Stanze, 139
Urban I (pope, reigned 222–230), 168
Urban VIII (Maffeo Barberini, pope, reigned 1623–44), 95
Urbino, 3, 5
Ursinus, antipope, 170

Vailate, 14
Valentinian III (419–55, Roman emperor), 20, 148
Valerian, St., 168
Valla, Lorenzo, 16, 159
Vanvitelli, Luigi (1700–1773, Roman architect), 160
Vasari, Giorgio (1511–74, painter, architect, and art historian), 33, 68, 95, 187, 229, 254, 255, 256; on Michelangelo's captives, 263
Vati, 65
Vatican, 8, 97 ff.; becomes papal residence, 98; Borgia Apartments, 36; Braccio Antico, 114; Braccio Nuovo, 128; Cappella Paolina, 99; Chapel of Nicholas V, 35; City, and San Marino, 65; Cortile del

Belvedere, Library and Braccio Nuovo, 99 ff.; entrance structure, 128; field (*ager vaticanus*), 65; Hall of Tapestries, 114 ff.; headquarters for Papal States, 65; Library, 43, 114; Logge, 99, 114, 225 ff.; Museo Pio-Clementino, 98, 99; Museums, 97 ff.; Picture Gallery, 114; rock, *mons vaticanus*, 45; Sala Regia, 99; Sistine Chapel, ceiling and *Last Judgment*, 12, 55, 58, 59; spiral staircase by Bramante, 100; Stanze, 129 ff.; Statue Court, 101 ff.
Vaticinii, 45
Vaux-le-Vicomte, 113
Venezia, Palazzo, 41
Venice: ambassadors, 15; ducal palace, Sala del Maggior Consiglio, 187; to expel French, 15; Republic of, 2, 9, 14
Venus: de' Medici, 107; 101; and Adonis, 110, and Anchises, 110, and Paris, 110; Felix, 107, 110, 113; of Cnidus, 107, 110
Vercelli, 9
Vespasian (9–79 C.E., Roman emperor), 113
Vexillum, 165
Via: Claudia, 75; del Corso, 34; di Ripetta, 23; Paolina, 34
Victories (female), tomb, 257, 263
Victory (male), tomb, 273, 274
Victory of Leo IV at Ostia, Stanze, 156 ff.
Vida, Marco Girolamo, *Christiad*, 22
Vignola (Giacomo Barozzi, 1507–73, Modenese architect), 94
Villas: Belvedere, 29, 101; Giulia, 100; Madama, 80, 168
Virgil, *Aeneid*, 42, 43, 105, 109, 140, 155, 263; *Fourth Eclogue*, 204
Virgin Mary, 136, 138, 245, 256, 276
Visconti, Giambattista, 110
Viterbo, 29; Peace of, 19, 154
Viterbo, Giles of. *See* Giles of Viterbo
Vitruvius, 83, 228; and *ambulationes*, 225, 227; castigates monstrous in art, 245; Giocondo edition, 1511, 83; and Persian Portico, 255, 264

Warfare, Italian, 5
Waterloo, 103
West, Benjamin (1738–1820, American painter), 103
Western Hemisphere, European occupation of, 236
Winckelmann, Johann Joachim, 103

Wolf Metternich, Franz Graf, 71
Wölfflin, Heinrich, 193
Workshop tradition of the Middle Ages, 228
Worms, Diet of, 25
Worship of the Brazen Serpent, Sistine Chapel, 207
Wright, Frank Lloyd (1869–1959, American architect), 128

Xenophon, 134

Zechariah, Sistine Chapel, 199
Zeno, 134
Zeus and the Fall of Phaethon (Michelangelo), Oxford, 219
Zeus, birth, 245
Zeuxis (5th century B.C.E., Greek painter), 229
Zoo, in the Belvedere, 233
Zoroaster, 135
Zwingli, Huldreich, 28